THE ICON HUNTER

THE ICON HUNTER

A Refugee's Quest to Reclaim
Her Nation's Stolen Heritage

TASOULA HADJITOFI

with Kathy Barrett

PEGASUS BOOKS
NEW YORK LONDON

Inspired by the words written on the tomb of the celebrated
Greek writer Nikos Kazantzakis

I fear nothing
As I expect nothing
I am a free woman
And, free I shall remain
as that is my strength

Those who place
their personal interests
above justice & human rights
should fear me
as those, I shall expose

Tasoula Hadjitofi, October 2015

This is a true story and, as a memoir, it is told to the best of the author's recollection. Much of this work—including dialogue—is reconstructed from the author's archives or available in written or recorded records. Certain names have been changed for the sake of privacy.

꧁

THE ICON HUNTER

Pegasus Books Ltd.
148 W 37th Street, 13th Floor
New York, NY 10018

First Pegasus Books edition April 2017

Interior design by Maria Fernandez

Library of Congress Cataloging-in-Publication Data is available.

ISBN: 978-1-68177-323-0

10 9 8 7 6 5 4 3 2 1

Printed in the United States of America
Distributed by W. W. Norton & Company

I dedicate this book to the more than sixty five million displaced and refugee people who have been forced by violence to leave their homelands and who long to return before they leave this world, but especially to my parents, Leonidas and Andriani, who have been waiting to go home since the 1974 Turkish invasion of Cyprus made my family refugees.

CONTENTS

FOREWORD

Love may have been the impetus for me to relocate to the Netherlands, but it was destiny that led me, as a refugee from Cyprus, to settle in The Hague, the International City of Peace and Justice. I found my voice, once silenced by the consequences of war, as Honorary Consul to Cyprus in the Netherlands and as a representative of the Church of Cyprus, repatriating looted sacred artifacts.

War took my identity as a Greek Cypriot child and forced my family and me to flee for our lives during the Turkish invasion of Cyprus in 1974. We lost our home, security, and material possessions that took a lifetime to accumulate. All that remained after everything was stripped away were the remnants of our faith. But the Turkish army took those, too, destroying and looting our churches, desecrating our graveyards, and taking action to erase all traces of our culture's existence.

An opportunity to see those responsible for the cultural cleansing of Cyprus brought to justice took me on a forty-year odyssey in search of stolen sacred artifacts, which led me around the world and often placed me at the brink of ruin. As I am drawn deeper into the shadowy underworld of art traffickers, I learn that dealers of God are everywhere.

Gaining the cooperation of a Dutch art dealer, I successfully orchestrate a sting operation (the Munich case) in conjunction with the Cypriot and Bavarian police, leading to the arrest of Aydin Dikmen, the Turkish art dealer

linked to the sacred artifacts looted from the occupied north of Cyprus, and the international trade. More than five thousand artifacts stolen from Cyprus and around the world were discovered.

The systematic destruction and looting of cultural heritage in areas of conflict threatens our religious freedoms and eliminates precious clues left behind by past civilizations. Our collective human achievement is now more than ever under direct attack as extremist groups value the looting of artifacts and antiquities as sources of revenue to fund their terrorist organizations.

My story speaks to the plight of every refugee in search of their lost identity and warns society about the dangers of leaving our religious freedoms and cultural heritage unprotected.

Culture is key to promoting understanding between different cultures and religions and connecting societies. Our heritage is an archive of the values and traditions we establish over time; it connects us to our past while building a bridge to our future. It is our most valuable inheritance, and my life's work is dedicated to raising awareness about the importance of protecting it.

A NOTE FROM THE AUTHOR

In September 2015, I was able to speak in depth with one of three intermediaries, working directly with Dutch art dealer turned informant, Michel Van Rijn, during the 1997 Munich operation described in the foreword. Our talks covered the months leading up to the Munich operation as well as what took place inside Aydin Dikmen's apartment in Munich during the actual sting itself. These never before revealed details are now included in my memoir to give the reader a multifaceted view of how the trade operates.

Introduction

RESURRECTION

D riven by their devotion to the Passion of Christ, thousands upon thousands of faithful Orthodox Christians pour into Jerusalem during Holy Week. On Saturday they stand shoulder to shoulder in a single perilously overcrowded place of worship to witness the miracle of the Holy Fire. A sea of Greek, Armenian, Coptic, and Syrian Orthodox Christians wave their unlit candles, while Christian youth from the Old City bang their drums and shout in Arabic, "The light is ours, glory to the Orthodox." Devout people from every corner of the globe gather in breathless anticipation, waiting for the spectacle to begin.

A vast complex of interconnected sacred structures encompasses the sites of Christ's torture, crucifixion, and burial, making the Church of the Holy Sepulchre the holiest pilgrimage site in Christendom. The excitement escalates as the arrival of the Greek Patriarch of Jerusalem draws near. Believers jockey for position closest to the mausoleum that contains Jesus's tomb. The evocative sound of ancient tongues including

Aramaic, the language of Jesus, builds to a crescendo that begins to quiet as security men lead the Greek prelate to the entrance of the church. Stepping inside, the Patriarch enters and passes the stone where Christ's body lay in preparation for his burial, and the ten-meter-long mosaic that hangs above it depicting three scenes from his resurrection. The Patriarch then walks directly to the sepulchre, where representatives of the Armenian, Coptic, and Syrian Orthodox churches are waiting. Greek Orthodox clerics wearing their ceremonial vestments also join the entourage. The robed men move in procession holding poles with icons. They make two circles around the rotunda, a ring of arches that surrounds the tomb. After they have completed a third round, the Patriarch stands in front of the mausoleum, known as the edicule, and removes his vestments. He is handed four bundles of thirty-three candles, a number that represents the length in years of Christ's life. He and the Armenian priest enter a small vestibule at the entrance of the edicule. Once the door is closed behind them, the Armenian cleric remains in the chapel as the Patriarch bends down to enter the chamber of the tomb holding his bundles of unlit candles. Around the tomb, a simple marble slab, are Greek Orthodox icons, also depicting the resurrection. To the right and left are moveable wooden icons belonging to the Armenian and Latin churches. Alone in the tomb now, the Greek Orthodox Patriarch kneels in front of Christ's Holy Sepulchre and prays.

Minutes—although it can feel like hours—later he rejoins the Armenian cleric in the Chapel of Angels, holding freshly lit candles, and invites him to partake of the light from the Holy Fire. They briefly open the door to invite the Coptic and Syrian Orthodox clerics into the chapel, and the Patriarch shares the Holy Fire with them. When the doors open again, the Patriarch emerges into the rotunda holding his blazing candles. This sends an electrifying charge through the crowds, like a surging wildfire. The sound of "Christ is Risen!" shouted out in every language imaginable is heard as the light is passed from person to person with unbridled enthusiasm, setting Jerusalem aglow with the spirit of the resurrection.

In the eyewitness accounts of pilgrims down the ages, the light that emerges from the tomb of Christ is often described as mysterious, tinged

with blue and unlike any other flame. People say they can pass their hands through the flame without being burned.

Bishop Vasilios, from Cyprus, moves his torch toward the light and catches the flame. "*Christos Anesti,*" (Christ has risen) says the Patriarch. The bishop bows his head, embraces the Patriarch and says, "*Alithos Anesti,*" (He has truly risen). Vasilios and many other senior Orthodox clergy rush to their waiting chartered planes to return to their homelands in time to pass the light of resurrection to the faithful who are waiting at Saturday evening services.

As a young Greek Orthodox girl, I would listen with fascination to my mother sharing this story, imagining one day that I would be among the thousands of believers and pilgrims in Jerusalem to witness the miracle of the Holy Fire firsthand. I was secretly curious and a bit skeptical as to how this mysterious phenomenon could occur. I would never dare put the question to my elders, as to inquire about such things was frowned upon and was considered rude and sinful by my devoutly religious mother. Questioning is what makes me who I am and makes me feel separate from other people.

EASTER EVE, CYPRUS

Touching down in Cyprus in that evening, Bishop Vasilios is met by clergy from every church on the island. They are waiting to bring the Holy Light to their parishes. As soon as they have captured a piece of the flame, they speed back to their respective communities. In each church, the same drama unfolds. As midnight approaches, most lights are extinguished and the faithful wait in darkness, anticipating the news that their Savior has risen and conquered the power of death.

The mood among the worshippers holding their unlit candles is similar to that in Jerusalem, full of nervous excitement. By this stage, only one tiny flame is burning in each church, on the altar hidden from the people's view: a flame whose ultimate source is Jerusalem. At last the priest comes out into the body of the church, bearing a single candle, and intones the ancient words: "*Defte, Lavete Phos!* (Come, receive the Light, from the Light without evening, and glorify Christ Who is risen from the dead!) The light is passed

around the church as one dripping candle illumines another. The faithful joyfully embrace each other and say, *"Christos Anesti,"* before sharing the Holy Light of Jerusalem with the next person. The darkened interior is now a luminous glow and reveals a kind of parallel heavenly universe.

Frescoes, mosaics, icons, and paintings with the images of saints and apostles and passages from the Bible glow in all their magnificence. At this moment more than any other these sacred images are inscribed on the inner mental map of every Greek Orthodox Cypriot. Even the image of Christ appears to be smiling at the news that he has risen. As the Orthodox world rejoices, church bells ring out all over the island in celebration of his resurrection, and the faithful march in celebratory candlelit processions throughout Cyprus. *Christos Anesti!*

THE ICON HUNTER

One

THE SET-UP

T he middle-aged Englishman checks his reflection in a glass window before entering a Munich apartment building located in the Schützenstrasse. William Veres, a professional numismatist and antiquarian, presses a few loose strands of hair gently back into place. His professional demeanor conflicts with his casual attire as he makes his way to the fifth floor and checks the time on his watch. He is there to meet Aydin Dikmen, the Turkish art dealer, a regular stop on Veres's buying trips in Munich.

The two men have a ten-year history of working successful deals together; something Veres takes personal pride in. The fact that there has never been the slightest hiccup between the two has helped build an unspoken trust between them in an industry where certitude is nonexistent.

Sixtyish and slightly graying, Dikmen greets Veres with a few words in Turkish.

"*Hoşgeldiniz.*" (Welcome) Dikmen's morose expression gives the impression that it may be painful for him to speak. Dikmen's apartment is small and compact, very much like the man himself.

"*Nasılsın?*" (How are you?) Veres replies.

Dikmen's wife appears moments later with Turkish coffee and a dish of baklava. Turkish coffee is traditionally prepared in a *cezve*, a coffeepot with a long handle made out of brass or copper large enough to hold two demitasse cups of coffee. Water mixed with coffee, and sugar if desired, is heated in the *cezve* and removed just before it is brought to a boil. A cream layer of froth called *kaimaki* is divided between the two demitasse cups, and the coffee is brought to a boil.

"*Sağolun*," (Thank you) Veres replies, noting that her disposition is almost as cheerless as her husband's.

The inside of Dikmen's study is lined with bookshelves and cluttered with boxes filled to the brim with antiquities of various types and value. Some are fakes; others are original, and it takes an expert eye to discern between them. The only source of light in the room is from the sun filtering in through one large window. Objects, even those of significant beauty, tend to appear dull in these gloomy surroundings. Dikmen places several coins on the green, felt-covered oblong table resting up against the wall just beneath the window.

The mostly Greco-Roman coins are of little significance. Veres recalls his eye being drawn to one in particular. A Macedonian kingdom Philip II AV Stater, he thinks. Upon closer inspection, he finds an "A" engraved under the bust of Apollo on the face of the coin. He marvels at the details of the raised face. The "A" marking is what makes this specific coin a rare specimen of collectible value. Veres remembers it going to auction for an unusually high price.

Dikmen knows the value of the coin, and Veres knows how much cash he has in his pocket. Veres takes a shot at undervaluing it to give himself a better chance at negotiating a price he can afford. Speaking in German, their chosen tongue for negotiation, Veres organizes his thoughts into a kaleidoscope of information as he quotes little-known historical facts relating to the coin. The beginning of his conversation is always directly relevant to the subject at hand, but he has a tendency to stray. He leads Dikmen on an

Alice in Wonderland verbal tour through anecdotal asides that leave Dikmen pondering the original point of his story.

Veres is engaging. He is extremely intelligent and always slightly on edge, as if he has inside information that the rest of us are not privy to. When his verbal gymnastics come to an end, one is usually left with more questions than answers.

According to Veres, Dikmen is also ardent about historic details, but his forte lies in the visual. As a restorer of ancient artifacts, Dikmen's eye is drawn to the nuances of an object's image and the materials used to form it. These complementary traits prevent competition from developing between them. Instead, they form a bond that makes their relationship as unique as the collectible coins they negotiate.

"I can pay ten thousand Deutsche marks ($5900.00)," says Veres. It is unlikely that his offer will be accepted. One can never really be too sure, because the price of an object always depends on whether or not the seller is in need of cash. When Dikmen declines, Veres offers to help find a buyer for the coin to leave things in good standing between them. The two men sip their coffees in silence without small talk as the spring rays of a fleeting afternoon sun bring their meeting to a close.

<div style="text-align:center">⚘</div>

The landmark nineteenth-century Gray Building in London's West End is the nexus of art and antique trading in the city. With more than two hundred different vendors to choose from, one can find anything from World War II shells made into candlestick holders to centuries-old antiquities. Veres sits in his small shop behind a glass counter reviewing his schedule.

The daily grind and uncertainty of walk-in customers is wearing on Veres, who sees himself as above his circumstances. His goal is to minimize the time he squanders negotiating with lower-level coin traders and build a base of elite clientele who will hire him as a curator to build their antiquities collections. All he needs is the proper introductions to the appropriate people.

A ringing telephone interrupts his thoughts. The voice on the other end of the line is that of Christian Schmidt, an old friend.

"This is a pleasant surprise," says Veres.

"I need a favor, old man, nothing invasive. Are you up to the call?"

"Tell me," says Veres.

"Michel Van Rijn, do you know the name?"

"Not familiar," says Veres.

"He's a dealer known for his expertise in Byzantine art. A bit of an operator, but he does have a flair for attracting deals. You two might be compatible. Okay if he stops by to meet you?"

"Sure," says Veres, who would normally ask why Christian wants to make the introduction but chooses instead to focus on the possibility that good luck has befallen him. Just as he's attempting to up the quality of his clientele, a potential link to the kind of wealthy customer he seeks presents itself to him on a silver platter—or so it seems.

When Van Rijn enters his shop a few hours later, Veres can sense his energy before they make visual contact. Van Rijn is examining a vase.

"How much for the replica?"

The man is a professional collector, thinks Veres. His sophisticated eye and desire to waste no time getting down to business are giveaways.

Van Rijn walks toward Veres, extending his hand. "William, I'm a friend of Christian's. I'm Van Rijn."

Veres remembers the intensity of Van Rijn's eyes, thinking them capable of scanning his soul in the few seconds it takes to shake his hand.

"Mr. Van Rijn."

"Schmidt says you are a master numismatist. I'm embarrassed to say I know very little about the subject but I understand you are an expert on currency." He points to a group of coins inside a glass case. "What makes these valuable?"

Veres relaxes into doing what he lives for: demonstrating the unique wealth of knowledge he holds about coins and antiquities. Van Rijn listens with intensity.

"I'd like to propose a few different ways we might work together."

꙳

In a café a few minutes' walk from Veres's shop, the two men sit drinking whiskey.

"The Cypriot government is going to pay me a huge amount of money to buy back their stolen artifacts," says Van Rijn.

"Really? I'm impressed! How in the world did you manage to strike that deal?"

"One crucial ingredient is missing that you might be able to help me with."

"Please, go on," Veres says.

"It's my understanding that you have a good working relationship with Aydin Dikmen?"

"What's your interest in Aydin?" Veres asks.

"He was a major supplier of artifacts coming out of Cyprus after the '74 war with a free pass in and out of the occupied area, which holds hundreds of ancient churches."

"Sounds like a Byzantine gold mine."

"You have no idea." says Van Rijn.

"Why come to me?" asks Veres.

"Dikmen and I had a falling out over a client I introduced to him from America. Are you familiar with Peg Goldberg and the Kanakaria case?"

"I vaguely recall reading something about it in the papers," says Veres.

"Dikmen and I sold Goldberg four rare mosaics considered to be among the oldest Byzantine Christian antiquities, depicting the archangel Michael, the upper part of the Christ child, and the Apostles Matthew and James."

"What period?" asks Veres.

"Sixth-century mosaics originating from the Kanakaria church. Revered by collectors and worshiped by the Orthodox, they survived the iconoclasts."

"So what happened?"

"Goldberg attempted to flip the mosaics to the Getty Museum for millions in profits and got busted. The trial between her and the Church of Cyprus became a huge headache for Dikmen and he holds me responsible."[1]

"What do you propose?" asks Veres.

"If you know Dikmen, you know his temperament. He will take his anger for me to the grave."

"So you're not on speaking terms?" Veres asks.

"All you have to do is act as my conduit. If you purchase the artifacts for me, Dikmen will never know that I'm involved. It's that simple. We'll get rich, and the Cypriots will have their artifacts back."

Veres asks, "What kind of fee are you talking about?" Van Rijn ignores the question as they continue sizing each other up.

"Veres, we do this deal, and if everything runs smoothly, we go to the next phase."

Veres is elated. What could be better than a no-risk, quick-cash deal and access to clients with deep pockets?

"I appreciate the opportunity. And, please don't take this the wrong way, but I will have to think about it," says Veres. He is the perfect shield for Van Rijn, because of his long, trusted relationship with Dikmen.

"Of course. Take all the time you need, Veres, but let me be straight with you. I feel like you're the guy. I'm willing to pay you good money. Let's not waste each other's time. You are replaceable, my good man. Don't test me."

Veres feels the bite. He wants to investigate Van Rijn beyond Christian's recommendation. Why would the Cypriot government be buying back their stolen artifacts? Veres would have to reach out to a Cypriot, someone connected to the government who could verify Van Rijn's story. The bartender pours another round.

"To all things old," says Veres, raising his glass.

❧

The next day Veres reaches for the phone and dials a number in Cyprus.

"My friend, a quick word. There is a rumor that Michel Van Rijn is working with the Cypriots?" The frown lines on Veres's face relax as his source in Cyprus reveals the inside information he seeks.

"I see," says Veres. "Honorary Consul in the Netherlands . . . a young woman, Tasoula Hadjitofi. Interesting."

Two

HERE WE GO AGAIN

THE HAGUE, OCTOBER 6, 1997

An early morning phone call jolts my equilibrium before my lips have a chance to sip the cappuccino just placed on my desk by my assistant. On the other end of the line is the voice of Dutch art dealer Michel Van Rijn.

"What do you have to say for yourself now?" I ask, knowing that Van Rijn is incapable of providing me with a straight answer. Instead, I opt to give him leave to say his piece, and then I can interpret his layers of meaning as needed. This morning, he is surprisingly brief.

"I'm out of detox. I leave London for The Hague in an hour. Meet me at the usual place. It's important, Tazulaah."

Van Rijn is streetwise and intelligent, yet he insists on calling me *Tazulaah,* instead of my given name, Tasoula. His attempt to rattle me with his exaggerated pronunciation fails. During the last ten years, I have tried to become a worthy opponent to his psychological gamesmanship. My focus steadily fixes on getting him to provide me with information that will indict

his former business associate, Aydin Dikmen, a Turkish-born art dealer known as "the archeologist." Dikmen is rumored to be a link between the illicit trade in the Turkish-occupied northern zone of Cyprus, and art traffickers worldwide. In reality, he is a man of great interest to the Cypriot police. He is suspected of leading a team of thieves into the Turkish-occupied northern zone of Cyprus, where the looting and pillaging of hundreds of Orthodox churches occurred.

Van Rijn and Dikmen were quite the team. Dikmen, the introvert, remained in the background acting as the conduit for the looted Byzantine treasures, while Van Rijn, the extrovert, falsely presenting himself as a descendant of the Dutch master painter Rembrandt Van Rijn, easily charmed a bevy of wealthy collectors to Dikmen's door.

"Van Rijn," I say with a sense of indifference, "you can't disappear in the middle of planning a sting operation, not contact me for weeks, and expect me to trust you to be reliable."

He responds with one of the many personalities I have seen surface through the years: that of the little lost boy, reaching out and in need of maternal rescue.

"Do you know how hard this is on me?" Then the tone of his voice changes again. "If we don't move on this opportunity now, it's on your head," he says, and then the line goes dead.

Van Rijn's time as one of the most successful dealers in the art trade is in his past, but the opportunist in him is always present and working. I feel as if I live in a perpetual game, always cognizant of the fact that he analyzes my every word in an attempt to checkmate my next move. I must always be three steps ahead of him. Van Rijn lives everywhere and nowhere, because his questionable business practices leave a trail of angry people in the wake of his deceit. His behavior forces him into a kind of nomadic existence, which means I have no way to contact him; he must always contact me.

Van Rijn is willing to lead me to a possessor who holds a large inventory of stolen Cypriot artifacts, but unless I move now they could be lost forever. The Church of Cyprus spends a fortune in legal fees for recovery efforts, with no guarantee of results. I feel my best choice may be to make a deal with a devil.

Cyprus lies at the intersection of Africa, Asia, and Europe, a lure for conquerors who coveted the island's strategic location and bountiful resources. With a history that dates back to the Stone Age, Cyprus became host to the Assyrian, Byzantine, Egyptian, Greek, Hebrew, Minoan, Ottoman, Persian, Phoenician, and Roman cultures. As each great civilization left its footprint, it transformed Cyprus into a treasure trove of cultural heritage. Archeologically speaking, Cyprus holds valuable clues to the past, but it has also become a target for present-day enemies wanting to eradicate the symbols, iconography, and traditions of other cultures and faiths.

After the Turkish military invaded Cyprus in 1974, they proceeded to illegally seize control of 36.2 percent of the island, prompting the unprecedented looting and destruction of Cyprus's sacred sites. Turkey used the occupation to divide the island and expel more than one third of the Greek Cypriot population from our homes and destroy proof that the Greek Cypriot culture existed, a culture and language adopted by the Cypriots when the Mycenaean Greeks permanently settled there during the Aegean Bronze Age.

Despite the Cypriot Department of Antiquities calling on UNESCO in December of 1974 to send an adviser in order to call for a stop to the destruction, Canadian scholar Jacques Dalibard, the expert called upon, did not arrive until March 1975.[1] Dalibard regarded Cyprus as "one huge monument." During his scheduled visit to the occupied area, he received limited access to churches and archeological sites, and even if he had been given full access, it was almost entirely too late: out of five hundred churches that stood in the northern occupied area of Cyprus, only five remained intact.[2]

During the first century, as recorded in the Acts of the Apostles, Cyprus played a major role in Christianity and held some of the world's oldest sacred artifacts.[3] Church interiors were brimming with frescoes, icons, and mosaics, dating back as early as the fifth and sixth centuries A.D.; those works had been brutally removed to be sold abroad. Archeological excavations conducted at Salamis, Soloi, Enkomi, and Apostolos Andreas-Kastros were ravaged. Cemeteries were desecrated and tombstones were shattered. The size and scope of

the destruction and looting was impossible to measure because the Turkish army militarily controlled northern Cyprus, and any access to enter that part of the island was denied, even to Dalibard, who called for the creation of a permanent overseer to be stationed in the occupied area to supervise the protection of cultural and sacred heritage. His observations were considered by UNESCO to be too controversial and his report was modified without his permission for political purposes, perhaps due to pressure from the Turkish government.[4, 5] I was told by two foreign diplomats, whose names I can't divulge for security reasons, that Mr. Dalibard's life had also been threatened.

The lack of intervention by the international community signaled to the Turkish military, art traffickers, and organized looters that they could continue to do as they pleased with Cyprus's ancient artifacts. The Cypriot government became aware of the scope of this problem only when the artifacts began turning up for sale on the international market. It is estimated that twenty thousand icons, several dozen major frescoes and mosaics dating from the sixth to the fifteenth century, and thousands of objects of significant historical and cultural value (such as chalices, crosses, wood carvings, and bibles) were looted and found their way into the illicit trade.

With access to the occupied area revoked by the Turkish military, it was impossible for the Republic of Cyprus to take an accurate inventory or evaluate the scope of the destruction and looting. It had been unfathomable for the Orthodox Cypriots to think that the art and religious symbols within the sacred walls of our houses of worship would ever be stolen or destroyed. Our churches were rarely locked.

The sacred treasures of Cyprus, even if located, were next to impossible to repatriate. The records kept by the Department of Antiquities prior to 1974 only chronicled the most significant historical artifacts. The information was documented by hand on index cards, and not every object was catalogued. Photographs of any of the treasures were extremely rare. The government did have access to eyewitness identifications made by the people who restored and cared for the artifacts, but most often it was the faithful parishioners who prayed before them multiple times daily who offered the most valuable information. Sometimes proof of provenance could be obtained from international scholars whose research was cited in academic reports and

publications. Still, this combination of incomplete, handwritten archives and insufficient church inventories presented enormous challenges for Cyprus, as the courts place the burden of proof on the original owner.

Stories about the restitution of art looted from Jewish collectors by the Nazis often grab headlines in the media, and it is worth comparing the framework for recoveries with Cyprus's situation, though the differences are considerable. It's important to remember that the Nazi government stole from its own citizens in the first instance: it was only after World War II broke out that they turned their attention to the occupied countries, plundering Jewish collections in the Netherlands and France. This was more than wartime trophy-hunting—it was part of a policy of racial persecution against a specific people that ultimately led to genocide.

Some Nazi-looted art was returned to the original Jewish owners after World War II by the Allies and the West German authorities. But most could not be traced, and a grey market in looted art flourished.

Even when Jewish families did manage to trace art that was stolen from them and prove it indisputably, there was—and still is—no guarantee they will get it back. Lawsuits to recover Nazi-looted art face considerable hurdles, among them statutes of limitations and other technical defenses. It wasn't until 1998 that the Washington Conference on Holocaust-Era Assets brought together the representatives of forty-four countries and nongovernmental organizations to endorse the non-binding Washington Principles. These require museums to conduct provenance research on their collections and achieve a "just and fair" solution on Nazi-looted art with the original Jewish owners or their heirs. In the Netherlands, for instance, the government-established Restitutions Committee adjudicates claims from the heirs of Jewish collectors for art in Dutch museums. This extrajudicial institution, which disregards statutes of limitations and similar technical barriers to restitution, has recommended handing over many artworks in public collections, including more than two hundred paintings returned to the heir of the art dealer Jacques Goudstikker in 2006.

Like the original owners of Nazi-looted art, Cyprus is frequently reliant on the goodwill of the current possessor to reclaim her lost treasures. Unlike Nazi-looted art claimants, Cyprus has no recourse to advisory panels like

the Dutch Restitutions Committee. Museums, collectors and auction houses could do much more to help by conducting due diligence and provenance research. The Washington Principles and the publicity surrounding Nazi-looted art cases have helped to raise awareness and sensitivity in the art trade about the need for a clean provenance during the years of the Third Reich. This should also apply to unprovenanced ancient Cypriot artifacts that suddenly appear on the market. The chances that they have been plundered since the occupation began are extremely high.

※

The Lange Voorhout is a tree-lined avenue in the old city center of The Hague that runs for about a quarter of a mile past grand homes and stately eighteenth-century former palaces now housing institutions such as the Supreme Court of the Netherlands, foreign embassies, and museums. The area is a popular draw for tourists and locals who in season pass a sea of multicolored crocuses on their way to explore the outdoor markets and art exhibits.

Stepping through the revolving doors into the lobby of the Hotel des Indes brings one back to a bygone era. Built in 1856 by architect Arend Roodenburg, the hotel's marble columns and high ceilings give this former palace an atmosphere of grandeur and elegance.

Accompanying me tonight is my husband, Dr. Michael Hadjitofi, a tall, fine-featured, blue-eyed Anglo-Cypriot who works as a Shell International executive. Whispering in my ear, he says, "I was looking forward to a quiet night, just the two of us, but instead I get to watch my beautiful wife match wits with a dealer."

Being referred to as beautiful still makes the tomboy in me blush. Growing up, I challenged the stereotypical definition of femininity by competing against boys in academics and physical competitions. It gave me a unique insight into male thinking and got me accepted into their inner circle as "one of the boys." My short bob hairstyle suits my active lifestyle, and my sophisticated style of dress is reflective of my respect for the Orthodox faith.

"Finding me beautiful after ten years of marriage makes you priceless, my mouse," I say playfully.

"You could be the female version of Richard Branson if you would focus your energy on your business instead of the icons."

"I need both, Michael," I say. "And you are doing me a great favor by being here tonight. Imagine a married consul meeting Van Rijn at the bar of des Indes in the evening. . . ."

"Tasoula, I respect what you do, but your mind is always on the artifacts!"

Michael is concerned about my obsession with the artifacts, and justifiably so.

"Michael, I promise to finish this meeting quickly so we can go straight home. By the way, I have a present for you."

Michael holds out his hand in a playful gesture, expecting to receive a gift. I lift my skirt to teasingly reveal the edge of a garter peeking out from beneath the hemline. It works. Michael responds with a devilish grin. Leading him out of the lobby traffic into an alcove, I take a moment to reassure him.

"I hear you, love," I say. "Understand, Van Rijn is crucial to the capture of Dikmen, who is a supplier of Cypriot antiquities to the international market. Please, don't ask me to walk away when I'm this close."

Michael places his arm around me, his way of confirming that he stands by me, but I sense it is only temporary. We walk past the central marble staircase that has welcomed luminaries such as Winston Churchill, Anna Pavlova, and Mata Hari, as we head for the bar, where Van Rijn awaits us.

Against the backdrop of plush jewel-tone draperies, we spot him sitting with another gentleman. Van Rijn's brown hair is trimmed short; his mustache is perfectly manicured, and he wears a cool, calculated demeanor as an accessory to his expensively tailored clothing. His contrasting colored Hermès handkerchief perfectly folded in his suit pocket reveals his flair for creativity. He has the taste and mannerisms of an aristocrat with a touch of gangster thrown in for good measure. He rises to greet us and introduces us to Robert Van Dorn, his financier, who wears a pair of round spectacles usually associated with the look of an accountant. Van Dorn is middle-aged, conservatively dressed, and has a friendly but authoritative demeanor.

"Madame Consul."

"Tazulaah . . . Michael, please sit down," Van Rijn says.

"Why did you disappear in the middle of planning the sting?" I ask, with a slight tone of irritability.

Mr. Van Dorn intercedes, "Mr. Van Rijn is under a great deal of pressure. His father's health is deteriorating and his girlfriend has left."

"Sir, I came here to speak with Mr. Van Rijn."

Van Rijn puts his hand up, "Let him finish."

Van Dorn continues, "I'm here to assure you that I will help support him through this process. He's just out of detox and not in a position to handle his finances. His fees should be paid directly to me."

"You can witness the deal, Mr. Van Dorn, but I know Van Rijn for ten years now, and I've only just met you. I would rather deal with the devil I know."

Van Rijn responds with his loud, boisterous, head-turning laugh.

"Convince me you are stable enough to follow through with Munich," I say. "You have no idea how much time and money you've cost the police and myself!"

Smiling, Van Rijn inquires, "Are you telling me you care?"

"Assure me that you have your sanity and won't bail on me again."

"I'm serious, Tazulaah. My men have been negotiating for days. I can't hold them up any longer. If we don't move now, we risk losing the artifacts. You must trust me."

I try to gauge if there is a trace of authenticity in his words. I have placed everything on the line to execute this Munich sting. The one variable that I cannot control is Van Rijn.

"I need Munich to be a success just as much as you do," he says. "If we don't put Dikmen behind bars, he will finish me. Isn't that enough motivation? Besides, I need a favor."

Van Rijn does nothing without an ulterior motive.

"My father . . . He's dying."

"I'm sorry to hear that," I say.

"He's read all the negative news about me through the years. I want to show him I can be the man he wants me to be. Please, speak to him. Tell my father I am helping the Cypriots to recover their artifacts. He will believe it coming from you."

"Does he know me?" I ask.

"I speak to everybody about you, Tazulaah."

I didn't see this coming. Van Rijn and I never speak about personal issues. There is a sense of urgency in his tone. His father's terminal illness, if true, would give him motivation to frame his former partner. But will it be enough to keep him sober until the mission is completed?

"Deliver Dikmen and the treasures, and I will speak to your father, but not a moment sooner. Your terms."[6]

"A fee of two hundred fifty thousand dollars plus expenses paid. I also want a month in a Cyprus hotel."

"Why?" I ask.

"To recuperate before I move to Australia to start a new life." He leans across the table and looks at me with his piercing eyes. "Immunity from prosecution for me and my men with the Germans and the Cypriots. I don't want your country coming after me for working with Dikmen in the past, and I don't want the Germans to implicate me for helping you now. My gypsies don't even know this is a sting. They believe it's a real buy," he says.

I finish taking my notes. Our eyes lock onto each other's. He takes a sip of espresso.

"We need two hundred thousand Deutsche marks ($114,000) for the exchange with Dikmen. This money is returnable to you once it is confiscated by the police."

I jot down his words.

"One more thing," he adds with a slight smile forming at the corners of his mouth. "You will be my hostage, or do you prefer, 'my guarantor'?"

Michael's body language tells me he does not appreciate Van Rijn's comment. "Shall we finalize the deal tomorrow morning and decide when to travel to Munich?" he asks.

I turn to Van Rijn with all the swagger I can muster. "You expect me to gain the cooperation of the Church, the government, the Cypriot and Bavarian police without knowing what we can expect to recover?"

"Tomorrow morning, ten o'clock, you'll get your list."

I agree.

"Now the golden couple can get on with their evening plans," he says, as he stands to see us off.

OCTOBER 7, 1997

Driving to my office situated close to the city center and government buildings, I think back to ten years earlier when I first founded Octagon, my IT services and professional manpower company. The company's immediate success shifts my image from refugee to "wunderkind." I go from working to survive to gaining my financial independence and giving the naysayers, who see refugees as a financial burden on society, something to ponder. The combination of business acumen and a desire to help my family back in Cyprus drives my ambition, but it is my instinct to seize the right opportunity at the perfect time that seals my success. It worked when I was founding Octagon, and now I am hoping it will serve me well once more.

I learn this morning that my pursuit of Aydin Dikmen and the return of the artifacts is coming at a steep price. The interim manager I hired to run the day-to-day operations of Octagon is using my contacts to boost his career while Octagon's profits dwindle under his supervision. Michael is right. When I focus my energy on my business it soars, but my attention is spread thin and Octagon's profits are falling.

While wearing the multiple hats of mother, wife, entrepreneur, and consul provides me with the mental stimulation I crave, I can no longer ignore the cost of "having it all." I am living in a state of constant turmoil, pulled between my responsibilities and the devotion I feel to seek justice for my native country. Michael believes that the Cypriot government should be doing the work that I am doing as a representative of the Church of Cyprus, but the Cypriot government does not see repatriation as a priority. Gaining Van Rijn's cooperation to take down Aydin Dikmen in a sting operation is a once-in-a-lifetime opportunity. I feel that this is something I cannot turn away from.

My sense of urgency is driven by the fact that these sacred treasures that Dikmen holds in his possession are more than just inanimate objects to the people of Cyprus. They are the vehicles through which our prayers are conveyed. Every inch of interior space of an Orthodox church is covered with paintings, mosaics, frescoes, and icons depicting scenes from the Bible that welcome us into a heavenly domain so that we may revitalize our faith. The

creative process for the artists themselves is a spiritual one. They fast and go into deep prayer to commune with God before they begin and during the process. Passages of the Bible are brought to life through the interpretation of these artists, whose pure state of creation exposes the nature of their own souls in producing these works.

Bringing these artifacts home to Cyprus will help to restore the identity of refugees displaced by war, like me. I feel a personal sense of responsibility, a calling that supersedes all logic and rationale, and goes beyond politics and ambition. My sense of injustice drives me to reclaim what was looted from Cyprus, and I will follow this vocation wherever it may lead me.

Buzzing my assistant on the intercom, I work the tasks at hand to secure my departure for Munich.

"Get me the archbishop, please."

His Beatitude Chrysostomos I, Archbishop of Cyprus, was appointed the spiritual leader of the Church of Cyprus in 1977 after the death of Archbishop Makarios III.

The archbishop and I share the same goal. We believe that every time a looted artifact is repatriated, it brings hope to the Cypriot people. The archbishop has an approachable ease about him.

"Your Beatitude," I say, "good morning. Are you alone?"

The archbishop treasures his collection of musical clocks and boxes, most of which have been given to him by visiting dignitaries. Chiming sounds play in the background at regular intervals, adding an element of surrealism to our fraught dialogue.

"The attorney general hasn't reached out to me yet," he says. "Is the MFA [Ministry of Foreign Affairs] aware of what is happening?" he asks.

"You know how politics works," I respond. "If Munich's a success the attorney general's office will claim the credit, and if it fails they will blame it on the actions of a 'rogue consul.'"

"Who will be looking after your family while you're gone?" he inquires.

"My in-laws are in town for my niece's wedding and they will stay on while I'm in Munich."

"Just a moment please," he says. The muffled sound of people bidding him farewell as they exit his office can be heard.

"*Parakalo*," (Now I am alone) he whispers.

"Your Beatitude, Van Rijn is ready to go. Do you approve of my making a deal with him?"

The archbishop's voice is calm and reassuring.

"The Church is behind you," he says. "I worry for your safety. Is there anything I can do?"

I remain silent, not wanting to show the underlying terror I feel hiding just beneath the surface. "You are not alone, Tasoula. God is looking out for you."

Ending the call, I feel an enormous sense of responsibility. Not everyone within the hierarchy of the Church agrees with the archbishop's decision to place his trust in me. The archbishop is risking his reputation should the Munich operation not deliver on its promise to bring the artifacts home. There are ambitious Cypriot clergy who will use any failure in Munich to create public doubt about his leadership.

※

Arriving at the Hotel des Indes for my meeting with Van Rijn, I find the reception area surprisingly empty. "Would you please ring the room of Lexicon?" I say to the young man behind the desk, using Van Rijn's requested alias.

Van Rijn rarely uses his real name. He carries multiple identity cards and checks into the finest hotels using false documentation. Van Rijn tips generously, gaining the trust of establishment management. He wears the façade of a wealthy man, parading himself as a descendant of Rembrandt Harmenszoon Van Rijn, the masterful Dutch painter and etcher, in order to lure wealthy purchasers into his field of play. He baits buyers, tantalizing their inner greed until they willingly follow him into his web of deceit. Van Rijn even sold a Rembrandt self-portrait to a Japanese museum by posing as a descendant of the painter.

Yet, here I am about to make an important deal for my country in partnership with him. Despite his reputation, I do believe that he can and will lead me to Dikmen's inventory, but it will be up to me to prevent him from sabotaging us both until we execute the sting.

Van Rijn arrives and ushers me to a table in a corner of the lobby. His jacket is neatly draped over an empty chair next to him, most likely concealing a recording device.

"My 'gypsy' and I leave for Munich on the four o'clock flight," he says, kicking the meeting into high gear.

"What do you mean 'gypsy'?" I ask, and then it dawns on me that he is talking about leaving for Munich today. "Van Rijn, there is no time for me to make arrangements," I say, trying not to sound as panicked as I feel.

"You better get busy," he responds, as if what he is requesting is reasonable.

"You're mad!" I say, unable to prevent my voice from escalating. "I have a business, children, and a husband to deal with, plus Interpol, the German and Cypriot police to coordinate."

He looks at his watch with no attempt to conceal his smugness.

"Time is not on your side."

This tug of war for power in the relationship keeps me in a state of constant vigilance.

"What are you guaranteeing in exchange for your fee, Van Rijn? Unless you give me a list, we go nowhere."

"The Saint Thomas and Andreas Kanakaria mosaics, a dozen frescoes, and two icons, one of which has its eyes gouged out. That's the minimum, but you'll get more."

"You realize your fee depends on delivering what you promise. Are we clear?"

Van Rijn nods in agreement.

"Just to confirm: you are guaranteeing the Andreas mosaic?"

"If the Andreas is not in Dikmen's apartment, you'll have Dikmen to tell you where it is. Your Bavarian police will find far more than what you hold me to the fire to guarantee, I assure you."

"Four P.M., then," I say, never taking my eyes off his. "Don't you dare disappear again." Several weeks ago, in the midst of planning the sting operation, Van Rijn disappeared. I vowed to manage him moving forward, placing my own reputation at risk.

In a race against the clock, I speed toward my home in the The Hague, while dictating last-minute instructions to my assistant over a mobile telephone.

"Book a ticket on the four o'clock flight to Munich. If there are passport renewals, reschedule them for next week. And, Ellen, please call and connect me with Sergeant Serghiou of the Cypriot police."

"He is on the line, Mrs. Hadjitofi."

Sergeant Serghiou is the supervisor of Officer Tassos Panayiotou, one of the two Cypriot police officers joining me in Munich.

"Sergeant Serghiou, Munich is on for today. Can you get the next flight out?"

"Impossible! There are no direct flights from Larnaca to Munich. Even if the police leave now, they can't arrive until tomorrow night. Surely Van Rijn can give us a day," he says.

"He's demanding I fly with him and his 'gypsy' intermediary. I will try to delay things on my end," I say.

"For God's sake, Tasoula, these are dangerous men. You can't be on your own."

"Have the Bavarian police book me on a different floor from Van Rijn and his men and give me round-the-clock protection."

"Tassos and Marios will be there soon," says Serghiou. "I pray for you."

What if something does happen to me in Munich? Aydin Dikmen supposedly has an order out to have Van Rijn killed. Will I become fair game if it's revealed that I orchestrated the sting with him? Who will tell my story if I don't survive?

This makes me think that I should have witnesses who can speak for me in case things go terribly wrong in Munich.

I telephone my younger sister Yiola in Cyprus.

"I'm involved in something very big, but I can't talk about it. What I do, I do for Cyprus."

"Please, you must tell me. I won't repeat a word of it to anyone," says my sister.

I cut the conversation short because I must not place Yiola at risk.

Next, I telephone Marina Schiza, a respected cultural reporter from Cyprus who has written several stories about my repatriation work through the years. I give her the same cryptic message with an additional request.

"If I don't return, there are those who will attempt to tarnish my good name and reputation. I'm counting on you to tell my story," I say.

"Give me something more, Tasoula!"

"I can't."

I also leave a message with Kyriacou, a news presenter for Logos TV in Nicosia. Now I feel confident that the people I have informed will let the truth prevail should something happen to me.

❧

Pulling into my driveway, I notice that the acorns and changing fall leaves have blanketed my garden and pond and need blowing. The scent of wet earth from a recent rain follows me as I make my way into the garage and up the back spiral staircase that leads to the kitchen. My Cypriot father-in-law, Kyriacos Hadjitofi, and my sweet, blond, blue-eyed mother-in-law, Violette, are in town visiting us from London and are in the midst of having their afternoon tea. I head for the glass room just off the kitchen, which overlooks our gardens and is my favorite place in the house. Michael looks up, surprised to see me.

"You're home early. What's up?" he says.

"I leave for Munich on the four o'clock. How can we manage this, love?"

"Of all times, Tasoula, my parents are here!"

"Let's be thankful they are here with us and that you are as well. If this happened next week, you would be in Russia and I would be unable to go. It's a blessing, Michael."

"Is the archbishop backing you up on this?" he asks.

"Do you think I would do this without his support?" I ask. "I'm all yours after this, Michael," I say, hoping these words will free me from further discussion.

"No more icon hunting after Munich?"

"You have my word."

"Another child?"

"Yes, God willing."

A part of me does not feel that I should have to negotiate Munich with Michael. There is no refuting that my family has been coming second to my pursuit of Aydin Dikmen.

Andreas runs into the glass room and jumps into my arms.

"Mommy!" he cries.

I smother him with kisses as I always do, and we all walk into the kitchen where my in-laws and my daughter, Sophia, are. Sophia can spend hours playing with a tiny piece of bubble wrap.

Sophia sits on my lap. As a lone tear runs down my cheek, she tries to stop it with her finger, and she is quite pleased with herself for doing so. It's moments like this that I wonder if she understands more than I think she does. Her smile makes me laugh, and my laugh causes Andreas to wrap his little arms around my legs. I realize these are the precious moments I am risking.

"Andreas, mommy loves you even when she must travel for work."

He nods in agreement, yet I feel his sadness. "I promise to call you every morning and again before you go to sleep each night from wherever I am." He buries his little face in my arms. With a big smile, he calls out to his grandmother.

"Come, Nanny, play dominos with me."

"That's my boy. Give me five!" I say, appreciative of what a cheerful and resilient child Andreas is. He slaps my hand laughing with abandonment. Biscuits and jam rolls from Marks & Spencer fill the countertop. "Mum, please don't give Andreas too many jelly babies. These English sweets are so full of sugar," I say, which she acknowledges with her beautiful smile.

I turn to Michael. "My darling, please help me say good-bye to my other babies?"

Michael follows me down the flight of stairs leading to our basement. We walk past the bar and billiards room to a floor-to-ceiling vault built into the wall, one of the alluring extras that attracted me to the house. Opening it requires some muscle. Inside sit thirty-two cartons filled with pieces of frescoes from the Antiphonitis church in Cyprus. He picks up the box holding the Kankaria mosaic of Thaddeus and places it on the billiards table facing up. I make the sign of the cross three times and bend down to kiss it and pray.

Three

THE SURPRISE

At a coffee shop just behind customs, in Schiphol airport, Van Rijn sits with a man he calls Lazlo, one of three men who will act as intermediaries in Munich, whom he refers to as his "gypsies." Dressed all in black with long, dark hair; I sense Lazlo's uneasiness in meeting me. Van Rijn says, "I'll be back in a moment with our coffees," and when he leaves for the self-service counter, I attempt to engage Lazlo in friendly conversation.

"What do you do when you are not working with Van Rijn?" I ask with a warm and friendly smile.

"Don't talk to me," he says in a tone that sounds close to a growl.

"Excuse me?" I say, confused by his reaction. He points toward Van Rijn.

"You talk to him. Never directly to me," says Lazlo. "That's the protocol. If you insist on crossing the line—" He runs his finger across his neck making a gurgling sound as if his throat was cut. As he stares me down with his vacant eyes, shivers run down my spine.

An announcement comes over the public address system. Flight 546 to Munich, Germany, will be delayed.

Van Rijn returns.

"Are you carrying the two hundred thousand Deutsche marks ($114,000) that we need?"

"I would never carry that kind of cash, and don't you dare question whether or not I've done my job. You control your people and I'll control mine." Looking at Lazlo, I continue, "That's my protocol."

"The flight is delayed, so come be my lucky girl at the casino," Van Rijn suggests.

"Casino! You're on your own," I retort.

Van Rijn says, "You have an obligation to keep an eye on me."

Van Rijn, unfortunately, is right. I can't risk having him out of my sight. I feel compromised just being in his company.

I look over and see Van Rijn is placing bets at the roulette wheel for a thousand dollars a turn, and losing.

"Isn't succeeding in Munich enough of a gamble for you today?"

At the roulette wheel, the dealer calls 47 black the winner. I hardly know where to cast my gaze when Van Rijn tries to goad me into participating yet again.

"Come on, girl, give me a number."

In the course of a few minutes, Van Rijn loses thousands of dollars. Remembering how my family in Cyprus struggled to begin again after they lost everything in the war leaves me with no tolerance for witnessing such wastefulness. Spending is an addiction for Van Rijn.

"You sabotage yourself," I say, alarmed by the fact that he is showing signs of instability en route to complete the sting.

"You will never get another penny from me or the Church if you go broke here," I say angrily.

"Come on, Tazulaah . . ."

An hour and a half later we arrive in Munich. Once we pass through customs, there is a glass wall leading out to the exit, which provides a clear view into the arrivals area. Van Rijn points to Peter Kitschler and, never having met him before, he says, "There's your dog, Tazulaah. I can smell him a mile away."

Peter Kitschler, chief of the art theft unit of the Bavarian police, is quite tall, with a muscular frame, and his jet-black hair and mustache give him an appearance more Greek than German.

Kitschler ushers Van Rijn and Lazlo into his car and places me in another car with a curly-haired man wearing a single earring who identifies himself as Helmut, my bodyguard. We check into the Hilton Hotel and make arrangements to meet later in the bar. I find Peter alone.

"Helmut is in the room next to you. He is your shadow twenty-four-seven." He points to several different people in the lobby. "There are seventy agents working undercover in the hotel. The telephone lines are bugged. Van Rijn's room is under surveillance. I want to assure you that we have taken every precaution to ensure your safety," says Kitschler. That Peter Kitschler has managed to arrange all this in such short time is impressive. Van Rijn and Lazlo join us.

Kitschler says, "No use of mobiles. Dikmen has links to a large criminal network. We can't risk them breaking into our conversations."

"How many of your men are on board for the sting, Mr. Van Rijn?"

"Lazlo is aware that this is a sting operation. Veres and Rossi believe it is a legitimate purchase and that I am working undercover for the Cypriots. We thought it best to use the name of Eftis Paraskevaides [an art dealer in London]. Paraskevaides stems from one of the wealthiest families in Cyprus, so Dikmen now believes that Eftis will be purchasing the artifacts to return to Cyprus."

"Is Eftis aware that you are using his name as a cover?"

"No. Eftis has no idea. Dikmen trusts Veres because they have a long history of doing successful deals together so Dikmen will believe whatever Veres tells him."

In this art underworld, reputations are not checked in traditional ways. You must have an established trust within the network, as most deals are executed with a handshake. The world-wide web did not exist at this time so access to information was not readily available as it is today. There was little concern that Van Rijn's cover as Eftis would be blown. The fact that Eftis chooses to work through an intermediary and not deal with the Turk (Dikmen) directly also makes sense, considering the history of feuding

between the two cultures. Veres believes this is a straight deal, which will not jeopardize his relationship with Dikmen. He will receive a tidy fee and believes access to Van Rijn's connections will expand his own business prospects.

"How are you planning to execute the buy?" asks Peter.

"Lazlo will be in constant communication with me by phone for the entire duration of the sting," Van Rijn continues.

Kitschler says, "I need to see the people involved."

"Of course," says Van Rijn. "Peter, regarding Veres, if anything causes Veres's trust to waver, Dikmen will feel it. We must not do anything to evoke his suspicion."

"And the other men?"

"Stephen Rossi is the younger, collegiate-looking intermediary who will be acting as Veres's assistant. Veres will be reporting to Eftis, my alias for the sting."

Kitschler says, "Special Operation forces needs photographs of your men to ensure their safety. They will be at the hotel at ten thirty tonight."

Peter thinks momentarily and says, "It's best if we photograph Lazlo separately at the station tomorrow. Veres and Rossi will be photographed tonight under cover."

Van Rijn interrupts. "Tazulaah, you'd better keep your distance."

"Remember who is in charge. I'm not going anywhere," I say.

"Your picture is always in the papers. We can't take any chances on you being identified and our cover being blown," says Van Rijn.

Kitschler says, "Leave this to me." He turns to Helmut and says, "Tonight in the lobby, you sit at another table with Tasoula. We can pose you as a couple. Your backs will be turned to Van Rijn's table."

"I will still manage to keep my eye on you regardless," I say, bringing a moment of levity into a tense situation.

Van Rijn continues, "Dikmen is the godfather of the underworld. He is under the protection of the Serbians and Montenegrins and already has one hit out on me. If he gets wind of my involvement in the sting, I'm a dead man."

"The phone call to Eftis will not raise suspicions for Dikmen?" Kitschler asks.

"No, he thinks that Eftis Paraskevaides is in the hotel with the money, and once the inspection takes place, he'll release the cash through his intermediaries. Remember that Dikmen is a Turk and Paraskevaides is a Greek Cypriot. Dikmen will understand why Eftis will not consider going to a Turk's house to buy. Trust me, the bad blood between the Greeks and the Turks goes back to the Ottoman Empire."

"When shall we begin?" asks Kitschler.

"My men have worked all week in preparation. I promised them a lunch tomorrow. Afterward we can go to Dikmen."

"But the Cypriot police don't arrive until tomorrow night," I say.

"I can't hold my men until Monday. It's tomorrow or never," says Van Rijn with complete conviction.

"We are in agreement, then," says Kitschler. "Tomorrow we sting. Let's meet down at the station first thing."

"I have to make a stop at the bank first to check on the transfer," I say.

"I'll have an officer accompany you," says Peter. He ends the meeting by saying, "For everyone's safety, please, no contact with the outside."

❧

That evening my bodyguard and I sit with our backs facing Van Rijn's table in the Hilton Hotel bar. Van Rijn, Veres, Rossi, and Lazlo are drinking heavily and talking about the lavish lunch they will have the following day at my expense. Van Rijn is being the "big man," cursing up a storm as he shares his adventures.

"Remember," he says to them. "Eftis expects to be given a list of preferred items, and he will tell you what he wants to buy. Eftis wants mosaics and frescoes, icons, bibles, crosses; he will buy anything originating from Cyprus and he has very deep pockets. We're all going to make a bloody fortune because of this guy," says Van Rijn. The men raise their glasses to him and they all drink.

Veres asks, "Van Rijn, are you alone here in Germany or do you have a hen in your nest?"

Van Rijn is only just out of rehab and he's right back to his old ways.

Van Rijn makes a final toast with the boys. "Let's nail this tomorrow. Cheers to Eftis," he says, as they raise their glasses one last time.

Helmut escorts me to my hotel room. "No need to worry. We have eyes on you. Sleep well."

Once inside my room, I wonder if having "eyes on you" means that the police have cameras in my room.

I step into the shower and push the curtain closed to ensure privacy when changing into my pajamas as my paranoia peaks. Checking my reflection in the mirror afterward, I notice a rash on the surface of my neck, a pale pallor and heavy bags forming under my eyes. My nervous energy burns more fuel than I can consume in food, and my gaunt appearance is reflective of the hunger I feel for this ordeal to be over. I slide into bed and pull the covers over my head but the sound of my anxious heartbeat prevents me from sleeping. Alone with my fears and anxieties, I remind myself about what I am fighting for as my thoughts drift back to my life in Cyprus before the war.

FAMAGUSTA, APRIL 1974

A few blocks from the sea in the most desirable resort district in the Mediterranean, artists, writers, musicians, and poets are drawn to the island of Aphrodite's birth. It is where Shakespeare set *Othello*. Hollywood stars and international society types vacation here, but to me, it is simply home.

I'm fourteen years old, lounging in my baby-doll pajamas at the onset of spring. I feel more drawn to feeding my shoebox of silkworms their diet of mulberry leaves than going to church. As I watch the worms nibble on the leaves for nourishment, I am filled with excitement knowing I will soon witness their metamorphosis, a process that takes twenty to thirty days. The silk generated by the worms will be spun into sheets or a tablecloth that will become part of a wedding dowry, a Cypriot tradition that begins at birth.

Hailing from a blue-collar, working-class family with limited financial means can limit the caliber of men I have to choose from, so emphasis is placed on the quality of my dowry. My parents instill in me that beauty,

intelligence, and a flawless reputation are what will dictate my chances of gaining upward social mobility; they enforce a strict moral compass for me to follow. Turning to the Saint Andreas icon that sits on my bedpost, I pray for added insurance.

As much as I would like to lounge around the house, it is Holy Week, and the Orthodox are flocking to churches and monasteries in anticipation of Easter. Every year on the first Sunday that follows the first full moon of the spring equinox, we celebrate the resurrection of Christ.

"Tasoula!" Mother cries a little louder, "you will make us late for church if you don't hurry."

Holy Week, the most sacred time in the Christian Orthodox calendar, is upon us. Every waking moment is a devotional experience as we attend daily morning and evening church services that are choreographed in elaborate detail to portray the circumstances leading up to Christ's torture, demise, and return to life. This is the culmination of a fifty-day fast, a strict vegan diet that ends with the arrival of Easter. Today being Holy Thursday, we revisit the final moments of Jesus's life and the collective heart of Cypriot Christians aches all over the world.

Vasilios, my cousin who is a young novice monk, invites us to attend services at the Saint Barnabas Monastery near the ancient city of Salamis, where he will assist in conducting the oldest form of the Eucharist, The Divine Liturgy of Saint Basil.

"God doesn't like to be kept waiting," I whisper before sliding the shoebox of silkworms back under my bed for safekeeping. In true tomboy fashion, I dress for church in under five minutes.

"Your sisters have collected the figs, fed the animals, and you turn up at the last minute!" My father, Leonidas, with his classic chiseled features, tries to hide his amusement in vain.

"How will you ever find a husband with zero interest in household duties?" asks my mother, Andriani, a brown-haired, petite beauty with Socratic wisdom. The matchmakers are always looking to negotiate a young girl's hand, and a few unflattering observations could be detrimental. Truth be told, my secret goal is to be number one in my class, win a scholarship to study abroad, and travel the world.

As we drive a short distance from Famagusta, we arrive at a domed monastery surrounded by green cypress trees. Three of the monks, Chariton, Stefanos, and Barnabas, are actually brothers in the literal sense, too, and all three have dedicated their lives to the church. Many days, they can be found outside painting icons in the courtyard, but today the Holy Thursday service takes precedence.

Every Cypriot child is familiar with the story of how our church achieved its independence. According to church tradition, Saint Barnabas's most dramatic intervention came in the fifth century, a time when Christianity was thriving but also riven by power struggles between different centers of the faith. The church of Cyprus was struggling hard to keep independent from the bishops of Antioch, a powerful city in present-day Turkey with equally ancient Christian roots.

Luckily, the ecclesiastical fortunes of Cyprus were boosted when Saint Barnabas appeared to Archbishop Anthemios of Cyprus in a dream to lead him to the exact location where the saint had been buried hundreds of years earlier. After digging, the archbishop found a signed gospel of Saint Mathew lying next to the relics of Saint Barnabas. He traveled to Constantinople (now Istanbul) to gift the gospel to Emperor Zenon, who showed his appreciation by affirming the self-governing status of the Cypriot church, which continues to this day.

As a young girl there is a part of me that would rather be outside exploring nature, but once I step inside and become surrounded by vividly painted scenes from the Bible, my spirit surrenders.

Skill and devotion to the fashioning of religious images has been one of the glories of Cyprus throughout the Christian era, and it has survived all its vicissitudes. There was a period in Greek Christian history when the emperors and patriarchs wrestled hard with the question of whether it was right to use imagery in prayer. In Islam, for example, pictorial depictions of the divine are forbidden. At certain times the opponents of images prevailed and set about destroying sacred pictures. But Cyprus, helped by its ecclesiastical independence, was able to stay out of the controversy and provide a refuge for iconographers. Byzantine scholars consider Cyprus an "iconography heaven."

We were taught that in some countries there were people equating reverence for icons with idolatry. But in the course of the Greek Christians' long spiritual struggle to find a correct, balanced attitude to these images, a very subtle understanding developed. Distinction was made between worshipping or praying to material objects, which is unacceptable, and venerating objects that navigate us to God, which is legitimate. As a child, though, I could not imagine anybody arguing over religious images. I simply could not have conceived a church without them.

<p style="text-align:center">⁂</p>

Vasilios stands just behind the royal doors, ready to assist his abbot. It's time to receive communion, and children always go first. I close my eyes and pray that my sins may be forgiven.

The abbot dips a long, thin spoon into a silver goblet where consecrated wine is mixed with tiny pieces of equally consecrated bread: as my parents have explained to me, tasting these holy gifts is the nearest we will come on earth to meeting our Savior. Vasilios stands just off to the side holding a plate of uniformly cut bread; these are fragments from the same loaf as the consecrated bread and they too bring blessing, albeit of a lower status. I step forward as the priest proffers the spoon and gently addresses me: "The handmaiden of God, Anastasia receives the body and blood of Christ." Tasoula is the Greek diminutive for the name Anastasia, which means *resurrection* in Greek. Tilting my head back slightly, I consume the sacred gifts and step toward Vasilios to take an additional piece of cubed bread, which adds to my feeling of purity.

After the ceremony, Vasilios, who is dressed in a simple black robe and a black cap or *skoufos*, greets us. "Come, let us pay our respects," he says as he escorts us to the grave of Saint Barnabas. He stops to fill several bottles with holy water pumped from a well next to the burial place. In keeping with Cypriot tradition, Vasilios hands my mother additional bottles of blessed water, which she will use for protection and to mix with flour to make the dough that will make bread for my family for the rest of the year and provide us with protection. He also asks her to convey some bottles to his own mother.

We enter a cavelike structure, and as we descend several steps, the temperature drops while the scent of raw earth rises. After we pray in a small, square space, my brother Andreas asks Vasilios in a whisper, "Is it true what they say about the saint's bones?"

Vasilios smiles. He is used to being asked this question and loves to share his spiritual knowledge, especially with young minds. "I see you know your studies, Andreas.

"Like many saints of that time, Barnabas was martyred for his religious beliefs, and his remains were buried in an unmarked grave. He sold all of his wordly possessions to spread the word about Christianity. That's why he was given the name Barnabas, which means 'son of encouragement,'" the young novice explains.

"Will you be an archbishop one day?" I ask as we climb the stairs back into daylight.

Smiling, he says "I wish to be of service to God, not to climb earthly ladders."

As a competitive fourteen-year-old, I add, "It must be hard to be a monk."

᪥

Along the coast from the monastery, where Barnabas was born, there is an even older settlement. Salamis is an ancient city by the sea that dates back to 1000 B.C. with a history of conquerors who have fought to possess the island. But even their large armies could never douse the fire that lives within the spirit of the Cypriot people, who have fought for their independence and to preserve their Hellenism since the earliest days of their existence. The fields are full of daisies, poppies, wild orchids, seasonal vegetables, and all kinds of herbs. We pick artichokes raw from the field and eat them with homemade tahini and bread while taking cover under a nearby tree.

Our playground was among Greek and Roman ruins—an ancient gymnasium, the king's palace, even an amphitheater became the backdrop for my siblings and me to reenact the actual battles fought in Salamis. When the Venetians ruled Cyprus in the fifteenth century they built and fortified the city's walls. After Famagusta fell to the Ottomans, they kept

the walled city of Famagusta for themselves, prompting the Greeks to build another settlement next to it, and this became the town of Varosha. But the older generation that drilled us in that history failed to anticipate that the past would repeat itself during the Turkish invasion of 1974. On this occasion, Varosha was fenced in and declared off-limits to its inhabitants. Varosha, the place where I came from and where I belong. These ancient landmarks heightened my awareness about my Greek Cypriot culture, history, and mythology, which fueled my imagination and enforced my identity. We lived our day-to-day lives walking in the footprints of kings and saints who had come before us.

"Don't forget to pull some *rizarka*," father cries, hoping his voice will carry over the sounds of my siblings and me teasing each other as we run through the fields. The *rizarka* root, as we call it in Cyprus (known in English as madder or rubia tinctorum), grows high in the moist soil near the sea. I find some and tug until the earth releases the root. The rizarka, daisies, and onion skins will be boiled and turned into red, yellow, and orange dyes, which we will use to color our Easter eggs once we arrive in Mandres.

~

The picturesque drive to the village of Mandres circles around the Kyrenia mountain range toward the Pentadaktylos peak. Passing through the Turkish village of Agios Iacovos, we carry a sense of guardedness because of the heavy history our two communities share.

"Do not look them in the eyes," my father would say. "If their eyes happen to meet yours, smile politely and look away."

Prior to the invasion of '74, the Greek Cypriots made up 78 percent of the population, Turkish Cypriots 18 percent, with Armenians, Maronites, and miscellaneous groups making up the remainder. Tensions between the two cultures stemmed from a three-hundred-year history of Ottoman oppression but more recently had to do with some Greek Cypriots wanting union with Greece (Enosis) and some Turkish Cypriots wanting unity with Turkey, or else partition. Under the treaty that granted Cyprus independence, from 1960, the Turkish Cypriots were given a 30 percent share of power,

which Greeks saw proportionately as too high, and the arrangement broke down violently after three years. For the most part, the majority of Greek and Turkish Cypriots lived in relative harmony, but the extremists on both sides stirred the pot regularly.

As the truck continues to make its way up the mountain road, the village of Mandres finally comes into view. It's set into a cliff on the mountainside and has spectacular views that stretch down to the sea and beyond. It is a small village with a population of a few hundred people comprised of farmers who grow everything from watermelon to tobacco leaves. Each family raises animals, mostly rabbits and goats, and donkeys are used as a mode of transportation. There is a wholesome simplicity to country village life where everything revolves around the local church and the coffee house where the village men play backgammon, exchange news, and debate politics.

After a warm welcome from the extended family, we get to work coloring the eggs for Easter as work both in the fields and in the house will halt tomorrow in observance of Good Friday.

Afterwards we head for the village church, to assist the priest and his young helpers drape long black linens over every sacred image in the interior of the church, to signify our mourning the death of Christ. The entire Orthodox community actively participates in this week leading up to Easter. This profound experience instills within me a rich sense of belonging.

Later we attend the evening service, in which we learn how Jesus Christ is betrayed and how he takes on every aspect of the character of our human vulnerability, including hopelessness. The priests and servers are all dressed in black. A large wooden cross is already present at the front of the church. Some people kneel and pray before it, showing their respect for the dead as they would at any funeral.

At the end of the ceremony people line up to pay their respects to the cross once again. We return to my aunt's home after the service; there is a little time for some lighter tasks, such as placing the colored eggs in bowls and positioning unlit candles around the house. If this were not Holy Week, we would perhaps take turns playing the flute and mandolin, or singing and dancing to folk songs.

❦

The next day is Holy Friday, the day Christ died on the Cross and was buried.

"Reflect on your sins today. Don't forget to ask for forgiveness," my mother instructs. We allow ourselves to eat diluted lentil soup (no olive oil) for nourishment while we consume small amounts of vinegar, the bitter drink Christ was offered instead of water while he was on the cross. The children play an integral part in preparing for the funeral procession. During the day we go from house to house and collect beautiful and aromatic citrus flowers, which we then use to decorate the *Epitaphios*, the wooden structure that is used in the evening service to represent Christ's coffin. The base of it is covered by a tapestry that bears the image of a man wrapped in a cloth in preparation for his burial; that too is covered in flowers. We sprinkle rose water over it as a symbolic substitute for myrrh, which is traditionally used to embalm the dead. We use string or pins to make bundles of lavender and citrus blossom to decorate every square inch of the *Epitaphios* which occupies center stage in the drama of our Good Friday devotions.

The evening service is a moving tribute to the slain Christ, tinged with hope that he will rise again. The most heartrending part is the series of hymns of lamentation, beginning with the familiar words "*I Zoi en Tafo,*" (Life itself in the Tomb), sung to a haunting Byzantine melody that everybody knows and joins in, singing softly. The words elaborate the theme of Mary's suffering, giving parents who have ever had to bury a child the opportunity to mourn anew.

Several of the faithful pick up the *Epitaphios* by the handles and carry it in procession around the church and outside. We young girls have baskets of flowers to hand out to the other worshippers, which they will continue to use in various rituals throughout the year. As a young Orthodox girl, I am mesmerized by the procession and reenactment of the Savior's burial. The experience gives me a kind of inner strength, something that will always remain with me.

On Saturday morning, the mood changes. The solemnity dies down, and there is tingling anticipation instead. The local ladies roll dough into squares

and triangles and then place a mixture of cheese, egg, raisins, and mint inside
to make *flaounes*, a traditional Easter pastry. The sides of the dough are folded
and we children brush them with egg yolk and then sprinkle them with
sesame seeds. The wood ovens are then fired up, and within hours the scent
of the freshly baked pastries lingers in the village air. My stomach, tested by
fasting, reacts with a wanting growl.

Arriving at church for the first service on Saturday morning, we
immediately notice that the priest and his helpers are no longer wearing
black. The atmosphere is lightening. They remove the black drapes from
the icons.

Although we only half understand the liturgical Greek words, an
extraordinary, enjoyable story is being told in the service that now unfolds.
Christ enters the kingdom of the dead. The prince of darkness lets him in,
thinking this is just one more mortal coming to be enclosed forever. But
far from being captured by death, Christ immediately begins liberating the
dead, sending hell's master into a rage. "You have tricked me! Why was I
so foolish as to let you in?" the devil rails.

With suitable gusto, the bishop rings the bells as we stamp our feet and
rattle our wooden seats, our way of showing that the powers of death are
being conquered at that very moment.

Back at the house, we watch my grandmother and mother prepare a
delicious *avgolemono* soup, made of chicken broth, rice, egg, and lemon, the
perfect first dish to ease our stomachs into accepting rich food again.

We try to rest a little before we head back to church toward midnight
and finally connect to the Holy Light of Jerusalem, the resurrection light that
will illumine us for the rest of the year. We walk in procession through the
village with our lanterns and candles to celebrate the return of Christ. Before
we enter our home, my uncle makes a black seal with the smoke from our
little piece of holy light, placing it to the right of our door to bring the Easter
blessing to our home. Inside we light the *kandyli*, which is a glass jar filled
with water and oil upon which a small wick is floating. It will illuminate our
prayer corner, adorned with icons old and new and photographs of family
members who have passed away. The Holy Fire is now within our domain,
and its miraculous power has come to our home to protect us.

The celebration can begin. We have our soup and *flaounes* to break the fast, and each of us children will select a colored egg. We knock each other's eggs to see whose will crack first, saying *"Christos Anesti"* all the while.

The following day, I watch my mother and aunts assemble the mouthwatering Easter feast of roast lamb and think about the day when I will carry on this tradition in my own home. Even today, I cherish these memories of Cyprus as if they were priceless personal antiquities, unwilling to let them fade as things naturally do with the passage of time. If only I had known the war was coming and that this would be my family's last supper in Mandres.

<center>⚜</center>

My eyes bolt open. I frantically call the front desk of the hotel.

"Why didn't I receive a wake-up call?"

"Madame, it is only two in the morning."

I shower and dress for the sting operation and lie back down fully clothed, waiting for the alarm to signal the true start of this day.

OCTOBER 8, 1997

The Munich police station is a flurry of activity. An officer takes photographs of Lazlo to circulate to his men, to go alongside the images of Veres and Rossi. Kitschler escorts me into his office.

"The two hundred thousand Deutsche marks ($114,000) have not been posted to my account. I'm worried about the money reaching us in time."

Kitschler reassures me, "We can change the plan. The intermediaries will tell Dikmen they will return with more cash after they view the inventory. It actually works better for us." I trust Peter's judgment. A feeling of relief washes over me knowing I won't be required to spend another dime of the Church's money to secure these artifacts.

We shift to the subject of Van Rijn.

"To secure Van Rijn's safety he must keep his anonymity," Kitschler says. "The intermediaries must leave Germany as soon as the operation is completed."

"I will advise Van Rijn."

"Are you ready, then?" Kitschler inquires.

I rise to shake his hand. "You have no idea how ready I am."

A few hours later back at the Hilton Hotel suite, Herman, my bodyguard, and I nervously wait for Van Rijn to return from the lavish lunch he promised his men last night.

The phone rings. It is Kitschler.

"You have to stop Van Rijn! He's in the car with the intermediaries on their way to Dikmen's."

"What?" I scream. "I'll call you back," I say, trying to camouflage the terror I feel. Van Rijn answers on the first ring.

"Get back to this hotel!" I say as if I am reprimanding one of my children.

"I have to be there," he says, sounding inebriated.

"Are you insane? If you don't return to this hotel immediately, I will have you arrested on the spot."

There is an awkward silence.

"Step out of the car," I say with all the authority I can muster.

"Okay, Tazulaah. You win."

With trembling hands, I dial Kitschler.

"I have a police car escorting him back to you."

This latest fiasco proves that Van Rijn is his own worst saboteur and possibly now mine. As he walks through the door of the hotel suite, I know my job is to get him focused on the matter at hand. I pour him a glass of water, and motion for him to sit.

"We have come a long way, you and I. If we don't succeed, we fail your father, and my people. Are you ready to get this job done?"

The telephone in the suite is ringing. He answers coolly, "This is Eftis."

I hold my breath as I hear Veres describe what he is being presented.

"Frescoes from the Church of Antiphonitis. Exquisite."

Van Rijn interjects, "Tell him you love the Frescoes."

"Eftis is interested in your Fresco collection," says Veres. There is a long pause. I search Van Rijn's face to see if there might be a problem, but he seems perfectly relaxed.

"Ah, an icon . . . Virgin Mary holding the Christ child, but the eyes are scratched."

"Ask him if he knows the origin," says Van Rijn.

Veres repeats the question to Dikmen.

"Cyprus," is heard in response to the question.

"Good, tell him you're thinking about it and want to see more," instructs Van Rijn.

Veres repeats to Dikmen what Van Rijn instructs him to say. There is another long silence. Then we hear Lazlo react to what he is being presented.

"Eftis, there is a mosaic of unprecedented beauty . . . very old."

"Good, ask him from what period," instructs Van Rijn.

"Saint Thomas, 525 A.D.," we hear Dikmen say in the background.

The situation looks more and more promising.

Veres inquires, "Is that from the Church of Kanakaria?"

"Yes," Dikmen responds.

Veres continues, "Do you have anything from the Monastery of Antiphonitis?" Both of these churches had treasures from the fifth and seventh centuries and were located in the Turkish occupied area of Cyprus heavily targeted by looters.

"Ask him the price," says Van Rijn.

"One hundred and fifty thousand Deutsch marks," says Dikmen.

"Good," Van Rijn whispers to Lazlo, "Now ask him to see more."

Dikmen continues to show the intermediaries artifacts.

"Tell him that you will take all the frescoes and the mosaic, the icon with scratched eyes, and the coins," Van Rijn whispers into the receiver.

Veres informs Dikmen, and Dikmen requests to see their cash.

"Now tell him you were not expecting to purchase as much. You must return to the hotel to get more money from Eftis."

We hear Veres say, "It won't take long. We're staying at the Hilton."

Van Rijn gives me the thumbs-up sign.

"Will be back shortly," says Lazlo.

Ten minutes later the phone rings. It's Lazlo. They are out of Dikmen's apartment and on their way to the hotel.

"MOVE, MOVE, MOVE," shouts Van Rijn giving me the cue to phone Kitschler, who is waiting for a signal that the intermediaries are clear.

Van Rijn paces the floor waiting to get word from Kitschler that they have Dikmen.

The phone rings.

"We have your man in custody," says Kitschler, "We searched the apartment and all we find is a few pieces."

"Kitschler is saying they can't find any inventory," I say.

Van Rijn screams, "Impossible!"

"How can this be? We all heard what went on in that room." I tell Kitschler.

"I'm telling you Dikmen is hiding the inventory!" Van Rijn, shouts, looking panicked.

"Your men had his apartment surrounded, the inventory has to be in there," I say to Kitschler, totally frustrated myself.

Meanwhile, Van Rijn continues to rant.

"Check the floors. Break open the ceilings. Look for dummy walls. Check the shed. Did you look through his papers? It has to be staring you in the face!"

Van Rijn becomes more angered.

"Rip up the floors. Bust through the walls. Find it!" He kicks the leg of a nearby armchair and orders a taxi to take him to Dikmen's apartment.

I alert Kitschler who says, "Absolutely not. We have no authority to let him enter the premises. You must control him," says Kitschler.

Van Rijn flings the chair across the room and my bodyguard jumps to his feet to restrain him. Without substantial proof of inventory, Dikmen will be released within the day.

The shock and disappointment open the door for paranoia to slip in and I watch Van Rijn with different eyes now wondering whether or not this has all been an act. Maybe he never intended to deceive Dikmen. What if

the throwing of the chair, the upset demeanor, is all a show? Dikmen put a price on his head when they had a falling out. Could Van Rijn be playing both sides of the fence to win his trust back?

What if his plan all along might have been to humiliate me? I can just see him saying, "I got you, Tazulaah. It took me ten years, but I finally made a fool of your government and the art traffickers of the world rejoice with me today!"

The hours continue to slip by with the police finding nothing. It is I who urged the Archbishop to spend the Church's time, money, and resources and encouraged the government not to arrest Van Rijn and work in cooperation with him.

The thought of having to return empty-handed terrifies me. Worst of all if Dikmen slips through the authorities, hands I will not have fulfilled my quest to see justice served. To the contrary, Dikmen can seek his own justice against me. I never contemplated failure until now. Pacing anxiously, I wonder if I might have wasted the last decade of my life. I curse the day that Van Rijn first approached me as consul, the day he walked into my life.

Four

DATE WITH A DEVIL

THE HAGUE, MARCH 1988

Freezing rain and wind pelt against the low-rise buildings in Jan van Nassaustraat, leaving a chill in the air that makes it impossible for my body to warm. The storm, blowing relentlessly off the North Sea, blankets The Hague with a wintry mix, making travel extremely challenging. Only one appointment remains on my calendar as honorary consul, with an art dealer named Michel Van Rijn.

These are the kind of days that make me ache for Famagusta (*Ammochostos* in Greek, meaning, "hidden in the sand"). The land of my birth lies in the easternmost part of the Mediterranean Sea, with more than three hundred days of sunshine a year. The sounds of ice and wind pelting against my office window reminds me of just how far away from Cyprus I am, but it does not diminish my warm feelings for The Hague, which became a safe haven for me to land after the heartbreak of war. The Netherlands opened its arms to me as a refugee, adopting me as one of its citizens while handing me a blank canvas to create a new future.

When I founded my company, Octagon, it gave me the financial freedom to work as a volunteer on behalf of the government of Cyprus, where I find my voice as honorary consul in the Netherlands. My recent engagement to Michael rounds out what I feel to be a perfect picture, which is now my life. For the first time since the war I feel whole again.

A sense of urgency in the footsteps of my secretary brings my thoughts back to the present. She hands me a cryptic message, which reads, "Office too dangerous, meet at the Bodega de Posthoorn. Michel vR."

"What does this mean?" I say, slightly impatient as I have asked my secretary in the past to be more precise.

"My apologies, Tasoula, Mr. Van Rijn hung up before I could get a word out."

An inner alarm sounds. I have no idea who this Van Rijn is, and I take issue with the fact that he is changing the location of the meeting at the last minute. I tend to have an open door as honorary consul—everyone is welcome to an hour of my time—but this situation has me question that policy.

My intern, Jeroen, who is not in the office today, scheduled this appointment. A few weeks ago, he mentioned meeting an art dealer, this Van Rijn fellow, who had information about Cyprus and wanted to meet with me to discuss it. In retrospect, I wish that I had done more due diligence before confirming the appointment.

I telephone Henk Aben, a well-respected Dutch journalist, a mentor and father figure who was most instrumental in educating me about and connecting me to the political world of the Netherlands. His mentorship contributed to my becoming an honorary consul at the young age of twenty-seven. "Henk, what can you tell me about an art dealer named Van Rijn?"

"Tasoula," he says, sounding a bit rushed. "I'm in Strasbourg, France, running to a meeting, but in a few words, be careful around this guy. Do not, under any circumstances, meet with him alone. Let's catch up next week."

Henk is the foreign affairs editor of the *Algemeen Dagblad*, a highly regarded newspaper in the Netherlands. When I first arrived in The Hague, I was surprised by the pro-Turkish articles I read and challenged Henk to hear my view. He was shocked at my age when we met. I was just a twenty-three-year-old sharing my views about the war in Cyprus.

He educated me about politics in the Netherlands, and introduced me into the cocktail circuit, where I met journalists, politicians, and policy makers, and soon became known as "the face of Cyprus in Holland."

I decide to take Henk's advice and call my fiancé, Michael, who is stationed in Oman but currently on holiday visiting me in The Hague. Michael's analytical skills make it easy for him to size people up with razor-sharp precision, a welcome asset for my meeting with Van Rijn. Besides, I want to spend every possible moment I can with him.

"Love, are you available to join me for a meeting at the Bodega de Posthoorn this afternoon?"

"Of course," he says. "How can I help?"

"Just observe for me, Michael. I'd love to get your assessment of him."

I freshen my lipstick and transfer a miniature icon of Saint Andreas from my purse into my suit jacket pocket. The icon was given to me by my mother to keep me out of harm's way. I was seventeen years old when I left Limmasol, the city my family fled to after the 1974 Turkish invasion, in search of a new future abroad. My father gave me a five-shilling note. On it he wrote, "Safe journey, my tomboy—14th of November 1976—Never shame the family." Moments before my departure he placed it in my hand and said, "I trust you."

My positive memories of Cyprus are always overshadowed by a flashback of war and a reminder that my home country is still under occupation. I turn my thoughts to seeing Michael and getting my meeting with Van Rijn over with quickly so I can enjoy the rest of the afternoon.

❧

The Bodega de Posthoorn is near the Binnenhof (House of Parliament) in the old city center. Inside the dimly lit café, a man seated at a small round table with another gentleman rises to introduce himself.

"Michel Van Rijn. Thank you for coming, Madame Consul."

His eyes are steel-gray, almost an icy blue, and they lock onto mine with a gripping hold. He is overly dressed for the occasion in an expensively made suit more appropriate for an evening gala, giving the impression that he is a bit of an odd showman. He seems to be in his late thirties, but the lines on his

face reveal the story of a man who might be carrying a burden made bearable by some fast and hard living. He turns to a young man whom he introduces as his assistant, Paul, who is in his early thirties and conservatively dressed.

We order coffees and, as the waiter leaves, Van Rijn says, "Are you aware of what has become of your churches in the Turkish area of Cyprus?"

"You mean the 'occupied' area," I say, correcting him.

It is only a question, but the timbre of his voice and the look in his eyes lead me to think he is heading into territory that I am unprepared to explore.

"Mr. Van Rijn, I am a refugee from Famagusta, Cyprus. My family and I were forced to abandon our home and belongings during the Turkish invasion. Are you not aware of the dividing line and the fact that part of Cyprus continues to be militarily controlled by the Turkish army? Greek Cypriots are forbidden to return to their homes in the occupied area. My city of birth is a ghost city north of the ceasefire line," I say, as the waiter delivers our coffees.

"*Efharisto*," Van Rijn says, thanking the waiter in Greek, trying hard to impress me, which I find rather amusing because the waiter is Dutch. Van Rijn motions for Paul to pass him documents.

"I spent time in Cyprus just after the war. It pains me to have to show you these images, as I have a profound appreciation for Byzantine art. It is a sin what the Turks are doing to your country."

The 1974 invasion of Cyprus ended with Turkey acquiring 36.2 percent of the island, which they continue to occupy. Part of Varosha, the former tourist area of Famagusta where I lived, is sealed off with barbed wire fencing and is heavily guarded by the Turkish military under orders to shoot trespassers.[1]

Van Rijn slides several photographs across the table. My eyes go to the photo of the monastery of Antiphonitis, built during the Byzantine period. A beautiful drive up a winding mountainous road with spectacular views of the coastline leads to the village of Kalograia, where the monastery sits in the Pentadaktylos forest. The photograph shows scaffolding in the interior of the church reaching up to the ceiling, but the well-preserved twelfth-century frescoes and mosaics that once adorned this sacred site are gone. The iconostasis, a wall of icons and religious paintings that partitions the nave from the sanctuary, is destroyed. Every last artifact has been picked clean, leaving a

hollow tomb where the symbols of centuries of cultural history once stood. Feelings of rage circulate throughout my body.

The next photo is of the Church of Panagia Kanakaria, which lies in the small village of Lythrangomi, about an hour northeast of Famagusta.[2] The church's apse, which once held some of the most famous and revered Orthodox mosaics, is stripped bare. This magnum opus of early Christian mosaics, one of the last to survive through the ages, has been violently removed from the ceiling.

The most sacred of religious treasures have been mutilated beyond recognition. The Kanakaria mosaic, depicting the Virgin Mary seated on a throne holding the Christ child on her lap with the archangels Michael and Gabriel around her encircled by a mantle of light, is one of the most significant religious artworks in the Eastern world. It was the first example where the Virgin is portrayed as the mother of God and Christ is revealed as a deity.[3] In each photo the head of a saint is numbered.

"Why would anyone do this?"

"These artifacts hold a lot of value for clients worldwide."

"What are the numbers on the heads?"

"When a client is found for that number, the instruction goes back to Cyprus to extract that particular artifact from the church," says Van Rijn.

I'm speechless. The last time I saw these images I was praying before them. The sacred artifacts so important to the people of my faith are now on sale for the rest of the world to buy as if they were ordinary commodities.

I detach in order to remain cool. I have to tread carefully, be cautious not to misspeak or to give Van Rijn any indication of how upset I am.

"Are you familiar with the Turk Aydin Dikmen?"

"No."

Van Rijn gestures to his assistant, Paul, who continues to present photograph after photograph depicting piles of icons being burned, decapitated, and used as target practice. Priceless artwork, chalices, bibles, and crosses dating back to the earliest days of Christianity have been looted or destroyed.

These images have now found their way into my subconscious where my darkest memories of war are buried, and they awaken a firestorm of emotional trauma.

Van Rijn continues, "I've traveled extensively through your country and have witnessed this destruction firsthand. These precious works of art have been drilled out of the walls and ceilings of your holy sanctuaries, and they are selling now on the international market to the highest bidders. I can get them for you."

A photograph of the Virgin Mary with her eyes gouged out stares back at me.

Van Rijn shakes his head in disgust. "It is shameful and unfortunate that the consequences of war and moral weakness leave such a permanent scar on your Cyprus."

I find a kindred spirit in these sacred treasures barbarically displaced by war; they are refugees like me, except that they are in the hands of criminals who care nothing of their true value. These images reveal the extensive looting and destruction that took place in the Turkish-controlled area of Cyprus. Could this have been executed without the Turkish government's knowledge?

"Is the Turkish government involved in this? How are these artifacts getting out of the occupied area?"

"This is the handiwork of soldiers," he says. "I also witnessed them using icons for target practice. I saved many of these treasures by paying the military not to destroy them, Tazulaah."

"Tasoula."

Van Rijn sheepishly grins. "Even foreign diplomats buy them."

"Mr. Van Rijn, I appreciate you updating me on the occupied area of Cyprus. Is there anything else you would like to discuss?"

"Yes, of course," he replies as Paul passes him a small pile of photographs.

Van Rijn places two more pictures in front of me. One is a mosaic of Saint Thomas, and the other of Saint Andreas, both from the church of Kanakaria.

"Look at these beauties," he says.

Despite my suspicions about Van Rijn, he is a connoisseur of Byzantine art.

"Here is my proposal. I will give the Saint Thomas mosaic back to your government if I am permitted to keep the mosaic of Saint Andreas. Your government must transfer legal ownership to me. Plus, I will throw in an additional two icons."

"Why do you wish to keep the Saint Andreas mosaic?"

"I am attached to it," he says.

Testing that theory, I ask him a question. "What if my government says that they want Andreas instead of Thomas; would you acquiesce?"

"I will consider it," he says.

The depiction of Saint Andreas is one of the oldest in the world and is worshiped not only by the Orthodox but all Christians worldwide. Both mosaics clearly have immense market value, but I find his attachment to Andreas ostensibly personal.

My thoughts return to my intern, Jeroen, who is well aware of my devotion to the icons. Could he have breached my trust? I have an image of Andreas hanging on my office wall. He could have easily spoken to Van Rijn about the special place Saint Andreas has in my heart.

Raised to live as one of the faithful, I am disciplined to pray before these icons in church and to miniature icons daily at home. My family's saint of choice is Saint Andreas, whom my mother believes was responsible for keeping us safe during the war. Icons serve as a reminder of our role as Orthodox Christians. The artists who made these works of art placed themselves in a spiritual mindset prior to creation, fasting and reflecting in order to attain a higher level of consciousness. It is this devotional energy that flows into the formation of these symbols that makes them culturally significant as well as sacred.

All that remains of northern Cyprus, according to the images in the photographs that Van Rijn presents, is a portrait of Christianity—and our history—obliterated.

If Jeroen had relayed any of this private information to Van Rijn, then I have another angle to consider, which is that Van Rijn may be targeting me. His motivation is yet to be determined. The thought that I might have a mole in my office concerns me.

I muster up a restrained face to bring the meeting to a close. "I will pass your request on to my government, Mr. Van Rijn. How shall I contact you?" Van Rijn, matching my demeanor, says, "I will be in touch with you, Consul."

I feel Van Rijn's eyes trying to gauge my emotional temperature. I nod to Van Rijn and his assistant before exiting. "Good day, sirs."

Once outside, Michael and I walk hand in hand in silence, giving me an opportunity to think about Van Rijn's offer to retrieve stolen artifacts in order for him to keep one of them legitimately. His absurd request for my government to surrender ownership of a sixth-century stolen artifact as a good will gesture provokes in me a deep desire to see all of those responsible for the looting of Cyprus brought to justice.

As we pull into traffic and out of Van Rijn's view, Michael gently pulls me closer to him so he can place his arm around my shoulders.

"I trust you will be cautious around him. Van Rijn may have a connection with the criminal world. Are you okay?" he asks.

These three simple words release an ocean of tears that I have been storing deep within ever since that summer of 1974.

Five

REFUGEE

FAMAGUSTA, JULY 15, 1974

onday, eight-thirty A.M., the day begins like every other. The Georgiou family, which includes my older and younger sisters and baby brother, is sitting around our large round wooden kitchen table having a typical breakfast while listening to the radio. My brother Andreas loudly sings along to his favorite song, *To Poukamiso To Thalassi* (The Blue Shirt) by George Dalaras. My sisters and I moan and groan at his off-key singing.

"I cannot stand one more minute of listening to this," my younger sister, Yiola, says. "Please, Mom, make him stop."

"Andreas," Mama says, "you are going to break the radio. Give it a rest."

The song stops abruptly followed by our simultaneous laughter and welcome relief.

"You see, you did break the radio!" laughs Yiola.

The national hymns of war play for a few minutes before we hear the sound of an announcer say, "The national guards are in control . . . The national guards

intervened this morning to save this land and put an end to the 'brother to brother' fratricide killings. The national guards have the situation under control and Makarios is dead. Makarios is dead. Remain inside your homes and stay tuned for further instruction."[1, 2]

By the end of the day, we learn the radio report is incorrect when we hear Makarios address us from a small local radio station before escaping from the island via a British military base. As a young teenager, I don't appreciate the gravity of my circumstances. Greece, the United Kingdom, and Turkey became guarantors of Cyprus as it gained its independence for the first time in 1960. Greek Cypriots, though, were unhappy with the power allocated to Turkish Cypriots: this Moslem minority made up only 18 percent of the population, but the new constitution awarded them 30 percent of the seats in the legislature with veto power.

The government under the presidency of Archbishop Makarios III included Turkish Cypriots in parlimentary cabinet who began to feel their positions inconsequential, and by 1964 they abandoned their posts in protest. Extremist groups on both sides reverted to fighting and disrupting the peace.

I know that my parents support Makarios, but politics is rarely discussed in our presence at home. My mother, Andriani, is a devoutly religious Greek Orthodox woman who despises conflict, and my father, Leonidas, has befriended many Turkish Cypriots working at the seaport while loading fabric onto his truck to deliver to customers. His Turkish Cypriot friends are welcome in our home, and we play with their children when they come to visit, but we are not permitted to enter their enclaves. Centuries of injustice make it difficult for Greek and Turkish Cypriots to trust each other completely. No other place has endured as many conquerors as Cyprus, and through it all Greek Cypriots have managed to maintain their Orthodox faith and language.

Post-independence, fighting also breaks out between pro-enosis (a movement of Greeks, wanting political union with mainland Greece), who become bitter nationalists, and those who want Cyprus to remain independent. On July 15th, a coup d'état led by Greek junta officers who called themselves "national guards" on the radio come to overthrow Makarios. Five days later, the Turkish army invades Cyprus in retaliation, using the excuse that they must protect the Turkish Cypriot minority.

FAMAGUSTA, JULY 20, 1974

It's six A.M. when sirens ring out across Famagusta. Turkish planes fly low over the island doing their reconnaissance missions. Mother turns on the radio to hear the announcer call for all men over eighteen to report to the nearest police checkpoint. She lines a small clay pot with olive leaves atop burning embers of charcoal. From a nearby cabinet where precious items from Holy Week are stored, she removes a vial of holy water, an Easter candle, and the consecrated flowers, which are used to decorate the *Epitaphios* during Easter. Placing the lavender and citrus flowers on top of the olive leaves, she performs a ritual to keep my father safe. Holding the pot over his head, she makes the sign of the cross three times. She dabs a piece of cotton wool into the holy water that was given to her by Vasilios from the Saint Barnabas Monastery and uses it to anoint my father. It dawns on me at this point that as much as she is preparing the ritual for my father to stay alive, she is also blessing him and preparing him in case of his death. She places the bottle of holy water in his hand.

"To keep you and the soldiers out of harm's way," she says. My siblings and I follow her outdoors to say good-bye to my father.

I did not understand the seriousness of the moment. In my eyes, my father was indestructible; after all, he is named Leonidas after the king of Sparta, a warrior who held the Persians at Thermopylae during one of the most famous battles in history.

Given the island's turbulent history of war and conquerors, having an underground shelter was as common as having a garage.

"You will be safe in there," my father tells her. "They will aim their bombs toward taller buildings."

He hugs each of us tenderly, bending down lastly to face my young brother, he says, "You are the man in charge now." As we watch his truck drive out of sight, the ground beneath us starts to tremble. I feel the vibration of the fighter jet before it comes into view. A Turkish plane on reconnaissance to mark bombing targets flies so low in the sky I can see the pilot waving to me from the cockpit just as he turns the plane around to head back out to sea.

That night it was eerily quiet across the island except for the faint sound of my mother praying before the icons.

The raids begin early the next morning. After the first bomb hits and the dust and debris get stuck in my throat, I am sure I will not survive. As I gasp for air, my mother comes to my rescue.

"It will be all right. Cover your face . . . look down," she yells.

As the sound of a bomb exploding on my neighbor's home shakes the foundation of ours, she ushers my siblings and me out of the shelter and back into the house, into our bathroom, which is equipped with a double ceiling. In her mind the double ceiling will provide added protection from the bomb, but in truth it is merely a storage area to house our dowries, which she had been collecting since our birth.

Mother's petite frame is no measure of the size of her courage as she is left to defend her four children against the Turkish air force's bombs. The fact that we are unable to see what is going on around us makes the situation that much more frightening.

The Turkish planes drop Napalm bombs, which generates temperatures between 1,500 and 2,200 degrees Fahrenheit, so surviving an attack could be a fate worse than death. Particles of dust, the smell of gunpowder, and burning flesh suffocate the air.

Mother is just outside the bathroom kneeling on a makeshift altar she created in order to pray with Apostle Andreas while keeping an eye on us children. We are all huddled together in the bathtub. The sacred Easter candle, the light of resurrection, is lit, to protect us. We ration our food and water supplies and for three days. I watch my mother sacrifice sleep to pray relentlessly before the icons.

As a fourteen-year-old girl, I wonder, where is the powerful Hellenic army that I read about in my history books? Where are the United Nations soldiers who have had a presence in Cyprus since 1964 to prevent inter-communal violence? Even the Americans, who save the world in the Hollywood movies I love to watch, are nowhere to be found. When I realize that no one will be coming to save us, any remaining sense of security is shattered. Everything I've learned about my history and my faith feels like a complete lie.

A knock on the shuttered window causes Mother to hold her finger to her lips, signaling us to remain silent. She trained us to resist capture should the Turkish soldiers enter our home. My religious mother has placed knives in strategic locations around the house, and every electrical socket has been opened to expose the wiring. My siblings and I are trembling.

"*He tan he epi tas*," she says in Greek, meaning, "Either with us or upon this." It is a battle cry that Spartan women would yell out to their husbands and sons as they left for war. Come back with your shield or die, as to return shieldless meant that you ran away and were a traitor. What she was telling us is that if a Turkish soldier comes through that window and you don't kill him, you must kill yourself.

"They will rape and torture you before they will kill you. If you must die, let it be with honor," she says. Hearing these words come out of her mouth is horrifying. Taking each of us by the hand, she carefully demonstrates how to short-circuit the electrical socket with a knife to secure a quick death. The shock of hearing my Orthodox mother instructing us to commit suicide and murder rather than face capture traumatizes me. I assumed my father to be the strong one in the family, but observing how my mother handles this crisis in his absence changes my perspective of her.

As the knocking continues, mother rises from her kneeling position before the icons. With knife in hand, she motions for us to take our positions and places herself to the side of the window ready to defend us from the soldiers. Each of us stands by an exposed electrical outlet. I pick up the knife; my hand trembles uncontrollably as I prepare for the possibility of death.

There is a moment of unbearable horror, seconds that seem like hours, during which our hearts pound, unaware of what will happen next.

"Aunt Andriani," we hear the voice of my cousin Savvas Kyriacou from Mandres. "Open the window. It's okay, there is a cease-fire." She opens the window. Seeing the face of my cousin brings welcome relief.

"I'm picking up medicines to deliver to clinics and to the Hotel Markos, where there is a staging area for the wounded." His voice cracks. "So many men are wounded."

When young men graduate high school in Cyprus, they are required to serve two years in the military. Savvas has had the unfortunate luck of experiencing war on the very first day of his conscription.

"There is still fighting going on, so be careful," he says, making eye contact with each of us. "On my way here . . . I stopped at the beach . . . the hotels are badly damaged. The Aspelia . . ." His voice cracks again. "A dead boy's body hangs upside down trapped between floors."

Mother hands him watermelon slices, Halloumi cheese, and bread wrapped up in a soft cloth for him to share with other soldiers.

"Did you see my dad?" I ask.

"No," he replies. "I reported for duty with my father and brother, and that's the last I saw of them. I really have to go now. Be safe," he says as we watch him run down the road to a waiting car.

The airborne debris filters into the house from the open window, and the smell of gasoline fills my lungs. Stepping outside, I see a gaping hole in my neighbor's house where the bomb exploded. On our way to check for survivors, we must step over the corpses of our rabbits and chickens, which are scattered about in the yard. All of our cats are missing.

Under the bloodred sky that remains after the bombing, we salvage whatever fruits and figs we can from our garden as the stench of gunpowder replaces the familiar aromas of jasmine and lavender. While Mother is busy taking inventory of our provisions, we sneak down to the Hotel Markos, now a makeshift hospital, in search of my father.

It is a scene out of Armageddon. We see hundreds of fatally injured, as well as family members frantically calling out the names of loved ones. What used to be a modern resort is now a sea of people grieving for the dead and badly wounded. Bloodcurdling screams force me to cover my ears. Men lie on stretchers with missing limbs, some have gaping holes in their bodies, and then there are the dead, whose open eyes tell the story of the terror they endured. As more and more people enter the lobby, my sisters and I get pushed farther into the room and separated from each other.

Yiola panics and runs toward the exit door screaming. The more I try to make my way through the crowd to reach her, the farther I am pushed back into the chaos. The unbearable impact of war rips at my innocence. I

set my sights for the exit once more, pushing past the mob of people with determined strength, until I am reunited with my sisters. Thankfully, we learn my father is not among the wounded or the dead. We run all the way home without uttering a word to each other or Mother about where we have been.

A few hours later we hear the welcome sound of my father's truck approaching, awakening a hope that our lives might regain some normalcy. Mother instructs us to pray in gratitude for his safe return, but one glance at my father tells me that he is not the same man who left the house three days ago. His smile is weighted with pain. His deadened eyes seem to look right through us.

Seeing our father in this condition is frightening. Mother waves her hand signaling us to leave so that she may be alone with him. I linger behind, out of view just behind the doorframe, determined to know what has happened to him. Through the slightly opened door of my parents' bedroom I see him holding his face in his hands, crying. I strain to hear what he is saying in between the sobs.

"They bombed the home for the handicapped! I was transporting the injured. The bodies were everywhere, young children badly burned, screaming . . . the look of terror on their faces was worse than their cries." He presses his hands harder into his face as if this will somehow erase what he has witnessed.

"I can't get the images out my head. I tried to save as many as I could." The rest of his words I can't make out. Mother gently comforts him, listening without commenting.

My world is turned upside down by the sight of my father's tears. I am so disappointed and angry with him and my schoolteachers for brainwashing me into believing the Greeks were superior soldiers with the mightiest army—all a lie! It was the moment I realized that no one could save me from this war.

The next day, my father piles us all into his bullet-riddled truck, and we drive to his sister's house in Paralimni, a village next to Ayia Napa, which is in close proximity to the British base, which will most likely not have been bombed. The conditions are not optimum as there were many others seeking

shelter as well, but we gratefully sleep on the floor. No one has any idea of what is to come, so after a few days we return home to Famagusta and do our best to continue our daily routine despite the uncertainty of our future.

We continue to pick figs and fruits from my mother's garden to sell door-to-door to expatriates. By the end of July the internationals living and working in Cyprus were being evacuated from the country, the tourists stopped coming, and the beaches were empty. Famagusta was becoming a ghost town.

Our Lebanese neighbor Mr. Mafoutas and his wife are leaving the country.

"When will you return?" my father asks.

"When the fighting is over for good," he says. "Andreas, I will give you ten pounds if you water my garden while I'm gone." My brother is thrilled to have the job.

"It will be my honor to do it for free, sir," Andreas says. My father smiles with pride as Andreas demonstrates how we were raised. Mr. Mafoutas insists on paying my brother.

As the NATO countries attempt to bring the conflict under control around the negotiating table, it becomes clear that Turkey has no intention of negotiating. The United Kingdom and Greece, both "guarantor powers" (along with Turkey) with the right to intervene if the terms of the Cypriot independence agreement are violated, have motives of self-interest to remain uninvolved.

The Americans and the British warn Greece to stand down, blaming the ordeal on the coup d'état. The coup d'état is rumored to have had the backing of American secretary of state Henry Kissinger.[3] There are some who wish to see President Makarios replaced with a pro-Western government.

In early August the Turkish planes return. Gunfire can be heard in the distance. The negotiations to end the fighting break down, and Father decides to move us to Paralimni, as he fears a second invasion is imminent. Holding up a suitcase, he says, "We have one bag between us. Take only one change of clothing. We will return in a few days." As we file into the truck, my father is yelling for my brother Andreas, who is busy watering Mr. Mafoutas's garden.

"Andreas, now!" His tone indicates that we are in danger.

My young mind tries to rationalize what is happening.

"What about Mr. Mafoutas's garden?" asks Andreas.

"We have bigger problems, Andreas," my father cries.

I can't bottle my emotions anymore. I want answers.

"Why has God forsaken us?" I ask out loud so that everyone can hear me.

Mother turns to face me, making sure that her eyes are locked onto mine. "We are alive and unharmed; we have each other, and our home is intact. You must believe he is protecting us."

As the truck pulls away, I look out the back window wondering how long it will be before I can return to Famagusta. Suddenly the walled city and the wide sandy beaches that I loved to roam fade from view. This is the last time I will see home. After my father deposits us safely at his sister's house, he returns to duty as Cyprus braces for a second invasion by the Turkish military.

The next day, on August 14, tanks carrying the Turkish army roll into Famagusta despite the fact that negotiations are still ongoing. The second Turkish invasion is far bloodier than the first. More than two hundred thousand Greek Cypriots are displaced, one-thousand six hundred and nineteen are missing and feared dead, and luckily my father survives to return to us again.

My family manages to escape with our lives, but we are marked by the events of war for life. I am no longer known by my name. I am called *refugee*.

Six

THE DANCE

THE HAGUE, MARCH 1989

A feeling of restlessness shadows me since my meeting with Van Rijn at the Posthoorn. I struggle to comprehend how the looting, smuggling, and sale of religious objects can take place on such a massive scale.

I feel as if my destiny is now tied to finding the stolen artifacts and the truth about what happened in the occupied area of Cyprus after the war.[1] In a fax to the minister of foreign affairs, Yiorgos Iacovou, I outline the details of my meeting with Van Rijn. He informs me that my fax has been passed on to Michael Kyprianou, senior legal counsel of the Republic of Cyprus, and that Kyprianou will be in touch shortly.

Several weeks later I reach out in confidence to my dearest friend and mentor Harris Orphanides, a press and media representative for the Greek embassy, for advice. Harris is politically insightful, and he is always willing to help me navigate the political waters.

"I'm waiting to hear from Michael Kyprianou. It's been a few weeks."

"You have to sit tight. If they involve senior counsel, it means there is a larger issue at stake."

"I suppose you're right, Harris."

"I'm always right," he replies, attempting to calm me.

"The statue of Naxos that you returned to Greece. What was the name of the dealer or expert involved?"

"Yes, I remember, a Mr. Roozemond. He proposed to work with my government," says Harris.

The conversation jogs my memory back to November of 1988. I had been on the job a week or so when a Dutch art dealer by the name of Robert J. Roozemond requested an inventory of stolen artifacts from the Cypriot government. I sent a fax to the Ministry of Foreign Affairs, but there was never a follow-up call. At the time, I thought Roozemond's visit to be insignificant. In light of meeting Van Rijn and the information he shared, I make a mental note to raise the situation again with Kyprianou when he calls.

❧

On the personal side, Michael's looming return to Oman brings up the subject of marriage for us. Unwed couples are considered taboo in the Arabic culture, making visits forbidden. We decide to postpone my dream of a big Greek wedding and marry in a civil ceremony on Michael's birthday, in Oudewater, a picturesque Dutch city, which became famous in the 1600s for the Weighing House, or Heksenwaag (witches' scales).

Henk Aben who organized the wedding selected this location knowing my love of cultural rituals and because of its historic relevance. After stepping on the infamous scale and receiving my certificate that I wasn't a witch, an intimate group of family and friends witness our nuptials.

My momentary feeling of elation at becoming Mrs. Hadjitofi gives way to the loneliness brought on by the challenges of sustaining a long-distance relationship. I occupy my days learning everything I can about the business of art traffickers and my evenings attending cultural events from operas and ballets to art openings. To keep myself at the center of Michael's heart and thoughts, I end each day with a letter describing every minute to him.

The ongoing politics in Cyprus cause me to vent quite a bit in my letters to Michael.

The new president of the Republic of Cyprus, George Vasiliou, presents a proposal to Rauf Denktash, president of the de facto state, the Turkish Republic of Northern Cyprus (TRNC), only recognized by Turkey, to establish a federal republic for the solution of the Cyprus issue. But peace talks between the two parties collapse with both sides unable to come to an agreement about the restructuring of property demarcation, a workable plan to deal with the claims of displaced people, and the division of power. The government of Turkey went on to illegally distribute Greek Cypriot property in the occupied area to members of the Turkish occupation army and Turkish settlers whom they imported from the mainland. Imagine leaving your home for one day and the next day your enemy is living in your house—using your dishes, sitting on your furniture, and enjoying the material possessions it took your family a lifetime to accumulate.

My parents, like other Cypriot refugees, have since lived in a state of continual limbo. Unable to make long-term decisions and unwilling to settle into their new home in Limassol, Mom and Dad see life through a temporary lens because their entire existence is based upon their wish to return to their home in occupied Famagusta. Like my parents, I wish to live out my remaining days in the city that holds the memories of our lives and those of the generations who came before us. There is a story of hopelessness visibly written on the face of every refugee. A sense of despondency weighs on our spirit, which dies a little bit more each day we are refused the right to return home.

JUNE 1989

A phone call from Michael Kyprianou, the Cypriot government's legal counsel, is followed by a fax from Stelios Karayias, assistant superintendent of the Cypriot police, informing me that Inspector Savvas Antoniades and Sergeant Andreas Anastasi of the Criminal Investigation Department Office of Public Safety in Cyprus CID (OPS) will be arriving in the Netherlands

on July 12. Interpol arranges for the Cypriot police to be picked up by Dutch detective Wim, who will schedule a meeting with Van Rijn at the Park Hotel in The Hague.[2]

The police officers from Cyprus are good-natured Cypriots: Antoniades is gregarious in personality; Anastasi is mild mannered, and Wim, the detective representing the Dutch, appears to be a man who enjoys his authority.

In The Hague's city center, next to the Palace Gardens, an area where pockets of medieval streets are juxtaposed with high-end boutiques and restaurants, Inspector Antoniades stops Sergeant Anastasi, Detective Wim, and me before entering the luxurious Park Hotel.

Antoniades asks, "Why are we not getting Van Rijn's statement at headquarters?"

Detective Wim responds, "He hasn't committed a crime . . . I think it's rather generous of the guy to invite us into his hotel suite."

The two police officers react with surprise at Detective Wim's explanation. I sense that we may be stepping into a world none of us are familiar with.

We exit the elevator and head down a hallway that leads to Van Rijn's suite, where we are met by brutish-looking security personnel, who take pleasure in questioning us before they announce our arrival. Van Rijn is dressed in a sweater and slacks, hair slicked back, wearing a trimmed mustache, fashionable for the time. He emerges from the kitchen followed by a pungent aroma of roasted lamb, and introduces us to his ghostwriter, who is working on a book about his exploits as an art dealer. Van Rijn motions for the police and me to sit across from him at the dining room table. Detective Wim takes a seat next to him, and I sit between the two Cypriot police officers.

The view from Van Rijn's premier suite looks directly over the Queens Gardens of the Noordeinde Palace; his suite projects an image of intimidating wealth. He politely asks, "What can I do for you?"

Inspector Antoniades takes a tape recorder out of his pocket, places it in the middle of the table, and hits the record button. Antoniades, void of any finesse, says, "You made an offer to Madame Consul that you could lead her to two mosaics, Saint Thomas and Saint Andreas from the church of Kanakaria, and two icons. How did they get into your possession?"

Van Rijn, poised and confident, replies, "They are not in my possession. This is clearly a misunderstanding. I assure you." He looks at me as he denies the details of our previous conversation.

Inspector Antoniades continues, "You deny a meeting took place between Madame Consul and yourself?"

"No, I do not deny a meeting took place, just about what transpired," says Van Rijn, who then turns to me while addressing the room. "Perhaps Madame Consul, who is new to her position, was a bit overzealous in her reporting." I feel flushed, and I don't know whether I am angrier at the fact that my face involuntarily turned red or that Van Rijn is lying.

Inspector Antoniades speaks with impatience. "During that meeting did you not offer to get looted artifacts in exchange for the legal ownership of either the Saint Andreas or Thomas mosaic, which, by the way are also looted."

Van Rijn's voice follows in an acrimonious tone. "Turn off the tape recorder, please." Inspector Antoniades hits the off button on the recorder. "Would you gentlemen mind giving me a moment?"

Van Rijn and Wim move to the bedroom to speak in private. Wim comes back and whispers to me, "Why don't you just take the deal?"

The police ask me in Greek what was said. I say that I'll tell them later.

Van Rijn comes back and asks to have a word with me in private. Wim directs the Cypriot police to follow him into the bedroom.

Even these experienced law enforcement professionals seem to have met their match in Van Rijn. I decide to roll with what is happening, despite my discomfort.

"You disappoint me, Tazulaah. I thought you were smarter than this. I don't work for dogs . . . dogs work for me." Van Rijn says. "If you want your precious artifacts back, I'm your only chance."

I don't respond. I can't. I am shocked by the audacity of this man, who then instructs his bodyguards to bring the others back into the room. Watching his deceitful ways, I vow to beat him at his own game.

"Gentlemen," says Van Rijn, "so sorry you came all this way for nothing." Van Rijn lies. "I do remember receiving one of those anonymous calls at some point."

Inspector Antoniades says, "And you have no idea who it is?"

"My memory fails me now," Van Rijn says. He never mentioned a phone call during our meeting, only that he had access to the artifacts and was able to sell them to the Cypriot government for a fee. "I'll contact you if I remember. Enjoy your stay in the Netherlands and have a safe flight home." With that, Van Rijn disappears into his vast suite while his bodyguards escort us to the exit.

❦

He is short in height but large in stature. Kyprianou is wise and street smart, and nothing slips by him.

"So what did Mr. Van Rijn have to say for himself?" he asks, with a take-charge demeanor.

Antoniades replies first. "He ran circles around us."

"I'm not surprised," Kyprianou says.

"Wim suggested that we take his deal," I say.

My assistant enters. "Tasoula, Mr. Van Rijn is on line one."

I reach for the phone, and before I can get a word out, he rattles off his demands. "If your government wants information, Kyprianou himself will have to be present at the next meeting. Tomorrow, five P.M., at the Okura Hotel near the Amsterdam RAI [convention center]. It was delightful to see you today, Madame Consul."

❦

After I reveal the latest turn of events to Kyprianou, he weighs Van Rijn's proposal and says, "You realize I will not be attending any of these meetings. Tell him I'm otherwise engaged, and let's see what he demands. Tasoula, I will need a recommendation for a Dutch litigation firm. Let's see what action we can take against Van Rijn in the Netherlands."

That evening as I write to my husband, Michael, in Oman, I am overcome with emotion. The fact that Van Rijn can offer to buy and sell bits and pieces of Cyprus's cultural heritage and sacred art without remorse makes me angry. I leave a brief message for Harris Orphanides asking for a recommendation of a law firm.

The next day we make our way to the Okura, a high-end modern hotel slightly out of the city center but within walking distance of Amsterdam's main attractions. The hotel carries a hint of art deco styling, as interpreted through the clean lines of Japanese design. Van Rijn is waiting for us at a table in the corner of the lobby that is somewhat private. Detective Wim sits next to him. Bodyguards surround both men. Van Rijn's demeanor changes when he realizes that Michael Kyprianou is not with us.

"A no-show again?" he asks.

I respond first. "Mr. Kyprianou sends his apologies. He is otherwise engaged, Mr. Van Rijn. If you would let us know your demands, we will convey them to Mr. Kyprianou."

Van Rijn extends one finger in the air, symbolizing his first demand.

"I need *your* government to assure me in writing that I will not be prosecuted for any of my past or future actions relating to Cyprus." He extends a second finger. "I want the Cyprus government to give me a thank-you letter for my services repatriating stolen artifacts. And bring your boss with you next time, Consul."

He hands me a card that says: Park Hotel den Haag, July 16 at six P.M.

We assemble back at my office later that afternoon, and after briefing Kyprianou, he says, "There is a very important court case taking place in America right now. The Cypriot government and the Church of Cyprus are suing an Indianapolis art dealer by the name of Peg Goldberg for the return of four Byzantine mosaic fragments that were stolen from the church of Panagia Kanakaria in Cyprus. The artifacts are from the same group of mosaics that Van Rijn recently offered to you. Whoever sold those Kanakaria mosaics to Peg Goldberg has the other two." Kyprianou's tone changes from informational to warning. "Be extremely cautious around Van Rijn. He may be trying to sabotage the Goldberg case by targeting you to compromise in some way. He plays both sides of the fence by trying to sell information to Cyprus and to Peg Goldberg and her attorneys. Everything rests on the decision of the American judge and whether he believes Goldberg had knowledge that the Kanakaria mosaics were looted when she purchased them. One photograph of me with Van Rijn can be used by Goldberg's legal team to influence the judge's ruling."

Turning to Kyprianou, I say, "I have reason to believe that Van Rijn might have access to even more artifacts than the Kanakaria mosaics."

"Continue to meet with him, but remember what I told you about his involvement in the Goldberg case. I'm impressed. If there is anyone who can get information out of him I believe it's you," he says.

He continues, "He is probably recording your meetings and having you photographed, which he will use to try and compromise people. He seems to be positively charmed by you. Use it to your advantage, but tread carefully. You do realize what is at stake?"

I don't want to reveal that I am terrified. Who wouldn't be? But there is something pushing me to step into this situation with abandon. An inner voice tells me to trust my instincts.

"I understand the risks, yes," I reply.

"Good." He hands me the card of the American lawyer in charge of prosecuting the Goldberg case in America, a man named Thomas Kline.[3]

"Keep me as your contact. I'll make sure that you and Thomas Kline have a direct line of communication." I nod in agreement, placing Kline's card in my top desk drawer.

❦

There is so much information flying at me from every direction. The more I think about it, the more questions I have. It was essential for me to read the documents that Kyprianou gave me about the Kanakaria trial. The way these dealers trade in illicit art reveals a complex subculture of deceit and money laundering.

When Peg Goldberg originally set out for Europe in the summer of 1988 it was to purchase a Modigliani painting.[4] After viewing it, she feared it might be a forgery, so Robert Fitzgerald, an art dealer who accompanied her, called upon his contacts for help. Robert Faulk, an attorney from California, and Van Rijn introduced Goldberg to the possibility of purchasing Byzantine fragments from Aydin Dikmen. Dikmen presented fragments from the church of Kanakaria, and a deal is consummated in which Goldberg is to pay $1,080,000 and agrees to split the profits from any future sale of the mosaics with Van Rijn and the others.

Goldberg and company met Dikmen in the Freeport area of the Geneva airport to examine the mosaics, which she then purchased. At the time of the purchase, there were no laws governing the import of cultural property in Switzerland, making it a safe haven for art traffickers and unscrupulous art collectors to conduct their transactions.[5]

Goldberg fell in love with the ancient mosaics at first sight.[6] Before the ink was dry on her loan to purchase the artifacts, she was caught attempting to resell the same sixth-century Kanakaria mosaics to the Getty Museum for twenty million dollars, prompting curator Marion True to alert the Greek Cypriot authorities.

This was the first time Dikmen and Van Rijn had come to the attention of the Cypriot government and the archbishop of Cyprus. In June of 1984, several Byzantine frescoes were sold to Texas philanthropist and museum founder Dominique de Menil through Yannis Petsopoulos, a Greek dealer based out of London.[7] Petsopoulos intermediated the sale with Aydin Dikmen, whose name was unknown to the Cypriots because both de Menil and Petsopoulos would not reveal his identity as part of their arrangement. Dikmen was paid $520,000 for the frescoes, one of which depicts Christ Pantocrator (Pantocrator is a title used when Christ is represented as the ruler of the universe, especially in Byzantine church decoration) surrounded by angels; the other shows the Virgin Mary with the archangels Michael and Gabriel.

In 1985, when de Menil flew to Munich to view the frescoes, she first saw the badly damaged treasures in a dimly lit room, yet their infinite beauty inspired her to build a chapel in Houston to display them. Suspecting they might be stolen, she secured them for purchase and went through political channels to investigate their provenance. It was determined that they were indeed stolen, so she contacted the Cypriot government and the Church of Cyprus and proposed a deal to buy and restore and display them in Houston, on loan for twenty years, in exchange for her paying for their restoration. De Menil spent more than five million dollars on restoration and the subsequent construction a chapel specifically designed to showcase the artifacts, which would eventually be returned to Cyprus. Her creative approach set an example for the rest of us to see the possibilities in alternative restitution

solutions. It raised my awareness to see that such forward thinking was shared not only by de Menil but by the archbishop of Cyprus, Chrysostomos I, who agreed to this visionary plan.

<center>⤛</center>

Over coffee and Dutch waffles in my office the next day, Kyprianou, the Cypriot police, and I continue to discuss our strategy regarding Van Rijn.

"Your request for a lawyer recommendation . . ." I say, handing Kyprianou a card.

"Beker CS Advocaten out of Rotterdam, terrific! I'll contact them today," Kyprianou says.

"Do you recall receiving a fax from me about another dealer a few months ago, a man by the name of Robert Roozemond?" I say.

"His name sounds vaguely familiar," says Kyprianou.

I hand him the file on Roozemond, which he reviews.

"Would it be useful to arrange to meet with him while you are here? He's trying to work with us."

"See what his availability is," he says and changes the subject back to Van Rijn. "Van Rijn will be ready with a list of demands tomorrow regardless of whether I am at the meeting or not. Do your best to assure him everything is okay. Go through the photographs one by one and notate every word he says."

The following day, July 16, is a Sunday, and although I am lonely without Michael, his absence provides me with an opportunity to work around the clock without restriction. I continue to familiarize myself with the Goldberg and de Menil cases in preparation for my next meeting.[8]

Returning to Van Rijn's suite in the Park Hotel the next day we sense Wim's frustration.

"Kyprianou's absence speaks volumes," says detective Wim. He continues, "Van Rijn needs a guarantee that the information he provides will not be used against him."

"Detective Wim, Mr. Kyprianou's absence does not prevent Mr. Van Rijn from stating his demands," I say. Van Rijn seems to enjoy being the focus of attention.

<center>68</center>

Wim continues, "If there are thousands of missing artifacts, and he is willing to provide details about their whereabouts, what is the issue of paying him?"

Inspector Antoniades responds, "Come on, Wim! In some circles paying for information like this could be considered to be unethical!"

"Call it cooperation, then. Buy the artifacts back, write a 'thank you' or 'forgive you,' letter, whatever the guy wants, and be done with it. Getting your cultural heritage returned is what is most important, isn't it?"

Wanting to expedite the meeting and end the bickering, I spread the photographs in front of Van Rijn.

"Yes, I'm aware of this one and that one and this piece, too. I know who the possessors are." His piercing eyes watch my every move.

"I was a middleman on most of the sales. Either you give me money to buy them back for you, or you pay me a monthly fee to track their whereabouts, and you can repatriate them yourselves."

"You're asking my government to buy back our own stolen treasures while you are left off the hook?"

Van Rijn laughs. "Under Dutch law, if these goods change hands several times, the sale could be deemed completely legitimate. Even if the original owners have proof of provenance, they will be unable to seek possession," he says, educating me about a method used by art traffickers to turn an illicit item into one that is legally owned. I do not let on that I am involved in the Kanakaria case, nor do the police. Van Rijn continues, pointing to artifacts, "This one will cost you three hundred fifty thousand dollars."

I record his every word, knowing this will become legal evidence in a case that Kyprianou will start to build against Van Rijn. He looks up from the pictures.

"I hope that this will give your Mr. Kyprianou what he needs for us to move ahead," says Van Rijn. I gather up the photographs and place them inside an envelope that I will turn over to Kyprianou later that day.

"We are done, Mr. Van Rijn," I say. "Please, leave a contact number with me this time."

He smiles and says, "I appreciate your tenacity, but you don't call me. I call you."

Back at my office, I find my assistant serving sandwiches and coffee to Michael Kyprianou, who has been awaiting our return.

"Van Rijn appears to have a strong connection with the detective," says Antoniades.

"That is not our concern," says Kyprianou before turning his attention to me. "Tasoula, Van Rijn might be thinking he can take advantage of your youth."

I nod. "Here are the prices he quoted," I say, pointing to the backs of the pictures.

Kyprianou inquires, "If Van Rijn wants to meet with him, are you willing to do so?"

I turn to him and say, "I want you to put him behind bars, Michael. I'm a girl from Famagusta; this is personal." We then set out to meet dealer Robert Roozemond.

<div align="center">⁓</div>

Coincidentally, the ART.E+S gallery is also in close proximity to the Noordeinde Palace, and is just around the corner from the Park Hotel where Van Rijn's suite looks over the queen's gardens. The area surrounding the royal chambers of the queen's work palace, where she receives foreign dignitaries and displays her golden carriages at the opening of Parliament season each year, is quite posh.

When Kyprianou and I enter the gallery, Roozemond is there to greet us.

He has red hair and glasses, and puts forth great effort to present an image of perfection both in his speech and in his attire. We are led into his elegantly decorated office, adorned with fine arts.

"I have been following the Kanakaria case in America, Mr. Kyprianou. Actually, the registry system I created speaks directly to the plight of your government's needs. If you choose to employ our database registry, we can create an accurate accounting of what was stolen from Cyprus so that we can better prevent the art traffickers from getting wealthy off of these stolen antiquities, at least the ones that pass through the Netherlands," he says, pushing forth his agenda. "What brings you to the Netherlands?" he inquires.

"I'm investigating reports of other Byzantine artifacts that might be for sale in the Netherlands," says Kyprianou.

"If there were artifacts from Cyprus for sale, I would know about them."

"That's interesting, because we hear information to the contrary from another Dutch dealer," says Kyprianou.

"Strange indeed," replies Roozemond. "Which one in particular are you searching for?"

Kyprianou bluffs, "We are expecting a list from the other dealer any time now. I'm afraid I will have to get back to you on that."

Roozemond leans back in his chair and springs forward, flips through his Rolodex and pulls out a card, which he passes to me across the desk. It reads, "Dr. Chr. Schmidt 064 7798."

"This is the name of a doctor who is known to have purchased a few artifacts from Cyprus in the past, but all legal buys, I assure you."[9]

I copy the information down from the card and hand it back to him. He continues, "As a token of my goodwill and desire to work with your government."

He continues, "If the dealer you are alluding to happens to be Mr. Van Rijn . . . I'm sure you know from the Kanakaria case to be skeptical of him."

"What is your issue with Mr. Van Rijn?" I ask.

"He used to be a star dealer. Now he does business with people like Dikmen, and there is no place for that kind of trading in my business."

"Encouraging to hear, Mr. Roozemond," says Kyprianou.

"Thank you for squeezing us into your schedule," I say, sensing a good exit point.

Kyprianou stands and says, "We will be in touch with you shortly."

Kyprianou and I exit the gallery and grab a cup of espresso at a nearby café.

Kyprianou says, "Let's see what the Dutch lawyers can dig up about this Roozemond character." He checks his watch. "I'll miss my flight if I don't leave now. Tasoula, you are a terrific addition to the team. I'm counting on you."

"I have a true master to learn from," I say, wanting him to be assured of my commitment. Driving back to my office, my thoughts go to Van Rijn. I make a mental note to see what information I can get out of him about Roozemond.

My office is bustling with activity, and I turn my attention back to Octagon trying to make up for lost time. I return a call fromThomas Kline, the lawyer handling the Peg Goldberg case in America. Kline has a reputation for being a cultural property dynamo of a litigator. His friendly and open demeanor puts me instantly at ease.

"I need whatever information you can find on Van Rijn and Dikmen and their network in the occupied territory of Cyprus," says Kline. "Can we find out who is doing the actual removal and destruction of the mosaics? This could help Cyprus to consider criminal prosecution and the extradition of these men." He says.

"I'll be in Oman for a week, but I'll attend to it once I'm back and report to you and Kyprianou," I say, wondering if Kline realizes that I have no experience in this field. The question is how I can now manuever Van Rijn into giving me more information that might help the outcome of the Goldberg trial.

Seven

A SIGN

JULY 1989

The gray silk sari, purchased in India, is the last item I place in my suitcase as I prepare for my departure to Oman. By day, Michael will continue his enhancement oil recovery work for Shell Petroleum Development Organization (PDO).

His evenings and weekends will belong to me. As newlyweds living in separate countries, one of us travels to see the other every three months, and this trip marks our honeymoon. As much as I miss Michael, leaving my responsibilities is difficult for me.

Meanwhile, in America, the Peg Goldberg-Kanakaria case promises to be precedent-setting and is attracting the international media in droves. I find myself obsessed with securing as much information as I can to help my government win this case. The only technology available to me at the time to aid me in my research efforts is a fax machine, a telephone, and the library. Calling experts, journalists, and soldiers is how I gather information. I leave for the airport from my office in order to handle some last-minute details and

to place a call to Beker CS Advocaten, the Dutch law firm now handling the affairs of the Church of Cyprus. I am hoping to find out if we currently have enough evidence to prosecute Van Rijn under Dutch law. Anja Middendorp, the lead attorney, is a smart, resourceful woman in her forties, and we have been getting along quite well.

"Unless we have proof that the Cypriot artifacts are in Van Rijn's possession and we can prove provenance, there are no grounds for a criminal or civil case," she says to close our call, to my disappointment.

The circumstances in Cyprus are not in our favor. At the time of the invasion, the most reliable records of the artifacts available were those of the government's Department of Antiquities, a handwritten card system describing the most valuable and historical artifacts. It was far from a comprehensive catalogue, and very few of the cards describing the artifacts had photographs attached to them. The most notable antiquities of Cyprus were studied by foreign scholars and referred to in international publications, and these records became a vital source of confirmation of provenance during court cases. In some cases the records of outside scholars were the only proof that these treasures existed. Experts the world over had come to Kanakaria to study unique iconographical characteristics of the mosaics in the Goldberg case. They were well documented, and the prosecution relied upon these records in the court cases. There was so much else that went unrecorded, as the people of Cyprus were not looking at the sacred artifacts as cultural heritage items; they were praying with them. And thus the icons occupied an unusual spot at the center of the intersection of the Greek Orthodox Church and the secular legal system.

The Holy Synod of the Greek Orthodox Church consists of a group of six bishops who rule over six regions: Kyrenia, Famagusta, Nicosia, Paphos, Larnaca, and Limassol. Each bishop governs his own region and they have the power to elect the archbishop. Each domain is handled independently and differently. Some regions kept very accurate records of the contents of the churches and monasteries, while others only listed the most valuable artifacts. All identifications came from eyewitness accounts of people in the community: priests, caretakers, restorers, and historians. To initiate a legal case one must first establish provenance to prove ownership. Having inadequate and

antiquated systems of recordkeeping created a great challenge in legal battles. The burden of proof of ownership lies with the church, the legal owners of the sacred artifacts, and with the government for historical artifacts.

"In consideration of these circumstances," says Middendorp, "why not see if there is a possibility to secure information from Van Rijn regarding the whereabouts of the artifacts."

"I want Dikmen and Van Rijn to pay for what they did."

"Your best bet is to win his trust and hope he'll lead you to the treasures."

No sooner do I put the phone down when it rings again. Van Rijn is on the line, which makes me wonder if my telephone is tapped. My burgeoning paranoia has me secure a job for my intern, Jeroen, with one of my customers, to get him out of my office in case he was is a possible mole.

"I have something very important to discuss with you, Tazulaah," Van Rijn says.

Knowing that I will never enjoy my vacation if I decline to meet him, I agree. The Hotel des Indes is his meeting place of choice. Van Rijn is sitting at a table waiting for me when I arrive.

"Madame Consul, I must commend you on your taste. That yellow Escada suit is perfection."

"Thank you," I say as I take a seat, "You are well versed in designers, I see."

"I'm an observer of people and works of art, Madame. Sometimes they are one and the same." He studies my jewelry. "Those Lalaounis earrings suit you," he says.

Lalaounis is a Greek artist who is world famous for creating jewelry inspired by Classical, Hellenistic, and Minoan Mycenaean art. My hand subconsciously touches the earring.

"A nice replica of a headpiece worn by Elena of Troy," says Van Rijn.

The waiter delivers a double espresso and a Pellegrino for him and a cappuccino for me. "So, what is so urgent?" I ask.

Van Rijn places an envelope on the table for me to open. Could this be a trap? A seemingly innocent photograph of me opening this envelope could appear as if I am accepting a bribe. Kyprianou's warning words are ringing in my ear now.

"Would you mind opening it for me?"

He opens it without hesitation and removes a photograph. It's a picture of an archangel Michael icon.[1] I notice the copy was stamped by a Dutch notary and dated October 16, 1987, and it shows three signatures. Van Rijn's is legible. Looking carefully, I see the other signature is Aydin Dikmen's, but I can't make out the third.

"A doctor has it," says Van Rijn.

"What's his name?"

"We are not there yet. Let me explain why I called you here." He takes a sip of his espresso. "You should be cautious around dealers like Robert Roozemond."

"Why is that?"

"Do you know why spiders never get caught in their own webs? They glide over it by way of the hair that is at the very tip of their legs. They never come in contact with it."

"How did you know that I met with Roozemond?" I ask.

"The art world is small. I know the players, the network, how the deals work." He points to himself. "That is not the case with everyone."

"Why should I trust what you say, Mr. Van Rijn?"

"No one can really be trusted. Only a fool would believe otherwise," he says.

"My word is bankable," I say.

"Everyone has a price, and when that price is met, their word becomes worthless."

"My integrity is non-negotiable."

"There is something about you . . . I will figure it out . . . count on it," he says.

"Mr. Van Rijn, what I do, I do for Cyprus. There are some you cannot buy."

"So I push on until I find your price," he says with irony.

Pointing to the photograph, I ask, "Tell me where the doctor lives?"

Van Rijn has a little trace of the devil in his smile. "That is for you to find out." Van Rijn's game is to give me bits and pieces of information, none of which add up to anything conclusive. He likes to test my capabilities by seeing what I can uncover with only a tidbit of information.

"May I take this?" I ask, pointing to the photograph again. He approves. "Give my regards to your Michael . . . lucky man . . . !"

Leaving the hotel, I remind myself to fax Kyprianou, who will be pleased with the new information. Van Rijn's parting comment about sending regards to Michael triggers additional anxiety. Could he possibly know I am on my way to Oman?

OMAN

Love and romance set against the exotic backdrop of Muscat. Located in the eastern corner of the Arabian Peninsula, the majestic Al Hajar Mountains that rise in the distance are a contrast to its beautiful signature whitewashed buildings. The house that Shell provides Michael sits on a cliff overlooking the sea. It is the perfect place for newlyweds to nest.

While Michael is at work, I entertain myself at the *suk* (open-air market). I make sure my attire fits the cultural surroundings, covering my arms and head when outside of the Shell camp. My Mediterranean coloring helps me assimilate even more easily, and in no time I make friends with the locals. The smell of frankincense emanating from burning resin in little pots transports me back to Cyprus in a single breath.

"Fresh fish, fresh fish, miss," yells a toothless elderly Arab man in a kind of pidgin English. His curly gray hair does not cover the lines baked into his face by the sun. He is holding a tuna that looks as if it was just pulled from the sea. I purchase two pieces for dinner. One day when I arrive at the market the fisherman places a shark he just caught before me and cuts its belly open. To my horror it was pregnant. I was unnerved by having to witness this fisherman's way of life, and when he sees my reaction he tries to make up for it. For the next two hours he carefully removes the teeth from the shark and gives them to me as a gift. He tells me I must bury the teeth in the sand for a few days so that the worms and ants will clean off the remaining flesh. He gives them to me as a memento of our friendship, and I am touched. Culturally, we can be so different and at times shocked by each other's ways and customs, but this is the beauty of a colorful society and the world of diversity in which we live.

I struggle thinking about how to reciprocate, and I decide that the most appropriate gift for him would be a Swiss Army knife so that he can work as a fisherman with a bit more ease. By embracing his rituals, I seek to create a space of respect between our two cultures.

While in Muscat, I also contact the honorary consul to Cyprus in Oman in order to connect Michael to the Cypriot community, so that I can leave him with a circle of friends outside of Shell, something he has been yearning for but unable to attend to with the demands of his job. At a dinner party hosted by the consulate, we meet a diving instructor who convinces us to take lessons, the best move we could have made. Diving in the crystal blue waters abundant with sea life, we see beautiful colored sea reefs and corals, and huge stingrays mate several feet above us, making the dive in Oman a spectacular adventure.

We spend the days making plans for our future; it is apparent that we both wish to start a family. I recall how lovingly Michael described his family on our first date, especially his relationship with his identical twin, Andrew. If he could only love me half as much as he loves Andrew, I thought, he will make a great husband. Michael and Andrew have been inseparable since birth. They studied the same subjects, chose the same jobs in the same industry, and their ways of thinking are also in sync. Marrying Michael meant I had to find my own space in our relationship without interfering in their relationship, which was little to ask in the face of the fact that I had found my soul mate.

We dine at the Al Bustan Palace, which was originally built to host the Gulf Cooperation Council (GCC) summit in 1985. The exotic setting creates the perfect ambiance for a romantic dinner, and an opportunity for me to wear my gray sari. The Arabian décor and its location overlooking the sea of Oman has us both feeling amorous. We sit opposite each other, lost in each other's eyes but restrained from displaying any affection in public. We leisurely enjoy a dish of prawns and lobster the like of which I've never tasted before. As I turn to glance at two local men dressed in white *thawbs* (cotton robes) and *keffiyeh* (head scarves) drinking alcohol-free beer at the next table, I feel my sari loosen.

"Michael," I say, in a bit of a panic, "will you excuse me, please?" As I stand to go to the ladies' room, the sari unravels. I quickly sit back down.

"My dress is coming apart," I whisper from across the table. I can tell by his expression that he does not realize that seven meters of fabric are about to drop to the floor. At least I am wearing my matching lace undergarments, but they are not meant for public display.

"Put your arm around me and walk me to the ladies' room."

"Physical contact is forbidden, Tasoula, we mustn't!"

"Michael, my sari is one piece of silk which is now coming undone! I have no petticoat on! Please! I will be naked in two seconds if you don't act now!"

He jumps to his feet, and he escorts me to the restroom with all eyes upon us as our risqué behavior creates quite a stir among our fellow diners. The dress continues to unravel with every additional step, and I'm sweating profusely despite the air conditioning. I enter the restroom just in time as my sari drops to the floor; I am, luckily, out of public view. We cried with laughter imagining what might have happened if things had not gone our way.

The climax of our vacation is sleeping in a tent under the stars at Ras Al Hadd, a remote village in the Ash Sharqiyah district. At the beach we witness the magnificent, endangered sea turtles (*chelonia mydas*) nest under the light of a full moon. We watch shadows rising from the froth of the waves, the turtles gradually making their way to the sand where they will lay their eggs. The sound of their digging and breathing mixed with the breaking waves becomes the lullaby that rocks us to sleep.

In the early morning hours just before sunrise newly hatched baby turtles make their way through an obstacle course of predators, like birds and foxes, to arrive at the sea. They mark their place of nesting, and after they travel around the world, they will know to return to the same place. This brings my thoughts back to the artifacts, my need to return home to Cyprus, and the art trafficking predators who are preventing the artifacts' return. We make love and fall asleep wrapped in each other's arms under a star-filled sky, knowing it will be three months before we feel each other's warmth again.

<div align="center">⚜</div>

I am met with a firestorm of activity in The Hague upon my return, causing me to work endlessly for weeks to catch up with the demands of my

business and my responsibilities as honorary consul. Kyprianou is looking for debt collectors in the Netherlands, something to do with tracking down a missing John the Baptist artifact. Van Rijn has called multiple times looking for me.[2] He leaves his contact information with my assistant, which signals to me that I am earning his trust. Roozemond sends a letter to me, copying the Cypriot authorities, in which he states that he has received no reaction from either Kyprianou or myself regarding his request for a list of Cypriot stolen artifacts for his registry.[3]

In a faxed letter to Kyprianou, I express my concern about providing any dealer with our archive list of looted artifacts, wondering if it would prove to be hazardous to us. If a dealer is in possession of looted artifacts they know what they have. By gaining access to our records, dealers will be privy to what evidence we do and do not hold. Once they realize that our inventory does not reflect every artifact belonging to Cyprus they will have an opportunity to legitimize unlisted looted artifacts they may be holding.[4]

After Kyprianou gets my fax, he calls. "You are turning into quite an investigator." He laughs. "Should I worry about you, Tasoula? When you hang around with criminals you begin to develop a criminal mind."

"You have to know your enemy to beat them at their own game," I reply.

My low energy and queasiness over the last few days make me wonder if I might have caught a bug in Oman, so I schedule an appointment with my doctor. An impatient Van Rijn finally reaches me.

"Is there something urgent?" I ask.

"One hour, at the usual?"

I call one of my employees who is also an old friend into my office.

"Do me a favor, Pim, go to the des Indes, turn left in the lobby, and you will see Van Rijn sitting at a table. Watch who he talks to, and who stops by his table, if he sets up a tape recorder, things like that. When I arrive, pretend you don't recognize me, but leave after me to make sure I am safe."

I stop off to take a few tests at the doctor's office and arrive for my meeting with Van Rijn, who startles me with a kiss on the cheek just outside the hotel entrance.

I look around for a camera, wondering if this ambush will come back to haunt me. Arriving at his usual table, he wastes no time getting to business.

"You are glowing! Were you on vacation with Michael?"

"What did you call me here to discuss, Van Rijn?"

"If the American judge does not rule in your favor on the Goldberg case, I want to discuss the possibility that I might side with your government on appeal," he says with candor. Van Rijn is placing his bets with both Peg Goldberg and the Cypriots to cover his losses. Whether the case goes to appeal or not, my government will never make a deal with him. All we are after is his information and I place my bet on litigator Kline.

"Why would you want to do that, Van Rijn?" I ask.

"Well, if your government pays me ten thousand Dutch guilders ($5,250) a month, I can inform you of the whereabouts of your icons, and for a bit extra I might be able to share some insights into the Goldberg side of things, to help you win the case."

"I'll pass your proposal on to Mr. Kyprianou. What were you doing in Cyprus after the war?"

"I was in business there for many years," he says.

"How did Aydin Dikmen get access to the churches in the occupied area?" I ask.

"It pays to have friends, Tazulaah."

"How did he get past the Turkish military?"

"He's a member of MIT Special Forces." Meaning Milli Istihbarat Teskilati (National Intelligence Agency, Turkey).

"He also moved freely in the southern part of Cyprus?"

He had an understanding with a few officers which gave him a free pass to go where he wanted." Van Rijn smiles. "I like your persistence."

"Dikmen must have had a small army of people working for him."

"A bunch of guys. You don't need to be smart to steal an icon from an empty church."

"How did he pass the stolen artifacts through customs?"

"Cash in hand opens closed doors." Van Rijn lights a cigarette and takes a very long drag. "Dikmen had the goods . . . I had the clients . . . we joined forces."

He lights another cigarette while the first is still burning in the ashtray. "Will your government appeal?"

"Only my government knows."

"Get word to Kyprianou. I want to strike a deal."

"Is there anything else?" I ask.

"Nothing equals the beauty of Byzantine art. I want you to know that I do admire and love these pieces too, although we may love them for different reasons."

"If you love them and know what they mean to people, why do you sell them?"

After a long pause, he says, "You are different than the others in your government. What escapes me is what you are after."

"Mr. Van Rijn, destroying the churches and selling our sacred artifacts is selling the soul of my people. We pray with these icons daily. It destroys the fabric of our village life when we don't have access to them. These artifacts are priceless to us, but not in monetary value."

His eyes read me to detect if I'm telling the truth.

"Dikmen duped me, too, you know. He swore to me that the church of Kanakaria was destroyed."

"Give me the information?" I ask.

"Do I look like a charity? Get Kyprianou to make a deal; then we can talk."

"If you are turning your life around, as you say, no strings attached?"

Van Rijn shakes his head. "It is bad manners to look a gift horse in the mouth." His icy stare shows me that he can turn on me at any moment.

"And Aristotle said, 'Moral excellence comes about as a result of habit. We become just by doing just acts, temperate by doing temperate acts, brave by doing brave acts.' My gift to you," I say, before making my exit.

He treats me as if I am his student. What his ego fails to let him see is that I plan to win this game.

After sending a quick fax to Michael Kyprianou to report on the meeting, I make my last call to Thomas Kline, who thanks me for retrieving such useful information.[5]

On August 3, the church bells ring across the island of Cyprus in celebration. An Indianapolis court in America has ruled in favor of Cyprus and against Peg Goldberg, calling the Church of Cyprus the legal owners of the sixth-century Kanakaria mosaics.[6] The case goes to appeal.

The bug I thought I picked up in Oman is not a bug at all. I am several weeks pregnant with my first child, and I see this pregnancy as a sign to turn to Saint Andreas for help. When faced with the challenge of delivering a son after having three daughters, my mother turned to Saint Andreas, who answered her prayers several months later when she gave birth to a son whom she named in his honor. In my case, it will be to recover the artifacts in his name. If I have a boy, I'll also name him Andreas, as my mother did before me.

To add to the spiritual significance, I know that Van Rijn knows the whereabouts of the Saint Andreas mosaic. I will turn to Saint Andreas for help to recover the priceless sixth-century mosaic created in his image. My search to find it is as much for my mother as it is for Cyprus.

Eight

CHASING TRUTH

THE HAGUE, 1989

C arrying another life within me expands my awareness about the miracle that is the human body. With minimal morning sickness and signs of pregnancy, I continue to juggle my multiple roles with relative ease. I'm also excited that Michael will return to The Hague permanently at the end of the year and we plan to purchase the apartment Michael was living in Wassenaar, an exclusive town adjacent to The Hague. Motherhood energizes me, and Michael is taking on my symptoms as well. I feel the baby kick and imagine that it is just as excited about meeting Michael and me as we are in anticipation of welcoming it into this world.

As the Turkish government begins importing thousands of Turkish nationals into the occupied area of Cyprus, a directive is sent to closely examine requests from Turkish Cypriots for passports. I switch roles and perform my duty as an honorary consul when my assistant alerts me that there are Turkish men seeking passport renewals without a scheduled appointment. To her surprise, I agree to see them.

The men enter dragging their old, beat-up suitcases behind them. One with a slight frame takes a step forward.

"Χρειάζομαι βοήθεια παρακαλώ," (I need your help, please) he says in Greek.

"Welcome, gentlemen. Please, sit down." Turning to my assistant, I say, "Order lunch for these gentlemen and bring us some Turkish coffee, please."

The fact that the man with the slight build speaks Greek is a good indication he is a Turkish Cypriot, as most Turkish nationals are not fluent in Greek.

The hollowness in their eyes reflects deep loss, a look that I am familiar with. The one with the slight build reaches for a piece of his luggage and feels around the exterior of the bag until he finds a self-made slit, invisible to the eye, on the underside of his bag.

"Denktash [then President of the unrecognized Turkish Republic of Northern Cyprus] forbids us to use our Cypriot passports."

"Then how did you get into Holland?" I ask.

He removes a piece of silver foil from the slit in the suitcase and opens it to reveal a Cypriot passport in his name about to expire.

"We traveled with the TRNC passport first by boat to Turkey. Then we took a bus to Holland, and we show our Cypriot passport to the Dutch authorities."

The Turkish Republic of Northern Cyprus is not recognized by any government except Turkey, so these men would have been barred from entering Holland had they not had Cypriot passports. I continue to ask the men to describe the village they come from to test the authenticity of their Cypriot citizenship. To my surprise they came from Agios Iacovos, a village in the occupied area just a few minutes away from Mandres, where my extended family lived. With lunch now set at the conference table, I motion for the men to join me there. They bow their heads in respect before we sit down to dine together.

"Tell me about the church in Mandres, the village next to yours," I say.

"I have seen nothing," he says.

"I'm interested because I am from Famagusta. You have my word on that."

He relaxes. "It became a target. Some people say it is the soldiers who steal, and others say that when the Greeks fled they took their icons with them."

"What do you believe?" I ask.

"I believe that war makes people do desperate things. We are also not happy with what is happening in the occupied area. We have no future there. Most of us Turkish Cypriots have left the island," he responds.

"Please understand that I depend on my government to check your information before I can continue."

"What can you do when war takes your job and the pennies you spent a lifetime earning? The foreign diplomats and rich outsiders come to Cyprus to buy them. Even the soldiers take them."

"In Mandres, Turks and Greeks also lived together. My mother taught Turkish Cypriot girls how to sew in the village. She even speaks Turkish." These men, know the devastating impact of war. "It's important that I know what is happening in the occupied area in regard to churches and archeological sites."

The man with the slight build takes center stage.

"Men come and take objects away from the church by truck."

"Do the United Nations soldiers not see any of this?" I ask, reminding myself that while some Cypriots are able to live side by side peacefully, a steady flow of intercommunal violence in 1964 along the line separating Greek and Turkish quarters in Nicosia (later known as the Green Line) prompted the United Nations to send in a Peacekeeping Force (UNFICYP). After the 1974 invasion, the UN Security Council mandated the force to remain in Cyprus to support the ceasefire and to serve humanitarian efforts. "How could this take place in their presence?" I ask again.

The man lowers his head as if he carries the shame for the situation solely on his shoulders. "The UN soldiers see, but then look the other way," he responds. I appreciate the courage it takes for this man to speak so openly to me.

"Where are you staying?" I ask.

"Most nights we go to the park," he answers. I feel for these men. Their lives were also destroyed by the invasion. Despite the political situation and the mistrust created between our two cultures, I can't blame every Turkish Cypriot for the invasion of Cyprus. As honorary consul it is my duty to serve every Cypriot equally. My instincts tell me these men are legitimate Cypriots,

but I will take the confirmation process further. I decide to put the men up in a hotel and pay for their dinner at my personal expense. I give them my business card with the hotel information handwritten on the back of it.

"Tonight, you are my guests. Rest, enjoy, and call me at this number in the morning." Their animated expressions reflect their appreciative disbelief.

"Madame Consul, we will repay your generosity. You can count on us to relay news from the occupied area," says my new friend.

"Thank you," I say as I scribble my private number on another card.

"Call me whenever you hear of something happening to the churches or monasteries. I'm as much your consul as any Greek who knocks on my door."

I watch my assistant escort the men from my office and immediately call my good friend Mohammed, the owner of a Turkish coffee house in Amsterdam. Mohammed first reached out to me two years ago to help a friend of his who was falsely imprisoned. I came to the aid of the man as I would any Cypriot, and word of my fairness soon spread through the Turkish Cypriot community living in the Netherlands and beyond. Mohammed then became my go-to person for confirmation of who is and is not a true Turkish Cypriot. His wide access to connections both in Cyprus and Turkey provides me with a reliable network to weed out those seeking false citizenship. His in-depth knowledge has never steered me wrong. Although Nicosia would have approved the passports, many of the records were destroyed during the war. If the requesters did not already have identity cards, it was left to our discretion whether or not we should issue passports.

"They are Cypriots, from Agios Iacovos in Cyprus," he says.

"I knew I could count on you, Mohammed. Hearing your voice reminds me that we have not shared a coffee for some time."

"My wife and I will visit you and bring *boregi* [Turkish pastry roll filled with cheese and coated with syrup]. Good day, Madame Consul."

I forward the request to Nicosia for further verification of their records. There are those who wrongly judge me for going into my own pocket to incur expenses for a position that is unpaid, but I consider it a privilege to serve my country as honorary consul. These men needed a compassionate heart today, and I have contacts in the occupied area of Cyprus now.

My talk with the Turkish Cypriots spurs thoughts about how the looted artifacts might be transported out of Cyprus. The occupied area is free of controls. One can easily travel by boat with contraband into Turkey and from that point gain access to the rest of the world. Cyprus is a small, independent country and most customs officials, when called upon, can't even pinpoint its location on a map. Most times they see it as an extension of Greece or Turkey. If these artifacts are accompanied by false documents from the Turkish Ministry of Culture made by corrupt officials, the shipment is sure to go through unchallenged.

The injustice of what transpired in Cyprus did not end with the war. Wealthy collectors from around the world lined up like vultures to pick at the bones of our looted land. Now that our cultural heritage is broken into pieces and sold to collectors and museums globally, the story that our ancestors meant for us to see can no longer be told in the same way to future generations. The loss is immeasurable. There is a way to stop the problem. Markets, legal and illegal, exist because there is demand. Without the demand, there is no market.

Nine

HAPPY NEW YEAR!

1990

A major break in information occurs. Bankruptcy records reveal that Robert J. Roozemond organized an exhibit in The Hague in 1977 drawn from the De Wijenburgh Collection, of which he was director. The receiver of the De Wijenburgh[1] bankruptcy case, Mr. Saasen, connects our lawyer, Anja Middendorp, to Victoria Van Aalst, curator of the A.A. Bredius Foundation who, by purchasing documentation from the De Wijenburgh Collection, has gained possession of thousands of the exhibit's photographs, slides, catalogues, and lists of icons, many of which are potentially looted.

"Unfortunately, this documentation provides no origination information, so an expert from Cyprus will be required to establish provenance. I did find two eighteenth-century Royal Doors among the icons," says Middendorp.[2] "It's possible they belong to Cyprus."

"I'll get back to you regarding an expert," I say. "It will be helpful if you can send me a copy of the catalogue."

I contact renowned Byzantinologist and director of Cyprus's Department of Antiquities, Athanasios Papageorgiou, urging him to schedule a trip to the Netherlands to view these slides. I also leave a message for Michael Kyprianou, who is now in the midst of the Goldberg appeal. Being one who likes to resolve things with a sense of urgency, I find my lack of authority and the bureaucracy within the Cyprus government to be frustrating at times because of the slow pace at which decisions are made that we keep having to navigate.

After the Goldberg appeal is completed a month later, I remind Kyprianou and Papageorgiou once again that the Beker CS Advocaten law firm needs to establish whether we will be expanding our investigation to include Roozemond and the De Wijenburgh bankruptcy and ask when Papageorgiou will be able to come to the Netherlands to view the slides.[3]

On March 15, Roozemond, bypasses communication with Kyprianou and me, and sends a letter directly to Papageorgiou along with twenty-one photographs of artifacts. He requests that Papageorgiou identify which ones are of Cypriot origin.[4] Papageorgiou confirms that both Saint John the Baptist and the Royal Doors are from Cyprus. I inform the lawyers in Holland of this latest development and phone Anja Middendorp with our concerns.

"Let's suppose, Anja, that an artifact is neither listed with Interpol nor recorded in the Cyprus database as missing. Can a dealer then claim that he has done his due diligence and that he is free to sell the artifact? Remember, Roozemond first approached me wanting the Cyprus government's database list of looted and missing artifacts from every cultural heritage site in the occupied area."

"In theory, he could claim due diligence, but its not that simple. According to Dutch law, the burden of proof is on the original owner. The Cypriots must prove that the dealer or possessor purchased the artifact in bad faith, meaning that they knowingly purchased it illegally. The dealer will try to prove that he purchased in good faith and did all that he could to check with the proper authorities: as an example, checking Cyprus's database records, as well as the Interpol database and media reports regarding the conflict in Cyprus. In addition it would have to be decided whether the artifact was purchased within the statute of limitations period. The judge would then evaluate the evidence before ruling."

"What do you mean by statute of limitations?"

"In Holland, a bad-faith purchaser after twenty years can acquire a legal title of ownership."

Anja's firm urges us to officially respond to Roozemond's letter of the fifteenth of March. Papageorgiou sends an official response to Roozemond's letter requesting to view the icon of Saint John the Baptist and the Royal Doors in person in order for him to officially authenticate their provenance.[5]

As I place the phone down, I think about the unfairness of it all. These laws protect the criminals and the art trade, and this is just one of many ways in which an unethical dealer can avoid prosecution. How can I possibly determine whether Roozemond's request for the database is well intended? One day I will challenge these laws by lobbying politicians.

<center>⚜</center>

I arrive at the VIP room at Schiphol airport to meet the president of Cyprus, George Vasiliou, who is on a layover in Amsterdam en route to the United States. Since there is no Cypriot embassy in Holland, I am the designated point person to meet such esteemed dignitaries in The Hague. We take the opportunity to discuss his upcoming official visit to the Netherlands as a guest of the queen and to attend a state palace dinner. I will be in charge of making the arrangements and handling the logistics of his visit in liaison with the queen's staff and the Cypriot Ministry of Foreign Affairs and in cooperation with the Cypriot ambassador in Brussels, Nikos Agathocleous.

The president and I have common backgrounds in market research, and as we begin talking, we immediately form a bond. Just before the president and his wife depart, he asks, "When are you due?"

"April," I reply. By this time, I am showing, so his remark does not catch me off guard. The president and his wife look at each other and nod.

"Just in time! We will christen your baby during my visit in June." This means they wish to be godparents to my son or daughter, according to Greek Orthodox tradition.

I am beyond flattered and surprised! It is such a thoughtful gesture that I accept his offer on the spot without thinking about it or discussing it with my husband.

"Our choice for a godfather should not be based on being politically correct," says Michael in response to my good news. He was quite disturbed that I would commit to something as important as the selection of a godparent without consulting him.

My work is cut out for me. Judging by his response, it may take me a little time to get my Englishman to see the president's offer in a more positive frame of mind.

<center>⚬</center>

I'm two weeks overdue and scheduled to deliver my baby today. In the middle of a deep sleep, Michael rolls over and whispers into my ear. "It's time, love." Michael has been preparing for the birth of our son for weeks now. I hand the reigns of my life over to him, knowing that my job is to deliver our baby and his job is to do everything else. He picks up two bottles of champagne, our pre-packed bags, and drives me to the Bronovo Hospital. Being the one who always takes care of every detail, I do nothing this time. My only wish is to be in the moment with my child as I welcome him into this world.

Andreas is born on April 9, 1990. Michael and I are deeply impressed with our baby boy who makes his debut appearance with a Beatle-like full head of hair. He is only minutes old, and I can see that his personality is wrapped in a blanket of pure sweetness. If a smile were to take human form it would look like Andreas.

Paying my respects to the icon of Saint Andreas, which I brought with me to the hospital, I name my son in his honor, hoping it will lead me to the stolen mosaic of his image, the one that Van Rijn dangles in front of me to keep me interested. Like my mother, I will now trust that I have the saint's blessing to guide me where I need to go.

At the time of Andreas's birth, business at Octagon is thriving, as I purchase the rights to a new software application from a company named Trimco. It revolutionizes the oil and gas industry with its document management

<center>92</center>

system, a paperless office solution, which creates a reputation for me as a *wunderkind*. As the head of the company, maternity leave was never an option for me, and honestly, it just isn't a part of my nature to focus on one thing.

The day that my stitches are removed I take my infant son and his nanny to my office and set up a temporary nursery. Andreas adapts to his new surroundings beautifully, and for the moment I get to breast feed and work and "have it all."

~❧~

Meanwhile, Anja Middendorp secures an opportunity for Papageorgiou to review seven thousand slides of icons from Roozemond's De Wijenburgh exhibit. The date is set for June, but Papageorgiou has to cancel when a conflict arises, and several more weeks pass without any word of when he can come to examine the doors. Timing is critical to our success.

After attending a meeting with the staff of Her Majesty Queen Beatrix at the Noordeinde palace, I pass by Roozemond's gallery. In the window hangs a set of Royal Doors. Standing across the street from the main entrance, I marvel at the temerity of Roozemond to display the Royal Doors in plain sight. I am no expert, but there is no question that these doors are works of art that came out of an ancient church in Cyprus. They also look exactly like the Royal Doors Anja Middendorp brought to my attention. Now it is up to us to establish that these doors were looted from Cyprus.

I place a call to Anja Middendorp, who advises me that there is nothing I can do until Papageorgiou formally confirms them to be of Cypriot provenance and provides evidence from government records or photographs taken prior to the 1974 war.

"Roozemond is flaunting them in our face," I say.

"Displaying them does not mean he has ownership of them. He understands his legal position, and you must do the same."

"Of course," I say. "I will check whether or not Papageorgiou sent a reply to Roozemond."

We soon learn from Papageorgiou that the Royal Doors are from the old church of Agios Anastasios located in the village of Peristeronopigi, in

the Famagusta district,[6] south of Lefkoniko in the Mesaoria plain. Agios Anastasios was just one of several hundred churches completely vandalized and looted of their contents after the 1974 invasion. When one culture targets the other's faith so disrespectfully, the resentment can be passed on from generation to generation.

In an Orthodox church, the Royal Doors are the doors in the wall of icons and religious paintings (the iconostasis) that stands in front of the altar leading to the sanctuary, the most sacred space in the church.

Returning to my office, I fax Kyprianou and Papageorgiou about seeing the sacred doors in Roozemond's gallery window and ask them to take action so that I can go through the proper legal channels to confiscate the doors. This is a hallowed piece of sacred art and should be held in the highest esteem, not hung in a window to lure wealthy collectors.

Dashing back to my desk to retrieve a ringing phone, I hear the sound of Van Rijn's voice.

"Madame Consul, you don't call or write. Have you lost interest in getting your precious artifacts back?" he says, slightly agitated.

It is true. I have been avoiding him, even refusing to meet with him during my pregnancy, feeling it vital to keep my personal life to myself.

"I have been traveling for my business, Van Rijn."

"Then you can meet me at our usual place at two P.M.?"

"Tomorrow," I say.

My reason for meeting with Van Rijn now is twofold: to retrieve information regarding Roozemond and the De Wijenburgh exhibit and to gain insight into who is in possession of the Saint Thomas and Saint Andreas mosaics. Being at the center of a living jigsaw puzzle reminds me to use puzzle strategy; search for the edge pieces to create a border, then work from within. In this situation the borders are not clearly defined.

Ten

BAPTISM BY FIRE

Holy Baptism is the first of seven sacraments received in the Orthodox Christian Church, which is also known as a christening. Its purpose is to remove the "original sin" we are born with so that we may unite with the body of Christ and begin our spiritual life's journey.

Having a sponsor or "godparent" in the Orthodox faith dates back to the Roman Empire when Christians were often slaughtered and godparents would need to step in to supervise the religious growth of a friend's or relative's child for the rest of their life.

The planning for Andreas's christening became a bit challenging, as I found myself caught in the middle between my husband and the president of Cyprus.

Michael did not want to mingle politics with a personal matter as sensitive as the baptism of our son. Yet the fact that the president offered this says a great deal about the man himself, and I respected what he was trying to give to our family. It was an honor, and I felt we had to accept.

"Why are we still talking about this? I deplore crowds of people," Michael says.

"Michael, I respect who you are. I want to shout to the world that my boy has arrived, and I cannot refuse the president's generosity. I plead with you to understand my side."

"I am a private person, Tasoula. If you want me to compromise it will be on one condition: no public affair. You and I must select who comes, and I don't want to have to follow any protocol."

We schedule the christening of Andreas to coordinate with the president's forthcoming trip to the Netherlands in June, a day after his official visit ends, in a private ceremony.

※

The square outside the Hotel des Indes is buzzing with tourists, and an ocean of multicolored crocuses are in full bloom. The crowded lobby makes it difficult to navigate my way to the bar to meet Van Rijn, who is already sitting at a table sipping espresso when I arrive. He is dressed in a custom-made dark navy suit with a scarf from Hermès, and he stares at my manicure as I nervously look down to see if there is a chip in my polish.

"You look well, Tazulaah."

I am dressed in a black skirt and a pink Escada jacket with my hair in a bun, wearing another pair of long chandelier earrings from Lalaounis's Helen of Troy collection.

"Thank you, Van Rijn."

"Is the offer of Kyprianou so big that it doesn't fit in your Chanel bag?"

"Let me remind you that you called me here," I say.

Van Rijn has a full-size diary open in front of him at every meeting. He takes notes with a green Mont Blanc pen. A waiter appears who seems to be extremely familiar with him.

"Give the consul of Cyprus her cappuccino. Do you know she is the consul?" There is always someone he makes a witness of, which makes me think he is trying to compromise me at every meeting.

"Now that you've won the Goldberg-Kanakaria case, it's time for your government to act. They can really use my services. Don't they see that?"

"Please, enlighten me," I say.

"There are illicit dealers quivering in their boots waiting to see if the appeal sticks."

In the case of the *Autocephalous Greek Orthodox Church of Cyprus v. Goldberg* (Goldberg-Kanakaria case), Indiana District Court Judge James Noland ruled that the right of possession of the sixth-century Kanakaria mosaics in dispute belonged to the original owner, the Church of Cyprus. Under Indiana law, a thief cannot pass the right of ownership of stolen items to subsequent purchasers. Because the mosaics were stolen from the Church of Cyprus, Goldberg had no right to title or possession of the mosaics. This precedent-setting case now has the world's attention as it awaits the final outcome of an appeal.[1] I wish that every European country would follow in Judge Noland's footsteps.

Van Rijn leans into the conversation and lowers his voice.

"What is ten thousand a month to your wealthy church? You will pay a lot more in legal fees and court battles. I know how to get the artifacts." He shows me a Polaroid of himself standing next to the "Feet of Christ" mosaic looted from the Antiphonitis church and a newspaper with yesterday's date. "How badly do you want it?"

If I reveal how badly I do want it, he will hold on to the information even more tightly.

"Enough already, persuade your government to make a deal with me."

"Why should my government pay you to give us the names of those to whom you sold our looted artifacts, then spend more money to sue these people in order to get back what rightly belong to us? If you have the 'Feet of Christ,' why don't you just give it to me?"

"There are others who have a stake in it. That's why I need the money: to pay the others off," he says, as he removes a Gauloise cigarette from an antique silver case.

"Cyprus will not pay to buy back looted art. If you want to win the trust of my government, tell me where they are for free and I'll move in with the police," I say.

"No other dealer will offer you and Kyprianou what I am offering."

"No other diplomat would agree to see and speak with you like I do," I say.

"You would make a brilliant art dealer."

"Teach me the trade and let's start with the De Wijenburgh exhibit of '77."

"What do you wish to know?" Van Rijn says with a smile.

"We know that Roozemond organized the exhibit. How many Cypriot artifacts were actually sold by him?"

"Information comes at a price, but I'll give you one piece for free. Roozemond's name is never found in a transaction."

"Did you introduce Roozemond to Dikmen, or did Roozemond purchase his inventory directly from you? How did it work?"

Van Rijn says, "Look, we all work together, Tazulaah. I admit to it, the others don't."

"Why did you fall out with Roozemond?" I ask.

"I like you, Tazulaah. You can't expect me to keep feeding you crumbs from my table without receiving some nourishment," he says, rubbing his fingers together.

I order him another espresso and myself a cappuccino.

"We could make a lot of money together. I'll make you my protégée."

Van Rijn actually believes he's giving me a compliment.

I shake my head in disbelief and laugh. "You don't get it, do you? When war takes everything from you—your home, your memories, your dreams—all you have left is your faith. You dealers steal our faith when you trade our religious symbols all in the name of greed. Do you get it now?"

He remains silent, studying me. "I can see that this issue goes much deeper for you, Tazulaah. I do care about these artifacts, which is why I want to help you recover them."

"Then why are you turning on the other dealers?"

"Simple. I take my enemies out before they take me. When you make the first move you control the game. I give you fair warning, my dear . . . If you don't have someone like me leading the way for you, these people will swallow you whole."

"Why not come clean about it all?"

"Information is power, and in this case it translates to money as well."

"Van Rijn, in our next lesson, prepare to give me all the information you have on the De Wijenburgh exhibition and maybe the Cypriots will look at you in another light."

Van Rijn puts out his cigarette. "You know nothing about your beloved government. Take my word, you will never find these artifacts without me." His mood shifts to a darker side. "Is that why your government is taking its time? Does Kyprianou think he can do this without me?" Van Rijn does not wait for a reply. "Then they misjudge this situation just as they did the war," he says, his face darkening.

I have witnessed this quick change in demeanor before. Once he is angered, he loses all reason.

"Keep in touch, Van Rijn," I say as I pay for our coffees.

"My offer will not be on the table forever, Tazulaah. I suggest you try harder to convince your government to take action."

※

On April 26, I write to the director general of the Ministry of Foreign Affairs about the importance of Mr. Papageorgiou's trip to the Netherlands to view the slides, and I request confirmation of his travel dates.[2] My every waking moment is consumed trying to put the pieces of this jigsaw puzzle together.

What is becoming more and more apparent to me is that the Netherlands is a hotbed for art traffickers, a painful irony, as this is the same country that provided me with a safe haven after the war. I'm struggling to assimilate into the Dutch culture, feeling guilty that I'm cheating on my Cypriot culture in doing so, and this realization holds me back from learning Dutch or identifying as completely Dutch. As I delve deeper into the world of illicit art in search of looted Cypriot treasures, emotional wounds I buried with the war begin to surface. I keep racking my brain trying to figure out how to get Van Rijn to reveal all he knows without my government having to pay a penny for the information. And then I get the idea to hire an investigator. Hiring a private detective posing as a potential buyer would give us the opportunity to approach Van Rijn and buy Cypriot artifacts.

With renewed vigor I set out to interview a few candidates. I am impressed by Mr. T. Thies, a freelance agent, who knows of Van Rijn but has never had any dealings with him.[3] I fax Michael Kyprianou and request the government's approval to hire Mr. Thies. A meeting between the Beker CS Advocaten law firm, Kyprianou, and me is scheduled for the beginning of July.[4]

The president of Cyprus is expected in the Netherlands any day now for his official visit. I am running back and forth to the palace to meet with the queen's staff, arranging everything from the kind of cigars he likes to his hotel accommodations. From the time he arrives at the airport until he departs, every minute is planned.

<center>⚘</center>

Cypriot President George Vasiliou arrives in the Netherlands on June 12, 1990 and my son Andreas's christening is scheduled for two days later. During a briefing with Agathocleous, ambassador from Brussels, I have Andreas in my arms, and he asks, "When did you get married, and why wasn't I invited?"

"We had just a small civil wedding, but next year when I have my 'big fat Greek wedding,' I will invite you," I say.

His face goes pale as he nearly chokes on the cigar he is smoking.

"You mean, you were not married in the Orthodox Church?"

"No, we were married in Oudewater," I reply, not understanding what he is getting at.

"This is a disaster. If you were never married in the Church, your certificate of baptism will read 'out of marriage,' and this is a political nightmare for the president! The headlines will read, 'President defies church to sponsor out of marriage child of consul with the blessing of the Brussels ambassador!'"

"What can I do?" My mind is reeling.

"No christening!" he says.

"There are a hundred fifty people coming!"

"Cancel, or marry again!"

I telephone Bishop Maximos to confirm what the ambassador has told me and I call Michael.

<center>100</center>

"Darling, please pick up your parents and meet me at the Agios Nikolaos church in Rotterdam. We must get married—again—tonight."

"Is this an order? What is going on here, Tasoula!"

"I'll fill you in later."

I am breast-feeding my son, so there are milk stains all over my business suit as I arrive at the church. Michael appears with both sets of parents, who were already in town to attend the Baptism and once again the big fat Greek wedding of my dreams is placed on hold as we wed privately in the Orthodox Church.

§

The embassy car pulls up behind the president's as we move through the gates of the Noordeinde Palace, a former medieval farmhouse that was transformed into a vast residence by Willem van de Goudt in 1533. Escorted by the queen's lady-in-waiting, Michael and I walk the red carpet up the steps and into the palace, where our names are called prior to meeting Queen Beatrix and her husband Prince Claus, who are standing just beyond the entrance, waiting to greet their guests. The queen has a beautiful, welcoming face and an outgoing personality.

Protocol is not to address the queen until spoken to. Wearing a dress by Dutch designer Gérard Brussé, a mustard-colored silk mermaid skirt with a marine blue top and matching ribbons in my hair, I feel like Cinderella.

"Thank you for making all of the arrangements," says the queen with a warm smile of appreciation. "Congratulations on the birth of your son Andreas." I am impressed with her sincerity and how well briefed she is. We enter the long Gallery Hall where we will formally dine this evening. Compared to other palaces I've seen in photographs, this one is quite demure and elegantly decorated. On one side of the room there are floor-to-ceiling windows surrounded by plush golden drapes. On the other side hang six-foot-tall mirrors interspersed with royal portraits that continue down the length of the room. The crown moldings and crystal chandeliers, the priceless antiques give one an impression of understated grandeur. This evening's formal dinner is set for twenty-four people, but the dining room could easily expand to seat

many more guests. This night a combination of captains of industry, Dutch personalities, the president of Cyprus, several career diplomats, Michael and I, are the privileged ones. In my wildest dreams I never thought that a girl from Famagusta would ever have the chance to dine with a queen. It was an exquisitely crafted evening, and like Cinderella, I was accompanied by my prince, Michael.

<p style="text-align:center">⁓</p>

Forty-eight hours later, we are back at the Orthodox church where Michael and I were married, watching Andreas's tiny body be submerged in holy water. The elegant godmother, Androula Vassiliou, stands by holding a towel as the bishop hands Andreas to her to dry him off and dress him in a ceremonial gown. After the bishop blesses the baby, he is handed to me, damp and squalling. I kiss his face and place a pacifier in his mouth to calm him down. I turn towards Michael who whispers, "Androula is lovely as is the Christening, thank you."

The bishop pours holy water on Andreas's forehead, symbolic of his immersion now into the Christian Orthodox faith. President Vassiliou's wife is standing in for the president as is Ambassador Agathocleous of Brussels, and by doing so accommodates Michael's desire to have a more private affair. Mrs. Vassiliou has gone out of her way to stay an extra day after the official visit ended.

The queen honored us by sending her lady-in-waiting to attend the service, which added to the media wanting to cover our private event. The ceremony is traditional, and many of our Dutch friends are experiencing the ritual of a christening for the first time. Michael and I lock eyes with the knowledge of how close we came to creating an embarrassing political issue for the president. Had he stood up for a child whose parents were not legally married in the eyes of the Church, it would have been a public relations disaster. I smile watching Andreas move his hands about in excitement as if he too is applauding the fact that we managed to avoid a holy disaster. Even though I am still enjoying the glow from Andreas's baptism, I never forget the shadows of lost lives and stolen icons.

~❦~

The Royal Doors continued to haunt me, so I decided to visit Roozemond's gallery to check on them. Much time has passed and the government still has not taken action. Call it intuition or coincidence; when I arrive at the gallery the doors are nowhere in sight. I approach the receptionist.

"Is Mr. Roozemond in?" I ask.

"Who may I say is calling?" the attractive young girl inquires.

Ignoring her question, I get right to the point. "I was wondering about the Royal Doors."

Roozemond appears within minutes.

"What a surprise to see you, Consul!" he says.

"Where are the doors?"

"Those doors didn't belong to me. The owner placed them here on consignment."

"The possessor, you mean? The Church of Cyprus is the owner. So you must mean the possessor. I'd like to have their name."

"Under Dutch privacy laws I have to protect the anonymity of my clients."

"You know from the letter of Papageorgiou that these Royal Doors are from Cyprus. Did you tell your client that?" I ask.

"It's not my responsibility to repatriate your icons," he says. "I did tell you and your government that if you make that database available, these types of issues would not occur. Good luck with the Goldberg appeal. Too bad the laws in Holland are so different."

There is no love lost between the two of us.

~❦~

A month comes and goes and still no decision from the Cypriot government regarding my request to hire Mr. Thies, the private detective I interviewed months ago, is on the phone.

"I'm sorry, Mr. Thies. I haven't a reply from my government yet, but we haven't forgotten you."

"I just received a tip that Van Rijn is on his way to Japan to make a mosaic sale. I wanted you to have the information regardless of whether or not we work together."

I send a fax to the minister of foreign affairs via the director general and ask for his guidance in what action to take and how to reach Kyprianou with this new information.[5]

The minister of communication requests that I provide a status report to the director general of my involvement in the recovery of stolen artifacts, summarizing our legal position and where we are in relationship to Van Rijn and Roozemond. Yet despite my requests for action, I receive no response. Nevertheless, I write the memo and send it within the hour.[6]

I wrestle with the fact that honorary consul is a voluntary position, compounded by the fact that I am young and new at the job, all of which seem to be stumping the hierarchy. The government sees the repatriation of the artifacts as being secondary to the Cyprus reunification issue. If I were able to act on Thies's information immediately without bureaucratic obstacles, I would be able to keep on top of the dealers. By the time the government responds to my memo, the mosaics will be lost—perhaps forever. Knowing how limited the government's resources are, it is unlikely that they will agree to hire Mr. Thies. I give up on the concept, but my frustration only grows.

Arriving home later that day in Wassenaar, I look past the gardens and the view of the lake that I normally find so comforting, I divert more and more of my energy and resources from Octagon to recovering the stolen artifacts, and each time I gather a piece of information or a lead that may bring me closer to recovery, I feel thwarted by the government's lethargy.

Andreas's room is cheerfully painted with brightly colored animals, musical instruments, kites, and numbers, in direct contrast to the events of my day. After I smother him with kisses and we dance to one song, I hurry to prepare dinner before Michael arrives.

Moments later, I hear Michael check on Andreas. The sound of him bonding with our little boy softens me.

"Smells delicious," he says, entering the kitchen.

Seeing my expression, he pours us each a glass of wine, and over dinner I unload my troubles. Michael listens attentively, letting me speak without

interruption, which is exactly what I need. He patiently waits until I am all talked out and then weighs in on the subject.

"I understand your frustration, darling, and there is no doubt in my mind that you are capable of handling more than you have the power to at the moment, but realize the government has limited resources and different priorities."

"I understand, Michael. The problem is that the traffickers know this and use it to their advantage. It's been eight months since Middendorp uncovered the information about De Wijenburgh exhibit. All I know is that stolen sacred artifacts from Cyprus are being sold under my nose, and legally there is nothing I can do about it! I feel as if I am at war all over again. This is my identity. Each artifact tells the story of every Cypriot refugee."

<p style="text-align:center">⁓</p>

There is a great deal of press about the Goldberg case in the Dutch papers; maybe it's because Roozemond initiates, and wins, a lawsuit against the Dutch newspaper *NRC*, which published an article entitled *"Weerloze kloosters"* ("The Defenseless Monastries"), which wrongly identified him as one of the dealers involved in the Goldberg case.[7] This new development makes the Cypriot government even more cautious, bringing the investigation into De Wijenburgh to a halt.

On October 24, 1990, the United States Court of Appeals for the Seventh Circuit upholds the decision of the District Court in case No. 89-2809, the lawsuit between the Greek Orthodox Church and the Republic of Cyprus versus Goldberg and Feldman Fine Arts, Inc. This is a huge win for Cyprus, and it sends a ripple effect through the illicit art trade as the U.S. Court of Appeals affirms Judge Noland's decision that an artifact, once proven stolen, cannot be legitimized in the United States.

It is a wonderful moment for the people of Cyprus, the Church of Cyprus, the government of Cyprus, Michael Kyprianou, the attorney representing Cyprus, Thomas Kline, and even me. Meetings with Van Rijn enabled me to secure vital information for Kyprianou and Kline to use during the trial. This little taste of success stimulates my appetite for more, and I hope will

reignite the government's desire to work with us to repatriate the icons and mosaics Van Rijn is dangling in front of us.

Now Cyprus has the right to ask for the extradition of Van Rijn and Aydin Dikmen for selling the looted artifacts to Goldberg. The Netherlands will not extradite their own subjects of their own volition, and the Cypriot government, to my disappointment, decides not to go after Aydin Dikmen, who is now living in Munich.

※

Romke Wybenga of Beker CS Advocaten, the attorney now handling affairs for the government of Cyprus, calls a meeting to summarize the current status of Cypriot affairs in the Netherlands.[8] With no proof of who is in possession of the stolen antiquities, there is no legal recourse to take against Van Rijn. Romke Wybenga's attempt to gain the public prosecutor's support in The Hague to open an investigation into Van Rijn fails. The Dutch art crime unit is small with limited resources. They do not feel that we have sufficient information to begin an investigation to incriminate Van Rijn. The firm suggests that we not hire a private detective at this point, which eliminates the opportunity to hire Mr. Thies, with whom I had remained in contact, and sends me back to the drawing board to find another way to lure Van Rijn into revealing who is holding the stolen artifacts.

Perhaps they are in the hands of Aydin Dikmen, the Turkish dealer who sold stolen Cypriot artifacts to the de Menil Foundation and to Peg Goldberg in the Kanakaria case and the same dealer that I am trying to get Van Rijn to help access. Or maybe Roozemond and De Wijnburgh hold the key. The De Wijenburgh exhibit did take place in Holland shortly after the Turkish invasion, and Van Rijn and Roozemond did admit to working together, but unless I have proof of whom they sold the artifacts to, I have no starting point for a case. I cannot act upon my thoughts. There might be other dealers who have not yet appeared on my radar. I need to narrow down who the dealers are, so I can focus my resources.

The Beker CS Advocaten law firm concludes that Van Rijn's exposure in the Kanakaria case, which garnered global publicity, might impede his ability

to generate income. Wealthy collectors might be wary of dealing with Van Rijn because of his involvement with Dikmen. Romke Wybenga concludes that the only course of action for Cyprus to take now is for me to continue to try and obtain information from Van Rijn.

The irony of paying dealer Van Rijn for information that frames his customers goes against my personal moral code. When priceless and sacred artifacts are traded as if they are just objects, I take great offense to it. Righting this wrong and seeing these dealers of God brought to justice does not seem to be feasible according to the laws of the Netherlands. I want Van Rijn's information, but I will not pay for it. I decide to point my compass in the direction of the De Wijenburgh materials, as I sense there is much more that lies beneath.

Eleven

LIFE AND DEATH

1991

The onset of spring ushers in a world of possibility outside nature's domain. Shell International offers Michael a senior position, but it will mean relocating the family to Egypt. Jobs like this are reserved for top engineers, so it is a great vote of confidence by Shell as well as an honor for Michael to be considered for such a senior post. I'm very proud of Michael's accomplishments, as he has only been with the firm for five years.

"How do you feel about moving to Cairo?" Michael wants to know.

With barely a chance to process the news myself, I speak of the positives.

"I think it's wonderful, Michael!" I say, embracing him.

"This is perfect for you, Tasoula. You are always tired and you look so pale. I want to take care of you. We don't need your income now. You have me."

"I'll always have my own money. I'll never be dependent. Even in Egypt I will find a way to work."

"Tasoula, I don't want you working this hard," he says.

"Let's enjoy the moment. We can always discuss this issue later!" I say, trying to avoid the subject.

As we toast to his wonderful offer, reality sets in. I must find the right manager to run Octagon in my absence, which I am confident I can do. All kinds of emotions surface at the thought of giving up my consulship. I believe that my fate is somehow tied to recovering the stolen artifacts, and relocating to Egypt will interfere with that. I found my voice in Holland, so I have mixed emotions and feel inner turmoil. I need to sit with the news and digest it before I can discuss it with Michael. The next morning over breakfast seems like the perfect time.

"You can serve your country from anywhere, Tasoula."

"I understand, but I work so closely with Kyprianou and Papageorgiou here. We're a great team, and that will change."

"You'll find other ways to serve your country with equal satisfaction."

Michael is right. I will make the best of the situation and find purpose wherever I live. The work that I do for Cyprus is important to me, but supporting Michael is also important. Besides, how do I know that moving to Egypt is not my destiny?

There will be several months to prepare for our move, so I continue my work as consul and find a manager capable of taking the reins of Octagon in my absence. Several weeks later, Michael is about to leave for Malaysia, and I have a trip to the doctor planned, as I have not been feeling well.

"I'll call you when I arrive in London to hear what the doctor has to say."

"Of course," I say. Today I feel as if I don't have the stamina to drive myself to my doctor's appointment, but I say nothing in order to avoid worrying him. My energy is low. I feel sluggish, as if I am coming down with a flu or virus of some kind. My clothing fits tighter as my desire to exercise fades. It is no surprise when the scale indicates that I've put on a few pounds. The doctor enters the examining room.

"I'm happy to inform you that your pregnancy test is positive, Mrs. Hadjitofi."

"That explains the weight gain and exhaustion," I say.

"True, but it doesn't explain your other symptoms. I would like to give you an ultrasound if you agree."

"Of course, whatever you think is best."

The doctor smiles as he gently moves a wand over my abdomen.

"My dear, there is a perfectly reasonable explanation for your symptoms."

"What is it?"

"You are carrying identical twins who are sharing one placenta."

"What?" I practically jump off the table hearing the news. "I can't believe it! This is a dream," I say. "I thought that the gene skips a generation."

"Evidently not in Michael's case. I'm going to give you some vitamins to start off with." He hands me a referral to an obstetrician at the same hospital where Andreas was delivered. I am unable to contain my enthusiasm, smiling at everyone I come in contact with. I arrive back at my office just in time to receive Michael's phone call.

"This is a miracle!" he cries. "You realize that you have just made my dream come true, don't you? You have no idea how happy you've just made me. I love you so much," he says before rushing off to catch his plane.

We are blessed! Being pregnant with identical twins is the greatest gift I can give to my husband, a twin himself. To be a twin is having a shared history with another from the moment of conception. Being married to a twin did take some adjusting on my part as I realized that Michael already had a life partner. It felt as if he and his brother, already their own unit, might view our relationship as an invasion of privacy. I came to understand that they are two separate parts of a whole and that our relationship and the relationship he has with his brother are distinct but equal. To be blessed with twin children with whom to identify is a longtime dream for Michael. As for me, I felt it to be a special privilege to give birth to two, when one is already such a miracle. It is the happiest day of my life.

Tulip season comes and goes in the Netherlands as we move into temporary housing in The Hague supplied by Shell. At this time our home in Wassenaar, because of the pending relocation, is rented and our valuables in storage. I am organizing our lives little by little so that by the time I deliver the twins early next year, all that will remain for us to do is to get on the plane.

I'm excited about the adventures that await us living in the land of the pharaohs, and I plan how I will spend my time there. Since the founding

of a unified kingdom by King Narmer around 3150 B.C., Egypt has an enduring history of invasions, and probably more than any other country suffers from the looting and destruction of its own cultural history. I can use my repatriation experience to help their recovery efforts, as I believe the responsibility to protect it belongs to each of us. Or I can begin another software division and expand my company to the Middle East. I could also offer to serve my country as honorary consul to Cyprus in Egypt. Our new home will be closer to Cyprus, so flying there to visit family on the weekends will be feasible.

What I am not comfortable with is being a stay-at-home wife. Experiencing the kind of loss that I did in the war molded me into a fiercely independent woman who is never comfortable unless self-reliant. Michael understands my need for independence and does not try to change this about me.

Lately, we spend most of our time making plans for the arrival of our twins.

"We must dress them alike and have them attend the same schools," says Michael. "My brother and I were separated at first as children, but we only thrived when they put us together. We pushed each other competitively in a positive way," he says, smiling.

"You will be the best father, Michael," I reply. His face is radiant. I've never seen him this excited about anything before.

"It could be difficult for Andreas as a singleton if our twins are boys. Seriously," Michael continues, "he might feel excluded. If we have girls, it may be easier for him to adjust."

"How lucky these children are to be born to you," I say.

"Listen, I know exactly what it feels like to be a singleton," reminding Michael that I am the expert in this area. "I will help Andreas adjust."

❧

The sound of the fax machine draws my attention to an image of an artifact coming through, a photograph of a John the Baptist icon. There is no cover page, and the fax does not state who the sender is. Examining the small and slightly blurred print more carefully, I see it is a page

from the De Wijenburgh catalog. The provenance is listed as "Cyprus—first half of 15th century." After a line or two of additional description it reads, "Literature—Hetty J. Roozemond, Ikon Gunt-Geist, Christies Icon 28th of October 1985, lot 199, Y. Petsopoulos, East Christian Art London 1987."[1]

It must be from Van Rijn. He hasn't been able to reach me so in order to draw me further into his game, he sends me a juicy tidbit of a clue, just enough information to pique my curiosity. He is testing me, and he's right. I have to know more.

I forward the John the Baptist fax to Michael Kyprianou and instruct my assistant to schedule an appointment with Van Rijn when he calls again, which he does the following day. I choose a garment that I hope will camouflage my pregnancy.

Van Rijn is waiting in the lobby of the Hotel des Indes at our usual table.

"You are becoming more and more difficult for me to reach, Tazulaah," he says, inspecting me with his glance. I wonder if he notices my weight gain.

"You may call me Tasoula, Van Rijn."

"I like your style, Tazulaah," he says.

"Petsopoulos," I say.

Hearing the name amuses Van Rijn. "At last a Greek who questions the actions of another Greek," he says as he lights a cigarette. I feel nauseated from the smell of his smoke but I don't dare say anything.

"Your usual?"

"I'd rather have fresh orange juice today."

Weight gain and reaction to scents could alert him of my pregnancy.

The waiter delivers the drinks and a small plate of chocolates. I have been able to give up coffee, tea, and wine, but I always have a weakness for chocolate.

"Why is it that your government looks at me as a criminal but turns a blind eye when it comes to Petsopoulos?" he says, as I reach for a chocolate.

Yannis Petsopoulos is a Greek London-based dealer who introduced the American collector Dominique de Menil to Aydin Dikmen in the summer of 1983, the same Dikmen who sold Peg Goldberg the Kanakaria mosaics.

"He's a Greek. That's why your government turns the other way." Van Rijn continues to vent his anger. "It would take the heat off the Turks if a Greek were caught dealing in illicit artifacts, don't you think?"

"A criminal is a criminal and should be punished. If he is Greek he should be punished twice, and if he's a priest three times, that's my philosophy."

"Don't be so naïve, Tazulaah." I offer your government the chance to recover their stolen artifacts and they do everything in their power to have me jailed for it. You think I don't know exactly what your lawyers are up to?"

"Van Rijn, you misunderstand. My government does wish to come to an agreement with you."

"You are different from the rest of them. Even you don't go after Petsopoulos."

"What are you talking about?" I say, trying to gain some time to inquire about the man. "Feed me evidence and I will."

"Bullshit," says Van Rijn. "You will excuse my language, Tazulaah, but let's put the facts on the table here between us. Petsopoulos deals with Dikmen. You have proof of it with the de Menil situation. The rest is up to you to figure out. Look in the shadows, woman. That is where you will see the true nature of your government."

❦

I go to a routine doctor's visit alone as Michael has a crucial meeting to attend at Shell. I'm not expecting anything but a regular check-up. I'm five months pregnant now and I'm feeling fine, if just a bit swollen, so I'm sure I will be sent home with a warning to keep my diet low in salt and my weight down. In the course of this one afternoon, everything changes.

"You have what is called a twin-to-twin transfusion syndrome (TTTS)," I hear the doctor say. If Michael, my scientist husband, were here, he would take control and question the doctor. In Michael's absence I must hold myself together as I hear the disturbing news.

"Your identical twins are sharing the same placenta but the distribution of blood is disproportionally flowing to one fetus at the expense of the other."

"How can we fix it?"

The doctor holds my hand, and I can tell from the way she is looking at me that the babies and I must be in danger. "I will have an ambulance waiting to take you to Leiden University Hospital."

"You can't be serious!" I hear myself say, my voice rising. "I feel fine. I'm a little swollen, but that is to be expected. I'm carrying twins. I don't understand! Could there be a mistake in the diagnosis?" I cry.

"Complications of this syndrome can jeopardize the health of the fetuses," she continues. For a moment everything freezes. My heart stops beating. I can't breathe.

"Leiden Hospital specializes in neonatal care and premature births. You will receive excellent care there."

"This must be a mistake. Please, I don't believe this."

"I'm sorry to bring you such upsetting news, Mrs. Hadjitofi. May I call someone to accompany you? We must get you to the hospital as quickly as possible."

I go directly into survival mode, compartmentalizing the emotional trauma to manage what I have to do next.

"Doctor, I have a young baby at home in the care of a nanny. I must make arrangements for my son, my business, pack a bag, and contact my husband," I say rapidly, holding back my tears, all the while thinking to myself, *this cannot be true!*

"I'm sorry, I cannot release you without an escort."

"Of course," I say.

"Mrs. Hadjitofi, I must impress upon you that it is essential for you to check into the hospital this afternoon," says the doctor.

I don't recall who came to pick me up from the office that day as I was in a state of shock. I just remember organizing things to run in my absence. The busier I am, the less opportunity there is for panic to set in.

At Leiden Hospital the news does not improve, but at least Michael is by my side. On the examining table, I feel vulnerable and exposed.

"I recommend we do an amniocentesis. I will place a needle into your abdomen and remove the excess buildup of fluid. This will ease the buildup and take pressure off the fetuses. It will bring you relief as well."

"What are the risks?" Michael asks.

"The procedure will have to be repeated weekly if the swelling continues. We are intervening here, but unfortunately, this process can also cause premature delivery."

Michael is caressing my belly as if to reassure the babies and me that he is there to protect us.

"What is at stake here is that the child with the decreased blood volume is in danger of growing more slowly than its twin and could die from lack of nutrients. The twin receiving the excess blood runs the risk of heart failure as the excess fluid places enormous pressure on its heart."

Michael and I need time alone to reflect and discuss our options before we can agree on how to proceed. The doctor gives us our privacy, but the choice becomes clear as soon as the doctor leaves the room.

"We must do it. Both children are at risk. We have no choice."

The procedure goes well. The swelling goes down, and I am placed on bed rest in the hospital. Because I am only twenty-five weeks pregnant, it is crucial to prolong delivery. Michael and I suddenly feel hopeful.

"I will do my best," I say. Michael gives me a kiss to lend his support. Just a few days later, my condition worsens. *Please, God, help me*, plays over and over in my mind. The doctor recommends repeating the procedure. Michael and I will do whatever it takes, so we agree.

"Mrs. Hadjitofi, unfortunately one of the fetuses must have moved, which is a risk of doing this procedure. I'm going to start you on a drug now that will help to avoid having an early delivery."

The nurses descend upon the room immediately, inserting a small needle that will connect me to an intravenous drip. Within minutes of receiving it, I begin to sweat profusely. It feels as if my body temperature is a thousand degrees. My heart pounds, my blood pressure escalates, I am so uncomfortable that I rip the sheet covering my naked body off and grab onto Michael's arm in desperation.

"My heart, Michael. It feels like it's going to burst." Michael turns to the doctor.

"Something is terribly wrong, please do something to help her!"

The doctor disconnects me from the drip.

And the labor pains begin. The sound of alarms and the actions of staff reflect emergency conditions.

"Let's get Mrs. Hadjitofi to the delivery room, stat," the doctor says.

I look to Michael, and he does what he is best at: being the calm to my storm.

"You must, for the sake of our babies, remain as serene as possible," he says firmly, as he holds my hand and rubs the back of my neck to relax me. My thoughts, of course, are anything but tranquil. One moment life is everything I've ever dreamed it to be and the next moment I am in danger of losing it all.

"I need to prepare you, Mrs. Hadjitofi. The gestational limit in the Netherlands for us to intercede is twenty-six weeks. The odds of your twins surviving delivery are not good."

The doctor's words feel like the edge of a scalpel as they cut into any remaining remnants of hope I have managed to hold on to. The room fills with additional medical staff in preparation for the delivery. The twins are born rapidly. Instead of the usual congratulatory words followed by everyone patting each other on the back for a job well done as the beaming parents look on with pride and joy, there is dead silence as the doctors struggle to keep them alive. Anastasia weighs 550 grams and Sophia is 720 grams. I dread the worst. I turn my face away from my perceived heartbreak and take refuge in the only privacy available to me. I close my eyes, but it doesn't stop the tears from washing away the sweat that lingers as a side effect of the medication that was supposed to postpone delivery. I know if I take one look at my daughters that it will break me into a million different pieces that I will be unable ever to put back together again.

Michael is holding me, but even his comforting shoulders cannot protect me from the devastation of this moment.

"The tube is in," a voice finally says, breaking the silence.

"They are beautiful," the voice says sincerely.

It is the voice of Ines von Rosenstiel, a pediatrician doing her first-year residency at Leiden who is assigned as our caseworker.

"I can't look at them," I whisper to Michael. The babies are quickly placed in incubators, wheeled into the neonatal intensive care unit, and given transfusions. Anastasia and Sophia have tubes coming out of every orifice. Michael is torn between comforting me and following the nurses to watch over the twins.

"Go," I say.

My daughters are in such a fragile state and at risk of infection. Michael returns a few minutes later.

"Tasoula, they are breathing. They are alive," he says.

"I can't bear to see them, Michael."

I am shocked at how hopeful he is.

"They are so tiny they can fit into the size of my palm. They are beautiful little miracles," he says.

"Please, stop, Michael. The doctor told us they will probably not survive!"

Michael gives me a calming hug.

"But, my darling, they are here with us now."

After the nurses bathe me, they deliver me to my room. Michael comforts me in silence. Once I drift off to sleep, he rushes off to be with the twins and returns later once the staff have set up a bed for him in my room. My heart breaks for Michael. It means everything to him to be the father of twins.

"The girls are beautiful, Tasoula. They are in separate incubators, but they are facing each other. Their heads are the size of a tangerine. They have hair! They are full of fight, just like their mother," he says, trying to lure me to visit them. "You will feel better if you just come and be with the children, please."

His voice projects such sweetness. I want to get up and run to be with my girls with every fiber of my being.

"Michael, I know I am going to love them. It will devastate me to lose them."

When I open my eyes this time, it is morning. Michael enters the room already having visited the twins. He pulls a chair up close to me, takes my hand, and says, "They are fighting for their lives, Tasoula. Please, they need their mother. They need you!"

His words cut through me and release the tears that wash away my fears.

"If they are fighting, then what kind of a mother am I that I am not fighting with them?" I say. "Maybe the doctors are wrong."

It is love at first sight. I can only stroke each of them by sticking my small finger inside an opening in each incubator, but I know they can feel

my presence. Anastasia's eyes are always open, and she stares directly at me. I thought, my God, look at how beautiful and aware she is. I didn't realize that she was blind at first but as the days went on, despite her inability to see, she would turn her head toward me whenever she heard my voice. I connect to my girls, heart to heart.

The nurses freeze my pumped breast milk, so there is an ample supply readily on hand. They feed the twins my milk via a syringe, which they inject directly into the stomachs of my girls. Ines, our pediatrician caseworker, meets with us daily to keep us abreast of the twins' progress. The reports are dismal, but Ines is more than the consummate professional, she is a kind person of unlimited patience dedicated to her job and to those she serves. She manages to bring Michael and me the touch of humanity we so desperately need right now.

Sophia suffers from thrombosis and Anastasia suffers from kidney issues. There are more complications on the horizon, no doubt, but they will reveal themselves slowly through the children's natural growth process. Sophia was also born without an ear, but Ines says it will grow. The twins are fighting to survive despite their tiny bodies having to endure all these complications.

I remember asking myself how could God give us such happiness with one hand and take it away with the other. Then I hear my mother's voice, and I am reminded of her advice. "God does not give you more than you can handle, Tasoula. You must trust in his divine judgment. There is a purpose to everything."

Over the next week, Anastasia's coloring turns yellow, a sign that her kidneys are failing. I reach out to my network of friends, who put me in touch with a kidney transplant center in Cyprus. I speak to a doctor in London, a Cypriot expert in fetal surgery, and implore him to rescue Anastasia. The reality that Anastasia is so little makes the transplant improbable. I plead and pray, but there is nothing that can be done.

Michael gently tries to raise my awareness to the inevitable. "My darling, this is poisoning her body, and even if she is lucky enough to survive her kidney failing, which according to all the specialists she cannot, she will be severely handicapped."

"What does this mean, Michael? I don't care if she is disabled."

In my mind I think, if Anastasia has disabilities, then Sophia will be okay and somehow we will all manage together. Michael tries to warn me that both children will have disabilities.

Several days pass. Anastasia's condition worsens, and the doctors request a meeting. We are led into a conference room where my gynecologist, the obstetrician, and hospital officials are gathered.

"This is not a conversation I like to have, but, as you know, Anastasia's kidneys are failing. We need your permission to discontinue the breathing apparatus."

I rise from my seat. "How dare you give us false hope, and now place the responsibility on us to pull the plug on Anastasia's life!"

The doctor attempts to calm me as the discussion continues. We are eventually placed back in my room, where Michael and I speak privately.

"I understand the anger you feel, Tasoula, I feel it as well, but they gave Anastasia the breathing apparatus to save her. And Sophia may still yet live."

"No, Michael," I say, sounding sure of myself. "They told us from the beginning that the babies would not survive. I begged not to see them, not to fall in love with them."

My hormone levels dropped drastically the moment the babies were born, and I am not in the best state of mind to handle the latest catastrophic blow. Now we are expected to choose whether our child should live or die.

I feel that I don't have the right to take a life. Being raised an Orthodox Christian, I believe that only God can do such things.

"We have to make this decision together," says Michael.

"I can't," unable to let the thought rest in my consciousness for even a second.

"We must, Tasoula, because we will have to live with this decision for the rest of our lives."

"Yes," I reply, "that is why you and I must come to our decisions separately."

I place a call to Bishop Maximos, who married Michael and me and also christened Andreas, to confide in him about our situation. He comes to the hospital and christens our daughters. My two girlfriends, Anna Franse and Elizabeth Sahin, the girls' godparents, stay to support me.

"Tasoula," Bishop Maximos takes my hand, "have you any idea what it means to care for a severely disabled child?"

"No," I reply.

"There is a young lady, a secretary who works in the Greek embassy, whom you should meet. Shall I arrange a call?"

"Yes, but what am I to do in regard to Anastasia's life support?"

"How long can Anastasia survive on her own?" asks Bishop Maximos.

"What are you trying to tell me?" I ask, wanting the bishop to relieve my pain.

"Some hospitals have a policy whereby if the child can breathe on its own for two hours, then they will intervene. If the child cannot survive that long without intervention, then you know that it is God's will to remove them from life support. Your situation falls in a very gray area because the hospital has already intervened."

After speaking with the bishop, I am still unclear about what to do. I decide to see a psychologist. I need to think about this very carefully. As Michael correctly stated, this is a life-changing decision that will remain with us for the rest of our days.

Have I explored my motivations for wanting to keep Anastasia alive? What is the best choice for my daughter?

Seeing the psychologist proves to be a valuable sounding board and a safe place for me to address the complicated issues at hand. I do take the bishop's advice, and through his introduction to the lady at the embassy, I am now aware of the reality of what I will face should Anastasia survive. Reflecting upon the information I acquire, I determine that I cannot take the responsibility of choosing life and death because of the Greek Orthodox faith so deeply rooted in me.

When Michael and I reunite to discuss our individual feelings, it is no surprise to me that he has come to the same conclusion. We will not supersede God's will.

That night we return home instead of sleeping at the hospital. Michael and I are both mentally and emotionally exhausted, and we decide to give ourselves a break for a few hours just this one evening to spend time with Andreas, who suffers from our absence. Looking into the eyes of my little

boy who is thrilled to have this time with me, I can feel his light ignite my own, which the events of the past several weeks have all but extinguished. For just a few short hours, life feels normal again.

The next morning we receive a call from the hospital that Anastasia's kidney condition is worse. We return to the hospital immediately.

"She is dying," says Dr. von Rosenstiel.

I manage to overcome the lump in my throat to speak.

"May we hold her?" I ask.

The hospital staff places a privacy curtain for us in the intensive care unit. Michael and I take turns holding Anastasia. When she is in Michael's arms, my thoughts stray. If only I stayed with her last night. She needed me, and I was not there to support her. She must have sensed my absence and assumed that I had abandoned her. Dear God, I can't live with the pain of knowing that I let her down. Please, forgive me.

When I am holding her in my arms, these thoughts subside as I connect with her, heart to heart. I want her to feel my love during her last moments, not my fear and guilt. I want her to remember me for as long as time continues. I have never witnessed the kind of courage I see in my daughter at this moment. This is the only time I have held her without wires being attached to her body. I curse all the days that I have taken life for granted as I watch my sweet angel fight for her life. The tears flow for Michael, but I cannot shed one tear. I smile instead, wanting Anastasia to remember me this way so I can feel that I was as strong for her as my mother was for me during the war. She takes her last breath in my arms as I watch her pass from this life to God's embrace.

The hospital moves us into a private room where Michael and I continue to hold her. There are no words to describe what losing a child is like. There is a numbness that takes hold of you, a paralysis that tricks your mind into believing you will never feel again. My daughter's struggle to survive ended, but mine is only beginning. Michael and I make preparations to bury Anastasia while caring for our two living children, no easy feat when all I want to do is give up. Seeing Michael so devastated makes the situation even more crushing for me.

"In your view, God chose to take Anastasia from us, Tasoula, but at the end of the day, I believe that it is Anastasia who chose for all of us."

"If only I had stayed . . ." I say, continuing to punish myself.

"Then it would have happened the next day or the day after that. It was not meant for her to survive. She knew it, and she chose when to leave us."

We selected a white, child-sized coffin and requested that those in attendance not wear black. It wasn't a funeral. It was a tribute to Anastasia for how she lived in the short time that we were graced with her presence. Fifty of our closest friends and family members attended a service in Rotterdam led by Bishop Maximos. I wore a pink suit and dressed Anastasia in a beautiful white gown. I placed a doll in the coffin that I had specially purchased for her before she was born, which I bury with her. I also purchased the same doll for Sophia and Michael as a gift to mark the unique connection they all shared being twins.

Because Michael and I own a house in Wassenaar, we are allowed to purchase a gravesite in the graveyard that surrounds the church in the middle of town, the place where we began our life together. We feel extremely lucky to be able to bury her in a place we consider so precious to the history of our family. I design her grave marker in the image of a beautiful angel with a butterfly, as their time on earth is also brief. Anastasia lived the same two-week life span as the butterflies who morphed from the silk worms I used to raise, the ones who created the beautiful silk threads that were processed into items for my dowry back home. For the short period that Anastasia was with us, she enriched our lives immeasurably.

When we bury Anastasia a part of me is buried with her. I suffer alone in silence. There are moments when the despair swallows me whole, and I think I will not survive another minute, and other times when I allow myself a laugh or two, especially when Andreas does something adorable, but it is fleeting. The anguish always returns, like a boomerang, to remind me of my greatest loss.

Three weeks after her death, I attend an annual Greek Gala in The Hague, which raises money for our church. No one is expecting me to attend. The Cypriot tradition when losing a loved one is to mourn in isolation for the first forty days. Despite, or perhaps even because of my heavy heart, I go to dance and to build a life for the daughter who lives, not the daughter who left us.

Twelve

WHAT LIES BENEATH

Weeks of exhausting, repetitive scheduling makes one day bleed into the next. It starts with caring for Andreas before heading off to the office to manage Octagon and perform my duties as consul. Late morning, I then go to Leiden Hospital where I meet with Ines to review Sophia's condition before I head over to the neonatal section to care for her. In the midst of all this, I prepare for our looming relocation to Egypt.

The sight of tubes coming out of Sophia's tiny body after weeks of hospitalization wears on my heart. She is too small to fit into infant clothing, so I rummage through doll shops in search of a fitting wardrobe, discarding the dolls after purchase so as not to be reminded of Sophia's vulnerability. Separated by a glass cocoon with only one small opening to reach in and touch her with my finger, I pine to do more, yet she is so delicate that I am sometimes afraid to even bathe her. The one-snap closures on the back of the doll garments make it easy to dress her, and the nurses oblige my need for an appearance of normalcy.

The neonatal nurses require me to set a schedule in advance in order to coordinate Sophia's feedings and bathing times with the hospital staff. It is difficult for me to be on time because of the responsibilities I have, and

conflict with the nursing staff occurs whenever I am late. I am judged as a woman more interested in my career than in the survival of and bonding with my child. This could not be further from the truth. I am scared stiff that I will do something wrong and hurt her while she is in my arms. What if a tube comes out? What if my touch is not as tender as it should be? These thoughts interfere with my ability to bond and mother her. There is also the constant pressure of having the eyes of the staff judging my every move. And the whole time I'm torn with guilt over having to abandon my son, Andreas, in order to care for Sophia. I wonder how it will impact him. I've yet to properly mourn my daughter Anastasia, whom I buried a few weeks ago, and I live in a constant state of terror wondering if Sophia will even survive.

What people see on the surface is me in survival mode. I wear the composed façade of a businesswoman who appears as if she has it all together, but in reality I know that if I shed one tear I will be unable to stop.

❧

Despite my personal woes, the world keeps moving. Word that a John the Baptist icon is about to be auctioned off at Sotheby's draws me away from my grief and places me back on track to recover the stolen artifacts. Being back at work brings me a needed reprieve from the world of doctors, nurses, and hospitals. I inform Kyprianou about the forthcoming auction, and he immediately sends a letter to Linda Jotham, the solicitor director of Sotheby's, informing her that the icon belongs to the Church of Cyprus, was stolen during the Turkish invasion in 1974, and should be pulled from auction.[1]

Sotheby's responds that the icon was previously up for sale in 1980, 1985, and 1987, and neither the Church of Cyprus nor the government made any claims then.[2] Jotham intimates that Cypriot monks and painters from Cyprus traveled and left their creations in other parts of the world throughout history. Famagusta was the center of trade between the East and West during the thirteenth century, so the possibility that traders could have also moved the icons out of Cyprus exists, but in this case we have

evidence to the contrary. There was no legal trade of sacred antiquities in Cyprus before or after the invasion of 1974.

Kyprianou enlists attorney Nick Kounoupias in the United Kingdom to represent Cyprus in preparation of a possible court battle. In 1985 when the John the Baptist icon was last for sale in the Christie's catalogue, it was identified as being from the Cretan school of icon painting. The correct geographic provenance (Cyprus) was not cited. In the trade this type of misinformation can mislead both buyer and original owner as to an artifact's true provenance.

My mind avails itself of the effort to uncover how the trade operates. Working in parallel to lawyers Kyprianou and Kounoupias in search of evidence to support their efforts to stop the Sotheby's sale becomes my oasis. Unlike the rest of my life, my actions here can actually impact the outcome. After more digging, a copy of a catalogue from the 1987 London exhibition of East Christian Art displaying the John the Baptist icon for sale is discovered. Yannis Petsopoulos is the man behind the exhibition.[3]

Petsopoulos is the Greek dealer whom Van Rijn insists is being given leniency by the Cypriot government, so it will be interesting to see how this scenario plays out. Setting my sights on providing evidence to show how the John the Baptist icon got from Cyprus into the hands of Sotheby's, I throw myself into the search.

Kyprianou replies to Sotheby's that the church is not disputing their assertion that the Cypriot icon was exhibited previously, it is claiming that the exhibition was not brought to the attention of the Church of Cyprus due to the false statement of provenance. This should not affect the basis for the Church's claim that the icon was illegally removed from the Church of Agia Paraskevi situated in the village of Palaesophos in the district of Kyrenia. Kyprianou further says that if the icon does go to auction, the buyer will be purchasing it at his own risk, as it is stolen Cypriot property.[4]

The burden of proof in most European countries is on the original owner, who must validate that the artifact was purchased in bad faith. Institutions, museums, dealers, and auction houses wearing a banner of legitimacy sometimes turn a blind eye as questionable artifacts supported by falsified papers present themselves for purchase on the market. It is clear that the depth of due diligence in investigating provenance is dependent upon the intent of the

buyer. Roozemond and Petsopoulos are both linked to the John the Baptist icon. I believe Van Rijn's name will also surface, and when it docs, I will have evidence of who the major dealers are. Untangling how the icon is purchased and sold will no doubt reveal how these dealers structure their transactions.

Amazingly, Kyprianou manages to secure affidavits from three elders who lived in the village of Palaesophos and who worshiped in the church of Agia Paraskevi prior to the invasion. They confirm that the John the Baptist icon in the Sotheby's catalogue is the same one they prayed before, with one exception. They remember the icon darkened by the charcoal residue from candlewax, though the photograph from the Sotheby's catalogue does not appear darkened. The icons could have been restsored prior to sale or cleaned by illicit dealers to confuse proper identification. Kyprianou forwards these statements to Sotheby's and demands the icon's removal from the sale.[5]

Sotheby's responds that the John the Baptist icon was bought and sold in the Netherlands three times in 1979, and that according to Dutch law it has acquired good title, intimating that the Church of Cyprus has no further claim on the icon.[6] The statement of ownership was provided by none other than Robert J. Roozemond. According to Roozemond, his company Kunsthandel De Wijenburgh (Wijenburgh Art Trade) purchased the icon from Mrs. M. Stoop (whom we learn is the daughter of the financier to Mr. Michel Van Rijn) in October of 1979.

In November of 1979, Kunsthandel De Wijenburgh sold it to a Mr. A. E. Mulié. In October 1985, Mulié sold it to Christie's.[7] Although there are records of sales, confidentiality laws prevent us from learning who their client is. I continue to search for the missing puzzle piece.

Sotheby's, through their client, offers the Church of Cyprus a chance to buy back the icon at a price to be agreed upon as a goodwill gesture. We finally have the attention of Sotheby's, but we still don't know who the possessor of the icon is. Now it is up to us to close the deal with conclusive evidence and a legal argument that will, we hope, encourage whoever the owner is to give the icon back freely.

As I grieve for my stolen cultural heritage, I experience a painful truth. The looted sacred artifacts that rightfully belong to the Church of Cyprus

are being sold to wealthy individuals, auction houses, and art dealers who apparently care nothing of the impact it has on a refugee like myself to see her identity traded. I feel betrayed again, and doubly upset as this is no doubt happening not just with Cypriot artifacts, but to countless other cultural treasures around the world.

Months ago I expressed to all related ministries in the Cypriot government, their legal advisers and the Orthodox Church the need to develop a plan for how to go about recovering the stolen artifacts. The minister of antiquities, Mr. Savvides, spoke of establishing a joint committee, but to date nothing has transpired. Fearing the lack of coordination within the government and how it may impact our investigation into De Wijenburgh, I'm faced with needing more experienced hands than my own. I hire a private detective named Gerard J. Toorenaar, the founder of Toorenaar Commercial Crime Bureau in Amsterdam, at my own expense. Mr. Toorenaar is in his late fifties, a former detective commissioner and chief of the Serious Crime Squad of the Amsterdam metropolitan police. He is a no-nonsense former cop who knows how to catch the bad guys.

Handing the tall, silver-haired gentleman a copy of Roozemond's ownership summary, I say, "Mr. Toorenaar, I'd like you to find any information to do with the De Wijenburgh bankruptcy, such as exhibition sale lists and catalogues. I need to know how the company was structured, see accounting records, anything to shed light on how the trade works."

The man of few words jots a few notes into his black book, carefully folds Roozemond's letter, and places it in his briefcase.

"I'll get back to you next week," he says as he exits my office.

❦

Shell recommends that it might be best for Michael to take his senior post in Egypt alone until Sophia is released from the hospital.

"You will never be able to manage without me, Tasoula," Michael says with deep concern because he knows well enough that my emotional reserves are exhausted. I don't want Michael to feel any more pressure than he already does. If he declines the post for personal reasons, it will derail his career. If

he chooses to go to Cairo and I remain behind in the Netherlands, it will place immense pressure on our relationship.

"We managed our relationship when you lived in Oman. Plus we have a live-in nanny to help now," I say, trying to comfort his worry.

"The Shell physician should speak with Sophia's doctors at Leiden. Knowing approximately when Sophia will be released from the hospital will help us evaluate how long a separation we will have to endure."

Ines is not only an excellent pediatrician; she is also a skillful communicator. She reveals the facts about Sophia's current medical status while presenting her strong reservations about separating the family and impresses upon the Shell physicians that the trauma we are going through as a young couple is harrowing. We lost one child, and have a toddler we are raising. If Sophia will survive, she will be faced with both cognitive and physical disabilities requiring intensive medical follow-up and day-to-day care. In Ines's opinion, a separation, even of a temporary nature, will not be good for the family dynamic. This added level of pressure on a family could break a marriage.

To our great relief, after being briefed by Ines, Shell cancels Michael's transfer to Egypt. The pressure that Michael and I have endured could have destroyed the strongest of marriages. Luckily, ours has been strengthened. I consider myself fortunate to be married to such a remarkable man who, without fail, places me and the children above all else. Michael makes it clear to me that I am not alone in this journey.

☙

Christmas is my favorite time of the year. Normally, we celebrate it with the extended Hadjitofi family in the United Kingdom and then spend Easter with my family in Cyprus. This Christmas is different. We can't travel to Scotland or to London and we are in no condition to host Christmas in our home. Michael and I do not feel like celebrating, but we must for the sake of Andreas. I decorate a tree and, in addition to the regular decorations, hang chocolates on the branches as a surprise for Michael and Andreas. I even place a small tree in Andreas's room so that when he opens his eyes it's the first thing he sees.

After breakfast on Christmas morning, I take over the role of my mother-in-law, who normally calls the name of the person written on each tag and hands the present to its recipient. Andreas receives a mountain of gifts this year. When I open the two small boxes for Sophia, I find they hold diamond and pearl earrings sent by my sisters, Yiola and Miriam. I weep.

I cook a traditional Christmas dinner of turkey that day and bring the leftovers to the hospital, where we spend the rest of the afternoon caring for Sophia. We place the teddy bear we purchased on top of the incubator so it will be the first thing she sees when she opens her eyes on her first Christmas.

<p style="text-align:center">⚜</p>

Michael Kyprianou gets an extra Christmas gift this year when he is elected to Parliament in Cyprus. He leaves his government position in the office of the attorney general to start his own law firm in Nicosia. His first client is the Church of Cyprus. I am happy for his well-deserved success but selfishly wonder how Mr. Kyprianou's absence will impact our efforts to repatriate stolen artifacts. His position in the government helped us to navigate through the bureaucracy with some efficiency. Without his efforts I fear the worst.

<p style="text-align:center">⚜</p>

New Year's Eve is an opportunity to reflect and, in truth, I am relieved to put this year behind me and wish to do it in a ceremonial way. We received many invitations to attend various parties and events, but we declined them all. Michael, Andreas, and I dress in our best evening clothes and depart for the neonatal section of Leiden Hospital with four chilled bottles of champagne and *oliebollen* and *appelflappen,* traditional Dutch pastries always served on New Year's Eve, for the hospital staff.

Andreas puts his little face close to the glass trying to figure a way to get the teddy bear inside the incubator.

"Love, Sophia's Teddy must remain here," I say. I guide his little finger inside the opening of the incubator, but it is too short to reach Sophia. Magically, she looks directly at Andreas, almost as if she is acknowledging his presence, which makes him smile. Wrapping my arms around Andreas, I run my fingers through his gorgeous black curls and reassure him that he is the perfect older brother for her.

"We must always watch over our little Sophia," I tell him.

He nods his head in agreement, too young to understand what he is committing to.

At the stroke of midnight we are the only parents in the neonatal center. We raise our glasses to the sound of fireworks exploding, watch the sky burst into magical colors and toast to love.

1992

Paraphrasing the Greek philosopher Heraclitus, there is an underlying order in the way that the universe unfolds itself, and there is an inherent wisdom in all human beings to understand it.

Events align themselves to convince me more and more that I'm right about my destiny being somehow tied to recovering the looted artifacts of my country. It seems that the elements have conspired to keep me in the Netherlands. Despite the obstacles we face raising Sophia, Michael and I are committed to designing what will now be our "new normal" as a family. What frustrates me is that I can't change Sophia's health. I wonder what lesson God is trying to teach me now.

✧

Mr. Papageorgiou finally gets an opportunity to view the slides that curator Victoria van Aalst had acquired from the bankruptcy of Kunsthandel De Wijenburgh, and he identifies a number of additional icons belonging to Cyprus.[8] I call Kyprianou.

"Why are we not pressing charges against Roozemond?"

"Can you prove that he is the owner or the possessor? When you have that evidence then we can talk," says, Kyprianou.

"We have a judgment in the Kanakaria-Goldberg case that says Dikmen and Van Rijn sold stolen art to Peg Goldberg."

"Yes, we could have chosen to extradite both men, but chose to focus on the return of the artifacts."

Kyprianou continues with a request. "Write a memo to His Beatitude summarizing your involvement over the past few years in tracing stolen artifacts for Cyprus."[9]

"Why, may I ask?"

"I plan to propose to the archbishop that you, myself, and Papageorgiou work as a team to recover illicit artifacts for the Church."

"What about the government?" I ask.

"The Church is technically the legal owner of the artifacts. The archbishop drives the legal cases, and the government raises awareness, through its diplomatic missions, about the various repatriation cases. The Church pays the costs associated with the recovery efforts so attorney general involvement isn't necessary unless a criminal prosecution is impending. As long as the proper governmental channels are briefed with what we are doing, they will be relieved. I know their thinking—the icons are not their priority." But they are the Church's. This new angle intrigues me.

"And what of Roozemond, Van Rijn, and Dikmen?" I ask.

"It's up to my successor at the attorney general's office to decide on the merits of extraditing Van Rijn and/or Dikmen to Cyprus. Remember, it's not our job to prosecute. You keep gathering evidence just as you are doing," he responds.

"I'll get the memo to you today," I say, thrilled about the possibilities that this new arrangement might provide.[10]

<center>⚜</center>

Mr. Toorenaar and I drive through the complex of modern high-rise buildings till we reach the Amsterdam World Trade Center, which lies in the center of the Zuid business district. Mr. Stoop is a refined man in his sixties.

"You are Mr. Van Rijn's financier?" I ask.

"I did finance purchases made by Mr. Van Rijn of certain icons and a Byzantine cross in September of 1979, which to this day I regret."

"Did you finance this one?" I ask as I place a photograph of the John the Baptist icon in front of him.

He examines it closely.

"Neither my daughter nor I were ever in possession of the icons. We were the owners only on paper. Van Rijn came to me with a proposition, which allowed me to legally pass tax-free equity to my daughter."

"What did he propose?" I ask.

"He asked me for a loan of two hundred forty thousand Dutch guilders ($120,000) and he promised to sell the cross and the icons the same day to another party for three hundred seventy-five thousand DFL ($188,255). We split the profit."

"So you are not being taxed on capital gains by placing the icons in your daughter's name."

"Van Rijn came to wealthy people like me who were looking for opportunities to make tax-free gains."

Mr. Stoop hands me a telex from Sotheby's confirming that the items were undervalued.

"This convinced me to do the deal."

"How did you pay for the artifacts?" I ask.

"I paid by check via B.V., which is a legal entity owned by me."

"To whom did Van Rijn sell the items?"

"Kunsthandel De Wijenburgh," he says.

"Were you returned the money plus the profit Van Rijn promised you?" I ask.

"No, unfortunately. I was paid with a check from Roozemond, and it bounced. De Wijenburgh went bankrupt, so I lost my investment."

Mr. Stoop presents me with legal documents from November 26, 1981, showing a dispute between his daughter and De Wijenburgh in relation to two icons purchased on the twenty-second of September 1979 from Art Trade Michel Van Rijn: "Theotokos" (Cyprus, twelfth century) and "Koimesis" (Movgorod, fifteenth century).[11]

"Just reading the file gives me a headache," I say.

"I gave Van Rijn a loan to purchase icons. He promised to sell them the same day for a profit we would split."

Stoop shows us another document dated January 1980 in which Van Rijn confirms receiving the money from Mrs. M. Stoop, and the description asserts that the funds are to pay for a common purchase of a "lot" of icons. Reference is made to a telex from Sotheby's dated September 1979.[12]

"I lay claim to the icons, and have a bailiff attach them in my daughter's name in the hope of getting my money back. The icons turn out to be owned by third parties," he says.

Also in the memorandum dated January 1980, it states that three hundred seventy five Dutch guilders ($197,622) was to be repaid to Mrs. Stoop no later than April 1989. The document goes on to state that the other artifacts offered by Sotheby's will remain in Van Rijn's possession. The second part of the document is believed to be a confirmation from De Wijenburgh that says the John the Baptist icon was purchased from Mrs. Stoop through the intermediary of Van Rijn for twenty-five thousand Dutch guilders ($13,200). The third part is confirmation that Mrs. Stoop purchased two icons, one being "Theotokos," which originated in Cyprus. What is not clear is if De Wijenburgh ever claimed to have purchased the John the Baptist icon, and if so from whom. Stoop's company, "Starlift B.V. acquired shares in Art Trade Van Rijn, Kunsthandel Van Rijn and Trade and Shape, B.V."

These icons were actually traveling around the world in exhibitions, and were sold and resold again numerous times to various parties who were actually buying shares in the icons and not the icons themselves. The profits would be split among the investors within De Wijenburgh.

"Not only did I never see any profits, I never got the icons that I paid for," says Mr. Stoop. "Thirty-six other people also believed they held ownership in the icons and then De Wijenburgh went bankrupt."[13]

"Complicated structure," I add.

"Yes, I'm afraid so," he answers.

I wonder if there is sufficient evidence against Van Rijn and Roozemond.

The thick web these dealers weave! Regarding the John the Baptist icon,[14] I wonder if it is possible that it was part of the nonspecific "lot" of icons that is mentioned in these documents.

We leave Stoop's office with more questions than answers.

"De Wijenburgh never owned the icons," says Toorenaar.[15]

"Mrs. Stoop was merely buying an option in the sale of the entire exhibition," I say.

"We still don't have a clear idea of who bought John the Baptist from De Wijenburgh," says Toorenaar.

"Make this your priority, please," I say to Toorenaar. "I want a name." The private investigator and I go our separate ways.

Meanwhile, I send Toorenaar's statement to our attorneys outlining the information we retrieved from Stoop. I ask if it is possible to get access to De Wijenburgh's receipts of sale through the court case to see if we can find a name in those records.

The Dutch lawyers acting for Cyprus in the Netherlands confirm that Mrs. Stoop invested in the exhibition, not in ownership of an individual icon, and never actually acquired the property rights to the John the Baptist icon, nor did De Wijenburgh, whose position was to obtain the icons for third parties. Victoria van Aalst, who supplied us with the documentation from De Wijenburgh, informs us that the papers pertaining to John the Baptist are missing.

Toorenaar phones me within days.

"I do have a name—Mulié, he lives in Naaldwijk. No address yet."

Now we are closer to solving the John the Baptist puzzle.

I telephone fifteen Muliés in the phone book, until I track down the right person.

"We are trying to investigate what happened with De Wijenburgh and, since you are one of the people who was cheated, I wonder if you would be interested in meeting with me?" I ask.

❧

At Leiden University Hospital, we are told that Sophia is refusing to eat. The hospital calls in an internist who places her under observation. Shortly thereafter, Michael and I are called into a meeting to discuss the findings.

"I believe there is a bonding issue between mother and daughter here," says the doctor.

"So you find nothing medically wrong with her?" inquires Michael.

"That's correct."

"What brings you to this conclusion?" he continues as if each of his words were a missile. The doctor doesn't have a chance to respond. Michael continues, "Has it ever occurred to you that Sophia might have neurodevelopmental issues and her difficulty in taking food may lie in the fact that she may be mentally challenged?"

Michael's words hit me like an emotional bomb. I can do something about the bonding issue, but I cannot help her if she is mentally impaired. At first I am angry with Michael, because it sounds as if he knows more than he's telling me.

"How dare you put my wife through this!" Michael demands.

Michael is the first person to verbally state for the record that Sophia's eating problems could be due to her mental limitations. A baby's ability to suck, swallow, and breathe does not develop until around thirty-four to thirty-five weeks of gestation, and Sophia was born at twenty-five weeks. There can be any number of reasons why Sophia is having difficulty. The tube may be causing discomfort or she could be experiencing gastrointestinal reflux if the sphincter muscle between the esophagus and the stomach is not closing properly. Michael and I take a moment privately.

"Maybe they are right about the bonding, Michael. I'm afraid to hold Sophia, and she must sense that. You are wrong! Our daughter is just underdeveloped."

Michael bursts into tears. I don't ask why. I'm not strong enough to hear what he is trying to tell me.

Sophia's exposure to this world has not been welcoming. Every time someone touched my daughter they hurt her.

As her mother, I refuse to be associated with anything that will bring her pain. Everything that is done to save her also tortures her to some degree. I want to be the person who comforts her after the needles and injections and examinations are over. Let me be a place of safety for my daughter so that she knows that once she is in my arms she is out of harm's way and under my protection. The nursing staff views this behavior as being unloving, but what I choose to be for my daughter is all about love.

❦

At a quiet café in close proximity to my office, I meet with Mr. Mulié, who turns out to be an intelligent, middle-aged, well dressed, articulate teacher of economics and law. I notice his body language is relaxed.

"How did you become involved in the icon business?"

"It was an investment vehicle for me," he says. "I never thought to question the legitimacy of investing in this icon exhibition. The minimum I would be left with at the end of the exhibition was John the Baptist with a confirmation from auction houses that it was worth more than I paid for it," he replies as he places a receipt from De Wijenburgh dated November 30, 1977, in front of me. According to his receipt he was guaranteed a share of John the Baptist before Mr. Stoop was. It states that the "Icon Gallery" will sell the icon for him. The Icon Gallery is owned by Hetty Roozemond, wife of Robert J. Roozemond.

"Hetty is my cousin," Mulié says, to my surprise.

The icon was kept at De Wijenburgh until it was declared bankrupt. At that point, Mr. Mulié asked for it back, but was forced to petition the receivership to get it.

"Mr. Mulié, will you consider sharing your documentation with our lawyers tomorrow over lunch?" I say, not believing my good fortune.

"I'll bring my file."

I am excited to inform Kyprianou that we hit the jackpot with documents that show how De Wijenburgh and Roozemond structured the business. De Wijenburgh proposes to individuals usually introduced by guys like Van Rijn that they purchase an icon as an investment. They show documents that assess it at a greater value and sometimes sell it the same day for a profit, which they promise to split with their new investors. The investors must agree to allow De Wijenburgh to exhibit the icon for three years. The icon travels around the world on exhibition at other galleries, and in return the investors are given a duplicate icon (a replica) until the original is returned after the contractual period. Somewhere in the travels, these icons, which were already sold, are sold again. The structure of De Wijenburgh gave us insight into the labyrinth of the trade. Never taking possession of these stolen artifacts keeps Van Rijn and

Roozemond free of culpability. Much of the evidence is considered hearsay and therefore it is difficult to initiate a court proceeding.[16, 17, 18]

Mr. Mulié's relationship to Mrs. Roozemond could have contributed to his good fortune, as Mulié did have possession of the John the Baptist icon, unlike Mrs. Stoop. He managed to acquire it from the bankruptcy receivership before any other claimants surfaced. He sold it to Christie's in October of 1985.

One question remains—who is the possessor of the John the Baptist icon now, and what is their legal position under British law? I send Mr. Toorenaar in search of information about Yannis Petsopoulos, who is listed in Hetty Roozemond's book as the last public owner of the icon. It is also time I sit down with Van Rijn, the only one who knows where the last remaining facts are buried.

⁓

Michael was correct about Sophia's mental disabilities impacting her ability to eat normally. Although, Sophia's condition is unchanged she is released from the hospital into our care. The full-time nurse that we hired is waiting for us at the front door when we arrive home. Alongside Sophia's bassinet is a stand that holds a feeding drip. Sophia's stomach is still so tiny she has to be tube fed through her nose day and night. Sophia also suffers from apnea, which means there are times when she may stop breathing.

The alarm sounds, indicating that either Sophia has moved and disconnected the feeding tube or the bag of food is empty. It doesn't matter why it is ringing; it always makes me panic. Michael rushes to check on her each night. Michael takes the night shift and I take the lead during the day. I'm too afraid to be alone with her should something happen; I am more comfortable caring for her when I have the nurse nearby.

The first few weeks I feel trepidation over every little sound and whimper she makes, questioning my maternal instincts and reactions, wondering if I am doing everything right. I worry how the stress is impacting Andreas. He was expecting a baby sister to play with, and he can't touch her. I wonder how Sophia's inability to respond to his efforts to bond will play out.

Thankfully, I become more relaxed as the weeks pass, more confident that I can care for her. Nevertheless, I can't help but compare Sophia's progress to Andreas's. Sophia only moves slightly, and she doesn't seem interested in anything. Her intestines are not functioning and need daily intervention. Andreas closes his eyes and puts his hands over his ears when she screams in pain, which brings me to tears.

Michael and I see her lack of development and speak to Ines about it. We spend countless hours researching and trying to find experts to help us support Sophia's growth.

The way I make this work is to place myself in a total state of hope and possibility. I cannot accept that my daughter will live anything other than a normal life. I am in a state of denial, and anything I see that is out of the ordinary I refer to Ines and Michael for a solution. They understand that I am not ready for the truth.

Michael tries to gently coax me to see that Sophia will never be a normal child, but I refuse to let anything diminish my hope.

"It will take a bit longer for her to grow into being normal," I say again and again. "I'm sure she will be absolutely fine."

Michael takes on the responsibility to confer with Ines and the other Leiden doctors about the road that lies ahead for my Sophia. I am not ready to break free of the cocoon into which I have spun myself.

I have yet to cry. I search inside myself for what holds me back, and I am reminded of the day that my mother instructed my siblings and me to commit suicide rather than being captured by the Turkish army. She seemed stone cold and without emotion. I questioned her motives then, but I understand them now. "If I collapse, all will collapse around me" must have been her thought process on that dark day many years ago. I now adopt that same mantra. We are so quick to condemn each other when it is far more peaceful to create a respectful space to try and understand our differences.

In Anastasia's death and Sophia's survival there is a purpose that has not yet been revealed. Until that day comes, I will not be free.

Thirteen

THE BIRTH OF AN ICON HUNTER

JOHN THE BAPTIST 1992

T he Church of Cyprus has to employ three lawyers to get back what rightfully belongs to it. Attorneys Kyprianou and Kounoupias confer with the Beker CS Advocaten lawyers for their opinion as to whether the John the Baptist icon will be considered a "good faith" purchase in light of the recent evidence acquired from De Wijenburgh documents.[1] There is no proof that Mrs. Stoop ever purchased the icon, which also was never in her physical possession. Mr. Mulié's awareness that the icon originated from Cyprus, added to the fact that he is a historian and the cousin of Hetty Roozemond, seems to create reasonable doubt as to the "good faith" theory advanced by De Wijenburgh and Mr. Mulié.[2]

Meanwhile, Kounoupias, a specialist in intellectual property law, makes an astute move to pressure Sotheby's to reveal the identity of their client by applying a copyright principle to the cultural heritage case. The Norwich Pharmacal Order is a court order to get an individual or corporation to reveal documents and information that might help with identifying a third party

suspected of wrongdoing. The premise that Sotheby's is not the wrongdoer, but has knowledge of who is, places pressure on them to reveal their client's identity, who as it turns out, is Greek.

Yannis Petsopoulos, a dealer of Byzantine and Islamic art and a publisher of art books, has an antique shop near Portobello Road in London. He is a tall, sophisticated man with an athletic build. He purchased the icon of Saint John from Christie's in 1985, and in 1987 he created the "East Christian Art" exhibit in London where the icon of John the Baptist was displayed as a Cypriot icon and was viewed by leading scholars and specialists in the field.

The exhibits are coveted events, attended by collectors, experts, and historians. Even diplomats are invited to mingle. Alcohol and gourmet food are in abundance as the upper echelon of society network among sacred treasures of old. These events can also serve as a shield for dealers to hide behind while they gauge whether or not the legitimacy of the artifacts will come into question. Mr. Roozemond says in his statement concerning De Wijenburgh, "I would like to express that we never kept anything secret about the collections or the icons . . ."³ He goes on to say that during the Brussels stop of the exhibition he sent a personal invitation to the attaché of the Cyprus embassy, who attended the exhibit and made mention of the importance of the icons at the event. This way, if the ambassador did not recognize the artifacts as being stolen from their country, dealers can use that fact in court when they claim they did their due diligence.⁴

It was obviously an oversight of the Cypriot diplomat, but then again, to be an art historian is not one of the expected qualifications for his job. The fact that Petsopoulos had individuals present who did not identify the icon as looted did not mean that it wasn't.

Those who deal in the trade should know that an artifact not listed on the Interpol database doesn't automatically make it a legal sale. In the case of the Cypriots, the Turkish government refuses to let us get into the churches in the occupied area to take inventory, making it impossible for us to report what's missing to Interpol.

Further investigation reveals that Axia Art Consultants, Ltd. financed the East Christian Art Exhibit in London. Axia is a Liechtenstein-based registered

company belonging to Yannis Petsopoulos.[5] The timing of this sale of the icon is particularly interesting.

According to British law, there is a six-year statute of limitations, which means that if I buy a stolen artifact and the Cypriot government discovers this six years and a day later, they no longer have a claim of ownership to the icon.

Attorney Kounoupias builds his case by applying the law principle of *"nemo dat quod non habet,"* a Latin term meaning "a person cannot grant a better title on the object than what he has." The law states that the purchase of a possession from someone who has no ownership right to it also denies the purchaser any ownership title. This, in combination with the reasonable doubt placed on the history of the sales, considerably weakens Petsopoulos's case. According to Nick Kounoupias, he and Michael Kyprianou went to see the art dealer in London armed with the evidence I received from Mr. Mulié. Petsopoulos openly admitted that the John the Baptist icon came from a village in Cyprus. During the meeting, the lawyers try to convince Petsopoulos to voluntarily return the icon. If the Church of Cyprus continues to press its case against him and his company, Axia, it could create unfavorable publicity, especially since Petsopoulos also played a role in introducing Aydin Dikmen to Dominique de Menil for her purchase of the Lyssi frescoes.

<p style="text-align:center">⁂</p>

In July, I receive an invitation from Michael Kyprianou to attend a meeting with the archbishop on August 5 in Cyprus.[6] Reaching out to my husband, Michael, I request that he reserve the time in his schedule to join me. It is important for him to see firsthand that my work is not only vital to Cyprus's repatriation efforts, it is valued by the head of the Orthodox Church. The archbishop is aware of my participation in the recovery effort as consul due, in part, to the fact that I send a copy to the Church of every memo I send to the government. My request for better coordination between government and Church is being heard. A strategy to heighten expediency in processing the leads we receive would be a dream come true for me, as bureaucratic sluggishness has been a source of frustration for months.

Kyprianou also requests that I write again to Roozemond to schedule a sit-down meeting, which I do. Roozemond stays at arm's length, continuing to require higher-level government representation before agreeing to a meeting.

꿏

Arriving at the Hotel des Indes in preparation for a meeting with Van Rijn, I scan the lobby for anything out of the ordinary. I am always aware of the fact that Van Rijn's intention is to compromise people. I find him sitting at the usual table. He rises to greet me and pulls out my chair.

"Tazulaah, it has been too long since I've had the pleasure of your company."

"Thank you." I say.

"This government of yours keeps you quite busy, I hear."

"I'd love to know more about what you hear, Van Rijn. Please surprise me."

A waiter brings us our standard order, which Van Rijn had ordered before I arrived.

"It would be far more interesting to hear about what you've uncovered, Madame Consul."

Van Rijn sees me as his protégée, so I play along. "Let's get right to it then, shall we? I know about Stoop, Mulié, and Petsopoulos. I must say that the whole 'investment scheme' was ingenious—misleading Stoop to think that he was giving tax-free money to his daughter and getting them to believe that they owned the icon."

He laughs.

"You and Roozemond were quite the team. I do have to ask you, Van Rijn, is there no limit to who you will cheat? I mean Stoop was a friend, a financier."

The corners of his mouth curl just enough for me to know that I have won this round. "You are fantastic, you have the moves of James Bond and the looks of Melina Mercouri!" he says. "Bravo."

"I'm glad you find this all so entertaining," I say. "By the way, your theory about the Cyprus government turning the other cheek when it comes to investigating Greeks is wrong."

"I'm impressed, Consul. Don't get ahead of yourself; you still need me."

"I am not here to impress you, Van Rijn. I am here to request that you give a detailed statement about your involvement with the John the Baptist icon," I say in all seriousness.

Van Rijn pauses to think. Without taking his eyes off mine, he answers, "What is your government prepared to give me in exchange?"

"Let's not play this game. It's time for you to prove something to us. Giving me a statement will be the first step toward achieving that."

"I like you, Tazulaah, I do. Your dedication to your country and your people is impressive. I will not do what you ask."

"I have a meeting with the archbishop of Cyprus coming up. It would be nice if I can tell him that you have agreed to give us a statement."

"I see, you want to impress the archbishop! Walk into that meeting with my statement in hand and show him what you're made of."

"Don't be ridiculous. There is a distinction here, an important one for you to understand. We will win this case if it goes to trial, with or without you and your statement. This is an opportunity for you to be of service to the Church and the government without it costing you."

"You have learned well, Tazulaah."

"So do I have your word?"

"You don't give an inch, woman."

He is not going to budge, so I call his bluff and start to gather my things.

"What kind of information are you looking for?" he asks.

"Verify whether or not Stoop ever owned the icon and what went on between you and Roozemond regarding De Wijenburgh."

He goes to light a cigarette, but I put my hand up to stop him.

"If you don't mind. Was it Dikmen?" I ask.

"Of course, it was Dikmen."

"Is the John the Baptist icon in the De Wijenburgh catalogue and the Sotheby's catalogue the same icon you purchased from Dikmen?"

"Yes. Every piece sold came from Dikmen. He is the link between Cyprus and the international dealers."

"Did Stoop ever own the icon?"

"On paper, yes! In reality, no."

"How did the deal with Stoop come about?"

"I went to Stoop and asked him for a loan to buy some icons and sell them the same day to Roozemond for a profit."

I start to take notes as Van Rijn is speaking.[7] "You're selling them to Roozemond with Stoop as the investor."

"Yes," he says.

"Tell me about what you have stored at the Schiphol airport free zone," I ask.

"You're a clever girl," he says. "How did you find out?"

I shoot him a look, which reflects that I will not divulge my sources. "It's for me to know and for you to find out, Van Rijn. Aren't those your words?"

"This is not your concern," he says.

"Convince me of that," I say.

Van Rijn shakes his head no. I've learned when to push and when to lay back.

"Give me a statement," I say.

"Give me a day to think about it," he says.

"What is there to think about? You were involved! We know you were involved. Say it and let's be done with it!"

"If I put this in writing your government is going to press charges against me."

"The Dutch do not extradite their own citizens nor are they prosecuting you for your involvement in the Kanakaria case."

"I do not trust your government, and I never will."

"I want the icon back from Petsopoulos. Even if I want to prosecute you, what is there against you in this case? You go on and on about how the Greek dealers are never prosecuted . . . This is your chance for satisfaction."

Sitting back in his chair, he considers my proposal.

"I never make rash decisions. You will forgive me, but I do have a prior commitment," he says.

"Of course. You know where to reach me."

I gather my bag and turn to make my exit, but I stop to deliver a final message.

"This offer is good for twenty-four hours, Van Rijn. After that, it will be useless to me." As I rise from my chair I notice that Van Rijn is smiling at me.

As the Hotel des Indes fades in my rearview mirror, I think about how having access to the legal resources that I do has helped me to gain a vast understanding of how some dealers, investors and curators walk a fine line as to what is legal and what is not in the trade of antiquities. The evidence I gathered contributed to winning the Goldberg-Kanakaria case and will hopefully help us secure the Saint John the Baptist icon. For whatever it is worth, Van Rijn has taken a liking to me. He is as mystified about my persona as I am about his. He gives me bits and pieces of information to which the government and the Church would not otherwise have access, and without my ability to put those pieces together they would lead nowhere. The private investigators and the journalists who cover the subject have all contributed to my understanding of the game and how to play it. I'm at a crossroads here with one primary objective, and that is to get Van Rijn to trust me. It comes down to this: whoever controls the game wins.

CYPRUS, 1992

The archbishop's Palace in Nicosia is the official residence and offices of the Archdiocese, a seventeenth-century two-story building reflective of Cypriot history. Next to it sits the current Neo-Byzantine-style palace, built some time before 1960 by Archbishop Makarios III when he was in office. Mr. Kyprianou and I agree to meet at the thirty-foot-tall bronze sculpture of Makarios III that stands near the entrance to the new palace.

Just a few seconds in the sizzling hot August sun transforms my cotton dress into a second skin. This is my first time meeting the archbishop whose assistant greets us at the main entrance and quickly leads us to a main sitting area, where I am grateful to be able to dry off in the air conditioning. The high ceilings give the place a feeling of grandeur but not in a typically palatial style as one's imagination might conjure; it has a more understated elegance. I admire the sacred art hanging on the walls as we walk toward the archbishop's office. The archbishop greets us, and I am surprised by his

towering height and stocky physique. His long white beard makes him look a bit grandfatherly, which complements his friendly demeanor. He is wearing an *exorasson* (an outer cassock with long sleeves) and a *klobuk* (a rimless hat designed for monastic clergy). Around his neck hangs an *engolpion* (a medallion signifying the archbishop's status). The medallion itself is the symbol of the Church of Cyprus, which contains a picture of the Virgin Mary surrounded on each side by an eagle's head. The heads signifies life on earth and life after death.

The large wooden structure that is his desk has a thronelike appearance. His high-chair is upholstered in red velvet, and just behind him and above his head there is an icon of Christ, with its eyes savagely dug out. This vandalized image is shocking to me but at the same time it speaks to my history as a Greek Cypriot in a way that no other image has ever done before.

The archbishop gives Kyprianou and me a tour of the gifts given to him by dignitaries. There is a table of photographs with him and his favorite visiting dignitaries. He stops at the photograph of President Carter.

"I told him that the presidential elective system of America was copied from the Church of Cyprus," he says. It is apparent that he takes great pride in this story and that he has perfected telling it to others.

"President Carter laughed and said maybe it was the other way around. Maybe the Church copied from us." His facial expression changes in the midst of his sharing as he adopts a more serious tone. "Dear Mr. President, we have over two thousand years of history in the Church of Cyprus. You Americans have only just begun!"

The archbishop is a studied and cultured man, a charismatic communicator with degrees in philosophy and theology from the University of Athens. His views reflect deeply conservative values.

I am a modern woman who is not considered to be a practicing Orthodox by church standards. I don't go to church on a regular basis, and I differ in view with some of the church clerics on issues like gay relationships and cremation, yet this doesn't seem to be an issue for the archbishop.

"Please, sit down." He takes a seat in a plush red velvet armchair. Mr. Kyprianou sits next to him, and I sit beside Kyprianou.

"Your Beatitude," says Kyprianou, "Mrs. Hadjitofi is the consul of Cyprus to the Netherlands who helped us on the Kanakaria case and has

done a great deal of work securing information on the John the Baptist case."

"You have done a marvelous job, Madame Consul, and I thank you deeply on behalf of the Church and the Holy Synod," says the archbishop.

"It's my duty, Your Beatitude. Every time a stolen artifact is brought back to Cyprus, it is a victory for our people."

The archbishop smiles to acknowledge that he feels the same way.

"Fifty thousand people came out to welcome the Kanakaria mosaics home last year," says Kyprianou.

"I followed it on the news in Holland," I say. "It brought tears to my eyes."

"You should have been here to witness it with us," the archbishop says, and his acknowledgment touches me.

"Your Beatitude," says Kyprianou, "We are still in discussion with Yannis Petsopoulos to surrender the John the Baptist icon to us."

"He is Greek, he should be less averse to negotiating with us than Sotheby's," says the archbishop.

"Mrs. Hadjitofi has asked Van Rijn for a statement."

"What will it take to close this case?" the archbishop asks Kyprianou.

"Petsopoulos might surrender more easily if we can get a statement from Van Rijn, but it isn't essential. And then there is the small issue of politics at hand," says Kyprianou. "If we make an example of the Greeks the Cypriots will be angry because they will feel that one or two Greeks should not let Turkey off the hook for their actions."

"The world is not foolish enough to believe that the actions of one diminish the destruction and ethnic cleansing caused by the Turkish military," the archbishop says.

"I'm afraid that will be the mindset abroad, Your Beatitude. There is little known about the cultural cleansing of Cyprus," I say.

The archbishop and Kyprianou continue to discuss the outstanding cases.

It is apparent to me now that the Cypriot government and the Church are two different entities, contrary to Archbishop Makarios III's rule of Cyprus, when he was the head of both Church and State. As consul, my

correspondence is directed to the government. The Church of Cyprus is the legal owner of the sacred artifacts.

"Mrs. Hadjitofi," says the archbishop, "you mention in one of your memos that you would like to see better coordination between church and government. Explain what you mean by that."

"Yes, Your Beatitude and, if you will, I am humbled to be here and to be doing the job that I am. It is frustrating at times, because I do have the attention of Van Rijn who can help us recover looted artifacts. He is feeding me bits and pieces of information on which I cannot act immediately because there is no coordination of approval. Many of my requests for permission to take action go unaddressed, and timing of these tips is crucial."

He continues to listen intently.

"As an example, the information I received about artifacts being held at the Schiphol Airport was never followed up. Mr. Kyprianou, myself, and Mr. Papageorgiou work smoothly together, but now that Mr. Kyprianou is leaving his post, I fear his replacement may not see the return of the artifacts as a priority," I say freely to the archbishop.

The archbishop nods, letting me know that he has heard my concerns. I assume that this is an issue to which he will be giving some thought when, to my surprise, he responds.

"How can I support your efforts, Mrs. Hadjitofi?" he asks.

"The icons are hidden behind the structures of shell corporations. I would suggest hiring the services of Mr. Toorenaar. He is a private investigator who can help us untangle the information we have and turn it into evidence."

"You have my permission to do so," he says.

I am stunned. I ask for something and receive it without sending numerous memos.

The archbishop comes from humble origins, and that is where his heart remains, despite his position. Given to the Church by his parents when he was a young boy, there is an independence in his personality with which I identify.

The archbishop's assistant enters.

"Mr. Hadjitofi is downstairs, Madame," he says.

The archbishop responds, "Please bring him here."

Michael arrives seconds later. The archbishop greets Michael graciously. "Mr. Hadjitofi, I thought I was the big man!" Michael is even taller than the archbishop. Everyone laughs.

"Thank you for the services you have allowed your wife to provide our Church and our people. I can image how many hours are sacrificed by your family," he says with a smile.

"Your Beatitude, I do miss my wife but this is important to me too. I am half-Cypriot. My dad is from Eftakomi."

"What are your parents names?"

The archbishop removes his red fountain pen from the left chest pocket to write their names.

"I will pray for your family," says the archbishop, as he places the paper in his pocket.

Leaving the palace, I wonder if my direct link to the archbishop will help me put the dealers behind bars once and for all.

<div align="center">⌇</div>

After the Turkish occupation shut down the Famagusta seaport, Limassol, only an hour's drive from Nicosia, became one of the most active commercial ports in the Mediterranean.

A couple of years after the war, the Republic of Cyprus offered Greek Cypriot refugees small plots of land in the suburb of Pano Polemidia, whose Turkish Cypriot population had fled to the occupied north during the war, and a few thousand dollars to build a house. This is where my family settled.

A simple one-level three-bedroom stucco house, it has a small garden and a narrow driveway separating it from other houses. In the back there is a covered patio where an outdoor clothesline hangs next to the door leading into the kitchen, which is where I find my mother hanging laundry.

"Μου έλειψες," I say. (I missed you.) While hugging my mother, my father dashes out, shouting "Το μωρό είναι πίσω." (My baby is back!) No matter where I go or what I accomplish, nothing feels as rewarding as being in the arms of my parents.

When you enter their home, a picture of Famagusta hangs prominently on a wall with framed photographs of the icons and family. The Easter candle sits next to miniature icons of Saint Andreas and the Virgin Mary.

The home is furnished minimally because they refuse to put any energy or money into a place they still consider to be temporary housing. Waiting years to return to their home in Famagusta has taken a physical toll on them. I try to visit them every two months, even if only for a few hours, when I return to Cyprus on business.

After catching up on their health and family news, I get down to the issue I wish to speak to them about. My mother, once an excellent cook, has stopped finding joy in it. I want to buy them new furniture, pay for the renovation of their kitchen, and build an outdoor brick oven on the back patio to entice my parents to stop living in this self-inflicted purgatory and to love the home they are in.

"Why waste your good money?" my father says.

"I want to build new memories with you and Mom, Dad," I say, knowing full well that even if I make the physical changes, it will do nothing to ease their heartbreak.

"I hope you don't mind, I just met your neighbors and invited them to coffee." My father smiles, recognizing his talent for attracting people now lies within me. Bringing new energy revitalizes the pall that lingers in their home. For a few short hours I distract them long enough for them to push their misery aside. They live vicariously through the stories I share about my own travels. I take them to their favorite seaside restaurant with a few of my friends who adore them, lifting their spirits even more.

That night before I lie down on the single bed in the spare bedroom, I open the night table drawer where I keep a book and a bottle of Chanel No. 5 perfume handy for my visits. I am content and become a little girl again. The simplicity and goodness within them is what I crave to be around. I live in a fancy house, have stayed at luxury hotels, and have even visited the queen's palace, but this is the place where I feel grounded.

I drift off into a peaceful sleep. In the morning I hear my father whispering, "Did the baby wake up yet? Let me take her some tea." For a few

short hours I am the baby again and get to be taken care of unconditionally in the way that only my parents can provide.

"Listen," I say to them, as I am about to leave. "I will be back on this date." And I would mark it in their calendar. "So let's not shed a tear between us," I say, wearing the biggest smile I can muster . . . "It's not 'good-bye,' it is I'll 'see you soon.'"

The moment the car service pulls away from their home, my tears flow all the way to the airport. Just before I board I call to remind them that I'll be back soon.

<div align="center">⚜</div>

Arriving home in the Netherlands, I spend the next few weeks finalizing a three-million-dollar deal for Octagon with a Japanese customer who is interested in our new software. This means that I must travel to Yokohama, Japan, south of Tokyo, to meet with the company principals. I research the Japanese culture before I go so that I will make the best possible impression on my potential client. Michael adjusts his travel plans so that Sophia and Andreas can be in his care while I am away. Although we have a full-time nanny, one of us is always present with the children. This year he has been working quite a bit in Russia and there have been many weeks when the children were solely in my care.

Michael and I are supportive of each other's careers. Caring for Sophia requires round-the-clock nannies, who come at considerable cost. Since Sophia will be dependent on care for the rest of her life, Michael and I work hard to secure financial independence for our family.

<div align="center">⚜</div>

Prinsjesdag or Prince's Day is quite the political event in Holland held every year on the third Tuesday in September. Prior to the monarch delivering a speech from the throne that summarizes government policy for the upcoming year, a royal procession carries Queen Beatrix in her Golden Coach from Noordeinde Palace to the Ridderzaal. Thousands of people

line up in the streets to catch a glimpse as the cavalry and standard bearers escort the horse-drawn Golden Coach back to the palace. Of course this makes travel a challenge as I make a last-minute attempt to get a statement from Van Rijn at the Hotel des Indes.

"How was your meeting with the holy man?" Van Rijn asks.

"Delightful," I respond.

"I bring you good news, Tazulaah. The price on my head is gone. The Yugoslavs and the Turks are no longer after me. I can give you a statement."

"What's changed?" I ask.

He smiles. "Not your concern. As long as you can guarantee that my statement will in no way incriminate me, I will do it."

"Do I have your word?"

"Tazulaah, I don't have the time to play games with you. I leave for Cuba tomorrow, and I won't be back for three months."

"If I have our lawyer draft a statement and send it to you later today, will you sign it before you leave?"

"If you can get Kyprianou to move that fast, I will sign it," he says.

I'm not sure I believe him. He's excellent at dangling the things you want in front of you in return for what he ultimately intends to gain from you. He hands me a piece of paper.

"Here is a friend's number. You can reach me here, but it's for your use only, do you understand?"

"Of course," I say.

"Call me when the statement is ready. When I return, I will review the photographs of missing artifacts and divulge the information you need."

"If someone were to offer to buy the Saint Thomas and Saint Andreas Kanakaria mosaics, what would it cost?" I ask.

"Around a million apiece. It will have to wait until I return to Holland."

There is something about Van Rijn's newly cooperative attitude that arouses my suspicions. I inform the archbishop of our meeting, but I secretly feel that Van Rijn is up to something and that he likely will not sign the agreement.[8] Generosity of spirit is not a natural quality to him. He always has an ulterior motive, and what he is after has yet to present itself.

Reading the statement draft prepared by Kyprianou, I write to Kyprianou fearing that the document's legal jargon may prevent Van Rijn from signing. I know Van Rijn and what triggers him.[9] I suggest that Kyprianou give Van Rijn an amended statement and a guarantee that he will not be prosecuted in writing, to eliminate his fears.[10, 11]

❧

In mid-September, I send a letter to the Ministry of Foreign Affairs to inform them about my meeting with the archbishop.[12] I summarize what we discussed and inform them that Mr. Kyprianou requests that I deal directly with him and the archbishop due to the sensitivity of the information being gathered and investigated.

By the end of October, I receive Toorenaar's findings regarding the artifacts held at Schiphol airport.[13] I cannot trust what Van Rijn says. There is always some truth to his story, but the picture he paints is highly exaggerated, and one must always decipher the facts from the fiction. Van Rijn claimed to have sold fake Cypriot icons to the Japanese for millions but did not. And what he had to gain out of making such a claim to me of all people is a mystery.

The real story is that Van Rijn asked Stoop several years ago to lend him 90,000 DFL ($52,000) so that he could clear a debt that he had with customs regarding the storage of the artifacts. Mr. Stoop did not grant him a loan. Customs then brought the icons to the Gerlach firm's warehouse at Schiphol. Van Rijn could not meet his customs obligations in addition to other debts he had accrued with the state, so the artifacts were auctioned off by the tax service for a mere 13,000 DFL ($7500). Van Rijn is cunning, and I realize that I can never take his word at face value.

The Cyprus newspaper shows a photograph of the archbishop, Kyprianou, and Yannis Petsopoulos, who deliver the Saint John the Baptist icon to the Church of Cyprus to great fanfare.

I feel an enormous sense of accomplishment that the artifact is back in its rightful home and take it as a positive sign that perhaps the tide of action (or inaction, as the case may be) has finally turned in our favor.

Nevertheless, there is no denying the fact that Van Rijn still withholds the whereabouts of the Saint Andreas mosaic as well as other Cypriot treasures from me, and and he continues to dangle this knowledge of their whereabouts in front of me. The fact that he can't buy me makes him want to conquer me. The last few years have helped to develop my knowledge base about how to maneuver through the art trafficking world.

Eight weeks after our meeting on October 12, the archbishop of Cyprus nominates Kyprianou, Papageorgiou, and me to become members of a committee responsible for dealing with all stolen artifacts from Cyprus.[14]

Fourteen

ON MY OWN

1993–1995

Van Rijn's book makes a splash in Holland when it is released in 1993. There is no way of knowing what is fact and what is fiction, but as I read the book, I still file names and bits of information away, details that may help me to connect with other pieces of information that Van Rijn has given me throughout the years. His views of Dikmen, Roozemond, and Petsopoulos are revealed in his book for the world to see. He even mentions me in his book: "Tasoula Georgiou . . . is a passionate young woman, utterly devoted to the cause of the suffering people of her country and to the fight for saving their cultural heritage. What she brought home to me was not the ordeal of a nation, but the agony of flesh and blood people."

Is Van Rijn in the process of transformation, or is his aim to flatter and then disarm me, to exploit the Church and the government of Cyprus? If he wants to make amends for trafficking my country's religious and historical symbols, he will have to make a sacrifice to prove his credibility. As a sign

that I can trust him, I want him to tell me the whereabouts of at least one artifact without asking for compensation.

I do believe that he has heard enough to come to some understanding about the nonmonetary value that these artifacts hold for people. Whether it is enough to change his ways is questionable. His knowledge of the beauty and magnificence of the art, how it is made, and what historical significance it holds, is impressive.

Trading in illicit artifacts, on the other hand, places the identity of the Cypriot people up for sale. The impact is devastating, especially because loopholes in the law make it almost impossible to recover these looted pieces of our cultural heritage. I cannot return home to Famagusta, now a "ghost city" wrapped in barbed wire and frozen in time since 1974 because it is still under Turkish military control. I identify with each looted artifact as a kindred refugee, and every piece that I can return to Cyprus is a win against the Turkish government.

<div align="center">⚜</div>

Approaching Leiden University Medical Center is always a trying experience since my daughter's birth. Today, Sophia's scheduled checkup includes a brain scan. Ines, her pediatrician, greets us wearing a smile of uncertainty.

"During the final weeks that a fetus is in the womb, the brain is building connections at an accelerated rate. Sophia was in the neonatal care unit during this critical period when the brain growth took place. I see neurodevelopmental disability and signs of her cognitive functions being affected."

"Will she be able to walk and talk?" asks Michael.

"Possibly, possibly not. It's too early to say at this point. There are issues with muscle control. Her IQ is affected. It is likely she will be dependent on caregivers."

With each piece of information I hold my breath just a little bit more. Sophia is undersized for her age, and a part of me still looks at her development in relation to her size, supporting my continued denial.

"I hesitate to say or predict more, as every child is different. I think we should continue to observe Sophia closely and take it a day at a time," says Ines.

My Sophia's head tilts to one side, and it pains me to see her struggle to hold it up. Her left hand moves differently than her right, and these symptoms all make sense now that I have been given this information.

"Hire a physiotherapist to come to your home. I will give you recommendations," she says.

Because premature babies lack the development skills to hold their limbs close to their bodies as full-term babies do, the physiotherapist uses positioning tools to help guide Sophia's muscles. I watch the physiotherapist work with Sophia so that I may exercise her when he is gone. In my mind, the more work I do, the more she may progress. Michael will often appear in her room while I'm exercising Sophia. He will place his hand on the small of my back and speak to me tenderly.

"You must not be too hard on yourself, my darling, if things don't change for Sophia."

I don't answer him. Surrendering is not an option for me. It must be even harder for Michael to deal with what we are going through because he carries the weight of knowing that Sophia will never be a normal child, while I still have my hopes, however thin. His concern escalates as he watches me work tirelessly to change things.

As a mother, I cannot give up the hopes and dreams I have for Sophia, the only girl in my extended family. Something inside me persists in finding the best experts to help her learn how to walk, talk, and maximize the abilities she does have. I spend an inordinate amount of time and energy researching practitioners with advanced techniques and teachers who have a track record of making strides with children living with mental disabilities. I search for the right schools, leaving no stone unturned.

Michael and I arrive in Scotland to spend the Christmas 1994 holiday with his twin brother Andrew and his family. Rachel, our niece, and Sophia were born just days apart from each other. Rachel is a typical, normal child, and as I watch her and Sophia being posed for a photograph under the Christmas tree, I am hit by the differences between the two girls. Rachel is playing with her Christmas toys, understanding that what she holds in her hand is a doll. Sophia is fascinated by the wrapping paper and is oblivious to everything around her. The inequality is striking, forcing me to recognize

the truth at last. Instead of running from my feelings, I finally sit with the pain and the sensations of loss and disappointment.

As the festive Christmas lights blink on and off in the background, I accept that I will never be able to walk my Sophia down the aisle or experience any of the treasured moments mothers dream about having with their daughters. I refuse to turn away or divert my attention until the depth of my sadness chokes me. Just when I can't bear a moment more, I surrender.

I let go of holding myself responsible for Anastasia's death and for Sophia's disabilities and let the river of tears I finally shed cleanse me. Sophia is perfect just as she is; I am the one who must change and acknowledge that.

Looking around, I see everyone else is engaged and enjoying the holiday, unaware of the major shakeup that is happening within me. I leave the room to compose myself. Michael follows me to hold me until there are no more tears to shed.

"I understand, Michael."

"I knew you would come around, my darling. It just took some time, that's all."

From this day forward, I lower my expectations and my desire to control the unknown. Sophia may never walk, talk, or be independent. I will no longer see her as the cloud over our family's sky. She is a star, just like Andreas, and as big of a blessing.

Sophia became my greatest teacher about acceptance, which came in the guise of an unwrapped present under the tree this Christmas.

❧

My reputation in business and as honorary consul to Cyprus in the Netherlands is growing, putting my company in a league of its own. Most of the diplomats coming to The Hague refer their partners and children to Octagon in search of employment.

My employees all have security clearance, and because of our location, Octagon is able to secure high-profile clients seeking to open up offices in the International City of Peace and Justice. Any European organization that requires security and confidentiality on their IT systems comes to me. All of

our business is derived from reviews and referrals. Octagon secures business with NATO, the International Criminal Tribunal for the former Yugoslavia, as well as many other prestigious institutions and firms. This gives me access to lawyers, judges, international law enforcement professionals, who in turn become resources I can turn to as my search for the icons and mosaics takes me across three continents.

These individuals become my friends and take an active interest in my mission, giving me unlimited access to vital resources and reinforcing to me that I am fulfilling what destiny has planned. Everyone who comes into my life seems to serve some kind of purpose in helping me repatriate the artifacts.

In the remote mountainous region of northern Cyprus, some time after the invasion in 1974, the sixteenth-century icons of the apostles Peter, Paul, John, and Mark were looted from a wooden iconostasis in the monastery of Antiphonitis. Set atop a rugged mountainside, the church looks as if God himself reached down from heaven to place it. The original church was built in the village of Kalograia in the seventh century, surrounded by wild forest. It was rebuilt in the twelfth century in the Byzantine architectural style. Additional sections, more Gothic in design, were added in the fourteenth and fifteenth centuries.

Some of the artwork that adorned the interior walls and ceilings was Byzantine in style, dating from the twelfth century. Unique fifteenth-century frescoes were also present, which made the monastery a perfect example of the varied cultural heritage of Orthodox Christianity that existed in Cyprus. The monastery was heavily looted, and sheep were kept in it once all the icons were pillaged. The iconostasis was destroyed and the frescoes stolen. There has been no information about the whereabouts of the icons until the summer of 1995.

The consul general of Greece, a lovely man and career diplomat, calls.

"My elderly Dutch neighbors own four icons, which they have attempted to sell to Christie's. Christie's informed them that the icons might be filched, and they ask me to check whether they are listed in Interpol's database of

stolen artworks. I write to my government in Greece and ask them to check with Interpol in Nicosia. The answer comes back that they are not listed. Can you help me?"

"Of course," I say.

"Shall I arrange an appointment for you to meet with the Lans family at their home in Rotterdam?"[1]

"Saturday will work best."

Michael joins me on my outing to meet the Lans couple, as it is the weekend and we are looking forward to spending leisure time together following the appointment. When we enter the Lanses' home, the first thing we notice is that the house is heavily decorated with expensive antiques. The Lanses, in their late sixties, appear to be serious collectors.

"The china is spectacular," says Michael, admiring a bowl in a glass-fronted cabinet. Mrs. Lans, a tall, stocky woman, opens the cabinet to give Michael a closer look.

"Beautiful. It's almost transparent," I say.

We are invited to take a seat on the sofa in the living room. The Lanses sit directly across from us in two chairs.

"Where are the icons?" I ask, curious that they are not on display with the rest of their collection.

Mrs. Lans hands us four photographs of the icons.

"I keep them in a bank vault. The Cypriot embassy told our neighbor that they are not on the Interpol list. I want to know if they are stolen or not," she says. Mr. Lans remains silent and appears to be nervous.

"When did you buy them? Before or after the war?" I ask.

Mrs. Lans responds, "It was in early 1971."

"From whom did you buy them?"

"An Armenian dealer, who was referred by a friend."

"May I ask who?"

"I'm not willing to comment on that just yet," she says.

"If you purchased them before the war in 1974, they are most likely fakes," I say. "These types of icons, over two feet high and wide, originate from the sacred iconostasis and would never be for sale. If they are original, it is almost certain that they are looted from a church, but that is something only an expert

can confirm." Mr. Lans is rubbing his hands nervously. Whether they are fakes or stolen, neither possibility is pleasant for the Lanses to hear.

"May I take these photographs?" I ask.

Mrs. Lans nods in agreement.

"If the icons were looted, the Church will expect you to return them," I say.

"I paid two hundred thousand Dutch guilders [roughly $125,000] for these icons, and I will not give them back without recompense," says Mrs. Lans.

"What if the Church will not agree to reimburse you?" I ask.

"Then I will hide them and the Church will never see them again!"

I compose myself before leaving.

"How sure are you that you purchased them in 1971?"

Mrs. Lans says, "Absolutely sure." Mr. Lans's face turns red as he nods in agreement.

"Give me a few days to check into this," I say.

Standing to shake their hands, I convey as much warmth as I possibly can to put them at ease. It is clear to me that the Lanses are collectors and educated and most likely familiar with the laws governing stolen works of art, which makes me question whether they are trying to mislead me by giving me the year of 1971, because the twenty-year statute of limitations under Dutch law becomes applicable.

Once outside, I ask Michael what he thinks.

"It's difficult to say," he replies.

Arriving home, I immediately send Mr. and Mrs. Lans a letter documenting my visit with them and request permission to bring an expert to their home to authenticate the icons.[2,3] I then fax Mr. Papageorgiou, the Byzantinologist, the photographs for authentication to schedule an appointment.

❧

Mr. Papageorgiou sounds more jovial than usual when he calls.

"I can't be sure until I see them, of course, but I believe they could be from the church of Antiphonitis, which you know is one of the most historically significant monasteries in Cyprus."

"I remember visiting it as a child," I say. "The setting of the church in the mountainside was magical."

"Yes, I agree," he says. "Here is the irony. In June 1974, just weeks prior to the war, I visited the church and actually," he says, laughing, "I marked the icons with cotton bits as I saw areas that needed repair. What you have in Rotterdam could be quite rare."

"Mr. Papageorgiou, I'm no expert. How can I tell if these are the real icons?" I ask, not forgetting the other possibility—that they are forgeries.

"Look at the backs of the icons. It is extremely rare to find signatures. The authentic icons of Antiphonitis were, unusually, signed by the artist," he says.

"Mr. Papageorgiou, We have one chance with these people, and if the icons are original, then I will have to have them confiscated. When can you come to the Netherlands? Our timing is critical here."

"I will have to secure approval from my ministry before I come over," he says.

"While you are doing that, I'll look for a Dutch lawyer to obtain a writ of confiscation in case we need it."

꩜

Feeling that time is of the essence, I fly to Cyprus and meet with the minister of foreign affairs.

"If it is a civil case, you must go to the archbishop for approval. Let me call him and get you an appointment," he says.

Led into the archbishop's office at the palace, I am reminded of the powerful company I am keeping by the high-backed red velvet chairs that decorate his office.

"Mr. Papageorgiou should come to Holland to authenticate the icons, Your Beatitude. If he confirms that the four icons are from the church of Antiphonitis, we will have to confiscate them, as Mrs. Lans has threatened to hide the icons if she is not reimbursed. We will need a Dutch lawyer to confiscate them. Can you give a power of attorney to someone in the government to lead this should it turn into a legal case?" I ask.

The archbishop leaves his office and returns with a signed power of attorney giving full authority to me.

"What does this mean?" I ask.

"I'm placing you in charge. You select the lawyer and you supervise the case."

I return to Holland with the Lans case now in my authority and the destiny of the Antiphonitis icons resting on my shoulders.

<center>⁓⁂⁓</center>

Robert W. Polak, who also represents Christie's, is a young, dynamic expert in the field. He is in his mid-thirties, has dark hair, and wears round-rimmed glasses. Working at the full-service firm De Brauw Blackstone Westbroek N.V. in Amsterdam, Polak gives the impression that he is a fierce attorney in an understated way—no bravado, just expertise.[4] In addition to his credentials, I would not want to ever face him as an opponent.

The archbishop trusts me to make some very critical decisions.[5] He sees my potential, as does Van Rijn, ironically, which makes for a curious triangle as I delve deeper into the world of art trafficking.

Polak prepares the confiscation writ prior to Papageorgiou's arrival, based on evidence I forwarded to him from the Ministry of Antiquities.[6] The Lanses agree to let Papageorgiou examine the icons, and we set out.[7]

Once inside, I occupy them with questions in their living room, leaving Papageorgiou alone to examine the icons now on display in their home office.

"Are you absolutely positive you purchased the icons before 1974?"

Mrs. Lans answers again, "Yes, in 1971."[8]

"From whom did you buy them?"

"An Armenian by the name of Edouard Dergazarian."

"Is he an art dealer?"

"Yes," replies Mrs. Lans.

"Where is his gallery?"

"He doesn't have a gallery," says Mrs. Lans.

"Well, how did you find him?"

"We belong to a circle of collectors. He visits us when he has something to sell."

"He comes to your home to make the sale?"

"Yes, that's correct," says Mrs. Lans.

"Do you have a receipt for the icons?"

"No, we purchased them before the war, before all of the trouble started, and we paid cash," she says.

With every question Mrs. Lans answers, Mr. Lans's hands shake a little more. First, there was never a time when buying sacred artifacts was legal in Cyprus. Being experienced collectors, their suspicions should have been raised. It was a cash transaction with a dealer who operated door to door. I excuse myself to check on Papageorgiou.

"One hundred percent authentic," he says in Greek.

I return to the Lanses in the living room and explain that our expert believes the icons to be authentic.

"The good news is that you did not purchase fakes," I say, smiling. "The bad news is that they were probably looted after the war."

"I've already told you," says Mrs. Lans. "We bought the icons before 1974 for two hundred thousand guilders [approximately $125,000]. If the Church of Cyprus wants them back, they will have to reimburse us that money."

"Mrs. Lans, it's not the Church's policy to buy back artifacts that were stolen from them. Doing so would only fuel the elicit trade. They can and will take legal action, if forced to."

"Let them do that," she says in a threatening tone.

"There are other alternatives. The Church can provide you with copies of the icons. You can return them to the people of Cyprus courtesy of the archbishop. We can look for a corporate sponsor to purchase the icons from you to donate them to Cyprus and take advantage of the positive publicity they will receive."

"We're not interested," she says.

After saying our good-byes, we leave their flat and head for the hotel a block away to call the Church's attorney, Mr. Polak.

"Confiscate them!" I say, and Polak calls the bailiff to confiscate the icons. Based on Mrs. Lans's comments, I feel I have no choice in the matter.

She will not give the icons back to the Church without compensation, and she has made it clear that the icons could disappear very easily.

By the time I return home, Mrs. Lans is calling me.

"You cheated me. You came into my home and stole my icons."

"I'm sorry that you feel that way. These icons belong to the people of Cyprus. We can stop all of this now if you are willing to work with me. Otherwise, we will have to drag this out in court." Before I can get take my next breath, I am disconnected.

Ironically, the Lanses telephoned Polak shortly after the confiscation, wanting him to represent them, totally unaware that Polak was the attorney who just seized their icons. Outraged by what just transpired, Mrs. Lans calls every newspaper and television news outlet to share how the honorary consul of Cyprus unjustly seized her personal property, and I am suddenly in the middle of a media frenzy.

The Lans couple speaks to the media. It is unlikely this couple could have purchased the icons before 1974. Mr. Papageorgiou saw them weeks before the invasion, and marked them for repair. The icons are original and signed by the artist.

They involved their neighbor, the Greek consul, to get confirmation that they were not on the Interpol list before their sale to the auction house. In addition, stating that they purchased the icons before the war also would place the works outside the Dutch statute of limitations for proof of provenance.

The confiscated icons, considered to be "disputed ownership" items, will be placed under the custody of an independent receiver who will hold them in a warehouse until the courts determine their fate. It's important that the artifacts are housed in a controlled environment, usually unavailable outside a museum, in order to preserve them. Now no one will have access to these sixteenth century icons.

Court cases have been known to take years to settle, which means the icons will be out of public view for quite some time. When I look at icons or mosaics I see the story that each piece tells to humanity. At the bare minimum, I feel that there should be a museum for disputed artwork so that these "homeless treasures" are always accessible to the world.

❦

My office is inundated with inquiries from the media when a phone call from Van Rijn slips through.

"Well done, my girl! I am proud of you," Van Rijn's enthusiastic voice says. "If you need anything, I am here to help you," he says.

"Do you know Edouard Dergazarian?"

"Of course I do; he's my Armenian friend. I can get you a sit-down with him."

Van Rijn never gives something for nothing. I do not jump at the bait.

"We are about to begin a civil case."

"Come to London," says Van Rijn, "and I'll introduce you." The sound of a dial tone follows. It could be that he merely wants to stay relevant in the recovery effort, since this is the first case where the information about a stolen artifact came from a source other than Van Rijn. Perhaps he feels threatened about losing his value as an informant.

❦

"Jan Fred van Wijnen from the *Vrij Nederland* newspaper would like to talk to you about looted Cypriot artifacts," my assistant says.

"Schedule an appointment with him," I say.

In preparation for my meeting with the investigative reporter, I pull a file of photographs, supplied to me by the Department of Antiquities and Mr. Papageorgiou of icons looted from the occupied area. I want the reporter to understand the importance that these sacred artifacts hold for the people of Cyprus and the role they play in the Orthodox Church.

Jan Fred van Wijnen is a young Dutch investigative reporter in his thirties. His long, dark wavy hair in combination with his penetrating blue eyes reminds me of how Jesus Christ is depicted on icons. After introductions, we sit down at the small conference table in my office to have our interview.

"Are you familiar with this icon?" he asks, as he places a picture of the archangel Michael of Platanistasa down in front of me. The icon originated

in the village of Platanistasa, nestled between picturesque peaks at 3,100 feet above sea level, in the Pitsilia region, a free area of Cyprus.

Depicting archangel Michael standing between Saints Evdokia and Marina, it was transferred, on temporary loan, to the bishop's palace in Kyrenia in the occupied area of Cyprus, where it was stolen during the invasion.

"Yes. It is the archangel Michael from Platanistasa."

"Why isn't your government doing something about it?" he asks in an accusatory tone. "Van Rijn told you years ago. Why delay?"

"Van Rijn told me that a doctor in The Hague was in possession of it. His name escapes me . . . what was his name . . ."[9] I say out loud to myself, sounding as if I know his name—but Van Rijn never gave it to me.

Van Wijnen says the name of the doctor. I immediately open the phone book and search for his address.

"Got him," I say. "Get your coat."

I speed walk to my car, making it difficult for van Wijnen to keep up with me.

"What the hell is going on here?" he asks.

"Van Rijn never gave me the name of the doctor. Now that I have it, I can do something about getting the icon back," I say, without missing a step.

"You tricked me! I didn't come here to reveal my sources!" says the reporter.

"Please! You gave the name freely."

"We are both being used by Van Rijn and we should be asking ourselves why."

Pulling up to the clinic where the doctor works, I leave the motor running and the reporter in my car. I ring the bell to the clinic; a nurse answers.

"I'm the honorary consul of Cyprus. I'm looking for the doctor."

"Sorry, Madame, he's gone home for the day."

"This is an urgent, confidential matter. Would you be able to give me his home address?" To my surprise, she does, and his home is actually around the corner from where I live. We arrive at the doctor's home minutes later. I ring the bell with one hand, holding the file in the other.

"Good afternoon, sir, I am Mrs. Tasoula Hadjitofi, honorary consul of Cyprus," I say. "Can you please tell me what you know about this icon?" I

open the file and show him the photograph of archangel Michael, and van Wijnen's card drops to the floor. He picks it up and notices the name.

"I know nothing," the doctor says nervously. "I don't want any part of this. Leave now!"

"Please, sir, if I may have just a moment more."

"Look," he says pointing to the card, "this journalist is already investigating me!"

"I am interested in working with people like you who have been taken advantage of by art traffickers," I say. "You don't have to fear me if you will assist me in getting the icon back. It is the dealers I'm after, not people like you. Please call me."

Returning to the car, I inform van Wijnen of what has taken place.

The doctor didn't admit to anything. Jan Fred van Wijnen published that when he spoke to the doctor he admitted to having the icon in his home.

That same afternoon, I return to my office and place a call to Polak, who sets the papers in motion to confiscate the icon. I see van Wijnen out.

Turning to van Wijnen, I say, "Did the Cypriot government act quickly enough for you today?"

⚜

The doctor is an elegant man of sixty and is accompanied by his son, who is a fortyish businessman and the more sociable of the two.

"How did the icon come into your possession?"

"Do you know Robert Roozemond?" the doctor asks.

"Yes," I say.

"Roozemond did warn me that the icon might be stolen at the time we purchased it."

"Yes," his son interrupts, "but he also told us he checked the icon's status with Interpol and that it was not on the list of stolen art works. Because of that, we assumed it was a legal purchase."

"I understand," I say, trying to show them compassion. "The proper due diligence is to check with the Cypriot government or with the Church of

Cyprus. Everything that is stolen or looted doesn't always show up on the Interpol list."

"I curse the day this icon came into my life," says the doctor.

"Father began getting calls from a guy named Van Rijn," says the son.

"What did Van Rijn want?" I ask.

"He was threatening my father. Telling us that if we didn't pay him he was going to leak our name to the Cypriot government and the press to create a scandal."

"Did you give him money?" I ask.

"I had to protect my reputation at all costs," he says, looking quite embarrassed.

Van Rijn leaves a trail of facts that hint at the true underbelly of his personality, the part that he hides whenever I am in his presence. I always learn of his dark side through another source.

"I don't want the icon anymore," says the doctor.

"My father paid fifty-six thousand guilders ($35,000) for it, so I would like to see if we can find a way to compensate him for his investment."

"A sponsor for the return of the artifact. Do you know of a Cypriot company in Holland that might be interested?"

"No, but I'm looking to strike a deal with a business, or a businessperson, someone who can benefit from positive publicity. Can you give us a few weeks to try and achieve that?"

I find the doctor and his son to be honest, decent people and truly remorseful, which is in direct contrast to my experience dealing with the Lanses. I agree to give them two weeks more to find a suitable donor or corporation to sponsor the icon's return to Cyprus.

In the meantime, I report to the ministry and the archbishop.[10, 11] Jan Fred van Wijnen writes an article revealing the story of how the icon was secured.

The doctor and his son telephone me, terribly upset.[12] "Why did you send people to confiscate the icon?" asks the son. "And if that's not enough, there is Jan Fred's article for us to deal with."

"Your name is not mentioned," I respond. "This icon has been missing for twenty-one years since the war. We can't risk losing it again. In regard to the article, the reporter had the story before he came to either of us," I say.

"It is an assault on my father's integrity."

"It has nothing to do with your father's integrity. I promise you that the icon is safe, and that I will do everything to resolve this matter discreetly. Remember, I gave you two weeks to find a sponsor."

Two weeks go by, and I don't hear from the doctor or his son. I reach out to them.

"Have you found a sponsor?" I inquire.

"I haven't found anyone. Can you give me another two weeks, please?"

Polak advises me that I can only give one two-week extension, and anything more will impede the confiscation writ.

Several weeks pass, the doctor asks to meet. His elegant wife greets me at the door.[13]

"We will be happy to give you a reproduction of the icon, and I would like to invite you and your wife to come to Cyprus as guests of the archbishop to return the icon personally."

"I appreciate the offer, Consul, but I just wish to be rid of the entire experience."

"I can't give you another extension. My confiscation writ will expire," I say.

The doctor nods his head to indicate he understands. I feel for these people.

"If you sign a transfer of title to the Church now, I can give you another two weeks." The doctor agrees.

"I wish to remain anonymous," says the doctor.

"I can guarantee you that on behalf of the Church."

"Madame Consul, I am grateful that this nightmare is finally over."

I am euphoric about being able to recover this icon without having to go through the process and the expense of a court case.[14] I telephone the archbishop.

"My child, bring the icon home to Cyprus as close as you can to August fourteenth," says the archbishop. Checking my schedule, I see that I am able to accommodate his request. Then I realize why he is asking for that date: it's the anniversary of the second invasion of Cyprus and the eve of the feast of the Dormition of the Mother of God which is one of the three most important feasts of the church calendar.

"Let's give the people something positive to remember," says the archbishop. Meanwhile, I extend an invitation to the reporter to join me in Cyprus. "I promised my wife a vacation—I can't," he says.

"Bring your wife," I suggest. "The archbishop invites you as his guests. It is important that someone of your caliber in the media witnesses the importance that these artifacts have for the people of Cyprus."

I have a box specially made by professional shippers to carry the icon safely home to Cyprus.[15] The night before we leave, I stand the archangel Michael next to my bed. I don't sleep a wink because it's in my possession, and it's my responsibility to protect it. I feel the energy of this ancient, sacred artifact and pray before it, asking for the protection of my family and children. My children will remain in Holland with my in-laws who will care for them in our absence with the additional help of the nannies. The next morning, Michael places the icon in its box and screws the lid shut.

<p style="text-align:center">⁂</p>

It is dusk when we arrive at Larnaca airport in Cyprus, but there are lights, cameras, and crowds of people. I question the stewardess.

"What are all of these people doing here?"

"They are here to greet the icon," she replies.

I have heart palpitations.

Michael picks up the icon, which has taken up three business class seats on the Cyprus Airways flight. The crew escorts us off, and we are halfway down the stairs when a group of Cypriots, journalists, policemen, and custom officers take the box holding the icon from Michael and run with it toward the VIP room at the airport.

"Be careful!" I shout, but no one is listening; they are so excited.

A bishop escorts us to the VIP room, where the press is waiting.

"Welcome home to Cyprus, Tasoula," says the bishop to me.

"Thank you," I say.

"You don't remember me, do you? I am Bishop Vasilios. The archbishop selected me to meet you here today because he thought it would make you comfortable to see a familiar face."

"My apologies. I have been living abroad since the invasion."

"I am from Mandres," he says.

"Mandres?" I ask.

"I am the son of Karayiannis."

I am stunned. The bishop standing before me is actually the young cousin with whom we would stop and visit at the Saint Barnabas Monastery on our way to the village of Mandres.

"I was a child when we saw each other last."

I take his hand to express the joy I feel in seeing him and knowing that he survived the war. My eyes, well up with tears. I see the recognition in the bishop's eyes as well and, for a moment, the two of us see each other through the eyes of the youngsters we once were, remembering the times before the war when Cyprus was a paradise.

"The archbishop wanted this moment to be special for you," he says.

The Monastery of Saint Barnabas is where I visited Bishop Vasilios, when he was a young monk. I remember receiving communion on Holy Thursday. I recall him giving us bottles of holy water along with some to bring to his mother in Mandres. It was the last time I saw Vasilios and Mandres before the invasion.

Arriving on this solemn anniversary, the day marking the second invasion of Cyprus, is a time of sadness and reflection. Surprising me with Bishop Vasilios as our escort says so much about the archbishop's sensitive and thoughtful nature. The gesture takes my mind off what I lost in Cyprus and emphasizes the treasures that remain.

꧁꧂

Hundreds of people have gathered outside the archbishop's palace waiting to welcome the icon. The church bells ring as we approach the entrance of Saint Paul's chapel by car. The archbishop waits to welcome us. As we step out of the car, two clerics take the icon and begin to chant. Hundreds of people join in the chanting; others drop to their knees as the icon passes them. People gently kiss it while making the sign of the cross. The intensity of the moment is reflected in their faces. It is as if Jesus himself had risen

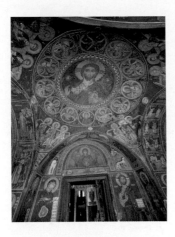 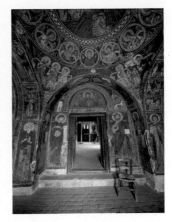

ABOVE (LEFT AND RIGHT): The Asinou Church in the Troodos mountains, filled with its sacred art. Image © David Hands. BELOW: A Cypriot church in the occupied area, stripped of all its art and icons. Image © David Hands.

A view of the ancient city of Salamis. Image © Kathy Barrett.

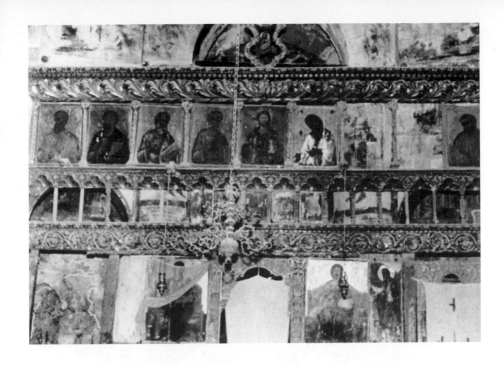

ABOVE: Iconostasis at the Antiphonitis Church in occupied Cyprus. BELOW: A small sampling of what was found in Aydin Dikmen's apartment during the Munich Sting.

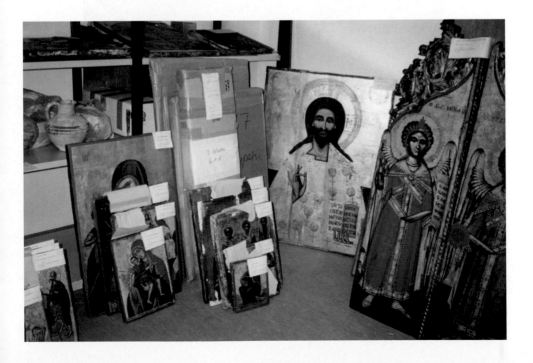

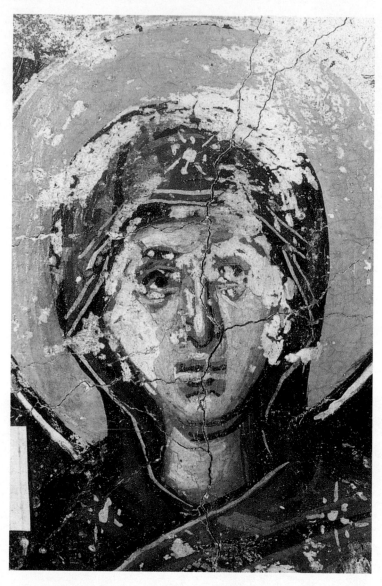

Part of a fresco ripped from a church wall and found
during the Munich Sting.

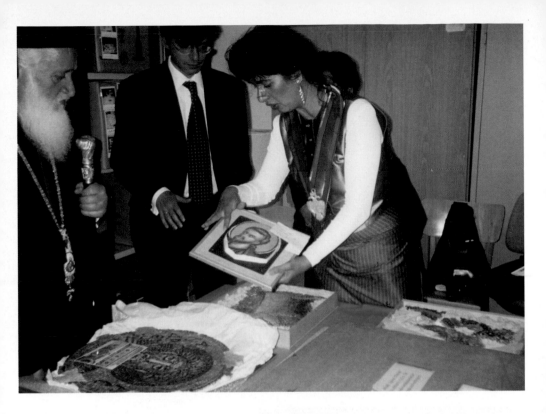

ABOVE: Tasoula surveys the findings in Munich with Archbishop Chrysostomos I and Rob Polak.
BELOW: Van Rijn, Peter Kitschler, and Tasoula hold an artifact recovered during the Munich Sting.

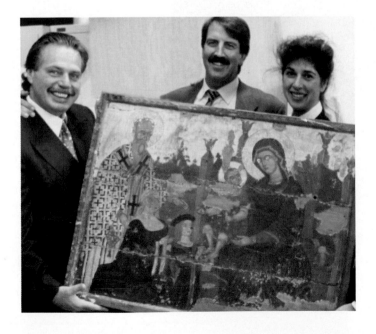

ABOVE AND LEFT: Tasoula's parents begin
to pray upon seeing a fresco of Kankaria's
"Saint Thadeos" upon its recovery in
Munich.

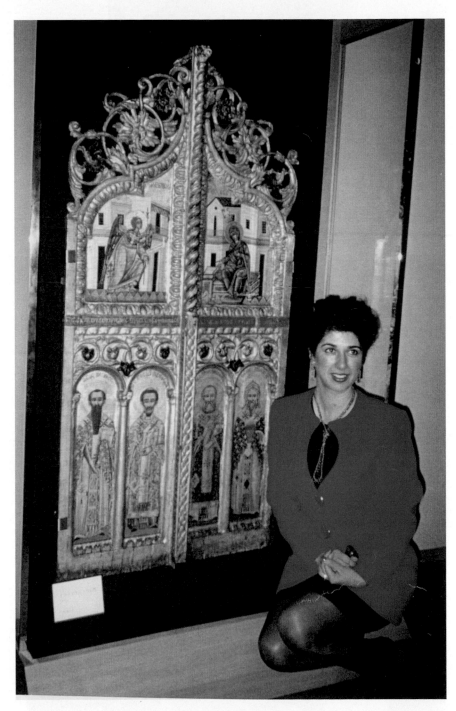

Stolen royal doors that were sold to Kanazawa College of Art in Japan.

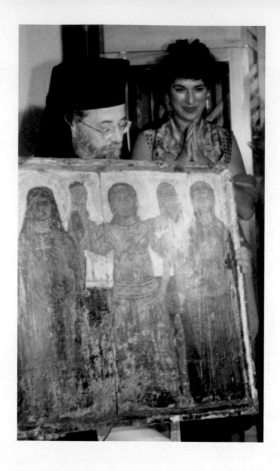

ABOVE: Tasoula and Bishop Vasilios returning the Archangel Michael to Cyprus. BELOW: Tasoula and the archbishop look at a fresco returned voluntarily by a Greek collector.

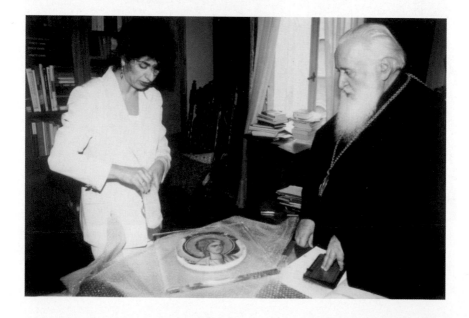

ABOVE: Demos Christou, Tasoula, Archbishop Chrysostomos I, Rob Polak, and Athanasios Papageorgiou. BELOW: The Order of Saint Barnabas medal ceremony.

ABOVE: Archbishop Chrysostomos I and Tasoula's daughter, Sophia. BELOW: Icons looted from the Antiphonitis Church after being restored and subsequently sold to the Lanses.

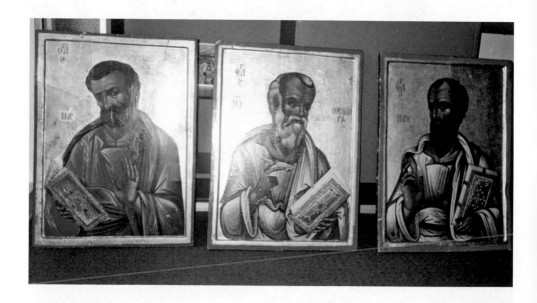

ABOVE: One of the four apostles of Antiphonitis after it was ripped from an iconostasis, prior to its restoration and sale to the Lanses. BELOW: Rob Polak, Tasoula, and Thomas Kline at the Peace Palace Conference, The Hague.

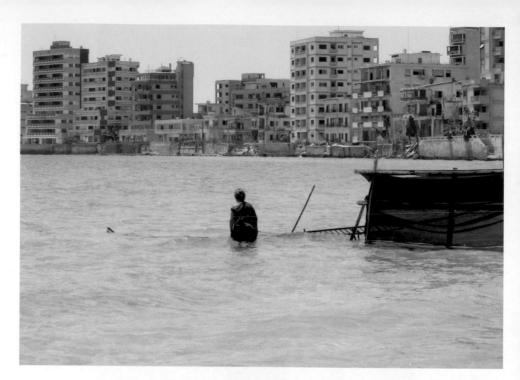

ABOVE: Looking into the past at the "Ghost City" of Famagusta.
RIGHT: Desecrated grave of Tasoula's grandmother in Mandres, an occupied area. Images © Kathy Barrett.

ABOVE: Surrounded by barbed wire—one of the few churches still standing in the occupied area. Image © Kathy Barrett. BELOW: Tasoula and her father prepare to face their past in the occupied area of Famagusta.

ABOVE: Tasoula, her father, and Savvas Kyriacou look out upon the area they once called home. BELOW: Michael Kyprianou and Tasoula in Cyprus. Image © Kathy Barrett.

Tasoula and her husband,
Michael—the "Golden Couple."

Tasoula with her son, Andreas.

ABOVE: Tasoula and Sophia. BELOW: Michael and Marina.

from the dead before them. We walk into the chapel of Saint John where the icon has been strategically placed so that the crowd of people can come in one door and leave through the other. People place flowers and basil on the icon. Turning to look at Jan Fred van Wijnen, I notice that both he and his wife are visibly moved. Inside the chapel Jan Fred gets a glimpse of how a non-looted interior of a house of worship normally looks.

Seeing the Cypriot women, children, and men filled with hope on the anniversary of the second invasion makes it all worthwhile. This is the first icon I've personally taken home to Cyprus.

"Now you understand why I do it, Michael."

My husband smiles and places his arm around my shoulder, his way of letting me know that he agrees. What is most important now is that Jan Fred understands how much these icons matter to my people. Turning to the journalist, I say, "I'm counting on you, to share this experience with the world so they understand the impact that losing one's cultural heritage has on people."

❧

Cyprus and the repatriation efforts of the Church have become big news in the Netherlands thanks to Jan Fred. My work on the Lans case and on the recovery of the icon of archangel Michael draws dozens of interview requests from media outlets from around the world. The favorable publicity places the issue of art trafficking and the importance of protecting Cypriot cultural heritage center stage. I forward copies of these articles from around the world to the MFA, in the hope that they will be pleased to see how the icons have become ambassadors for Cyprus. The archbishop and Polak advise me what to say and not say when discussing open cases. Having access to someone of Polak's legal caliber is a godsend. He coaches me on the legal side of repatriation, which enables me to advocate the issues to the politicians and media with confidence and ease.

On August 4, Polak forwards correspondence from the attorney representing the Lans couple. I can feel the blood drain from my face as I read that the four apostle icons that we just confiscated from the Lanses had been exhibited from December 1976 to January 1977 at the Museum Prinsenhof

in Delft. The exhibit was organized by none other than Michel Van Rijn and Edouard Dergazarian.[16]

Here we go again! I am drawn into another one of Van Rijn's mind games, there is always an ulterior motive with him. First, he took advantage of the doctor, taking money by using his association with the Cypriot government to scare the family. Now he has withheld valuable information regarding his involvement in the Lans case and his partnership with Dergazarian.

Every move that Van Rijn makes must be scrutinized. There is too much at stake to make the slightest error.

According to Polak, the challenges we face in the Lans civil case have to do with the twenty-year statute of limitations. Since the icons were confiscated in 1995 and twenty-one years have passed since the 1974 invasion, we are at a critical point in determining if the statute of limitations is applicable. The burden of proof is on the Church, which must demonstrate that the Lanses purchased the icons *less* than twenty years ago and that they purchased them suspecting that they were stolen, in order to prove bad faith.

Polak brings up the possibility of invoking "The Convention for the Protection of Cultural Property in the Event of Armed Conflict" in order to spare the Church having to go through the uncertainty of a civil case. The Hague Convention, as it is known, was adopted in 1954 in response to the enormous destruction of cultural heritage that occurred during the Second World War. It is the first international treaty to attempt to secure worldwide cooperation for the protection of cultural heritage in the case of armed conflict and has been ratified by 127 countries. This international treaty and its protocols have never before been invoked.

"In times of war," Polak says, "there is an obligation to uphold the protection of cultural heritage, and Turkey, Cyprus, and Holland are all required to do so because they are parties to the treaty and all three have ratified it. Holland has an obligation to take the icons from the Lanses and return them to Cyprus, and the Lanses have the right to request compensation from Turkey for not protecting the artifacts during the invasion and occupation of Cyprus, but only if they acted in good faith when acquiring them."

"I just faxed you the statement of reply that I received from Mr. Lans. I think we should discuss it."

Grabbing the fax, I quickly read through the statement and find myself feeling ill.

"I don't believe this."

"Which point?" he asks.

"All of it! Nonsense! Paragraph B says, 'The icons were purchased from a Greek art dealer, according to Mr. Lans,'" I say.

". . . who shall remain nameless," adds Polak.

Van Rijn knows every move these dealers make because he is either actively a part of the deal or he is watching it happen from a front-row seat. As I read through the reply, the knot in my stomach gets tighter and tighter.

"Look at Paragraph C. They sent the icons out for repair, which confirms Papageorgiou's statement that the icons were in need of repair due to the regular wear and tear of people constantly touching and kissing them," I say.

"Let's meet and discuss how to respond," says Polak.

Fifteen

NO JUSTICE

1996

Giving up is not part of my DNA. If I can't change the circumstances along the way, I change the way I view them.

Recovery efforts place me deeper inside a web of deceit woven by art traffickers to protect their escalating multibillion-dollar underworld. My financial resources are being stretched as more and more of my energy is drained by my pursuit to unravel this complex network of thieves, and yet my determination to disempower them escalates.

When Polak informs me that we have an extension until March to file a statement of reply in the Lans case, I am relieved.[1] There is much to prepare for, and the extra time is a lifesaver, as this trial is coming at a juncture when every other facet of my life is demanding my full attention.

Michael wants to have another child, but my sights are firmly set on exposing the art traffickers and tracking down the whereabouts of the Saint Andreas mosaic of Kanakaria, one of the oldest and most treasured

artifacts of the Orthodox people. It has survived the wrath of earthquakes and the brutality of conquerors for centuries, only to be cut out of the sacred walls of an ancient church by the hands of those who worship greed instead of God.

My attempt to be all things to all people causes great anxiety for the ones I love. Michael prepares to leave for the airport on a planned business trip and unleashes some of his frustration.

"We made a deal; one of us will always be with the children when the other is out of town," Michael says in a tone that is a mixture of anger and hurt.

"I'm sorry, love. I did try to change the date. It's one day. I must brief the archbishop on the Lans case. I've taken care of every detail and the nannies are here. There is nothing for you to do." He is not impressed. His tall frame bends in half to kiss Andreas good-bye, who is sitting at the breakfast nook.

"No kiss for me?" I ask.

"Stop taking us for granted," he replies.

The kitchen door swings shut behind Michael as he leaves. I continue to feel the heat of his words throughout the morning as I prepare the nanny to take over the care of the children during my upcoming absence. This is no way to begin the new year.

Octagon is in full swing when I arrive, which gives me a false sense of security that the company is running smoothly. Sometimes we see what we want to see in life, and right now I need to see that things are going well, because I have minimal time to allocate to it. Reaching for my ringing phone, I wonder where my assistant is.

"Happy New Year, Tazulaah," the voice of Van Rijn says cheerily. "Are you having a good new year so far?" he asks in a sleepy voice.

"It sounds as if the celebration may continue for you," I say.

"Have breakfast with me," says Van Rijn.

"Those of us who work for a living actually have a schedule to keep. So, unless there is something important, I really can't spare the time," I say.

"Is recovering the Royal Doors a good enough reason? You know, the ones that once hung in Roozemond's gallery window."

"Don't play games, Van Rijn."

"I'm trying to help you," he says.

"Come to my office."

Van Rijn appears shortly thereafter, dressed in a long navy blue coat with the collar turned up and wearing a brown felt fedora.

"Do you have any idea how full my day is?" I say to him.

"You should never be too busy for the icons," he says.

Holding a bit of anger from my morning fallout with my husband, I take my frustration out on Van Rijn, whom I believe is the cause of my issues to begin with.

"You and your games. Where is the Andreas mosaic you promised me? Now you want to tease me with the Royal Doors. You're all talk and no action."

"This is how you treat me? What other dealer gives you tips and helps you recover stolen artifacts?" he says with annoyance.

"What are you angling for, Van Rijn?"

"I can bring you the Royal Doors, but there are conditions."

"Of course. What is it this time?"

"I have to negotiate on your behalf. You need to get me a power of attorney on consulate stationery, and I'll deliver the doors within the week."

"Never," I say. "Tell me where they are and I'll move in with the police or the embassy."

"They're my clients. I want to keep them that way. If you move in with your big boots and stomp around like you usually do, you will make me look bad."

"This is going nowhere," I say, ready to throw him out.

"Tazulaah, these are nothing terms! You give me a hard time for the sake of it."

"I'm not going to lie about who you are, and secondly, the Church or government will never approve of you acting on their behalf."

"I am acting on your behalf!"

"Van Rijn, if you are serious, let's get on with it; otherwise go. I have had enough of you and your deals for one day. Where are they?" I ask him again.

He leans back in the chair and lights one of his Gauloise cigarettes.

"There will be travel involved. I expect the Church to pay my expenses."

"Location, Van Rijn!" I say, really annoyed now.

"Japan," he says, which spurs my curiosity.

"A collector?" I ask.

"Institution," he says "That's all for now!"

"Tokyo?"

He puts out his cigarette and faces me from across the table.

"When will you start believing that I am your man?" he says.

"When will you give me information without demanding something in return? Is Roozemond involved?"

"It's more complicated than that. I want answers or I don't continue."

Raising my voice, I say, "Damn it, Van Rijn, give me the whole story for once. I'm searching for the contents of five hundred looted churches, and you give me a crumb of information at a time."

"Calm down. You know about Dikmen and how the artifacts traveled out of Cyprus into Turkey and then to Europe and America. I know what you want: you want to see me behind bars, and I'm the one dealer who's trying to help you!"

"Roozemond?" I say.

"If you give me power of attorney, I'll get the doors. Roozemond sold them to the Japanese. That's my deal."

I shake my head back and forth.

"Not interested, then," I say.

Van Rijn slips a piece of paper across the table. It's a photograph of the Royal Doors.

"You're making a mistake, Tazulaah. I'll have my lawyer inform you of my whereabouts in case you change your mind."

"I don't know why I waste my time with you," I say.

"I don't know why I put up with your insults. You should be much nicer to me if you ever want to see your beloved Saint Andreas again," he says before he and his damaged ego disappear out of my office.

❧

The rest of my day is filled with issuing passports and meeting with the new manager of Octagon. Michael's words hang over my day like a cloud that stands in the way of the sun shining through. After faxing the photograph of the Royal Doors to Mr. Papageorgiou for verification, I surprise my son, Andreas, by picking him up after school.

"Mommy!"

"You are happy to see me, aren't you, my precious?" I say.

"Can we go for *Nu niet* please?" *Nu niet* is the Dutch word for "not now," which is what the nanny tells Andreas, every time he points to the cupboard in the house where the sweets are stored.

"Of course, but first I must smother you with kisses, as I have missed you terribly today," I say to my young giggling boy.

We arrive at a small café located not far from our home. The waiter delivers a hot chocolate with a towering scoop of whipped cream along with a slice of apple pie. Since the waiter knows us, he also brings a bowl of Andreas's favorite sweets. We spend time talking about football, his toy cars, and his friends at school. My little man is growing up fast. He pushes the dish of sweet delights across the table to offer me a taste.

"Mommy, why is Sophia not normal like my friends' sisters?"

Andreas will turn six in a few months, but he is a child with an old soul.

"Sophia is a special care baby, Andreas. You're right to notice that she is different." His expression reveals the fact that he has more to say but is not sure whether to say it.

"My friends make fun of her."

"Then they are not good friends," I say. "It's not nice to laugh at people who are different. Sophia is a girl with special needs. Why does that bother you?"

"They make fun of me because she is my sister. Will she have to come to my birthday party this year?"

Knowing how loving and sweet Andreas is with Sophia, I am surprised by his question, but then, looking at him, I realize he is just a child, and his questions are normal.

"How would it be if you have two parties: one with your friends and then we have a separate party with Sophia and our family?"

"Deal," he says and puts his hand up to slap me five.

I think about how lonely it must be for him not to be able to bond with his sister in the way that his friends do with their siblings. I feel so guilty at letting down Michael and Andreas. Andreas reaches for the hot chocolate, taking a big spoonful of whipped cream in his mouth.

"Ah, you have a big smile now. Any other worries I can take away?"

"Mommy, you're the best," he says.

"There is a solution to every problem, Andreas. Remember that," I say as I watch him ponder the advice he's just been given. Because he is such a sweet child, I take for granted how little he asks of me. That goes for Michael as well. I feel the struggle of being pulled in multiple directions. The guilt of spending less time with my family weighs heavily on me, but living a life that is fully expressed is a part of who I am. If I stop, I will be depriving my family in another way.

<p style="text-align:center">⁂</p>

A light rainy mist is falling as the airplane touches down at Larnaca Airport. More than a thousand protesters are expected to demonstrate in Nicosia, demanding the enforcement of a 1929 law in Cyprus criminalizing homosexuality.

I am ushered into the archbishop's quarters, where I find him signing documents. The icon of Jesus Christ whose eyes have been scratched out stationed behind his desk is still mesmerizing.

"Your Beatitude, why do you choose to have the defaced icon in your office?"

"It empowers me," he says as he places a document in his out box and stands to greet me formally. "When you drive here, you see the Turkish flag the army painted into the Kyrenia mountainside after the invasion. It forces us to confront our occupation from every vantage point on the island—a thorn in the side of every Greek Cypriot."

"If I were the president of Cyprus, I would demand they remove that flag before ever sitting at a negotiation table. It is psychological warfare on our people," I add.

"It is a test of our faith every time our eyes rest on this indecency. Instead of it destroying us, it fuels our determination to return home to the occupied area one day." The archbishop turns toward the icon of Jesus Christ.

"The eyes of an icon represent a window into heaven," he says. "And what we see when we pray before them is God's gaze returned. The cowardly act of gouging the eyes out of icons is committed to deprive us of our connection to God. With or without the eyes we continue to pray with them. The cross is also a target as fanatical Muslims reject the resurrection of Christ, the symbol of Christianity. Even our dead must endure this hatred as the crosses marking their grave sites in our cemeteries are desecrated and destroyed."

As he leads me to the sitting area, I notice that his slow and graceful movements are in tune with his calm and serene demeanor. I find myself feeling strangely at ease around him and impressed that he can be this calm despite the protesting. I sit on the red velvet settee and admire how the sunlight filtering in from the floor-to-ceiling windows reflects off the crystal chandelier.

"How is Kyprianou doing with the Lans case?" he asks.

"The Lans case lead will be R. W. Polak, the Dutch lawyer we just hired. Mr. Kyprianou will be an asset to Polak, with his experience on the Kanakaria case and in Cypriot law. I will need Kyprianou and Papageorgiou to come to the Netherlands."

There is no hesitation on the archbishop's part to proceed with the case. What is clear is that he and I share the same passion about seeing these artifacts returned.

I remove from my case the photograph of the Royal Doors that Van Rijn gave me and place it before him.

"Van Rijn says the Royal Doors are in Japan. His book is about to be released there and he is looking to publicize it. His supposedly non-negotiable terms are to be the lead negotiator on behalf of the Church and to have his expenses paid." The archbishop continues to listen thoughtfully.

"I sent the photograph to Mr. Papageorgiou, who confirms that the Royal Doors are from the old church of Agios Anastasios in Peristerona."[2]

"How do you suggest we proceed?" the archbishop inquires.

"Van Rijn cannot be trusted. I'll have to go to Japan with him because he is withholding the location. If we agree to pay his expenses, after giving me proof of the Royal Doors' whereabouts and revealing who the possessors are, I will take over the negotiation and see to it that he doesn't compromise the Church in any way."

"Can you manage this trip alone? It sounds far too dangerous," he says.

"Michael will accompany me," I say.

"And the children?"

"My parents will be with them while we are gone and they will have the support of our live-in nannies."

"Let me pay for your tickets," he says.

"If you pay, my compatriots will accuse me of using this trip to further my personal business, and there will be questions about why I was sent. I would rather pay my own way so that our actions cannot be questioned."

"I admire your dedication. The Church is grateful to you." The archbishop scribbles several telephone numbers on to a sheet of paper. "This is my personal fax number. The others are private numbers no one has access to. When you need anything, you call me without hesitation," he says. Knowing I have the archbishop's unconditional trust gives me immeasurable strength.

"Van Rijn's deals can be full of traps. I plan to lead him to believe he will be speaking for me, but when I meet the possessors I shall ask to speak to them alone."

"Will there be any repercussions?"

"I will not deceive him, just outsmart him, which he will respect."

The archbishop smiles, and a feeling of regret passes through me.

"Your Beatitude, it is probably not proper for me to say such things," I say.

"I like that you don't change who you are in my company. I get to know the real you and the you I am getting to know, I like. You remind me of myself," he says.

"I'm flattered," I say. "May I speak candidly, Your Beatitude?"

He nods his head in agreement.

"Shouldn't your views show the compassion you have for the plight of homosexuals?"

"A parade of people march through these doors each day, most of whom pretend to agree with my views. You are the exception."

"Your Beatitude. I mean no disrespect. I understand that the Church has its rules and teachings, but as a modern woman of faith, who is influenced by the Dutch in some ways, I happen to disagree with a few things."

"I'm interested in what you have to share. Please, go on."

"Being a bishop in the Orthodox faith, one must be celibate. Which is more disturbing to you, the fact that a bishop has an active sexual life, or that he lays with a man and not a woman?"

"Both, of course! Bishops must live in celibacy."

"Let's take a moment to debate this."

The conversation deepens as I reveal my thoughts on everything from the Church's position on banning cremation to my views on homosexuality. To have the archbishop's ear like this is a poignant moment. As a child, my nonconformist attitude was discouraged, and I was continually reprimanded, especially when it came to the topic of religion. To be engaged in this kind of debate with the archbishop is to receive an acceptance that I've longed for. As he sees me to the door, I feel that my own faith has been deepened from this experience.

"My regards to Michael and the children," he says, as I bow my head and kiss his hand.

"Next time, it would be nice if we can continue our discussions over lunch or dinner. You are always welcome."

❧

Valentine's Day is spent at my office meeting with Papageorgiou and Kyprianou, who flew in from Cyprus to meet with Polak and me regarding the Lans case, so my romantic dinner with Michael is postponed until Saturday. Polak discusses the materials we must secure by the end of the month, of which the biggest challenge will be getting a statement from Dergazarian, the dealer who sold the four icons looted from the church of Antiphonitis to the Lanses. The statement must include the date of sale, the purchase price, when the icons were restored, and the name of

the Greek dealer involved.[3] I didn't have high hopes that the Armenian would give up the Greek dealer; getting the date that the icons were restored was more likely.[4]

In an attempt to reassert himself, Van Rijn leads journalist Jan Fred van Wijnen to Dergazarian, which I believe is his way of showing me that I do need his help. The Dutch are consumed with the breaking story that two of their citizens are involved, and the media frenzy continues.

Van Rijn calls to see if I've changed my mind about the Royal Doors and Japan; this is my opportunity to negotiate for what I want.

"Introduce me to Dergazarian. Then we can speak about the Royal Doors," I say.

"Come to London tomorrow," I hear him say as the phone disconnects.

<p style="text-align:center">⤝⤞</p>

Traveling to London is easier for me to arrange because it's a short flight and I can return home on the same day without disturbing the family dynamics.

In the middle of central London, on a side street somewhere between the palace and Parliament, I meet Van Rijn at a Lebanese restaurant. As I enter, he and Dergazarian are engulfed in conversation. Both men stand to greet me. Dergazarian is tall and dark, with slightly grayish hair and sharp features. The waiter places bowls of tabbouleh and fattoush salads on the table, accompanied by smaller saucers of hummus and baba ghanoush.

"I'm sure Tazulaah will find what I ordered suitable, as the food is similar to her native Greek dishes. *Efharisto*," he says to the Lebanese waiter, who turns to me and says, "*Milao Ellinika*," which means "I speak a bit of Greek."

"It's nice to be surrounded by so many Greek friends today," I say, in an attempt to relax everyone, but it has the opposite effect.

"What do you mean by 'Greek friends'? Do you speak of dealers? Are you selling icons?" Dergazarian asks.

"No, I'm sure Mr. Van Rijn has told you I'm here in search of information specifically about four Cypriot icons you sold."

<p style="text-align:center">185</p>

Van Rijn writes in his book that he first met Dergazarian in a teahouse in Istanbul and later in Beirut, where he became Van Rijn's source for Russian artifacts.[5] Their friendship runs deep, as did their loyalties to each other.

"Not every icon that is sold on the market is from Cyprus, Madame Consul, and not every piece of art from Cyprus is looted. Artifacts were shipped out of Cyprus by your own people after the war as well. What can I do for you today?" asks Dergazarian.

"Mr. Dergazarian, I am not here to argue about what was shipped by who or to take anyone to task for it. I'm here to get a copy of a receipt or a statement about when you sold the Antiphonitis icons to the Lans couple."

He laughs. "So you can prosecute me for selling them?"

"My priority is to get the artifacts back, not to prosecute people. If my strategy is to prosecute, your friend here would be long gone," I say, looking at Van Rijn.

The look in his eyes says my sense of humor doesn't appeal to him.

"You can trust her," says Van Rijn to Dergazarian.

"How can I prosecute you without an address anyway?" I say. "Why don't you just give me a statement now?"

"Excuse us for a moment." Van Rijn speaks a few words of Arabic to the Lebanese owner and disappears into another room with Dergazarian. While I'm enjoying my hummus, I see Van Rijn and Dergazarian in a heated debate, but I can't hear what they are talking about. They appear ten minutes later and hand me a statement.[6] I notice that it has all the points Polak wanted me to obtain for the Lans trial. However the writing is Van Rijn's and not Dergazarian's.

"I need a statement from Dergazarian, Van Rijn, not from you! Mr. Dergazarian, can you please compose your statement here in front of me."

"Finalize Japan, and you get your statement," says Van Rijn. "See you at the des Indes tomorrow."

I allowed Van Rijn to drag me to London, away from my family and business, and make a fool of me. How can I consider going to Japan with him? My mind works overtime preparing for all of the different scenarios that Van Rijn might try to pull next.

٭

The spring blooms in their infancy mark the end of a gray winter. When I arrive at the Hotel des Indes, Van Rijn is sitting at a table in the back of the lobby smiling like a Cheshire cat.

"You better have that statement today," I say to him.

Van Rijn, turns over Dergazarian's statement to me.

The statement says that Dergazarian acted as an intermediary for Van Rijn in selling the four Antiphonitis icons to the Lans couple in 1978, not 1971 as they originally told me, which proves our argument that the Lanses purchased the looted icons after the war, not before as they claimed. As much as this document helps to prove that the icons were bought from the conflict zone after the invasion, there is still the unknown of how the statute of limitations issue will be judged. What is clear to me, from the date of Dergazarian's statement, is that Van Rijn has had this short document in his possession for the last six months and has been holding it to use as a bargaining tool. We have an understanding. He sees me as his window to clearing his name. I see him as an open door to lead me to the rest of the dealers. Even if I had enough evidence to have him arrested, I wouldn't have him prosecuted at this point because I would then close the door to the world of art trafficking.

"Where are we with Japan?" Van Rijn asks.

"It's clear that you are not going to tell me who the possessors are and that I will not give you the power of attorney to act on behalf of the Church. We are at an impasse."

"I've already been corresponding with them from Malta," he says. "They are an institution and very anxious about Cyprus taking legal action against them. They don't want negative publicity, Tazulaah. If you don't trust me, I can have the Royal Doors delivered to Scotland Yard, but you are to do as I say."

"Enlighten me," I reply.

"Write a letter to the possessor stating your position as acting on behalf of the Church of Cyprus and say that the Royal Doors were looted from Cyprus during the invasion in 1974. Also, confirm that you will not prosecute them if they agree to return the doors. Everything must be on consulate stationery.

You must show proof that the icons were stolen and that they came from Cyprus. I'll have my lawyer send you a fax later on this afternoon with an example of what I need you to say. So, do we have a deal?"[7]

"In theory, we have a deal *but*, in terms of the letter, I can't give you a blanket yes on that because it will have to go through the Church's attorney."

"Deal," he says as he taps his espresso cup to mine.

Seconds after I fax the statement of Dergazarian to Polak, he rings me at my office.

"Well done, Tasoula. This statement establishes that the icons were purchased after the war. I'll draft some legal text for you to include in your letter to the government requesting they invoke the Hague Protocol."[8]

The Cypriot foreign minister makes the request to the Dutch government to invoke the Protocol of the 1954 Convention for Protection of Cultural Property in the Event of Armed Conflict.[9] This is the first time the Protocol will be invoked, and it draws the attention of global media as well as UNESCO, who sends an observer to follow the case. The Dutch government reply is that because the question of ownership has already been taken to the court of Rotterdam, they cannot intervene in the civil procedure until after the court's ruling. Since we can't invoke the treaty at this point, having Dergazarian's statement is essential.

<p style="text-align:center;">❦</p>

On March 11, I forward a copy of the letter that Van Rijn asked me to write to the possessors of the Royal Doors to Polak for his comments. Van Rijn is still refusing to reveal who the possessors are, so I am acting with him as though I may pull out of the negotiation without having that information first.[10] Polak suggests a few edits, as the draft can be construed to read that Van Rijn is negotiating on behalf of the Church. I fax a revised copy of the letter to Van Rijn's lawyer for added protection, in order to have third party witness to what Van Rijn is promising me. He is not pleased with the revised letter or that I sent it directly to his attorney.[11, 12]

We continue to disagree about format until he calls me from Malta.

"Just do what I tell you, woman, if you want to see your doors," Van Rijn says.

"Send me a fax where to go," I say, leaving the dial tone ringing in his ears.

On April 19, I update the archbishop on the Japan trip.[13] I receive formal approval to cover Van Rijn's expenses, after securing proof of the doors and the identity of the possessor. I send a fax to Van Rijn's attorney giving them the go-ahead to schedule an appointment with the possessor for April 23 and 24.[14, 15, 16] Michael and I rarely have the opportunity to travel alone together and look forward to our trip to Japan.

OSAKA, JAPAN

When we arrive at the hotel in Osaka, a petite Japanese woman greets us at reception and hands me a letter and a gift. The letter has five bottles drawn on it. Under the bottles appear the names Dikmen, Van Rijn, Roozemond, Dritsoulas, and Petsopoulos. The text reads, "Wouldn't you like to see all of us dealers bottled up like this?" I unwrap the gift, which is a bottle of Japanese clear alcohol with a gutted salamander in it. Supposedly, when the two elements are joined they make an aphrodisiac. After one look at the lizard you could hear my scream at the opposite end of the lobby, which is where I hear the sound of Van Rijn laughing at the top of his lungs.

Making our way over to Van Rijn, I ask him, "Do you find this funny?" Van Rijn is hysterical. Michael and I join him at his table.

"Who are the possessors?"

"Relax. Please let me get you each a drink."

The waiter brings us drinks.

"The doors are at the Kanazawa College of Art. It's a several hour train ride from here. Tomorrow we will meet the professors at their attorney's office."

"Van Rijn, you told me the possessors are going to give the Royal Doors to me. Why are lawyers involved?" I ask.

"One look at you and they will turn the doors over."

Now I know I'm in for a fight tomorrow.

"Don't let me be the one to interrupt the golden couple's getaway," he says. Van Rijn hands me the address of the possessor's lawyer. "I'm in negotiations with them on other business, so I'll be there when you arrive. We will finish at ten A.M. Be on time. Enjoy the aphrodisiac."

Heading back to my room, I feel all kinds of guilt about exposing Michael to the antics of Van Rijn and to this situation in general. I can't sleep, wondering if the Japanese will be cooperative and return the doors or if I will have to begin a civil case with the college. Knowing Van Rijn, he is scheming, and I'm waiting for the plot to unravel. Michael and I have a private breakfast in the room.

"In case I don't return or something goes wrong, here is Polak's mobile number. Call him. He will know what to do," I say as I leave for the appointment the next morning.

I validate that the address is indeed connected to a lawyer's office and take a taxi there alone. As I walk up the long flight of stairs leading to the office wearing a dark blue Louis Féraud dress with a white-and-blue-striped short jacket, I see Van Rijn waiting for me at the top.

"Wow, you look smashing!"

Van Rijn leads me to a conference room where there are four Japanese men standing. Van Rijn says, "I introduce Mrs. Hadjitofi, honorary consul of Cyprus."

The Japanese men bow. I'm well versed in their culture, so I know not to shake their hands. Bowing slightly, they each offer a business card using both hands. I hand them each a Consul of Cyprus card in return, keeping eye contact but not bowing.

"Good morning," I call the meeting to order. Everyone sits at a rectangular table.

Van Rijn sits next to me, asserting his position as my spokesman.

"Gentlemen, thank you for receiving me today, and I want to thank Mr. Van Rijn for making this introduction. For the record, he neither represents the Church of Cyprus nor the Cypriot government, and it is for this reason that I wish to discuss the details about the Royal Doors without his presence."

Van Rijn is livid.

Facing the lawyers, I say, "I come here in good faith without legal representation to make a personal plea on behalf of the people of Cyprus."

The lawyers and professors confirm that the Royal Doors are at the Kanazawa College of Art, and I am welcome to go and see them the next day. They tell me they were purchased from a gallery in Holland that belonged to Roozemond, and their position is that they had no idea that they were stolen. I tell the lawyers about the conflict and the cultural cleansing that took place in Cyprus. I show proof of provenance for the Royal Doors that Mr. Papageorgiou has supplied. They hold each piece of evidence up to the light to scrutinize. They are not convinced that the records are authentic, and through their interpreter they ask to see documents that are officially stamped by the government, along with photographs of the doors prior to the war. And sadly, this kind of photograph does not exist in our records, and so I must try another angle.

"You know, gentlemen, that in 1990 Cyprus won a landmark case, which set the precedent that once something is proven stolen it cannot receive good title."

"That is American law, Madame. I would like to read about this case. Perhaps you can send a copy to me. We will also require proof of your consulship and a power of attorney to confirm that you have permission to negotiate on the Church's behalf," says Shiro Kuniya, the spokesperson for the legal team.

"You'll have all the documentation you need this afternoon, but in return I would like to see the Royal Doors," I say.

"We have scheduled an appointment for you at eleven A.M. tomorrow."

From my hotel room, I spend the rest of the afternoon confirming what transpired in my meeting with the lawyers representing Kanazawa College and secure the requested paperwork.[17] Feeling guilty about the fact that Michael is stuck in the hotel room helping me, I ask reception to recommend an authentic local restaurant, not one catering to tourists. She writes the name of a restaurant in Japanese, which we hand to a taxi driver.

A short distance away in the middle of a busy shopping area, we find the door to the restaurant to be so low that Michael and I practically bend

in half to enter. The restaurant is informal in style with a large circular sushi train dominating the room. Michael and I take seats and eye the individual dishes of sushi and sashimi as they move slowly past us on the conveyor belt. Although Michael and I often eat sushi, there is such a great variety of fresh fish, and many of the dishes are unknown to us. This restaurant has stimulated our taste buds, and Michael and I are grateful for some much needed time to relax together.

"I can't believe what you are up against between the lawyers, the games that Van Rijn plays, and the fact that the law itself doesn't side with you. A college of art should know to do their due diligence and should be held accountable for purchasing stolen property," Michael says.

"Let's see what tomorrow brings."

We take our empty plates to the cashier, who charges by the dish for the dinner.

Michael places his arm around me.

"It means the world to me that you are here, my darling," I say, placing my head on his shoulder. He maneuvers his body to kiss me, and as he pulls away he says, "One day at a time, my love."

KANAZAWA COLLEGE OF ART

As we travel to the college, Van Rijn says to Michael, "Did Tazulaah tell you how she embarrassed me yesterday? Kicked me out of the meeting like a dog." He turns to me and says, "You are not going to do that to me today. I won't allow that."

"Outside is exactly where you will be during this meeting again. If you want your money, you will let me finish my business," I say. I realize that he has lied to me once again and that the Japanese lawyers are not ready to give the doors back, contrary to what Van Rijn initially said.

He turns to Michael and says, "Can you please tell her this is no way to treat the person who is here to help her?"

I make a facial expression that lets Van Rijn know he is not the help he believes himself to be. He has had his hand in and has made money from

every stolen artifact, including the Royal Doors. He has led me around the world with the understanding that the Japanese would hand the doors over freely, and now I face a possible civil case in Japan, too. "She is the honorary consul. She calls the shots. I will remain outside here with you," says Michael, not taking the bait.

Kanazawa College of Art is a small municipal college for art and industrial design which is a several hour train ride from Osaka. The city of Kanazawa itself is admired as a cultural center of traditional arts and crafts. We are led inside a series of rooms decorated with sculptures by the French artist Auguste Rodin. I see the Royal Doors mounted upright on a transparent base supported with wire and provided with a Japanese plaque. The doors, with their Byzantine detail, look so out of place. Just the sight of them brings back so many memories from my childhood in Famagusta. Seeing them among these relatively modern paintings stirs my emotions. These are the doors that my grandmother and mother prayed before. I visualize them inside the church from which they came, and it unnerves me. Van Rijn asks me to stand next to them, and he takes a photograph for me. We admire them for a few minutes. Van Rijn and Michael stay behind as I move on to join the awaiting professors.

Professors Tsuneo Ueda and Katsuyuki Nakanishi are present but the director of the university is not in attendance.

"Where is the director?" I ask.

Mr. Nakanishi replies, "He is busy. He sends his apologies, but he can't meet you today."

"What about his deputy or the secretary of the college?"

"They are busy, too," says Mr. Ueda. "You should speak to Mr. Kuniya, the attorney representing the university."

"I came here to discuss this with the director of the college to see if we can find an amicable way to end this dispute."

"That is a decision that only the mayor of Kanazawa can take, because the doors were purchased with taxpayer money, as we are a municipal college. Unless we are compensated for the money we spent, we cannot return them."

Although the lawyer is not present today, the response to every question about their intentions is for me to contact their attorney. I, in turn, request

a copy of the legal export license and a receipt of purchase that they would have had to have received from Cyprus in order to prove that the university purchased the doors legally. Negotiations continue to deteriorate, and I end the meeting by giving them forty-eight hours to decide whether the mayor will be handling things or their lawyer.

Van Rijn goes on to Tokyo to promote his book launch there. Michael and I take the train back to the hotel, where he tells me that Van Rijn confessed to him that the Rodins that the rooms at the college filled with were all fake.

"We are expecting them to know about Byzantine art from the churches of Cyprus, and here they are teaching modern art, and they can't tell a fake Rodin from a real one," I say.

When I arrive back at the hotel, I call the mayor of Kanazawa's office asking for a meeting. His assistant tries to fit in an appointment.[18] An hour later the mayor's assistant calls, saying, "The Kanasawa College of Art says there is no need for you to meet the mayor; they will deal with you directly."

I feel that they are hiding behind each other forcing me to start a civil case.

Van Rijn sends a fax to the hotel: "Dear Golden Couple, Tazulaah would have made a great art dealer who would put me out of business." Van Rijn goes on to brag that he does not rely on the archbishop's money, that he installed a fax machine in his private hotel suite in Tokyo, and that he will not leave Japan until he hears about the latest developments.[19]

The following morning Michael and I are preparing to leave for the airport when Van Rijn calls the hotel.

"You are famous in Japan, woman! The *Asahi Shimbun* is the largest newspaper in Japan, and you and the Royal Doors are all over it."

I arrange for the hotel to send me up a copy, and there is a picture of me standing next to the Royal Doors and an article about how Van Rijn discovered the stolen artifacts and led me as honorary consul to repatriate them. His motives become perfectly clear. I always knew that it's been about the launch of his book, but now I see his motives for wanting to try to negotiate for the Royal Doors. The Royal Doors enabled him

to receive the news coverage he wanted to promote his book. Plus, the more he associates himself with me, the more he sells himself as being legitimate.[20] The *Asahi Shimbun* news coverage could have put some embarrassing pressure on the university, but instead it deepened the line in the sand between us.

Sixteen

NO PEACE

As the tulip season fades in the Netherlands, the Royal Doors impasse with Kanazawa College continues to develop. For the past several months, I have appealed to the people of Cyprus to sign a petition for the return of the Royal Doors, reached out to Cypriot groups to organize demonstrations at the college, and gained the interest of a Japanese journalist, Kunihiro Yamada. I hope to place pressure on the Japanese to come to the table to negotiate so that the Church does not have to initiate a civil suit.[1,2] The Japanese court will have jurisdiction over this case. Since the Dutch and Japanese laws are similar with regards to "good faith," it will come down to the reputation of the dealer and the method in which the doors were purchased. In this case, despite what I know about Roozemond, I can't prove that he is not a legitimate dealer, and the professor from Kanazawa who purchased the doors from Roozemond professes his innocence about their history and feels they are not required by law to return the doors to Cyprus. This gives us no other choice but to threaten legal action unless they cooperate.[3] The cost of a trial in Japan will be substantial and it could drag on for years.[4] I report to the ministry on the steps taken and what evidence has been provided and request that all media for this case be co-coordinated through me.[5]

Vara television in the Netherlands is producing a program for their series *Zembla* which will highlight the illicit art trade and interview me, Polak, and the archbishop in relation to the Lans case.[6] Van Rijn approaches Geraldine Norman, a renowned English writer from the *Independent*, regarding the case of the Royal Doors.[7] Although pleased to have an introduction, I ask him to stop reaching out to the media on my behalf. As much as I welcome publicity for the cases, I must protect my reputation. Four days later Van Rijn is prevented from entering Malta because he is on a special "swindlers list" of Interpol.[8]

❧

The mounting legal fees of the Church influence me to start petitioning the Cypriot government for support. There is resistance from the government yet again. I'm constantly asked by bureaucrats to provide summary explanations of the issues, and most of the time they go unaddressed. Now we have the Lans case in the Netherlands, a possible case emerging in Japan, and a civil case that has already been lingering in the courts for six years in Greece under Kyprianou's supervision.

As long as the Lans civil case is ongoing, the government of Holland will not intercede in the case. Polak advises that if he drops the civil case on behalf of the Church, the Dutch government will then be able to invoke the protocol. The new minister of foreign affairs, Ioannis Kasoulides, will have to repeat the steps of his predecessor and send another letter to the Dutch government requesting them to invoke the protocol.

In June, Polak and I meet with Dutch cultural and legal advisers to discuss the Lans case further. It turns out that the minister's advisers take the position that the Protocol needs to be implemented in Dutch law in order to be effective, a step the Netherlands had never taken, despite the fact that it ratified the Protocol in 1958 and it entered into force in 1959. We take the position that no implementation is needed, feeling the Protocol is self-executing. The meetings end in a stalemate.[9] Polak and I continue to search for a way forward.

❧

Despite continuous efforts by our attorney in Japan to entice Kanazawa College to work with us, it claims that we have not fully demonstrated the identity of the Royal Doors. The college intimates that they might be open to accept an exchange for another icon.[10] Polak knows the technicality of the laws and asks the Japanese law firm to investigate if, under Japanese conflict of law rules, Cypriot law may apply. Mr. Polak is implying that Cypriot export prohibition rules must actually be followed in Japan, in the event that the doctrine of "Eingriffsnormen" (super mandatory law) is applied, meaning foreign law would take precedence in lieu of what would normally be governed by Japanese law.[11]

On June 26, I send additional documents of identification for the Royal Doors along with information about Roozemond's knowledge that the doors belonged to Cyprus. The Church counters their request for another "icon" with an option to exchange the Royal Doors for a famous copy of an icon that will be specially made for them by Cypriot monks. The archbishop also offers to host two Japanese representatives to return the doors to Cyprus.[12] The Japanese college declines my offer to exchange the Royal Doors for an icon replica. The Japanese paid 14 million yen ($140,000) for the Royal Doors, and if they are reimbursed for that amount, they will consider returning the doors to Cyprus.[13] Even the former president of Cyprus, George Vassiliou gets involved in trying to secure the return of the Royal Doors and instructs one of his personal contacts to intercede on his behalf.[14] The president's contact believes the Japanese will come around,[15] but then a few days later I am informed that the college will not return the Royal Doors. Every other option seems to be exhausted. If Cyprus wants the doors, they will have to take legal action.[16]

✤

With challenges continuing to mount, I become cognizant of the bitter fact that being on the side of right does not guarantee justice. I suggest that journalist Willem van der Post from *Algemeen Dagblad* do a story about the cultural cleansing that took place in Cyprus following the war, and I set up interviews for him with the archbishop, Cypriot government officials, and

attorney Polak, hoping that at least telling the story to the wider public will be a ray of positive light to our situation in the midst of all the mounting legal battles.

In the article, the archbishop does not name the Dutch dealers in order to prevent further legal action. He does say that the same two Dutch dealers' names appear repeatedly whenever there are cases to do with stolen icons from Cyprus and profiles me as a worldwide coordinator of repatriation cases. When the journalist questions the minister of foreign affairs in Cyprus about the government's involvement in the repatriation efforts, Alecos Shambos responds that in the fall the Cypriots will establish an embassy in The Hague, and one of the duties of the new ambassador will be seeing to the return of stolen icons.[17]

My eyes circle back to reread the section again. How is it possible that I would not be given the courtesy of a phone call telling me that an ambassadorial position is being created in The Hague and specifically that one of the roles of the new diplomat will be handling repatriation efforts for stolen Cypriot artifacts? The archbishop is also unaware.

"I'm not surprised," the archbishop says. "As an honorary consul, you are not supposed to outshine paid career diplomats, and this is what you are guilty of."

I place a call to the ministry to inquire about the issue.

"We are opening embassies in all European Union countries to support our entry into the European Union. I expect you to give the new ambassador your cooperation and help him to establish himself," says the director.

"Of course," I say. "May I inquire about the status of the MFA's letter to invoke the protocol in the case of the Lanses?" I say.

"Take it up with the new ambassador when he arrives," he says.

Alecos Zenon, the son-in-law of Judge Andreas Loizou, whom I greatly admire, is the new ambassador to the Netherlands. Judge Loizou was the president of the Supreme Court and a catalyst in my appointment as honorary consul. I volunteer to establish the new Cyprus embassy in The Hague, and handle the countless professional and personal details involved in making the ambassador's relocation a smooth transition. By the time the ambassador arrives in early October, everything is ready for him to begin his work. I

hold the belief that the friendship I once established with the judge and his family will make for a positive working relationship between the new ambassador and me.

To my surprise, dealer Robert Roozemond reacts to the *Algemeen Dagblad* article condemning the archbishop and me in an open letter to the Archbishop.[18] Roozemond takes great offense at the archbishop's comments, feeling that he will be unfairly regarded with suspicion as one of the two unnamed Dutch art dealers cited by the archbishop in the article. Roozemond accuses me of damaging the interests of Cyprus as honorary consul and names Van Rijn as the dealer involved with stolen Cypriot art. He says that my association with Van Rijn taints me as being involved with the international criminal trade.[19]

Roozemond's open letter to the archbishop and comments to Vara are very upsetting to me. I fax the letter to Polak, and we decide to respond strongly to Roozemond's slander and libelous statements.[20] The archbishop supports me with the full power of his office and responds with a point-by-point rebuttal of Roozemond's accusations.[21] Despite the absurdity of Roozemond's statement, the timing of his letter could not be worse. The Roozemond letter will not help our position concerning the Royal Doors, as it will divert attention away from the important issue. Roozemond manages to give me the equivalent of an emotional knockout. I choose not to retaliate against Roozemond with a lawsuit needing instead to conserve all my energy for the repatriation cases.

Aristotle said it best: "Our judgments when we are pleased and friendly are not the same as when we are pained and hostile." I want justice for the cultural cleansing of the northern part of Cyprus. There is an unrelenting need for me to expose the unprecedented looting that took place under Turkish military occupation and to understand why the rest of the world does nothing while Turkey continues to occupy our homeland. The invasion traumatized me, and as I struggle to integrate into the social fabric of the Netherlands, my repatriation efforts address my inner identity conflicts.

I want to expose the dealers who traded in our looted cultural heritage. I was so lost in the details of wanting revenge that I didn't realize my focus had changed. I'm not James Bond; I'm just a girl from Famagusta. Through prayer I gain clarity and abandon the idea of confronting Roozemond. There

is enough negative energy circulating, and I will not generate any more of it. It is time for me to take stock of myself and get back to my real mission, which is to bring the artifacts home to Cyprus.

᳨

Several months later, in mid-July, Van Rijn's attorney faxes a letter to the British Museum, referring to a stolen Saint Peter icon currently in their possession. Van Rijn claims that he personally smuggled the icon out of Cyprus in 1982 and placed it in the hands of restorer Stavros Mihalareas, yet another Greek, who later sold it to the British Museum when he was unable to contact Van Rijn for several months.[22]

I follow up with a letter to the British Museum stating that we are in a receipt of Mr. Van Rijn's correspondence and are not in a position to comment on whether or not his statement is factual, but we inform the British Museum that the legal owner of the icon is the Church of Cyprus. As a representative of the Church, I ask to be kept abreast of the investigation.[23] Phoning the director of the British Museum, I introduce myself as representing the Church in the matter of the Saint Peter icon and request an opportunity to meet with them in person.[24]

Van Rijn appears suddenly, asking that I join him for lunch at the Bodega de Posthoorn, the place we first met.

"Did you like my fax to the British Museum? They might not return the Parthenon Marbles to the Greeks, but they will give them to you, I'm sure," he says, quite pleased with his actions. "I took the liberty to order some Dutch delicacies before you arrived."

With my knife I cut a hole in the croquette to release some of the steam, and say, "You presume everything is yours for the taking, don't you?"

He gives me one of his wounded little boy looks.

"Where is your gratitude, woman? I expose the museum and myself, all for the love of you and your icons, and you still treat me as if I were a criminal."

"Do you think your confession justifies your actions?"

My eyes are fixed on his, neither one of us willing to budge from our beliefs. Van Rijn shakes his head disappointedly.

TASOULA HADJITOFI

"God forgives, so why can't you, Tazulaah? I thought you were a Christian!" he says with a hurt undertone.

"Redemption happens when you come clean. You can't have one leg in the criminal world and with the other pose as a hero."

"Whether it be avenging the Turks for what they did to your Cyprus or a desire for something else, you also operate according to your own agenda."

"I earn no salary, I volunteer to do this work, and I pay my own expenses. I live by my own moral code and ideology, neither of which is corruptible by people like you."

He's right, there is resistance on my part to see him as the hero he sees himself to be. Granted, he is trying to help Cyprus, but Dikmen's fingerprints are not the only ones all over our missing artifacts. Van Rijn is enmeshed in many of these deals and it aids my refusal to sing his praises.

"I'm waiting for you to give me information without getting something back."

"You say I give you nothing without gaining. Look to a case in Greece. That's all I am willing to say."

Jotting down his words on the back of a napkin, I wonder if this is another wild chase that leads to nowhere. There is a part of Van Rijn that is looking for redemption but he could be feeding me information to use as weaponry against the person he mentioned.

❦

Meanwhile, the Lanses' lawyer disputes that the four icons are from the church of Antiphonitis. The Lanses maintain that we misidentified their icons. These assertions require me to contact Papageorgiou to obtain additional proof.[25] Polak and I make a side-by-side comparison of photographs sent by Papageorgiou with those presented by the Lanses legal counsel. Pointing to both images that show the back side of the icons, Polak says, "In both photos, the signatures and the grain patterns in the wood are an exact match." The case is again postponed until end of October. The Lanses receive another court extension until September, a reprieve that actually comes in the nick of time for me, too.[26] I crave spending time with my

202

family. When I am together with Michael and the children they are my world and there is nothing else in it. The quality of love and attention that I shower them with compensates for the times I cannot be with them. This is our normal way of life and together we thrive.

❧

Waiting in Schiphol airport for Ambassador Zenon to arrive, I can't help but to wonder how our responsibilities will be divided. It could be quite useful to have his assistance in expediting government approvals, as cracking the government bureaucracy has proved near impossible thus far. The passengers deplane. The ambassador's nickname among diplomats is "The Prince," and I see why, as he walks with the step of a man who carries a great deal of importance. I give him the same warm greeting I give to everyone.

"Welcome to the Netherlands."

Michael and I have him to our home for dinner almost every night. His laundry is even done by our domestic help. We want him to feel comfortable in his new home in The Hague while he waits for his wife and daughter to join him.

It is common for Ambassadors to invite their staff and honorary consuls to attend the ceremony where they present their credentials to Queen Beatrix of the Netherlands. I'm not invited by the Ambassador, but I volunteer my staff to organize his celebration party.

With the holiday season before us, I decide to view the situation in the best possible light and look forward to having a small break, if only to catch my breath. But this break is short lived when I realize that my company needs dire attention. In my compulsion to recover the artifacts, I leave Octagon in the hands of several different managers. My company's bottom line has been affected adversely, and Michael is terribly upset with me for letting it get to that state.

"If you continue to chase icons instead of looking after your company, you will soon be bankrupt. How can you do this! Do you realize we are personally liable for the credit line you took out?" He is right. I focus my

energies on Octagon and pump some life back into it, and then turn my attention back to icon hunting.

I can't justify my obsession. What takes me away from my family and other responsibilities reflects a need to stop any "merchants of God" and the upper echelons of society that trade Cyprus's cultural heritage out of greed.

<center>⚜</center>

The ambassador summons me. I walk from my office to the Archipel neighborhood, one of the most prestigious areas of The Hague, and arrive at the new embassy at Surinamestraat 15. The Cypriot flag flies in front of the building.

"Did you buy a bicycle yet?" I inquire. "Everyone in Holland has one, including our queen and prime minister."

Wearing a serious expression, he says, "Everywhere I go, people are talking about the honorary consul!"

I assume he is teasing me until I realize he's quite serious. I am liked in these diplomatic circles.

"I pick up the newspapers and your picture is everywhere. You over-shadow my position as ambassador. How can an embassy survive in this confusion?" he asks.

"Alecos, I'm sorry, I don't understand what the issue is. I've lived and worked in Holland for over fifteen years. I speak their language."

"Your work is eclipsing mine. Forget your direct contacts with the Ministry of Foreign Affairs in Cyprus. You now report to them through me. Going forward I am to be copied on all of your correspondence," he says.

"Ambassador . . ." I begin, but he interrupts.

"Very importantly, you are not to use your consular stationery on any correspondence having to do with the recovery of stolen artifacts."

"I don't understand," I say. "I'm an honorary consul."

Shaking his head to the contrary, he says, "You work for the Church. When it comes to repatriation, use their stationery. As the ambassador, I must be in control of what is happening in my territory, wouldn't you agree?"

"Of course," I respond.

"We have two separate roles. I am government and you are the Church representative. The only government duties you have are to issue visas and renew passports. Even then, you will seek authorization from Cyprus via my embassy."

"This makes my situation more complicated," I say. "The fact that I can utilize both Church and government positions sends a clear signal to the art traffickers that we work together. I need to lobby politicians—like now in the Lans case it is essential that I am able to use my title as consul. The Dutch government will not invoke the Hague Protocol until the Lans civil case is decided. Polak is advising me to go back to the Dutch government and ask the new minister of foreign affairs whether they will reconsider invoking the Protocol if the Church drops the civil case. This is why I need to utilize my consul position and work with you."

"Let me make this clear. You report to me. I report directly to the Ministry of Foreign Affairs. My office briefs the media. Lastly, I will not do as you ask and risk the support of the Dutch for our entry into the EU, to help you recover four icons. That will be all," he says.

Wanting Zenon's decision on record, I send a letter confirming his refusal to take action in the Lans case. The Church is now left to continue the civil case. This meeting with the ambassador creates problems for me. Being able to speak as both a consul of Cyprus and representative of the Church in repatriation efforts gives me leveraging power. Now that the ambassador has clipped those wings, I must figure a way to work around it.

As a Church representative, I lobby two Dutch MPs who pose questions to the House of Parliament to Prime Minister Kok to implement the Hague Protocol so that the Netherlands may comply with their international obligations. The motion is done, and the reply from Minister of Justice Mr. Sorgdrager will be in October 1997.[27, 28] My actions could worsen the situation between the ambassador and me, but it is the right step to take to recover the stolen artifacts Cyprus.

Seventeen

THE ROAD TO MUNICH

L ife and time move ever forward, and, like the rapid flow of sands in an hourglass, my search for the stolen artifacts approaches the decade mark. The location of the Saint Andreas mosaic continues to elude me. Van Rijn and I circle each other like two boxers in a ring waiting to land the punch that will declare one of us the winner. Knowing that the Saint Andreas holds personal value for me is exactly why he will never reveal its location, and thus our twisted "dance" continues. As long as he holds the key to its whereabouts, he believes he has the upper hand. The more proficient I become at repatriation, the more he tries to lure me with the promise that he is the only one who can deliver this particular artifact to me. We are becoming psychologically entwined.

Van Rijn believes he is a reformed man because he is helping the government repatriate artifacts that he had a hand in profiting from. There is a desperate need in him to be acknowledged as a wrongdoer who turned his life around. I see a man whose established image of himself does not match up to his current actions. What drives his insatiable need for recognition I do not know, as Van Rijn and I never engage in personal discussion. I do see the person he aspires to be struggling to break free of the clever manipulator

that he is, and I hold on to the hope that he will one day become the hero that he longs to be. He wants to turn me into a dealer like himself, and I wish him to be a completely reformed citizen.

In facing off against Van Rijn I recognize a similar drive that lies within me. Living abroad as a foreign refugee, it is so important to feel that I fit in. I am considered different and not acknowledged as one of the Dutch. Going home to Cyprus, where I no longer have a vote, I am viewed as a foreigner. I'm longing to be one of the Dutch or one of the Cypriots, but I'm a little bit of both, which leaves me always on the outside of both places looking in for acceptance.

Over the years I have managed to impress upon Van Rijn the impact that losing one's cultural heritage has on a person, especially when that person is also a refugee. It's important to me that everyone understands the value that cultural heritage holds and the role it plays in keeping communities together. As a child who experienced conflict and trauma, I choose to hold on to my happy memories of Cyprus. I believe that politics and religion tend to divide us. If we take the view that every archeological discovery or religious monument holds different, and important, memories for each one of us, it can serve as a neutral platform to discuss our different perspectives of history and faith. Cultural heritage holds shared memories and stories of civilizations that came before us. No one has a right to destroy these items, because they belong to humanity. The monuments serve as the silent witnesses of our shared history. Nicolas Roerich, the Russian archeologist and social activist, said, "Where there is peace, there is culture and where there is culture, there is peace."

My soul is immersed in the subject of cultural heritage, but time is running out for me. Michael wants to have another child, as he believes it unfair that Andreas has only Sophia as a sibling. Sophia's mental challenges impose a great responsibility on Andreas, and Michael feels it would be unfair to deprive him of the experience of having a healthy sibling. As I approach the end of my thirties, Michael urges me to rise above my fears that something could go wrong during pregnancy again.

"Leave the repatriation in the hands of your government," he says. "You've done enough. Let the paid diplomats do the job."

The government will not put their full efforts behind repatriation so I cannot, in good conscience, abandon my mission at this time. I feel that I am the right person, at the right time, in the right place to do this job. Michael knows me better than anyone, and he sees me losing myself in this process, sacrificing the bits and pieces of my life that bring me into balance in order to grab the bits and pieces of information that lead me to recover stolen artifacts.

Like Van Rijn, I also recognize that there is a sense of desperation within me. War has traumatized me, turned me into a refugee, and as I struggle to integrate into the social fabric of the Netherlands my repatriation efforts address my inner identity conflicts.

Michael understands that my need to deal with my past has taken over, and he is doing everything in his power to prevent me from drifting further. The more he tries to exert control over me, the more I pull away. What is not apparent on the surface is that I believe the return of the artifacts to be a key to my own healing. My desire to rid myself of the betrayal I experienced due to war overrides everything else.

<center>⚜</center>

The legal fees in Japan, Greece, Holland, and the U.K. are placing additional strain on the archbishop, which adds to the pressure I feel. Our witnesses are aging, and the court cases are long, with uncertain outcomes, given the weak laws in Europe regarding stolen art. The magnitude of the looting makes pursuing every case prohibitive. I search for more situations where we can work with alternative solutions instead of becoming mired in legal battles.

Within the archbishop's circles there are some who disapprove of using the Church's resources for repatriation and of the trust he places in me. Anxiety brings sleepless nights and infiltrates my waking moments. At times I feel as if I am on the brink of collapse, but the adrenaline rush becomes my life preserver, keeping me afloat and intensely focused on winning this war at all costs.

1997

The first week of the New Year brings the witness hearings in the Lans case. This gives the defendants an opportunity to refute the Church's claim that the sixteenth-century icons were stolen after the 1974 invasion. The Lanses' attorney subpoenas Jan Fred van Wijnen, the Dutch journalist, to reveal the whereabouts of the Armenian dealer, Dergazarian, but the reporter refuses to do so. Van Wijnen's article supports the Church's claim that the stolen icons were purchased by the Lans couple after the war.

Protecting the journalist's right to protect his sources becomes the headline story across Dutch and other European newspapers. Everyone is following the Lans case now, especially other journalists who are vested in how the judge will rule in the matter. Instead of celebrating the wide attention the case is receiving, I find myself wondering how Ambassador Zenon will react. The judge and the Church's attorney, Polak, each question the witnesses. Afterward, the judge's findings are read aloud in court, and lawyers for each side respond to the judge's comments.[1]

My front-row seat to the legal process gives me insight into how much the laws differ from country to country in regard to art trafficking and how the lack of international unity creates loopholes for the criminals to slip through. I pray that the Dutch will respond as the Americans did in the Kanakaria case, in which Judge Noland ruled that the Kanakaria mosaics be returned to Cyprus. But the international laws are terribly flawed, and at the present time there is no one rallying to change them. I store that idea in my subconscious, knowing that my heart is committed to take on that challenge in the near future. Right now I must fight one battle at a time.

I tell Michael that another trip to Cyprus is needed to discuss with the archbishop several issues that were raised during the Lanses' questioning of witnesses.[2] Caught up in arguing, we are unaware that Andreas has wandered into the kitchen.

"What is it going to take for you to stop, Tasoula? Now you are off to Cyprus again when I am scheduled to go to Moscow!"

"Michael, I'll change plans and go next week. Is that fair?"

"Tasoula, life is passing us by," he says, increasing my anxiety. "There will never be anyone good enough, in your eyes, to take over your icon hunting."

Andreas looks at my hands, which are clenched into tight fists at this point. If only Michael could realize the full extent of what I do. I am juggling the responsibilities of three people, and his home runs without a glitch. Yet it never seems to be enough.

"Mommy," Andreas says in his sweet child's voice, which startles me, as I didn't realize he was present.

"Yes, my darling," I reply. As I take a seat next to him at the kitchen table, he brings his tiny fists up to my face and makes an angry face.

"Stop."

It literally takes my breath away as I realize that he is imitating me. My young child teaches me a valuable lesson. Michael continues to be angry, so I tiptoe around him in preparation for my trip to Cyprus. His dissatisfaction forces me to do everything out of earshot as he now looks for evidence to prove his point. I'm actually looking forward to getting away to Cyprus to escape the pressure, and I compensate by filling the house with his favorite English sweets, biscuits, and cakes from Marks & Spencer.

CYPRUS

The month of February marks the end of the rainy season for the country of my birth, and we are just three weeks away from the start of the Great Lent. Throughout the Mediterranean island of Cyprus, Greek Cypriots will soon begin their five-week cleanse in preparation for the Orthodox Easter celebration. Knowing that my stay in Cyprus is booked solid with appointments, I arrive the day before my meetings begin to visit my beloved parents, whom I find in the process of cleaning the house.

"I will hire someone to do this for you," I say, not wanting them to work so hard.

"We are preparing for Easter; this is not work, it's our duty as Christians," my mother says. Every Greek household, in addition to fasting, cleans out

their home to create a pure environment in which their recommitted souls can dwell. The celebration of Easter is a time of tradition and rituals, reflection and recommitment to our faith.

"Please, bring the children to Cyprus for Easter," my father says.

"They must learn our traditions," my mother adds while my father whispers to me, "It will be good for your mother." His comment lets me know that her spirit needs lifting.

In truth, my children have been raised in the Netherlands with other traditions and rituals, quite different from their Greek Cypriot ancestors. As much as I would like to return with my family so that they may experience Orthodox Easter, it is not feasible to do so this year. The Dutch school holiday schedule extends through the Greek Orthodox Easter, which makes it very complicated for us to celebrate it in Cyprus.

I long to be able to walk my children through neighborhoods of my childhood so that they may know the rich traditions of my own upbringing. The border is closed to the occupied area. We can't return to the Saint Barnabas Monastery near Salamis or drive to the village of Mandres nestled in the foothills near Mount Pentadaktylos where my extended family lived and where we spent many weekends and held Easter celebrations.

The Saint Barnabas Monastery was taken over by the Turks during the war and turned into a museum in 1992 that remains off-limits to Greek Cypriots. I have heard from Turkish Cypriot friends that the monastery of Panagia Tochniou in Mandres has been completely desecrated and turned into a stable for animals by the Turkish military.

My children are unable to walk in the footsteps of their mother's memories. They will never experience the unity of a small village like Mandres celebrating the resurrection of Christ, or be able to witness the locations where I practiced the traditions I was raised to follow throughout Holy Week. War and continued occupation prevent me from sharing with the new generation all that molded me into who I am.

Watching my parents prepare the house for Easter reminds me that what we have lost will never come again. I can tell my mother is troubled, so I lure my father into the yard under false pretenses.

"Is everything okay with Mom?"

"Every Greek is talking about the icons now. We are very proud but we also fear for you."

"You know how everything is politicized in Cyprus. There is nothing to worry about. The archbishop stands with me."

"Tasoula," my father says in a concerned fatherly tone, "be careful."

I dial the archbishop's number.

"Your Beatitude, good evening to you. May I bring my parents along to our lunch? It would mean the world to them to meet you." The archbishop graciously agrees and invites us to come to the palace. This is a lifelong dream for my mother, who is devoutly religious. To be able to dine with the leader of the Church, whom they normally see only on television, is a great honor for my parents.

As the archbishop welcomes us into the palace and my parents enter his world, they are drawn away from the past and into the present. The archbishop invites them to join him at services on Holy Saturday, the Day of Resurrection. To watch my parents find joy in this moment is a gift to me.

⁓

Back in Nicosia, meetings with Kyprianou, Papageorgiou, and Polak are long but very productive working hours.

"The records document the four icons before they are restored," says Polak.

"We need to find who restored the icons so that we can explain to the court why the four icons look different than they did before the war," says Papageorgiou. He shows photographs of the icons, front and back, to establish that they are signed and also to show what the natural wood pigment looks like.

Part of the information I must gather involves UNESCO between 1974 and 1978 having to do with Jacques Dalibard, the Canadian scholar who was sent to investigate claims by the Greek Cypriot government that cultural properties in the Turkish-controlled areas were being systematically destroyed. These documents establish the conditions of the island at the time, so the Dutch court can have a clear picture of the circumstances the Cypriot government was facing.

THE HAGUE

On a tip from Van Rijn, I telephone a restorer in London. Van Rijn had sent the four icons from the church of Antiphonitis to be restored before Dergazarian sold them to the Lans couple in 1978, which is where they were cleaned. I reinforce to the restorer that any information he can provide me will help us in gaining possession of the icons and that my government is not interested in prosecuting anyone. The Lanses argue that there is a difference in the condition of the icons in the photographs presented by the Church from their current status. Their attorney argues that the icons in the photographs are not identical to the ones in their possession.[3] Once Brown confirms the condition in which he received them, it will be clear that they are indeed the same artifacts. Our witness hearing is postponed until the beginning of May.

Moving back and forth between two cases from two different countries has my head spinning. I ask a Japanese friend to speak to the college in lieu of an attorney in the hope of steering the situation away from the courts. For a moment there is a ray of hope when, through the facilitator, the college conveys their willingness to return the Royal Doors without compensation if they receive a direct request from the archbishop. I send a letter from the archbishop along with one from the president of Cyprus, but the university goes back on its word.

I then reach out to Asahi Broadcasting, which is in the process of producing a television special on the Royal Doors, to see if they are willing to help me find a sponsor, a company or individual who might be interested in receiving good publicity in return for funding the college's return of the doors.[4] If these events are not enough to liken this situation to a three-ring circus, the "Turkish Republic of Northern Cyprus," which is only recognized by Turkey that continues to occupy Cyprus, has the audacity to put a claim on the Royal Doors as their property just as they did with the Kanakaria mosaics. However, the onset of spring fills me with hope that these legal setbacks will be temporary.[5]

❧

May marks festival season in The Hague. The city streets become alive with outdoor entertainment while Polak presents witnesses for the Church in the Lans case inside the courtroom. Mr. Papageorgiou, the director of antiquities for Cyprus, takes the stand. His quiet, unassuming demeanor and his compact size do not reflect the power of his stature. He makes a brilliant presentation about the icons from the church of Antiphonitis. From their historical significance to the meaning they hold for the people of Cyprus, everyone in the room is riveted. He closes by describing how he visited the church just weeks before the invasion in 1974, and demonstrates how he personally examined the icons and marked them with pieces of cotton wool to show where they needed to be restored. At the closing of our witness hearing in the Lans case, the court rules that Jan Fred van Wijnen does not have to reveal his journalistic sources to the Lanses' attorney, and international journalists everywhere celebrate.

The Church's case, in summary, is that the Hague Protocol says that any cultural property illegally removed from an occupied area and found in a territory that is party to the convention must be returned to the country of origin. If the court does not accept this argument, the Church will invoke the laws of Cyprus, which require that a registered dealer be involved in the sale and that an export license be issued for the artifact in question. The fact that neither requirement has been satisfied plays into our claim that the Lanses made a bad-faith purchase of the icons. If the court does not accept this, then Mr. Polak will call upon Dutch law, which states that the Church has twenty years to claim the icons if they were purchased in bad faith. The Lanses receive an extension until mid September to respond to the "*nadere conclusie*" (further claim), which, thankfully, helps relieve some pressure on me at home.[6]

In the interim, we consider initiating a lawsuit against Dutch dealer Robert Roozemond; selling the doors to the Kanazawa College of Arts in Japan interferes in the Church's ability to reclaim their ownership. Mr. Papageorgiou informed Roozemond way back in 1990 that the Royal Doors in his possession were stolen from the church of Ayios Anastasios in Cyprus. Roozemond, according to our records, ignored that information.[7]

June roses are in bloom, a reminder that summer is approaching. I sip my morning coffee flipping through the pages of the *De Volkskrant* newspaper and come across an article written about Van Rijn calling himself "Robin Hood." The writer phoned me a few days ago asking for a comment.[8]

"If Mr. Van Rijn is a real Robin Hood, he would just tell the Church of Cyprus where our cultural treasures are, particularly the mosaic of Apostolos Andreas," I say.

In the photograph of Van Rijn, he is dressed to the nines, wearing a Panama hat. He reminds me of a proud peacock in the act of displaying its feathers. Minutes later he makes a surprise appearance at my office. This is highly unusual and probably means he wants something. Van Rijn is wearing the same Panama hat he wore when he was photographed for the article.

"You won! I will lead you to Andreas and the rest of the Cypriot treasures."

"You are so full of it," I say.

"Seriously," he replies as he invites himself to sit down in a chair facing my desk. "Your treasures are hidden in Germany and they're going to be sold any minute now. If I don't step in, someone else will. I need a million and a half dollars to purchase them."

"Is Dikmen the supplier?" I ask.

"He might be one of them." As I eye him closely to see if he is lying or not, he adds, "I can't say."

"I need to know if you are planning to buy from Dikmen," I say, shaking my head adamantly. All I know about him is what Van Rijn tells me. I dream of the day when I can sit face-to-face with Dikmen and ask him why he did what he did. I respect his culture and I want him to respect mine.

"Listen, Tazulaah, Dikmen has a piece of practically everything that came out of Cyprus but, as you now know, multiple dealers could also own percentages of it. There is a rumor that a large inventory of artifacts is about to be moved from Munich to Turkey.[9] If this is true, someone may be looking to unload what they have quickly."

"I'm not interested in buying anything from Dikmen."

"I don't know who is selling what! This is your last chance to get the Andreas and to score a large quantity of your stolen artifacts." His tone softens

suddenly. "I need this just as much as you do. I don't want to be portrayed as a suspected criminal. I want to do something good in the eyes of my father," he says. "Get back to me quickly," he says as he makes his exit.

"Nice hat," I comment, holding a slight smile. "I think its more Indiana Jones than Robin Hood, though."[10]

Van Rijn's proposal might be the perfect way to get off the repatriation treadmill I find myself on, trying to recover one sacred artifact at a time. It could be an opportunity to turn the tables on the dealers and have Andreas within my grasp. All of these possibilities call me to view Van Rijn's proposal seriously. The problem is that, in order for me to act upon this information, a deal must be struck with a devil.

Eighteen

NOT SO FUNNY BUSINESS

The Greek philosopher Aristotle said, "There is only one way to avoid criticism: do nothing, say nothing, and be nothing."

Neither the Church nor the government can embark on buying looted art because it will compromise our existing cases and fuel the trade. There are many situations in which we know that artifacts are of Cypriot origin but we cannot prove which church they were removed from, as our records are inadequate and these items are traded daily around the world. How do I get them back? I ask Polak if the Church is allowed to buy the artifacts back legally, and his answer is yes. However, it would be a public relations disaster.

Thinking about an alternative solution, I envision a telethon to raise funds to recover these looted artifacts that are impossible to win via legal routes. If there is any truth to Van Rijn's offer, money raised this way could be used to finance the purchases. The telethon could be an opportunity for we the people of Cyprus to build our future on the ruins of the past.

The logistics of getting proper governmental approvals and licenses for such a telethon will be arduous, but it is an idea worth investigating. In Holland, I would need approval from the Central Bank. The process in Cyprus is

unknown to me. These thoughts occur just as I lie down to sleep. Unable to turn off my mind, I rise to send a quick handwritten fax to the archbishop. Knowing that President Glafcos Clerides of Cyprus will be coming to the Netherlands, I ask for an appointment with him to present the idea and to bring him up to date on Van Rijn's latest offer.[1]

I am bombarded with phone calls from diplomats and journalists trying to schedule time to see me in Amsterdam when the president of Cyprus arrives. I call Ambassador Zenon to inquire as to what my role will be as honorary consul.

"There is no role for you during the president's visit. I have everything in order," he says.

"Won't I even greet him at the airport?" I ask.

"No need for that," says Zenon.

I inform the archbishop that the ambassador will never permit me direct access to speak to the president while he is in Amsterdam. The archbishop tells me he will make the arrangements himself.

On June 20 I write to Ambassador Zenon to formally request a half hour of the president's time in order to update him on the recovery efforts in the Netherlands and to pitch him on the telethon idea.[2]

"I'm afraid there is no room to accommodate your request for a meeting. What is so important that you can't tell me?"

"Alecos, you asked me to separate my two jobs. Anything to do with the repatriation of artifacts I do as a representative of the Church. This is a Church matter, which I wish to share with the president and the archbishop. As a representative of the Church, I do not report to you. That's what we agreed."

"You will do nothing without me. If you cannot tell me what it is so that I present it to the president, you will not see him," replies Ambassador Zenon.

Michael witnesses my struggle with Zenon and my shame in having to tell my peers that my ambassador sees no need for my presence. He devises a solution and surprises me with tickets to Wimbledon in London the day after the president's arrival. Going to Wimbledon is a great excuse to avoid the embarrassment I would face with my peers because of Zenon's actions.

"When people ask you why are you not attending, you can tell them that you have VIP tickets to Wimbledon to watch tennis instead," he says. "That's a good enough reason, darling, isn't it?"

His thoughtfulness is beyond sweet in this moment. Fate strikes. The match we are scheduled to attend is postponed due to rain. Michael and I had cleared our calendars but had not left for London yet. I receive a telephone call from one of the president's assistants in Amsterdam.

"Madame Consul, the archbishop and the president spoke and the president would like to see you this afternoon at four. Will you be able to make the meeting?" he inquires.

"Of course. I will be there," I say, quite surprised.

All Michael can do is shake his head and hand me the keys to his car, as mine is a mess from the kids.

In an hour I arrive at the Hotel de l'Europe, a five-star luxury palace built in the nineteenth century overlooking the Amstel River in Amsterdam. I stop at reception desk and ask the attendant to park my car and call the president's suite.

A Greek Cypriot man standing next to reception introduces himself as one of the president's guards.

"There has been a misunderstanding. The president cannot meet with you at this time. Come we will have a drink at the bar," he says.

"I don't understand. We have an appointment?"

"His schedule changed."

"Excuse me, I am not the type of woman to hang around bars! Where are the ambassadors from Brussels and The Hague?"

"How do you know these people?" he asks, sounding concerned.

"I am the honorary consul of Cyprus in The Hague, they're my colleagues."

Looking shocked, he says, "I'm so sorry. I don't want to be involved. I didn't know that you are a consul." And he walks away.

As I pass the lobby bar, I see two of my colleagues and friends from the Embassy for Cyprus in Belgium, ambassador Michalis Attalides and press officer Dimitris Komodromos. Attalides volunteers to place a call to Ambassador Zenon. His expression causes my heart to sink.

"I see," he says. "Yes, I'll explain it to her."

The ambassador turns to me and says, "There has been a misunderstanding. It is probably best that you leave."

"What is going on?" I ask. "Who telephoned me and asked me to meet with the president?" He just stares at me, unable to comment on what he knows.

I dial Ambassador Zenon on his mobile phone.

"Alecos, where are you?"

"In Amsterdam," he replies. "I'm out in a restaurant dining with the minister of foreign affairs."

"Well, I was asked to attend a meeting with the president."

"I have no knowledge of this, its not on the schedule," he responds.

"Can I wait for you to return?"

"No, I'm afraid I'm busy until very late tonight. I will see you when I return to The Hague tomorrow," he says, and hangs up.

Humiliated, I brush the tears out of my eyes as Attalides and Komodromos kindly comfort me. I can tell that they are equally embarrassed, which makes it worse. Outside the hotel, as I wait for my car to arrive, I run into the ambassador's driver, making his way into the hotel. He is a lovely man whom I actually recommended for the job.

"How are you, Christos?" I ask.

"Delivering cigarettes for the president and his crew upstairs," he replies.

"Have you seen the ambassador and the minister of foreign affairs?" I ask.

"They are on the second floor having drinks. Come, I'm going there," he says.

Meanwhile, Komodromos comes to check on me.

"Are you okay, Tasoula?" He leans in close to me and whispers, "Zenon blocked your appointment. You didn't hear it from me. Please give my love to your family."

I retrieve my car from the valet. I'm so upset that I can't find my way out of the one-way roads and the canals surrounding the hotel. Fifteen minutes later I am right back where I began, facing the hotel again. In the distance I see the ambassador and the minister of foreign affairs from Cyprus walking with several other diplomats. I slouch down in the car to prevent anyone from seeing me.[3]

Speeding out of Amsterdam, totally distraught, I stop a few miles away and accidentally fill up Michael's sports car with diesel fuel. Minutes later, on the highway in the middle of nowhere, I feel the car slowing down, so I steer it out of harm's way to the side of the road where it dies. People stop to help me and I burst into tears, unable to communicate a word.

"Are you okay?" a concerned man asks.

I ask to borrow his phone, which I use to call Michael.

"I'll get there as soon as I can," he says.

I'm in the midst of having a full-blown panic attack. The first one I ever experienced occurred during the war. I remember the vibration of the ground as the shell exploded and the dampness of the earth made it into my nostrils and lodged itself in the back of my throat. The feeling that I was going to die any moment is also with me now.

When Michael finally arrives, I weep in his supportive arms.

"I never want to see that man in our house again," he says.

꙳

Preparing breakfast for the children the next morning I notice a missed call and check my voicemail. The sound of the archbishop's voice is heard.

"How was your meeting with the president?"

The phone rings and I pick it up thinking it's the archbishop but it is Zenon.

"Tasoula, hello, what a terrible misunderstanding," he says. "I didn't know that you were coming to Amsterdam."

"Alecos, save your performance. You no longer exist for me from this moment onward." I say as I hang up the phone.⁴

꙳

Even a beach holiday in the Peloponnese cannot remove the weight of the world from my shoulders. The olive trees are abundant in Kalamata, an area famous for the best tasting olives on the planet. The olive tree itself is the symbol of peace, but there is no peace within me right now. The

responsibility of managing multiple court cases, Octagon, and the escalating costs surrounding the repatriation efforts are drowning me.

Michael, Andreas, Sophia, and I are alone in a gorgeous rental house by the sea without the normal caretakers and cleaners. Although taking care of Sophia on our own places additional responsibility on Michael and me, we are desperate for privacy.

My mind relaxes in the rays of the sun as my tired body rejuvenates in the Mediterranean waters that surround the white sand beach. One large suitcase carries Sophia's diapers, food, and medical supplies. She is six years old and her big brown eyes and short brown hair turned golden by the sun make her look like a stunning princess. She only just learned how to walk, at the age of five, fulfilling a dream for me. She looks adorable in the summer dresses I spoil her with. I'm so excited that I don't focus on the feeding tube that dominates her face or the fact that wherever we go people stare but are afraid to inquire about her. It is their looks of pity that I despise. All the books in the world cannot prepare you for what life is like raising a mentally and physically challenged child.

Andreas is having a wonderful time. We bury him in the sand, swim all day, and collect shells at the beach. Every night as we dine out he sits between us. After we order the food, Andreas speaks directly to the Greek waiter.

"Just three plates, please. My sister doesn't eat. She is a special care baby." Michael and I realize that Andreas is accepting responsibility for Sophia in his own way. His studious eyeglasses make him appear older than his seven years. He gathers the leftovers and places them in a napkin.

We dine to the setting sun, retire early, then Michael and I catch up on just being together and falling in love with each other, our babies, and life once again.

When I wake up, I find Andreas outside feeding the stray cats with the leftover food.

"Can I take them with me back home?"

"No, honey."

"Can you buy me a small cat in Holland?"

"We will talk to daddy and see."

Being with the family in uninterrupted solitude is such a rarity, and we enjoy our time together immensely.

That is, until Van Rijn interrupts our vacation in paradise. There is urgency in his tone. He is pushing me to take a position to purchase the stolen treasures about to be sold in Germany. He wants a million and a half dollars to do this deal, and he is insisting that if we don't act on these treasures now, they will probably be lost forever. Over the years I have heard many things from Van Rijn, but his persistence this time leads me to believe that there might be some truth to this story.

My cell phone is ringing over and over again. It's not Octagon calling, so it must be Van Rijn, as the same telephone number keeps trying to reach me.

"Tazulaah, we will lose this opportunity if you don't move on it. I can't wait anymore. My father is dying. I want to clear my name."

"We will be buying from dealers, right, and not possessors?"

"It's two or three people tops."

"I'll be back in a few days and I'll call you," I say.

Michael says, "Tasoula, he doesn't leave you alone."

Van Rijn is proposing to lead me to a large supply of looted artifacts which are under the control of two or three dealers. After what happened in Amsterdam with Zenon, this could be the perfect vehicle for me to make an exit.

Arriving home to the Netherlands, Andreas opens the front door and finds the baby kitten Michael and I arrange to have waiting for him upon his return. He names him Speedy.

Nineteen

IN THE NAME OF THE FATHER

O n the flight to Cyprus I think about the story of Leonidas, the great king of Sparta and my father's namesake. I remember how Dad's face lit up when he shared heroic tales of Greek warriors and how they outsmarted their opponents with great intellect and integrity. As I contemplate the Church's position in the battle against the art traffickers, I realize that I must become one of these warriors if I'm ever going to recover these artifacts for Cyprus. Unless I come up with alternative solutions to deal with the issues blocking my efforts, the odds are against me.

Attorney General Alecos Markides is a man in his early fifties, who carries an air of confidence. He wears exceptionally thick eyeglass lenses, which make him appear studious. His body language intimates that he is skeptical of me, so I do my best to impress him and place him at ease. I wonder if his initial reluctance to help has anything to do with the fact that Mr. Markides has political aspirations. Perhaps he is sizing up my relationship with the archbishop and trying to assess my political clout.

As a woman whose entrepreneurial success is due in part to introducing the concept of the paperless office to the European market, I am astonished by the antiquated way in which the attorney general works. There are piles

and piles of files stacked everywhere the eye can see, many of them seemingly untouched for years, marked by a heavy layer of dust on their surfaces and an odor lingering in the air.

Now I understand why approvals take so long.

Compared to my digitized Dutch company, their methods are from the Dark Ages. Yet there is no shortage of brain power in Cyprus, which places high in the world when ranked by percentage of population earning advanced degrees.

"So you wish to appear on national television and call upon the people of Cyprus to contribute money to repatriate art in cases where we have no legal option?"

"Yes. I believe it will help the Cypriot people heal if they have a stake in rebuilding their future through helping to repatriate stolen sacred artifacts. The legal fees are costly."

The idea of me being the face of the Church on national television seems to disturb him. He questions me about my company, my husband, and my social status. The attorney general ends our meeting requesting that I fax him and Assistant District Attorney Stella Joannides a written copy of my telethon proposal. As I exit his office, he alerts Stella that I am on my way to see her.

Dusty files seem to be an epidemic throughout the building. The hallways are lined with trolleys of more files with men pushing them into different offices. Alecos Markides and Alecos Zenon share more than a first name. Both men are seemingly uneasy around young, independent, assertive women.

Stella's office is quite similar to the attorney general's. She wears shoulder-length blond hair and has long, bright red fingernails. Stella smokes a cigarette from a long cigarette holder, popular in 1940s Hollywood movies.[1]

I do my best to pitch my telethon concept to Stella, but she is more interested in speaking about her own accomplishments, telling me about the various cases she is working on that are in the media. She also keeps mentioning that she is a favorite of the attorney general, and when she's all talked out she ends the meeting.

"Send me your plan, darling, and I will see how I can help you," she says with all of the enthusiasm one might have about getting a tooth extracted.

Entering the Church palace gates, I feel protected by the forces of good. At my meeting with the archbishop, I am greeted with a cold glass of lemonade to quench my parched throat from the sweltering summer heat.

"RIK [the national television channel] and *Phileleftheros* [the Cypriot newspaper] love the concept of a telethon and they will support it. The attorney general is less impressed," I say.

The archbishop disagrees, "Forget about the attorney general and collecting money from the public. The religious artifacts belong to the Church, and the Church will have to pay."[2]

"Van Rijn is asking for a million and a half dollars to lead me to the looted artifacts in Germany. He won't move without cash this time," I reply.

"Do you trust him?" he inquires in a concerned tone.

"Even telling you this proposal, my mind says, is madness. But my female entrepreneurial instincts tell me he will deliver this time," I say with reservation.

"Elaborate on that," says the archbishop.

"His father is dying. He wants to make peace with him before he goes. We need to turn the tables on the dealers. There are approximately twenty thousand artifacts missing and we can't possibly handle twenty thousand court cases. Mr. Papageorgiou is aging, and he is a vital witness for the government because he was director of antiquities just before the invasion. He speaks with conviction, which wins us cases. It's 1997, twenty-three years after the war, and since the burden is on us to prove when the artifacts were taken out of Cyprus, our only reference point is 1974 when the invasion occurred. In these cases the statute of limitations works against us. We need to act now, and be as unorthodox as we possibly can!" I say to the archbishop, who finds humor in my phrasing. "We might be able to recoup a large amount of inventory in one shot."

The archbishop responds, "I share your concerns and agree, we need to approach this unconventionally."

After a sip of tea, I continue, "Here are the risks and how I suggest we mitigate them: I say we let Van Rijn purchase the artifacts with his own

money and reimburse him only after Papageorgiou authenticates them. I'll open a bank account in Rotterdam in the name of the Church and both Papageorgiou and I will be cosignatories. This keeps the financial transactions transparent. We get a minimum list of what we will get for that money and pressure Van Rijn into exposing the dealers involved. We need him to supply evidence to incriminate the dealers. I want to be sure that these artifacts are not coming from Van Rijn's personal stock. He purchased inventory from Dikmen, they did a lot of business together, so this is a good method to safeguard us."[3]

After reflection, he remarks, "Tell him you have only been able to raise half a million. I trust you to negotiate what we will get for that, but I need you to send me a fax, just one paragraph, saying that you request a half million dollars for the bank account. No other details, as it may interfere with the Holy Synod's approval."[4]

"Van Rijn should believe that the money comes from outside investors for your protection as well as the Church's. I'll make sure that I get the maximum value for the money we pay. I'll send you a fax after I've negotiated the details."

<p style="text-align:center">⚘</p>

At the Hotel des Indes, Van Rijn is waiting at our usual table. Instead of the cool, collected guy he usually parades in front of me, he is now clearly anxious, fidgety, and on edge. He seems vulnerable for the first time.

"Did you get the one and half million?"

"What are you guaranteeing me?"

"One sixth-century Thaddeus Kanakaria mosaic and thirty-one twelfth-century frescoes from Antiphonitis."

"That's a rip-off."

"Tazulaah, come on! Peg Goldberg paid one-point-two million dollars for the four mosaics from Kanakaria, and she was going to sell them for five million apiece. This is a good deal for you!"

"She was a fool, as you should know. I secured five hundred thousand dollars from a group of religious investors. Take it or leave it."

"Give me the money."

"You'll be paid when you deliver and Papageorgiou examines the artifacts and confirms their authenticity. I'm asking you to give the Church something for nothing in this deal to prove yourself worthy of our trust."

"I can't buy anything with that kind of money."

I ignore his request for more funds. "Advance it yourself. You'll get your money when you deliver."

"I'll call you when I have the goods," says Van Rijn.

Driving home, I think about the safest public location to have the transaction take place. My bank in Rotterdam comes to mind. The bank manager at my personal bank, ABN AMRO, opens the bank account in the name of the Church of Cyprus with Mr. Papageorgiou and me as cosignatories. I fax the archbishop the account number so that he can transfer funds.

Van Rijn calls me before I arrive home.

"Will you give me half of the money once I deliver the mosaic?"

"Fine," I say. "You'd better deliver, Van Rijn, and they'd better be real."

My last fax of the day is to the attorney general informing him that we are going to enter into negotiation for artifacts with Van Rijn with the aim of exposing the dealers and collecting incriminating evidence against them.[5]

Twenty

THE RETURN

FRIDAY, SEPTEMBER 5, 1997, ABN AMRO BANK, ROTTERDAM[1]

The late afternoon sun begins to fade when I check my watch and wonder why Van Rijn is a half hour late. Waiting nervously with Mr. Papageorgiou, I question whether or not Van Rijn will show, but since there is money involved this time, I am convinced he will. The question I should be asking myself is what antics will he try to pull when he does arrive.

Van Rijn shows minutes later, pale, empty-handed, and visibly shaking.

"You show up late with nothing!"

"Look into my eyes, Tazulaah," he says anxiously.

I look directly into his eyes. "Where is the mosaic?"

"Promise me that you will not arrest me when I give you the mosaic."

He doesn't trust me as much as I don't trust him.

"I need you to deliver more than the Thaddeus, remember? You will not be arrested. Let's get on with this before the bank closes."

"I need to have your word that the police will not arrest me."

229

"You have my word."

"On your honor," he says.

"Don't insult me. You have one minute to deliver."

He exits the bank and walks to a waiting car where the limousine driver hands him a regular cardboard box, the kind you might carry your groceries home in from the supermarket. As he approaches the counter in the bank where we are standing, I feel my body begin to tremble. Papageorgiou opens the box and carefully examines the mosaic of Thaddeus.

I weep at the sight of it. Looking into the eyes of this artifact I recognize the same sadness present within me. We are fellow refugees, adrift in an unfamiliar place, unable to return home. On the inside I am still that broken little girl who is trying to mend her shattered heart. A heart that witnessed the cruelties brought on by a war and injustice while the rest of the world stood idly by. Looking into the face of the Thaddeus mosaic, it is clear to me that it was cut from a wall.

Papageorgiou examines the mosaic under the strain of similar emotions. There is a slight trembling in his hands as he looks carefully at the top and the sides of the artifact. He examines the plaster, scrutinizes the paint color, and places it back in the box.

"It is authentic," he says.

Turning to Van Rijn, I say, "Our agreement is for five hundred thousand American dollars. I will have to pay you in Dutch guilders, so let us agree on 487,500 guilders, which is two hundred fifty thousand dollars at a 1.95 average rate of exchange. We agree and call it a day?"

"We agree," he says.

"I will see you on Monday, same time," I say.

Van Rijn is staring at me, speechless. He has never seen me cry.

"You are just as priceless as what is before you, Tazulaah. I hope the Cypriots appreciate you as much as I do."

Papageorgiou cringes. As Van Rijn exits, he says, "Don't believe a word that comes out of his mouth."

"He is our only option right now."

I load the box carrying the ancient mosaic into my car and drive Mr. Papageorgiou and the sacred mosaic back to The Hague.

"Listen, the pressure on us both is too great right now. I need to take a day for myself. You do the same. Let's collect ourselves over the weekend and meet on Monday," says Papageorgiou, and I agree.

My parents are visiting me from Cyprus so when I return home, Michael locks the mosaic in the basement safe. My parents, Michael and I, and the children enjoy an evening of dinner and bowling. For a few hours, I enjoy my beautiful family, able to push Van Rijn and my search for the looted artifacts out of my focus.

Early Sunday morning I am awakened by the sound of a ringing telephone. I glance at the alarm clock, which reads one thirty A.M., before moving into the living room so as not to wake Michael. It's Van Rijn calling from a hotel room.

"I have the frescoes spread out all around me, all twenty-seven of them. I wish you were here to see this, Tazulaah. They are beautiful, our beautiful babies. Look at what we can do together."

"Twenty-seven? You promised me at least thirty-two!"

"It was a miracle to get these. What do you expect with your shit budget."

"Van Rijn, a deal is a deal."

MONDAY, SEPTEMBER 8

Papageorgiou and I are scheduled to meet Van Rijn later that day at three P.M. at the bank in Rotterdam to receive the frescoes but Mr. Papageorgiou calls me in a panic.

"I've made a terrible mistake. The mosaic is a fake!"

"You were positive on Friday."

Mr. Papageorgiou is the most qualified person to judge the authenticity of an artifact. The panic in his voice tells me that I must act quickly.

"I will have Michael come from work to unlock the safe. If you still feel it is a fake after you examine it again, I will have Van Rijn arrested, so there is nothing for you to worry about. Please, calm down. I'll come and get you."

I call Polak and tell him that we might need an arrest warrant for Van Rijn for this afternoon in Rotterdam if Mr. Papageorgiou deems the Thaddeus mosaic he sold us to be fake. Michael rushes home, opens the safe, and

takes the mosaic out and places it on the billiard table in our basement. Mr. Papageorgiou examines it carefully, and I see a look of relief cross his face a few moments later.

"I'm so sorry. The mosaic is authentic. The stress of this situation is getting to me."

I sit him down in a nearby chair and have the nanny bring us all cups of strong coffee and some cake. I call Polak and tell him no arrest warrant is needed.

The mosaic is real. These are the extraordinary circumstances we ordinary people find ourselves in. Despite my attempts to make everything appear normal, my parents wonder what is going on. I have been trying to keep it a secret from them but I look up and there they are standing at the door watching us. No words are needed. My mother steps forward and crosses herself three times. My father follows. In Greek, they thank God for the opportunity to have this moment with the Kanakaria mosaic. They get down on their knees and pray.

I turn to Papageorgiou and say, "This is why we do what we do." For the first time in two days I see Papageorgiou smile.

ROTTERDAM, PART II

Papageorgiou and I arrive early and have lunch at a small café across the street from the bank while waiting for Van Rijn to arrive.

"I can't believe he's an hour late."

Van Rijn calls me at four P.M. to tell me he is on his way but it is 4:55 P.M. and he has yet to arrive. Two stretch limousines pull up a few meters away from the café. Van Rijn exits one of the cars followed by a film crew who jump out from the other. He appears to be very drunk and giving them an interview. I have never witnessed him drink anything but espresso before, so in addition to wondering why the hell there is a film crew with him, this comes as a complete shock. The burning sensation in my stomach kicks into overdrive. I take one look at this circus before me and run toward the bank. The film crew is now chasing me.

"Madame Consul, show us your tears," the reporter shouts. When he is two feet from me he shoves a microphone in my face and asks, "You purchased a stolen artifact on Friday and you are about to purchase more today. Do you do it as a private citizen, as honorary consul, or as a representative of the Church?"

"Who are you?" I demand to know.

"I'm Peter Watson, a lecturer at Cambridge University making a film for Channel Four in the U.K."

Making my way into the bank, the manager, who is a friend of mine, is anxious about the commotion we are causing.

"Tasoula," says the manager, "I wasn't expecting this kind of disruption. If I don't get you into a private room I will be fired."

"Stop!" I shout to the film crew, to Van Rijn speaking to the reporter, to the men carrying boxes who are now being diverted into a private room.

"Mr. Watson," I say, with authority, "as you can see, I am in the middle of a transaction. If you release your footage you will place me in personal danger and jeopardize the recovery efforts of my country. I will agree to sit down with you on Wednesday to arrange an exclusive interview, but you must keep this between us and agree not to air any footage until we can come to terms." Mr. Watson, thank God, agrees to my request, and he and his film crew put their cameras down.

Mr. Papageorgiou, Van Rijn, and I enter the private room, which is now completely stacked with boxes. As he unpacks the frescoes, I find myself unable to hold back the tears again. They are a very different kind of tears than the ones I shed yesterday.

"I told you they were lovely," says Van Rijn.

"I should have you arrested this very moment!" I am so angry with Van Rijn that I can barely contain myself.

"You swore to me, Tazulaah. You lied!"

"I didn't lie. You will not be arrested, but you should be for pulling this stunt with the press."

"I had to protect myself and prove to you that the supply of artifacts is not coming from me."

"I can't trust you, Van Rijn."

I carefully begin to count the frescoes he's delivered.

"There are only twenty-seven. Where are the remaining four? And what will you be presenting to the Church for nothing?" I ask, holding back my rage.

"I'm good for them!"

"Have you lost your mind? Your actions confirm that you are unpredictable. You're not getting paid until you deliver the final four frescoes. Otherwise, no deal."

"I need money to buy the rest." I hate to give him anything at this point but I know that unless I do, he won't continue.

"I'll prorate your fee 27/31, and that's as good as it gets."

"You can't do this to me!" he screams.

"You are in no position to negotiate. You broke the trust between us the minute you marched in here with a television crew. You've put my life in jeopardy and you're lucky I don't have you arrested."

He gives me the look he always gives me, that of a child being scolded by his mother.

"Come on, give me all the money. I will bring you four more on Wednesday. But I must get paid, Tasoula."

I have the bank pay him the prorated amount in Dutch guilders, and this time I get Peter Watson to sign as a witness when he receives the money.[2] I schedule a lunch with Watson the next Wednesday, and I secretly put Mr. Papageorgiou on a plane back to Cyprus. I can't let Van Rijn know that Mr. Papageorgiou is gone or he will try and sell me a fake.

THURSDAY, SEPTEMBER 11

For my lunch date with Peter Watson, I ask Michael to join us. There is too much at stake right now, and I can use another pair of trusted eyes to evaluate the man.

At the Restaurant Plato, on Frederikstraat, around the corner from my office, I learn that Peter Watson is an author and a research associate at the McDonald Institute for Archaeological Research at Cambridge University.

"I can verify that the artifacts are coming from Aydin Dikmen," Watson says.

Watson takes a sip of his coffee. Michael and I have a quick visual connection, and from it I can tell that Michael believes him.

"Van Rijn is petrified that you're going to have him arrested once you get what you want."

"Do you have the buy on film?"

"Yes. We placed an undercover camera in the suitcase of one of the intermediaries."

"Who are the intermediaries?"

"Two guys, one named Lazlo the other named Veres—Van Rijn's men. Dikmen and Van Rijn have been enemies since the Kanakaria trial. Van Rijn had no choice but to do the transaction through intermediaries."

"Is Van Rijn on the film?"

"No he's negotiating from a hotel room nearby."

"If I need a copy of the film to show my government that the artifacts are not out of his stock, would you give it to me?"

"Yes."

The air feels as if it is being sucked out of the room. Van Rijn was cagey about who he was purchasing the artifacts from when he first approached me because he knew I would decline his proposal if Dikmen was involved. Now I have evidence that he is buying from Dikmen, and it changes everything. I strike a deal with Peter Watson. In exchange for not airing the footage for six weeks, I agree to give him an exclusive interview.[3] Michael returns to work and Peter Watson accompanies me to the bank in Rotterdam as I withdraw money to retrieve the last four frescoes from Van Rijn. I wrap the balance of Dutch guilders owed to Van Rijn in a plastic bag and place them in my purse.

ROTTERDAM, PART III

After Monday's fiasco, the bank has refused to allow us to continue doing business at their premises. Peter Watson and I arrive at the airport to wait for Van Rijn, who is expected to land in a private plane he hired to deliver the final four frescoes. His flight is delayed. When he finally arrives, he is

drunk again and is accompanied by his friend Roger, who owns an antiques shop in The Hague.

Van Rijn is wearing his hat sideways and holding a bottle of champagne in each hand. Behind him, two customs officers in green uniforms follow closely, pushing his luggage, which contains the four additional frescoes. Van Rijn passes thousand-guilder notes to compensate them for their services. These are the moments I wish I had on film.

"Here is the address in The Hague where the exchange will take place. Ralph van Hessen runs a public relations company," I say. "He's a friend."

Van Rijn follows in his limo as Peter Watson and I drive to van Hessen's offices. When we arrive, Watson's camera crew is jockeying for position to film us, but Ralph kicks them out. I count the frescoes and pray that they are not fake. I'm in no position to authenticate them, so I must take Van Rijn's word for it.

"If these are not authentic, you will be behind bars in no time."

"You shake me up, Tazulaah."

"Van Rijn, don't be a drama queen."

He shakes his head back and forth and can't help but to smile.

"You and I are cut from the same tree," he says.

"What tree is that?" I ask.

"You are the soft, beautiful part of the wood and I am the coarse exterior bark. We both have the same passion for Byzantine art, and that is why we are cut from the same tree. Take a look at these." He spreads photographs of frescoes, icons, crosses, and the Saint Thomas Kanakaria mosaic across the table. "Come on, you have to ask the old boy for more money and we can get these."

"So you can put more money in Dikmen's pocket? It wasn't smart of you to film the transaction, you know. Now you either work with the police or my attorney will confiscate that film and I will send both of you to jail."

It is the first time that I see Van Rijn turn pale. "There will be no more additional funds for you. I'm calling the police in to work with us, and you will have nothing to say about it. We will get the rest of the artifacts back from Dikmen, but now you're going to do it my way."

"Are you mad, woman?" he says. "You can't do this to me! I knew I couldn't trust you!"

"You have twenty-four hours to make up your mind. You either work with the police and myself or I will confiscate the footage from Channel Four and incriminate you and Dikmen!"

Van Rijn has a meltdown. "My God," he shouts.

"I've learned from the best, Van Rijn. Isn't that what you always tell me? You are the master and I am the student," I say as he departs.

Ralph van Hessen says, "Tasoula, if you pull this off, I will organize the biggest press conference the world has ever seen." I arrive home exhausted and having stomach pains. Michael helps me place the artifacts in our vault, where they will be held until we can transport them back to the archbishop in Cyprus.[4]

I notify the archbishop and the attorney general that the artifacts have been successfully secured and that in the process I have acquired video footage taken by Channel Four where Dikmen can be heard as the possessor.[5]

At this point I must involve the police. Aydin Dikmen has managed to avoid prosecution by the Cypriot government since 1974, despite the fact that Cypriot authorities believe that he is the mastermind behind the organized looting of churches in northern Cyprus. It's difficult for the career diplomats and civil servants to fathom that an ordinary woman is in a position to bring Aydin Dikmen to justice.

Michael and I get a chance to sit down together to enjoy the rest of the evening.

"You did it," he says. "I'm so proud of you, Tasoula."

The phone rings. It is van Wijnen, the journalist.

"Remember me?" he asks.

"Jan Fred, what can I do for you?"

"I understand that you just purchased a bunch of stolen artifacts from Van Rijn. Would you care to comment?"

The blood rushes from my toes to my face.

"There is no comment," I say. I cannot let him run this article.

"You know that the magazine goes to print tomorrow night."

"Are you trying to get me killed?" I ask.

"I have an exclusive story about the honorary consul of Cyprus purchasing looted artifacts as a representative of the Church from the shadiest art dealer in the world and you think I'm not going to run this?" he says, sounding exasperated.

"You're interfering in government and Church business here, Jan Fred, in addition to placing me and my family in danger."[6]

"I wish I could be more sympathetic to your story. I've known about the Thaddeus mosaic since early July when I saw it in Van Rijn's truck. Don't you think I've held this story long enough? My editor goes to print tomorrow, so you'll have to speak with him."

"My attorney and I will see you first thing in the morning. I suggest you and your editor hold off on printing the story."

⁓

Polak and I arrive at the attorney's offices for the *Vrij Nederland* magazine, located on Van Eeghenstraat, in Amsterdam, where Jan Fred, his editor, and the same lawyer who represented Jan Fred in the Lans case face each other around a conference table. After informing them that Channel Four and Peter Watson have the video exclusive, we are able to negotiate a deal. Jan Fred and his editor agree to hold the story for six weeks in return for daily updates by phone giving them the exclusive inside story as the events were unfolding as well as the right to print the story first.

Returning to The Hague, I think about what a roller coaster ride my life has turned into. Now I must catch up on the other existing repatriation cases. Polak informs me that the attorney for the Lanses is inquiring whether the Republic of Cyprus may be open to supporting them in litigation against Turkey to receive compensation.[7]

Meanwhile, because we now have evidence on Dikmen, the Cypriot police are involved and waiting in my office for Van Rijn, who is a no-show. I reach out to Peter Watson, assuming that he and Van Rijn are together. Peter tells me that Van Rijn is in a detox facility in Phuket, Thailand, also known as "Sin City." I question how much detoxing is actually taking place.

Without Van Rijn's presence, the Cypriot police are forced to leave the Netherlands empty-handed.

I toss and turn at night, wondering if I will ever be able to gain Van Rijn's cooperation to meet the six-week deadline I negotiated with the media to keep the story quiet. If either one of the stories goes to press, it will destroy what I have been working to accomplish for the last eleven years. Will Van Rijn be able to pull this sting off if he is facing addiction problems? Will he disappear to be by his dying father's side? The illicit art trade is tied to other criminal networks like drugs and arms as well as terrorist groups. Yet I continue. There is no time for me to look after myself; my eyes are too fixed on the finish line.

Twenty-One

TESTING . . . ONE, TWO

V an Rijn surfaces three days later and the Cypriot police, who have
only just landed in Cyprus, must now return to the Netherlands.
We meet at the airport to pick up Van Rijn, who arrives drunk and
accompanied by his friend Roger. Van Rijn is in no condition to discuss
anything, so the police and I drop him off at his hotel.[1]

I discuss the evening's plans with Tassos Panayiotou, one of the Cypriot
policemen, of where to go to dinner with Van Rijn.

"He doesn't trust police. He thinks that you're going to arrest him. I
think it might be best if I don't attend tonight. It will give all you boys a
chance to bond," I say.

Being alone with the "dogs" (Van Rijn's nickname for the police) is sure
to keep Van Rijn on his best behavior. It may even keep him sober, which
means he will be in better shape to discuss business tomorrow. My evening
will be spent convincing my husband Michael why it is necessary for me
to accompany Van Rijn and the police to Munich in the morning to plan a
sting operation with the German police.

When I arrive home that evening, the expression on Michael's face tells
me he has been anticipating this conversation all day.

"Tasoula, why must you go? Let the police handle this! You have recovered a safe full of priceless artifacts. Enough is enough!"

"Michael, Van Rijn doesn't trust the police. He will only negotiate through me. I have to be there. This is my predicament."

"You are going to bankrupt your company and we need you with us!" he says. And Michael is right. My company is in serious trouble because I have allocated all of my time to the recovery efforts. My business needs me, my family needs me, but it will all have to hold on for another few weeks until I put Munich to rest.

"Most importantly, I'm concerned about you. You can't keep food down, you're pale, and you have big bags under your eyes. Does this mean so much to you that you are willing to sacrifice your health for Cyprus?"

"I will never be free unless I finish this, Michael."

"I'm trying to understand, Tasoula. It's not easy for me. What about my niece's wedding coming up? You're the matron of honor, for God's sake."

"I'll plan around it," I say, hoping to calm him.

"Do you realize it's been five years and you haven't been able to get pregnant because you are constantly in a state of stress!"

"Let me finish with this! I promise you I will focus on getting pregnant after Munich."

MUNICH, SEPTEMBER 28

The police, Van Rijn, and I take a commercial flight to Munich. Van Rijn insists that I sit next to him on the airplane.[2] He is petrified about landing in Germany. His entire body is quivering as he grabs my hand and he tells me about his Jewish descent.

"My mother is a Jew. The Germans must have a file on me, Tasoula. This doesn't feel right. Promise me you won't let them arrest me."

"You are not going to be arrested. The German police work with us, not against."

"Look at how Tassos stares at me. Sooner or later he's going to come after me, too." Van Rijn is paranoid.

"If you cooperate and give them Dikmen and the other dealers, you will be the only dealer who remains a free man."

"No information until you secure my freedom with the Cypriots and the Germans. You must call my father now or I won't help you."

This is typical behavior of Van Rijn. He goes from thinking I'm the best person in the world to threatening me in ten seconds. Van Rijn's father never approved of his lifestyle, and Van Rijn is desperate to heal their tumultuous relationship.

"Lead me to the treasures and Dikmen, and I will sing your praises to him."

The tense lines in his face ease up. His expression softens.

"I already told my father about you. He will never believe I turned my life around until he hears it from you."

The irony that fate has forced us to be interdependent on each other challenges us to also face our fear of trusting each other.

"I asked you to give the Church something for nothing, Van Rijn. Am I speaking to the wind?"

"I have something for you that I think you will like. You will have to wait and see, Madame Consul."

"How much of the money I gave you actually went to Dikmen?" I ask, believing he paid a lot less for the artifacts than the half million dollars he received.

"My men and I had a lot of expenses. Plus, I'm paying them and we have been working on this for months."

"Show me you are that reformed man you say you are."

The plane touches down on German soil. Peter Kitschler, who is in charge of the Bavarian police, is waiting just outside of the customs area. Looking through the glass doors into the waiting area, Van Rijn says, "That tall man, he's your German dog."

His innate radar can spot the police in a crowd. Kitschler escorts us to cars waiting to transport us. Tassos and I will be staying at one hotel with Van Rijn and Marios (the other Cypriot police officer) at another.[3]

At the last minute, as soon as the two Cypriot policemen get into their car, Van Rijn pulls me into the car that is transporting him and Kitschler. This leaves the Cypriot police in a bit of a panic, because they are supposed

to be protecting me. Van Rijn and I are dropped off at his hotel. The Cypriot police are dropped off at my hotel and arrive a half hour later, embarrassed that Van Rijn managed to put one over on them.

The champagne is flowing into Van Rijn's glass as he stands next to a grand piano in the lobby singing off-key and dedicating love songs to me. I'm surprised how quickly he becomes inebriated.

There is a bit of a Madonna complex in his view of me, I worry what the police must think. This professing of love is a new gimmick, and I don't buy it for a second. He's putting on a show for these gentlemen to undermine me in their eyes so he can set himself up to manipulate them. I can spot one of his schemes from miles. For now, though, he still needs me.

Van Rijn is too drunk to find his room so the police and I determine that Marios will stay in the room next to Van Rijn with a connecting door for easy access should he need it. I stay at a different hotel with Tassos, and we agree to meet for breakfast the next morning.

The next day is like a bad dream from which I can't awaken.

I'm asleep when the phone rings.

"Good morning, trouble for breakfast," Tassos says. "Van Rijn is missing from his hotel room."

Without a chance to wake up to a sip of coffee, I jump in a taxi with Tassos and head for Van Rijn's hotel, where Marios is waiting anxiously for us to arrive.

"When I put him to bed last night he was ossified. I had to lock him in his room for his own safety."

"You had the adjoining room. You didn't hear anything?" I ask.

"Not a peep! The front desk said he phoned them at around three A.M. and asked for someone from reception to come up and unlock his door. He advanced himself three thousand Deutsche marks from the credit card that secured the room."

"What! He took three thousand DM ($1600) from my credit card! I'm the one paying for this!"

We try to speculate about what could have happened to Van Rijn. Did he commit suicide due to the pressure? Did he hurt himself in an accident because he was so drunk when he fled?

We return to Van Rijn's room and find his luggage is there. We are even more worried now. It is nine A.M. and Tassos and I continue on to meet with Kitschler at police headquarters. We leave Marios behind in case Van Rijn returns.

The Polizeipräsidium München is a series of connecting buildings built in 1975, and the headquarters of the 7,100-person Bavarian police force. Peter Kitschler quickly leads us into a private room to begin our talks.

"Peter, Van Rijn has disappeared. His luggage is still in the room."

"The beer festival is going on in Munich. Let me send my men there. He probably fell asleep in a ditch, given how smashed he was last night," Kitchler says.

"We need Van Rijn here, so let's focus on finding him," says Tassos.

"We are aware of Dikmen," says Kitschler.

"So you know he trades in the illicit arts?" I ask.

"Van Rijn's book says that, but when we checked a few years back we found nothing in Dikmen's apartment."

"You did a search already?" asks Tassos.

"We followed the Kanakaria case in America and our Central Tax Office taxed Dikmen on the sale of the mosaics. We catalogued his assets to auction them to pay his bill but we found no significant art in his apartment," says Kitschler.

"Peter, they tax him for what he sells, but you don't prosecute him for selling looted art?"

"Neither the Cyprus government nor the United States authorities asked to extradite him for prosecution," says Kitschler.

Kitschler follows us back to Van Rijn's hotel room where we are joined by Siemandel, Kitschler's number-two man.

"What will we do with his luggage?" I ask.

"You can turn it over to us. You can also press charges against Van Rijn for taking the advance on your credit card," says Kitschler.

"If I hand over his belongings and press charges against him, we can forget about him collaborating with the police. The bags have to stay with me."

"Fine," says Kitschler.

"If I am to take this luggage back to Holland, I want to know what's in it," I say. "Let me open it in front of you. God only knows what he has in there."

Opening Van Rijn's luggage gives me a sad insight. There are clothes, packed not so neatly, tiny little presents for his kids, and lots of photographs I've seen before of stolen artifacts that he says are in Dikmen's possession.

The Cypriot police and I split at the airport. They return to Cyprus, I head for the Netherlands. My final humiliation is having to pay for Van Rijn's overweight luggage.

I soon learn of his whereabouts when he calls me from Curaçao. On the one hand I'm angry because of what he just put me through, but I am also relieved that he is alive.

"I'm in a bad state, Tazulaah. I can't go through with this until I am detoxified."

"Time's almost out. It's now or never for us both. Jan Fred van Wijnen and Channel Four are calling daily. We have a drama but no story."

"I'll call you from London," says Van Rijn.

I'm completely disgusted and wondering why I don't walk away from the whole situation. My tolerance for Van Rijn's antics is running out. Another week passes before Van Rijn's friend Roger leaves a contact number for me to reach Van Rijn. After several attempts Roger answers the line but he is drunk and vulgar and I hang up on him. Minutes later Van Rijn calls, apologizing.

"I'm sorry. You are a gracious lady and I never intended for you to hear all that," he says.

"Your behavior is unacceptable. Munich offended me. It just isn't right," I say.

"I'm sorry, Tazulaah, but when I woke up and found my hotel door locked I thought that the Cypriot police were in the process of arresting me. I had to flee."

"And the three thousand Deutsche marks ($1600) on my credit card? How dare you do that!"

"I'll give it back to you, I swear, Tazulaah. The Cypriot police scare me. I don't trust them."

"Van Rijn, If you can't trust me, then we can't go on."

"It's not you. It's your people that I don't trust. My intermediaries and I have to be guaranteed immunity from Cyprus, Germany, and the Church. I want it in writing, signed by lawyers, and it has to be ironclad; otherwise I will not do this. Do you understand?"

"Loud and clear."

"Give me time to clear my head, Tazulaah. When I come back to you next, be ready to go. I'm sorry for what I did back in Munich. You didn't deserve that. I need you to take care of the immunity. I have to know that my men and I will not be prosecuted."

"You'd better take measures to sober up, Van Rijn. I have Jan Fred van Wijnen and Peter Watson breathing down my neck ready to release the story because my extension is almost up. Do you want it to be a story of a hero or a fiasco?"

"Tazulaah, one other favor to ask, please, call my father now?"

"No, absolutely not, Van Rijn. A deal is a deal. You come through with your part of the bargain and I'll come through with mine. You might think about spending some time with your father instead of pouring your energy into the bottle."

A few days later, he calls. "I'm ready," he says.

This is my best and I fear last chance to recover a large quantity of stolen artifacts from Cyprus and expose the illicit dealers to the world. As I head into uncharted territory, I make peace with myself knowing I do what I do for Cyprus with pure intentions. As exhaustion leads me to slumber, I pray: *please let this be the finish line for me. I don't want to dance with this devil anymore.*

Twenty-Two

CAPTURING THE GOLD

And now, dear reader, you know the story of how this all began. I return you to the day of the sting, October 8, 1997, when seventy Bavarian police are in the midst of raiding Aydin Dikmen's apartment in Munich. The intermediaries acting on Van Rijn's behalf are in the process of fleeing Munich (with the exception of Lazlo). Van Rijn is screaming at the police, and I am feeling like a complete failure because the stolen inventory I thought was in Dikmen's possession is nowhere to be found. Even the artifacts presented to the intermediaries just moments before the police burst onto the scene are missing. Aydin Dikmen, in true magician style, somehow managed to make the stolen inventory disappear. But this is not the end of my story. It is the beginning of another.

HILTON HOTEL, MUNICH

Van Rijn is screaming at Peter Kitschler over the phone.

"I know the Turk! The artifacts are hidden in plain sight! Break open the floors. There must be double ceilings and false walls! Come on! You are the police, for Christ sakes!"

What the hell is going on? Is Van Rijn lying, or are the police incompetent? I run to my purse and take a drink of my antacid medication, wondering if it's possible for the pain in my stomach to worsen. Everything is riding on securing these artifacts.

"Listen," says Van Rijn, "I'm coming there to look." He turns to me and says, "These policemen are fucking useless!" Luckily, I catch the phone he throws in midair. He kicks the chair as if it were a soccer ball. Kitschler is firm. "Tasoula," he shouts into the phone. "Control him. He can't come to Dikmen's apartment. Keep him in your sights."

"Idiot dogs! Couldn't find a bone if it was stuck up their ass!" says Van Rijn.

His face is bright red. He's going to have a heart attack. He turns to me apologetically.

"Excuse the language, Tazulaah," he says, still trying to pretend he's a gentleman.

Then, like the sound of birds singing after a summer storm passes, Peter Kitschler interrupts Van Rijn's rant with the sweetest words.

"We got it."

The police break through one wall to find a false wall, and behind that they find cartons of priceless artifacts. Another group of officers is pulling up planks of floor boards and finds artifacts stashed underneath. The police poke the ceiling and listen for hollow sounds. They pull a tile down, and there is an artifact hidden in that location. One by one, the police pass the cartons of artifacts they find in the apartment down to a line of waiting officers who carefully store them. Some of these priceless sacred pieces of art are wrapped in newspaper and others in pieces of fabric.

There is no question that Aydin Dikmen is who we believe him to be, as the police find photographs showing how Cypriot church walls were stripped and diagrams showing the location of where the mosaics were to be cut. Van Rijn and I are both on separate phone extensions listening as Peter describes the discovery process. Unfortunately, there is no picture of Aydin Dikmen extracting any of the frescoes and mosaics. There are no faces in the photographs to prove who is stripping the churches. This alone limits us to accusing him of selling looted art, because we don't have

evidence that he has looted the art. Van Rijn is still screaming at the police over the phone.

"He has another apartment! Check the basement! Look for keys!"

He turns to me, looking really excited now.

"It's Christmas, woman. We did it!" He roars like a lion and grabs me to kiss me on the cheek. He is so proud of himself and thrilled to have found the artifacts. He turns his attention back to the police on the phone.

"There is another flat and a shed. Did you look in there? Dikmen probably has goods stashed all over Munich in different locations. We have to get to his supply before his people do."

"Tasoula, tell him to calm down. We have it covered."

"Peter, fantastic job! Thank you, on behalf of the church and the government but especially the people of Cyprus."

"We went in with Special Forces and no one was harmed in the process. It went better than we thought," says Kitschler.

<p style="text-align:center">⌘</p>

Before leaving for the airport to pick up the Cypriot police, who had just arrived, I write a note to the archbishop and the attorney general telling them that our mission is accomplished. I also remind them we have a media freeze until our contracts with Channel Four and Jan Fred van Wijnen are honored.

Remembering that it's the weekend, I call the archbishop.

"Have you read the fax?" I ask.

"Amazing! But your voice sounds different; are you okay?"

"I'm fine," I say, but I'm really not. The tears are running down my face. I'm so exhausted, and torn up inside from the strain and stress, I fear I might collapse.

"Tasoula, I'm worried about you. What is the point of Cyprus winning its treasures if we lose you in the process?"

Some people misinterpret my drive as a characteristic of being unfeeling, but the archbishop sees through the mask I wear to protect myself.

<p style="text-align:center">⌘</p>

In the back of a car provided by the Germans, I take a deep breath, probably my first since I started this venture eleven years ago. I telephone the attorney general on his mobile phone to tell him personally that the sting was a success. Having the top man of the church and law enforcement behind me places this work above any politics, which is exactly where I believe it should be.

Herman, my bodyguard, and I are already in the car when Van Rijn enters, wanting to join us on the ride to the airport to meet the Cypriot police who have just landed.

"Ah, yes, the Cypriot police arrive just in time to collect the credit for a job they didn't do," says Van Rijn.

"Be nice. It's not their fault they couldn't get a flight here earlier," I say.

"Tazulaah, if it were you in that position, you would have walked here!"

"Everyone is safe and in one piece and Dikmen is behind bars. What could be better?" I say.

⁘

Taking Van Rijn's directions, the police enter Aydin Dikmen's prison cell and find a key in his pocket. It leads to a cellar door in his apartment house, and they recover several more cartons of artifacts hidden throughout the three rooms in the basement. Back at Dikmen's apartment, they find another set of keys that lead them to a shed. All told, they gather up more than five thousand artifacts from Cyprus as well as other countries like Greece, Peru, Germany, and Russia, to name a few. Aydin Dikmen invokes his right to remain silent and says nothing while in prison.

⁘

Both Tassos and his partner Marios appear weary from the long journey.

"Nice of you to finally arrive," says Van Rijn. "Just in time for the celebration!"

The police are ecstatic, slapping each other and giving Van Rijn high-fives as they hear of Dikmen's capture. This is a moment for me, for them,

for all of Cyprus. Once we are in the car, Tassos wastes no time in calling the chief of police in Cyprus.

"We did it," he says in Greek and rattles off the details that we gave to him as if he witnessed them firsthand. Van Rijn, understanding a little Greek, smiles.

HILTON HOTEL, MUNICH

It feels like a dream. Two feet away stands Arnold Schwarzenegger and to my left is Cindy Crawford, the supermodel, and she's talking to another celebrity. Hollywood has coincidentally descended upon our Munich celebration as they attend a party for Planet Hollywood. In my mind we are the true stars tonight.

Van Rijn, Tassos, Marios, and I are sipping champagne, celebrating Dikmen's arrest among all of the celebrities. Today is the most surreal day I've ever known.

Van Rijn makes a toast. "None of this would have happened without you, Tazulaah."

I smile and say, "Listen, you and I had the help of many to pull this off, but the bottom line is, you would make James Bond proud."

"We should call your father," I continue.

Van Rijn looks at his watch. "Tomorrow, too late now," he says.

With that, he smiles and toasts my glass. "To Cyprus," he says.

Van Rijn's phone rings.

"Jan Fred," he says. "We did it and we are celebrating with Cindy Crawford and Arnold Schwarzenegger."

"You're drunk," says Jan Fred. "Give me to Tasoula." He passes the phone.

"He's seeing stars, Van Rijn, he must be wasted," Jan Fred says.

"He's actually telling the truth this time."

"Are you both high?" asks Jan Fred.

"High on the way things turned out, yes!" I say. "You can run your story in next week's edition," and I bid Jan Fred a good night.

Van Rijn turns to me and says, "That's good for Jan Fred."

"Channel Four is airing their program Monday night," I remind him.

With the media about to descend, I feel exposed in Munich. I don't want my face or name to be known until I'm safe at home.

"Listen, woman," Van Rijn says, in a very drunken state, "one day you will become the president of Cyprus, and I will be so proud because I know I was the builder. It was me who made you."

"This drunken talk means it's time for me to go to bed. Good night, gentlemen."

"Hey, when you are president, will you give me a casino license?"

"Sure," I say in jest. I retire to my hotel room to end the longest day of my life, not realizing at the time just how dangerous one word can be.

∾

Arriving at police headquarters later the next morning, Peter Kitschler escorts Van Rijn, the Cypriot police, and me into a room where the recovered artifacts are held. Tassos and Marios are all smiles as photographs are taken for the Munich press release. Frescoes, icons, mosaics, bibles, coins, chalices, and other sacred works are stacked almost to the ceiling. It is awe-inspiring.

The sixth-century mosaic of Saint Thomas from the church of Panagia Kanakaria stands out among all these other treasures. Many of the frescoes, a few from "The Tree of Jesse" and "The Last Judgment," were part of a major work that once hung on the north and south walls of the monastery of Antiphonitis, built between the twelfth and fifteenth centuries. Like anything that has survived war and captivity, some of the artifacts are in great need of care and repair. Among the findings are a handful of ancient coins and urns. It's like walking back in time. There are breathtaking pieces everywhere.

From the Agios Ioannis Chrysostomos monastery in Koutsovendis, an icon of the Virgin Mary lies alone on a table looking like a mutilated corpse. Her eyes are brutally dug out, probably with a sharp instrument. I try to imagine what kind of person could be so full of hate and fear that they would vandalize such a sacred piece of art.[1]

"Peter, is this everything?" He nods in agreement.

I turn to Van Rijn. "Where is the Andreas you promised?"

"Don't worry about it. I told you if it is not found in Dikmen's inventory, you can get him to tell you where it is," he says, trying to squirm out of his responsibility.

"How fast can you get an expert to come to Germany to identify what belongs to Cyprus?" asks Kitschler.

"Mr. Papageorgiou. We will be able to get him here within the week."

"Great," says Kitschler. "Once we know what belongs to Cyprus we can start negotiating with Aydin Dikmen to get him to agree to waive his rights to the Cypriot art. I will offer that if he returns the art to you he will receive a lesser sentence. It's the least I can do for you and Cyprus after all you did for us."

"You have Dikmen right where you want him," says Van Rijn. I choose to lay back about Andreas for now and see what develops.

Kitschler continues, "Tasoula, we found guilders on Dikmen."

"It must be the money we gave Van Rijn to buy the first lot. I'll put a claim on them."

The German police are doing everything in their power to make the process as simple as they can in order for the Church to retrieve its artifacts. The ideal situation would be to get Dikmen to sign over his hypothetical rights to the Cypriot artifacts in favor of a reduced sentence. Many artifacts belonging to other countries have also been recovered. Because the Church had orchestrated the sting, the Germans are giving us first opportunity to claim our goods.

"Time is of the essence," Kitschler points out.

He knew from his experience with German law that all kinds of variables can come into play that could make it difficult for us to claim the artifacts.

"I noticed that Dikmen's passport is Turkish and that he has no residence permit, so I can't figure out how he is staying in Germany." This makes me wonder who his connections are and if his name is even really Dikmen. Kitschler moves to prepare a release for a press conference scheduled for Monday afternoon.

"Under which capacity, Church or consul, do you wish to be called in the press release?" Kitschler asks me.

Tassos interrupts, "You don't want to be mentioned in this at all. If you care about your safety, it's better to keep your name out of the papers," he adds. "Besides, this is a police-to-police matter now. Your work is done."

"Well, if I'm not working with the police, whom am I working with?" I ask.

Peter Kitschler interjects his opinion. "Tasoula initiated and orchestrated the sting and for our procedures, Tasoula is the key witness. Van Rijn and his men have anonymity. Tasoula needs maximum media coverage to ensure her safety."

"Or she can be 'an informer for the Cypriot police,'" Tassos says, shrugging his shoulders as if to intimate that my role and responsibilities in the operation were equivalent to the women who volunteer to replace old candles with new ones in church.

"Let's call her 'the lady of the Church' for right now," says Kitschler.

I'm confused by the Cypriot police and the discussion about my role in all of this, and too exhausted to deal with it right now. It seems there is a lot of jockeying for position on the part of Tassos. My concern now is not about receiving credit but returning safely to my family. I do not want to be alone in Munich when the documentary on what we are calling "The Munich Sting" airs on Channel Four Monday night.

Turning to Kitschler, I say, "Once I appoint a lawyer to seize the artifacts on Monday, I will return to Holland. The Cypriot police will attend the press conference."

<center>⚜</center>

Arriving back at the hotel, Van Rijn says, "Now that our business is finished, I need an evening to myself," and he sheepishly returns to his room. It dawns on me that we have not called his father, but he seems more interested in his new plans now.

Tassos invites Lazlo to join us for dinner at the restaurant in the hotel and starts to interrogate him. Knowing firsthand how Lazlo reacts to outsiders, I make an attempt to get the attention of Tassos, who is trying to determine if he can split Lazlo from Van Rijn. Tassos wants information about Dikmen,

which he will never retrieve from Lazlo, Van Rijn's loyal puppet. At the first opportunity, I pull him aside and say in Greek, "It's not wise to get in between these two, Tassos. Lazlo will not speak against Van Rijn and vice versa. What are you looking for?"

"This is my job. I need to know who did what."

At this point I wish to avoid making a scene in front of Lazlo, and refrain from making additional comments. After dinner, in private, I engage Tassos again.

"May I speak to you in confidence?" I ask. He nods in agreement.

"Tassos, I think it will be best if we can speak freely to each other as it is important for us to work in unison," I say.

"Fine," he replies.

"You are compromising the trust that I established with Van Rijn. I know how he operates and all about his relationship with Lazlo. I want to turn the case over to the police, and secure the same trust between you and Van Rijn but there are details that must be executed first. For you to interfere like this without discussing it with me is not helpful."

"I don't understand what the hell you are talking about," Tassos responds. "Maybe you misinterpret the way I interrogate as a policeman. You've done a spectacular job. It's time for law enforcement to take the lead." Tassos is a tall man whose eyes seem to see everyone as a suspected criminal until they are proven innocent. When he speaks, he talks slowly and guardedly.

"I take my orders from Stella Joannides, who is under the command of Attorney General Markides," he says.

Tassos doesn't understand how to deal with the Dutchman. Once Van Rijn realizes that the government and the Church are not in unison, he will drive a wedge between us. He will promise Tassos the world, then he will compromise both Tassos and the attorney general's office. Van Rijn's sights are always set on getting as much money as he can out of every situation. If the police do not take my warning seriously, it can spell disaster for the outcome of the Munich operation. I can feel something is brewing.

At this point, Van Rijn returns to the hotel drunk and jolly, with an attractive woman he introduces as the mother of his son. I assume he is speaking about the woman with whom he currently lives.

"My ex and I have a son together, and she came here to celebrate with me."

I think about reminding him to call his father, but I realize it's not the right moment. I retire to my room, looking forward to my escape from Munich.

❧

A new sunrise brings the sad news that Van Rijn's father passed away in the middle of the night. I find Van Rijn in the lobby in terrible pain, emotionally distraught and completely broken. He is crying, and I feel helpless.

"I told you to call him. You really let me down," says Van Rijn, to my horror.

"I promise you that I wanted to," I say with all sincerity.

"Get me a private plane out of here. I want to see my dad," he says, the smell of alcohol dominating the atmosphere.

Lazlo pleads, "He needs your help."

Despite my sympathy for Van Rijn, my conscience cannot permit me to spend the Church's money to fly him home on a private plane. The Cypriot police appear, but they remain in the background, unclear about how to handle the situation. Kitschler gives me flight information, and I purchase him a ticket for the early evening flight.

"I sacrificed being at his deathbed to be here for you, woman, to give you and Cyprus your artifacts. Why didn't you call him a few days ago, Tazulaah?" he says, unable to hide his resentment. "You are just like the rest."

Van Rijn continues drinking scotch, to numb his pain. He blames me.

"I'm so sorry. I'm sure he is looking down on you with great pride."

As I watch Van Rijn get into the car, I feel terrible. He longed for his father to hear from the honorary consul and representative of the Church how his son was helping the Cypriots recover their stolen treasures. No one could predict that his death would preempt that. What I don't see in this moment, because I am exhausted as well as preoccupied with overseeing all of the details that need to be attended to before I can leave Munich, is that in Van Rijn's eyes I am no longer the revered Madonna figure he has held me up to be. I am now just another woman who failed him.

⊰⊱

Herman, my bodyguard, drives me to meet David Hole, the German attorney recommended by Stella Joannides to handle the Munich case for Cyprus. I submit the power of attorney letter from the archbishop and instruct him to confiscate all artifacts in Dikmen's possession on behalf of the Church as well as any cash found on Dikmen.[2]

I land at Schiphol with a sense of foreboding, which began that evening after the sting operation when I first saw Tassos questioning Lazlo. I should be free of worry now that I have accomplished what I set out to do, yet I cannot let go of the visual evidence that keeps mounting. I'm not feeling confident about the way the Cypriot police are managing Van Rijn and Lazlo. My mission is to bring the artifacts home to Cyprus by Christmas and their interest is to prosecute Dikmen. I hope our priorities do not conflict.

Michael, my children, and Bishop Vasilios (sent by the archbishop to be with my family during the Munich operation) greet me with a hero's welcome. I allow myself to be in the moment to savor them and their loving support. After we turn in, I watch Michael sleep, until my racing heart sends me to the kitchen, where I make myself a cup of tea and continue on to the basement, feeling a need to be close to the recovered artifacts.

As I sit in a chair facing the artifacts, I realize that I have not crossed the finish line. Munich is far from over. The Saint Andreas mosaic I have been searching for is not among the sacred treasures recovered in Munich, which Van Rijn guaranteed as part of our deal. My work is not done until I find the Andreas and the artifacts recovered in Munich are returned to Cyprus. My mind swings into full gear, planning the next courses of action that will be required to complete this job. When the first morning light appears, my exhausted mind and body finally surrender. I return to bed, hoping to get a few hours' sleep in before I begin the next leg of this race.

⊰⊱

Professor Dr. Willy Bruggeman, the deputy director of Europol, phones me with his concerns after reading articles about Munich in the Dutch

papers. I invite him to dinner. Prof. Dr. Bruggeman is a serious man with a quiet demeanor who was shocked to read my name in the paper alongside Dikmen's.

"From a police point of view, Dikmen is a very dangerous man. Sometimes he works for himself, and if the money is right he will work with law enforcement, but when it suits him, he will work against the police."

"I want to meet him face to face to understand how he can sell my religious artifacts so freely. I respect his faith and I demand he respect mine," I say.

"Stay as far away from him as you possibly can. Here's my mobile number. Be sure to go to the Dutch police and tell them you need security."

Prof. Dr. Bruggeman has taken me under his wing over the past several years. He gave me crash courses on everything from international extraditions to complex criminal matters. This is where fate has played its hand in my life. Every person I meet, either personally or professionally, plays a role that furthers my cause. Because I go out of my way to provide the best customer service for my clients, I develop lifelong friendships and tend to draw a similar quality from others. It gives me access to legal experts, international crime specialists, and justices, who become voluntary resources.

On October 10, the Bavarian police, led by Peter Kitschler, discover an additional forty boxes, a utility bill, and another key belonging to Dikmen. On October 16 Peter Kitschler phones me with the news that the police discovered a rented apartment under another name, which held twenty-five additional frescoes along with an assortment of crosses, bibles, and other objects worth millions of dollars.[3] Hopefully, the Germans prosecuting Aydin Dikmen, or whatever his real name is, will expedite the artifacts' return to Cyprus.[4]

Twenty-Three

LESSONS LEARNED

OCTOBER 19, 1997

Hospitality holds a prominent place in Greek mythology and culture. Despite my active life, my home is always open to people, especially those who travel from afar.

Stella Joannides, the Legal Counsel of the Republic, and I have been in each other's company once or twice. We are both women making our way in a man's world, which under certain circumstances would forge a perfect union. Instead, She negates my strategies using legalese. What she doesn't realize is that I have had access to the best legal counsel in Holland, America, and Cyprus now for ten years.

I welcome Stella and Bishop Vasilios of Trimithounta from Cyprus as guests in my home to attend the press conference on Munich being held in The Hague the following day. At my request, the Church will pay the costs of having the German police, the Cypriot police, and Cypriot government officials attend, as I feel it important to show a unified front to the dealers.

My home is my haven. Visitors who stay with me are exposed to what's behind the curtain, and what I hope they see is a loving wife, a mother of two children, and caretaker to many animals. I am also a successful entrepreneur and an honorary consul. I consider myself proficient at multitasking, as I find most women are. I field phone calls with one hand, share a glass of wine with you, prepare ingredients from my refrigerator for dinner, and entertain my special-needs daughter, Sophia, who keeps me company at the kitchen table while I cook. I am every working mother who comes home to a large load of dirty laundry after putting in a challenging day at work. I still manage to find time for love and laughter and entertaining my friends.

After dinner, we move to our living room, where my stone fireplace relaxes even the weariest of travelers. The crisp October weather and the warmth of a crackling fire make it the ideal location for a relaxing conversation. Stella wastes no time in getting down to business.

"Is it possible for me to take a peek at your speech?" Stella asks.

"For the press conference?" I ask.

I comply. It can't hurt to have a set of legal eyes review it. The intense look on her face while she reads through my speech places me a bit on edge.

"Ah, you will have to correct this here," she says with a disapproving look, pointing to a specific paragraph.

I glance at Michael to see if he is listening, but he and Bishop Vasilios are deep in conversation.

"Come," I say to her. "Let's move to the other room so we can talk."

Around my kitchen table, we sit opposite each other.

"What are you referring to?" I ask.

"Here," she says, pointing to the place in the speech where I talk about how many sacred religious artifacts were recovered.

"You need to edit this to reflect that there were more archeological artifacts discovered in the Munich sting than religious ones."

"Why?" I ask.

She leans back in her chair as if she found my question insulting.

"There were both kinds, were there not?" she says.

"Ninety-nine percent were religious artifacts. What difference does it make?"

"Please do as I tell you," she says without offering any explanation. I can see from her reaction that something bothers her, but I can't work out what it is.

"I'm going to retire for the evening. Good night," she says as she climbs the staircase leading to one of our guest rooms.

I join Michael and the bishop in the living room to share what happened.

"Why would she want to change the facts?" Michael says.

Bishop Vasilios reacts with a hearty laugh.

"My dear Tasoula, you have been away from Cyprus far too long."

"What do you mean?"

"You are the one who holds the 'power of the attorney' from the archbishop, as a representative of the Church. You are also the honorary consul who orchestrated the sting operation. The attorney general's office has no role outside prosecution unless there are archeological findings. This is your success. Unless they twist the facts to give the government a bigger role they look unimportant."

"Is this what it is all about? Who gets the credit?"

"My dear, that is all that matters in this case to them. It also has to do with the timing. Did you know her boss Markides is rumored to be running for the presidency?"

The puzzle pieces begin to come together. The Cypriot police report directly to Stella, who reports to the attorney general who might be running for president.

Everyone involved played a part in this sting operation, some bigger than others. The fact is, none of us could have executed this sting alone. I have no problem sharing the success, but I resent being presented as an instrument of the police.

I choose my words carefully in the speech, adding that "some archeological artifacts" were found, because that is technically correct.

OCTOBER 20, 1997

The press conference is due to begin shortly at the Museum Het Paleis in The Hague, a former eighteenth-century palace of the Royal Family

located in the historical heart of The Hague, now housing the Escher Museum. Van Rijn calls and asks me to meet him in a coffee shop nearby. He is risking exposure as his name is being kept out of the press. This is the first time I will be seeing Van Rijn since the death of his father.

"Don't you fear you'll lose your anonymity?"

"I had to see you, to wish you luck," he says. He hands me a key. "I wanted you to have this."

Looking at the key, I ask, "Is this what I think it is?"

Closing it in my hand, he says, "Locate the safe that this key opens and you will find your beloved Andreas. Whether it's fake or real I cannot say. I'll leave that in Papageorgiou's hands to determine."

"Van Rijn, let me remind you that Andreas is part of what you guaranteed the Church."

His icy stare makes me anxious.

"Listen," I say, "It's been ten years now that you and I have been playing this game. It's time to stop, don't you think?"

"There is only one way for me to keep you in my life, Tazulaah. Once you have Andreas, you don't need me anymore."

"There are other ways, but you must be willing to give up the game. No offense; there will be a price to pay unless you come forward with Andreas."

Despite his look of contempt, I continue to crack down on him.

"I will find Andreas with or without you," I say, falling right back into the trap of dueling wits with him. "Did you think I would not read Jan Fred's article? I know you purchased Andreas, realized it was a fake, but chose not to derail the sting."

His expression softens.

"I was planning to give the fake Andreas to you as a gift. I withheld the information to surprise you."

"Who are you kidding? The church agreed to pay you a fee in exchange for a list of guaranteed artifacts."

"That key," he says with passion, "unlocks your peace of mind. I beg you, don't hold up my money or mess with our deal. You knew as well as I did that I made a best guess as to what would be in Dikmen's inventory. Look at what you did recover!"

We both take a pause to reload some verbal ammunition.

"Don't call me a crook at the press conference," he says.

"I can't say your name! You and your collaborators will lose your anonymity and the Germans will not be able to guarantee your safety." I remind him.

"Please, just call me something other than a crooked dealer. That is old news."

"Controversial dealer?" I inquire.

"I can live with that."

My instincts tell me to leave him feeling reassured.

"Come to dinner tomorrow night with Bishop Vasilios, and we can finalize your deal," I say.

"I'm proud of you, Tazulaah. I came to wish you well." For a moment I find myself softening toward him, until he says, "Show the press that I gave you the key!"

<p style="text-align:center">⚜</p>

At the Museum in Het Paleis, Ralph van Hessen, the publicist, says, "Look at the turnout. You're a star! This is big news!" Top media companies from around the world overcrowd the room with their video crews and reporters.

The lights and the media erode my nerves, and I begin to lose my voice. I've never been at the center of a press conference before. Taking my seat next to host van Hessen, I smile and acknowledge the other panelists. Just in front of the panel where the table of artifacts are displayed there is a group of photographers jockeying for position to snap pictures of the thirty-two frescoes and the Thaddeus mosaic that we recovered in the first stage of the Munich operation.

Searching the room for Michael, I find my husband's loving face smiling back at me. He is my rock, my stabilizer, the person I trust explicitly, and his unconditional support has made it possible for me to arrive at this moment.

The photographers take their seats. Ralph van Hessen introduces the panel, which represents the Cyprus attorney general's office, the German

and Cypriot police, an antiquities expert, and Bishop Vasilios. Pointing to me, Ralph says, "I introduce you to Tasoula Hadjitofi, representative of the Church and honorary consul to Cyprus in the Netherlands. She is the woman behind all this success and who has worked for the last ten years on this project."

As I look out on the sea of press people, I have one intention, and that is to take the lessons learned from Cyprus and share them with the world. In my pocket lies a small icon of Saint Andreas, a gift from my mother as I left Cyprus to secure a new future after the war. I stop and appreciate how far I've come since that day. From refugee, to the icon hunter, and a host of other things in between.

My throat is so parched it cracks as I speak my first few words. I stop talking, clear my throat, and force my voice to rise to the occasion.

"In the last few weeks, the Autocephalous Greek Orthodox Church of Cyprus, in close cooperation with the attorney general's office in the Republic of Cyprus, the Cypriot police, Interpol, and the German police, have succeeded in recovering several icons, frescoes, and mosaics, which once adorned Orthodox churches in what is now the occupied area of Cyprus. These pieces were illegally removed following the Turkish occupation of the northern part of our country in 1974.

"The wider story spans the last twenty-three years since the willful pillaging of the cultural heritage of our country. Since the invasion and occupation of Cyprus in 1974 by the Turkish army, many, if not all, of the artifacts belonging to five hundred churches, monasteries, castles, and museums of the occupied area found their way illegally to various parts of the world. We estimate fifteen thousand to twenty thousand icons have been removed, several dozen major frescoes and mosaics dating from the sixth century to the fifteenth century have been segmented for sale abroad, and some destroyed forever. Several thousand antiquities and individual objects of historical and cultural interest such as chalices, crosses, wooden carvings, and bibles have just disappeared. Apart from the individuals involved in the removal, art dealers from several countries provided a vehicle for the trade in our antiquities and religious objects for which they have received large sums of money from wealthy individuals.

"As a Cypriot and a refugee from Famagusta, I can attest that we have lost many, many things since 1974. However, there can be no greater loss than one's culture. In 1988 in my official capacity as honorary consul, I was approached by an art dealer in the Netherlands who offered to return one of the Kanakaria mosaics and one icon in exchange for him to legally retain the mosaic of Kanakaria called 'Andreas.' Naturally, the response was no. Driven by strong feelings of injustice, I collected information about how the destruction occurred, who the key players were, as well as their methods of trading. The same Dutch art dealer approached me with a proposition to deliver a large cache of our important stolen treasures. Initially, we financed the purchase of thirty-two frescoes from Antiphonitis and one mosaic from Kanakaria, a transaction that was filmed. Armed with the knowledge of who the key players were, we moved on to stage two, which was a sting operation involving the Cypriot and German police. For the record, the Dutch art dealer volunteered to cooperate with the police for his own motives.

"The destruction of culture is a matter for all of us to reflect upon: Why are we forced to resort to such methods to retrieve what is rightfully ours? No Cypriot should have to pay for the return of their culture, although there is no price a Cypriot would not be prepared to pay when all else fails."

The photographers' sense something is coming as the sound of their cameras capturing the moment fills the room.

"Today the dealer whose name I cannot reveal for judicial reasons handed me a key to a safe that holds the Kanakaria mosaic of Saint Andreas, one of the most ancient and revered artifacts to the Orthodox community."

A sea of blinding flashes force me to adjust my vision before speaking again.

"I would like to pass on a message to him."

The room is so quiet I can feel the journalists moving to the edge of their seats.

"Stop playing games. There are many more Cypriot treasures still at large and in the hands of illicit dealers. Step up. Make a difference. Lead us to them."[1]

As I say this, I look around the room to see if Van Rijn sneaked in, but there is no trace of him; for once he adhered to my request. I return to my speech.

"Before I leave you, I want to bring this photograph to your attention. It's an icon we recently recovered in Germany."

I hold up the first photo from our records in the Department of Antiquities in Nicosia.

"This is the original condition of the icon before the war," I say and then holding up the recent photograph taken in Munich, "This is how it looks today." My voice is strong but quivering slightly with emotion.

"Can you tell me a reason why anyone would wish to scratch the eyes out of the Virgin Mary before they sell it? There is no greater insult to another's culture and religion than this."

The journalists are practically jumping out of their seats waiting for the questioning to begin. I remind myself to be careful about what I say, as I can't jeopardize the criminal case in Germany or Van Rijn's immunity, but maybe I'm overthinking the situation.

A *New York Times* journalist asks the first question:

"What is the future of divided Cyprus?"

"That is up to the politicians to solve," I reply. "I know what I would like it to be—free for all refugees to return home."

Another journalist from the BBC steps up to the microphone.

"I would like to ask if the Dutch art dealer is granted immunity and if that is why you're withholding his name."

"Yes, that is correct. I call him 'Lefteris,' meaning *free man*. He's the only dealer to walk free because of his cooperation," I say.

A Dutch journalist from the *Haagsche Courant* says, "I know that the dealer is Michel Van Rijn. I just had coffee with him."

Even in his absence, Van Rijn attempts to control the press conference by manipulating the journalist to say his name. This not only sabotages his immunity, it takes the attention away from the artifacts and places it on him.

"You mentioned the name, not I, and I state that for the record. Next question."

A Turkish journalist from Germany inquires, "Will the artifacts be returned to the churches located in the Turkish part of the island?"

"You mean the *occupied area*," I say. "Thank you for your question. Based on the way these artifacts were treated, do you really think we should send them back for more abuse?"

Ralph van Hessen says, "Final question, please." A reporter from the *Kathimerini* in Greece asks, "You have the artifacts here and more in Germany, so when will they be reunited and brought back to Cyprus?"

"The ones in front of us, which were acquired during the first part of the operation, will be exhibited in the Gemeentemuseum here in The Hague until December. We hope the Germans will release the rest of the artifacts by then so that they can return to Cyprus for the holidays. This will make for the best Christmas for Cyprus since 1974."

<div align="center">࿊</div>

Later that evening, Ralph van Hessen visits me at my home.

"I'm bombarded by journalists from all over the world, Tasoula, wanting to interview you. The possibilities are endless now. You have to write a book. This story plays like a Hollywood movie."

Michael explodes in front of Ralph and the bishop.

"Enough! I don't want to live in a circus anymore, Tasoula. You promised me!"

Turning to Ralph, I say, "Sorry, I can't do any more interviews. Subject closed."

I never imagined that the events would turn out to be as big of a news story as it was. After all, I'm just a girl from Famagusta.

Twenty-Four

POWER STRUGGLE

Scheveningen, a district of The Hague and popular seaside resort area, has a four-hundred-meter pier that juts out into the North Sea, offering a spectacular view. References to it date back to 1280 when fishing was a major source of food and income for local residents. Its long, wide, sandy beaches run parallel to a boulevard lined with restaurants and sea life sculptures that attract tourists and locals in droves.

Wanting Bishop Vasilios to experience Dutch "culinary gold," raw herring, we embark on an excursion to Scheveningen during his stay. Although herring tastes best during the summer season, this dish is in a league of its own any time of the year. We pass herring stands and watch people dip their raw herring into onions, then hold it between their fingers as they lean back and drop it in to their mouths like trained seals.

Inside the Simonis restaurant on the boulevard near the beach, the bishop's attempt to master the art of eating herring is interrupted by an incoming mobile phone call from Cypriot journalist Marina Schiza, which I place on speaker.

"You will never believe what I am about to tell you," she says, in Greek. "At the attorney general's press conference last week with Tassos and Stella

in Cyprus, the AG briefed the press as if his office and the police orchestrated the entire Munich sting. Your name never came up!"

"But I saw an official press release where the attorney general gives praise to the archbishop and mentions me too," I say.

"Tasoula, Kyriacos, the news presenter, and I were outraged when we heard them take credit for your work. We stood up separately and publicly declared that we had the inside story about Munich because you phoned us just hours prior to leaving for the sting. We asked why he didn't mention your participation in the events."

I feel slightly embarrassed by the news Marina is sharing with me.

"You should have seen their expressions when they realized we knew the facts of the case," Marina continues.

"It's not *what* you do, it's what you *claim* you do, in Cyprus," says Bishop Vasilios, to the amusement of all. "When you are a civil servant or an attorney, your job is for life and you have nothing to lose," Vasilios adds.

<center>⁂</center>

The scent of savory roasted lamb is everywhere as I set the table for our dinner with Van Rijn. He leaves for Cyprus in a week, so my focus is to finalize arrangements for his one-month stay. Bishop Vasilios, the archbishop's right hand, joins us.

Van Rijn arrives with flowers in hand and humility in heart.

"I'm so honored to be here having dinner with the bishop and Michael. It means the world to me," says Van Rijn.

He is highly intelligent and cultured, and his in-depth knowledge of Byzantine art is impressive, making him a charming dinner guest. Conversation and dinner go on for about an hour or so. Coffee is served.

"How did you manage to secure the mosaic of Thaddeus?" the bishop inquires.

"Veres set up the buy with Dikmen and agreed to act as an intermediary for a fictitious character we made up, which, of course, was me. Veres and another Hungarian by the name of Andrash purchased it and met me outside a casino in Wiesbaden to make the exchange."

<center>269</center>

"Fascinating," says the bishop. "And Andreas?"

I pull the key he gave me out of my pocket and hold it up for him to see. "Where is the safe?" I ask Van Rijn.

"I thought you didn't need me anymore?" he says, laughing. I've never seen Van Rijn's soft side, which he uses expertly to work the room tonight.

"Tazulaah, not to change the subject, but Patricia my girlfriend and I have resolved our issues. Do you think the archbishop will mind if she and my two boys join me in Cyprus?"

I look at the bishop, who says, in Greek, "I think the archbishop will be pleased to hear that Munich did not cause a divorce for him."

"I think we will be able to arrange it," says Bishop Vasilios.

"I want to feel like a normal citizen in Cyprus. I don't want to fear the police."

"The police will not bother you," I say.

"Tassos wants me to work with the attorney general's office to recover more artifacts."

"Maybe you should work with them."

"Only if you're in charge. You know I don't trust the police. Since the Munich case, they are constantly calling me. I just want to have a rest with my family."

Van Rijn hands me an A4 envelope. "These are photographs of artifacts that Dikmen had in his possession at one time. There is one of Andreas."

The images are ones that he has presented before. I put the envelope away, trying to give him the benefit of the doubt. Maybe he truly believed the real Andreas was in Dikmen's inventory; maybe not.[1]

"One month stay in Cyprus with your family. No more, no less," I say to reiterate the new change in our agreement.

Bishop Vasilios extends his hand to Van Rijn, who bows his head.

"Thank you for your contribution, and may God bless you and your family. I hope you enjoy your stay in our country," says the bishop.

"The fake Andreas is my gift to you when this is all over."

"The fake Andreas might be a gift; it's the real one I'm after."

"Please, Tazulaah, this has been a perfect evening."

"Van Rijn, we are almost at the finish line. Where is the fake Andreas?"

"In due time," he says.

As Van Rijn disappears into the night, I turn to Bishop Vasilios to say, "He's up to something."

Bishop Vasilios responds, "Make sure the police are informed not to pressure him when he arrives. The last thing we need is for him to create chaos in Cyprus."

❧

With the Munich case now in the hands of German law enforcement and under the aegis of Germany's judiciary system, the Office of the Attorney General in Cyprus takes the lead in the prosecution of Aydin Dikmen.

There is more chill inside my office at Octagon the following day than there is outside in the brisk October air as Stella and the Church's lawyers, Polak and Hole, join me in a meeting to discuss the best way to move the Munich case forward. The German police see me as their key witness, and up until this point they have had direct access to me.

"We have a criminal case that involves the prosecution of Dikmen under German law. Stella, I understand your office is in communication with the attorney's office in Germany."

She nods and Hole continues. "The German police are willing to reduce Dikmen's sentence if he doesn't object to the artifacts being returned to Cyprus. The German police warn that if we don't negotiate quickly, we can become caught in civil litigation, which, as we all know, is a costly and lengthy process."

Polak says, "If Dikmen refuses to cooperate and there are no applicable international treaties to force his hand, then a civil case is our only option. We should avoid this at all costs. Has Germany ratified the Hague Convention of 1954 and its protocols?"

"I know we signed it, but I don't believe we ratified it. I'll check into it," Hole replies.

"The German police want my statement, urgently," I say. "We also have to put in a claim on the cash found in Dikmen's possession so that I can tie it to the money that the Church paid to Van Rijn for the artifacts purchased

during the first part of the sting. The Germans also asked for Papageorgiou's preliminary list of which artifacts belong to Cyprus."

"What is the maximum sentence Dikmen can get under German law?" asks Polak.

"Up to fifteen years. If he cooperates, the Germans will reduce the sentence considerably," Hole says.

Up until this point Stella has not engaged in the conversation.

"The attorney general is keeping his options open and is investigating extradition of Dikmen for prosecution in Cyprus," Stella says.

"He's being tried in Germany for dealing in looted art. What crime can you tie him to in Cyprus?" Hole asks.

"Stealing, of course."

"Can you prove it?" asks Polak, knowing full well that I am the person holding the most information on Dikmen, and that it would be difficult to substantiate.

"What would the sentence be if he were convicted by Cyprus?" asks Mr. Polak.

"Two years," says Stella. "Van Rijn will be our witness."

"He's an unreliable witness. You'll need more than Van Rijn to extradite Dikmen," Polak replies.

At this point the lawyers and I are baffled. We share the belief that it may be best to separate the criminal case from the return of the artifacts. There are only forty days to present evidence that Aydin Dikmen took the artifacts from the occupied area, which is still militarily controlled by the Turkish army. Why would the attorney general's office risk losing time and delaying the return of the artifacts?

"The attorney general supersedes the president and the archbishop in international legal matters. He decides the direction of this case," says Stella.

"As long as your strategy does not conflict with our aim to repatriate the artifacts at minimal cost. Keep in mind that we three represent the Church, which is the legal owner of the artifacts," Polak adds.

Thinking about the larger picture and how extradition will play to the international market, it will surely politicize the issue because of Dikmens,

Turkish origin. If prosecuted in Germany, he will get fifteen years as opposed to two in Cyprus.

<center>⤳</center>

Behind the floor-to-ceiling windows of my conservatory I sit in a rare moment of silence, reflecting on how to tie up the loose ends of my repatriation duties. The phone rings. It's Van Rijn, and he is severely agitated.

"The police were waiting for me at the airport in Cyprus! You promised me the dogs would not be a problem, Tazulaah! Are your people trying to arrest me?"

Placing a call to Tassos, I plead with him to wait for my arrival to Cyprus to secure Van Rijn's cooperation. Van Rijn faxes me newspaper articles from Cyprus regarding the current controversy over the opening of casinos. He writes of his interest in getting a license along with his desire to develop real estate.[2]

I reach out to the attorney general, emphasizing the importance of working together with one strategy for the best of Cyprus. The Church takes the lead in the repatriation efforts with the government assisting; in the criminal case the government takes the lead with support from the Church's attorneys and me. I suggest I continue to coordinate until the end of the year to ensure the quickest return of the artifacts. It will enable me to tie up loose ends of the repatriation efforts to the government, I hope.

Twenty-Five

TACTICAL WARFARE

Polak advises the archbishop and me that Turkey can try to confiscate Cyprus's artifacts if they are exhibited in the Netherlands. He recommends that we take preventive measures by submitting an application to the Hague District Court that will guarantee the Church a hearing before any potential seizure can take place.[1] In the final week before the opening of the exhibition, Michael and I are editing the press clippings from the press conference that we are using in lieu of original text and organizing photographs that will go into a catalogue that we designed for the exhibition.

Wall-to-wall posters and banners are plastered everywhere the eye can see in The Hague, advertising "The Lost Treasures of Cyprus" exhibit. Being able to produce this event with our Dutch and Cypriot friends is particularly meaningful. From the day I left Cyprus, I carried guilt about having dual citizenship. Although a luxury for some people, it places me in constant inner turmoil over where my loyalties lie. Watching my Dutch and Cypriot friends blend together seamlessly as we work as volunteers on the exhibition allows me to realize that I can live in both worlds without losing my identity.

<div align="center">⌘</div>

Outside my kitchen window I watch the bird feeder attract the abundant wildlife in my yard. Sophia and I witness a red squirrel battle a blackbird for the food mixture. As I prepare for a speech that I will deliver to the Organization For Security and Cooperation in Europe (OSCE) in Warsaw tomorrow, Ralph van Hessen calls with the first of many challenges I will face this day.

"The Turkish ambassador is demanding that we shut down the exhibit," he says.

"What is the ambassador's problem?" I ask, trying not to panic.

"He says that Cyprus is shamelessly using the exhibition as a political ploy, which is a big problem for the Gemeentemuseum, since it's state run and can't be used for political propaganda."

"I don't understand; the museum is city run, so that's not true. We wrote no text for the exhibition. We are only using existing press clippings," I say.

My other line is ringing so I place Ralph on hold and pick up a phone call from an agitated director general of the Ministry of Foreign Affairs in Cyprus.

"Ambassador Zenon says you are causing an international incident with the exhibition! What is going on there, Tasoula?" the director general asks in a worried tone.

"The Turks are trying to politicize the exhibition. I will turn it into an incident between the Dutch and the Turks and remove Cyprus from the equation," I say.[2] "The best option for our government is to stay out of it, so please trust me to handle this." I add, trying to secure his confidence.

His tone softens. "You don't have Ambassador Zenon's support, so you'd better be right about this," says the director. "I'm counting on you."

My call with Ralph van Hessen has been disconnected, so I get him back on the line only to hear the panic in his voice escalating.

"Ralph, there is no rule prohibiting the museum from exhibiting political propaganda—not that our exhibit is about that, it is anything else!" I say.

"The Dutch can't risk damaging relations with Turkey. The Turkish ambassador knows it, and he's pushing to shut the exhibition down. He wants us to pull the press clippings off the wall," says van Hessen.

The international newspaper articles we display on the walls are either about the Munich Operation or about the press conference we held.

"What exactly in the text of the articles is he objecting to?" I ask.

"The words 'refugee,' 'invasion,' and 'occupation,'" says van Hessen.

"The Turks have not been reprimanded for what they did to Cyprus but Cyprus must be chastised for speaking up about it? So, in other words, he wants to censor us."

"If you take the articles down and just display the artifacts, that will be enough to satisfy him," says van Hessen.

"Ask the Turkish ambassador if he will accept us leaving the articles up but placing red tape over the words that offend him. If he agrees, our problem is solved."[3]

The ambassador from Turkey accepts the compromise and the director of the museum instructs the staff to place the red tape over the offending words in all text, including the posters and programs. The visual effect of this censorship becomes an exhibit in and of itself.

At Schiphol airport, as I wait for my plane to depart for Warsaw, I telephone Dutch journalist Jan Fred van Wijnen to share details about my recent experience with the Turkish ambassador.

"The Turkish ambassador threatened to shut the exhibition down unless we cooperated. This is out of my hands. I'm leaving the country for a day to deliver a speech. I have to tell you, this says more about the power that Turkey holds over your government than it does mine," I say as I board the plane.

The reporter is outraged over the fact that freedom of speech is being suppressed. There is a history between the two nations. During a labor shortage in the Netherlands in the 1960s, the Dutch entered into a "recruitment agreement" with Turkey. The Dutch accelerated the migration of Turkish immigrants into the Netherlands, which lessened the Dutch labor shortage while improving Turkey's unemployment issues. The fact that the ambassador was able to impose the kind of pressure he did speaks volumes about the voting power of the Turkish population in Holland.

Jan Fred van Wijnen from the *Vrij Nederland* writes an article that inspires the rest of the Dutch media to campaign against the Turkish ambassador's censorship. The story picks up momentum in the international press and draws publicity for the event.[4]

༈

The OSCE offices in Warsaw are located near the old town, badly damaged in World War II but now restored to its original character. This event marks my debut as a speaker on the international stage. I learn that there is global interest regarding the repatriation of stolen artifacts and understand how it links to security issues. Despite all the good work of organizations like UNESCO and other similar cultural institutions, there is no nongovernmental organization to engage the public. The Cyprus issue has only been told via politicians and religious leaders, but my speech sheds light on what the artifacts mean to ordinary people as told through the journey of a refugee. Relating the impact that war has had on my cultural identity enables me to engage further in cultural diplomacy. Speaking as an activist about the importance of protecting cultural heritage feels like a natural next step for me. I want to take the lessons learned from Cyprus and share them so no country will have to go through what Cyprus did.

When I return to The Hague, I discover that I averted what could have been an international incident for Cyprus. By merely exposing the situation, the act of censorship backfired on the Turkish ambassador's attempt to suppress our freedom of speech.[5] I pray that the press and notoriety of the exhibition and the events surrounding it will encourage the Lans couple to have a change of heart and drop the litigation.[6] Our best hope is that they will voluntarily return the icons to Cyprus in time for Christmas.

༈

The hallway leading to "The Lost Treasures of Cyprus" exhibition is lined with people waiting to gain entry. Some people come with flowers, others bring letters of encouragement. I am not alone in this fight as dignitaries, press, invited guests, and the public crowd the room.[7] Bishop Vasilios, dressed in his formal robe, opens the exhibition with a ceremonial blessing of the artifacts.

The Bishop dips his hand into the chalice and delicately sprinkles the Holy Water around the area where the artifacts are displayed. My attention

is drawn to the mixture of cultures, races, and religions in the room as they demonstrate perfectly what is possible when we respectfully honor each other's differences.

Bishop Vasilios finishes the blessing, makes the sign of the cross: "In the name of the Father, the Son, and the Holy Spirit, amen." The Orthodox faithful in the room bless themselves from right to left three times; the Catholics make the sign of the cross from left to right. Other religious faiths in the room bow their heads and worship in their own ways. We witness a moment of unification and diversity as the ceremony states that the value of these ancient pieces of art runs far deeper than their appearance. Their significance and the spiritual importance they carry is felt by all.

My Andreas, dressed in a suit, looks adorable while waiting in line to examine the frescoes. He taps the woman standing next to him.[8]

"My mommy found these," he says, quite happy to sing my praises.

I step in between the two and take my son's hand.

"Mommy, I am going to find the Andreas mosaic for you when I'm a detective," he says, as he stretches to make his seven-year-old body appear taller than it is.

Hearing the words spoken by my young son reminds me of how my mission preoccupies the entire family. The last thing I want to do is drag my precious son into my unfinished business. The stories printed in the Bible about Saint Andreas are manifold, and some are passed orally from generation to generation. These stories were a part of our early development, which helped to build our cultural identity along with the rituals we perform in the Orthodox faith. And looking at my son and saying his name, I know there is one piece of the puzzle still waiting to fall into place.

How can I explain to the world the importance that this lost Saint Andreas artifact holds for my mother, for my family and to the Orthodox? It's impossible for me to abandon my search for it, despite my promise to Michael. I must find it.

Twenty-Six

THE DEVIL IS IN THE DETAILS

Attorney General Alecos Markides is rumored to be considering a run for the presidency, according to several Cyprus newspapers. If he is extraditing Aydin Dikmen to Cyprus to bring him to trial for the stolen artifacts, it makes for perfect conditions to win favor with voters. If Cyprus is granted extradition for Dikmen, it could expedite the artifacts' return, as they will be considered evidence. The challenge is that chances for extradition are less than favorable. When current President Glafcos Clerides warns Markides that a run for the presidency while he's attorney general will go against the constitution of Cyprus, I become concerned about the artifacts' return.

The attorney general's office has not released my statement to the Bavarian police, who are calling for it consistently. I'm also spending hours fielding duplicate requests for the same information from different Cypriot government departments. Their disorganization is costing me hours of time and efficiency.[1]

I'm constantly at odds with the Cypriot police who are aggressively pursuing Van Rijn to establish a relationship. Once he senses there is a division between me, the attorney general's office, and the police, he will seize the moment to play one against the other.

Hearing the archbishop's normally calm demeanor upset, I fly to Cyprus on December 9 to meet with him. He leads me into his office to have a cup of coffee.

"The attorney general doesn't want the record to show that a girl from Famagusta recovered the artifacts on her own. I told them that is how it really happened, and they went on and on."

"They will not release my statement," I say, trying not to sound frustrated. "Legally they have no authority to stop me from giving it to the Bavarian police because I am a Dutch citizen."

"If you release your accounting of Munich without their approval, they will place the blame on you for anything that goes wrong with the case."

"They don't have evidence to extradite Dikmen, yet this is their plan."

"That's not our only issue. Van Rijn is accusing you of withholding evidence about Dikmen."

"What! Ridiculous. Your Beatitude, the civil servants are walking directly into his trap! Kitchler told me they want Van Rijn's statement. As it turns out, the fake Andreas is the only way the Cypriots can tie Dikmen to an illicit sale."

I shake my head in disgust. The attorney general's office wasted all this time on trying to extradite Dikmen when the Bavarian police could have prosecuted Dikmen immediately and negotiated with him to release the artifacts to Cyprus in exchange for a lesser sentence.

Continuing our discussion: "Now that the police have made Van Rijn aware of the fact that they need his testimony and cooperation in prosecuting Dikmen, it is my opinion that he will use it to try and manipulate the situation for more money," I say.

"You know Van Rijn well," says the archbishop. "He wants to stay in Cyprus and is claiming he was shorted money due to a disagreement in exchange rates for his two-hundred-fifty-thousand-dollar fee."

"Every payment made to him was documented and witnessed and each transaction signed by him."

"How shall we proceed?" the archbishop asks.

"Your Grace, in my opinion Van Rijn is trying to use the these Cypriot officials. I've told him the church will not pay another penny. He is going

around me to the civil servants to get to you directly. Let me get to the bottom of all this."

<center>⚜</center>

The Hilton Hotel in Nicosia is just minutes from the old historic district where significant churches and mosques are surrounded by Venetian walls originally built in the Middle Ages and reconstructed during the sixteenth century. Van Rijn and I meet in the lounge area set among tropical plants and trees, designed to bring the outdoors in.

"Now I understand what you love about this country," he says.

"We are not here today to discuss pleasantries," I say, getting straight to the point.

"I don't believe the archbishop appreciates what I did for Cyprus."

"He arranged a private tea for you at the palace to thank you one-on-one. Come on, Van Rijn. Stop playing games. What do you want?"

"I plan to make a life here. There is a piece of land near the supermarket Charalambides, and I want you to ask the old man to sell it to me at a reduced price. Of course he can always give it to me in gratitude for my services."

I feel the corners of my mouth tighten. Now I know exactly what he is up to.

"How do you know about this plot of land?" I ask.

"I know more about what is happening in Cyprus than you do."

"I see your fear of the police has subsided."

"Tassos and Stella are in charge now, and they tell me the attorney general is a powerful man who can help me. Maybe I'll finally get the credit I deserve," he says, trying, without success, to get a rise out of me.

"If you want to make your life in Cyprus, do it. I will not ask the archbishop to sell or give you land. The best I can do is recommend a real estate agent to you."

"Tazulaah . . . After everything I've done for Cyprus, it is humiliating to have to beg for what is owed to me," he says.

"We fulfilled our commitment to you, Van Rijn. Asking the archbishop for land is not part of our deal, nor is staying in Cyprus."

<center>281</center>

"Why don't you want me to stay in Cyprus?" he asks.

This is Van Rijn doing what he does best, changing his game plan; just when he gets you to believe he's being straight, he detours. He is maneuvering himself into position to secure money from this situation. To make him think twice about where he is taking this conversation I remind him, "And what about the unfulfilled delivery of the Andreas? The mosaic was part of the minimum guarantee. Or did you forget about that part of our agreement?" I ask.

"You don't tell the real story. You speak about me like I am a criminal," he says.

"There are heroes and paid informers, Van Rijn. You have been paid for your services. Heroes are not paid. To traffic illicit goods and make money informing others about their whereabouts are not the qualities of a hero," I say. Van Rijn has an unquenchable thirst for recognition that in this moment I sort of identify with. His has to do with his unfulfilled relationship with his father. Mine has to do with having a desperate need to see these sacred artifacts returned to Cyprus. This is my only chance to put the broken pieces of a shattered childhood back together. This is his opportunity to cross the line into legitimacy. Despite my willingness to understand what lies beneath, I still feel he cannot be trusted.

He continues, "Seeing you behave like this worries me. What has happened to you? When did you begin withholding information from the police?"

Van Rijn is masterful in the way he twists the facts to suit his aims. He is feeding Tassos's ego to make Tasso believe he will surrender the fake Andreas to him. Tassos will begin to trust him and, as soon as he does, Van Rijn will flip the facts on him just as he is attempting to do to me now. I have observed this man for eleven years, and I know him better than the Cypriot police do. The Cypriots are seeing what they want to see to move their agenda forward.

"I wish you well, Van Rijn. As far as your dispute about the exchange rate . . ." I pause, wanting to control any sarcasm. "We both know the exchange rate discrepancy is a fabrication. The nondelivery of the Andreas is not." His anger emerges.[2]

"I've been providing you with information to recover stolen artifacts since 1987. John the Baptist, Archangel Michael, The Royal Doors . . . I gave you Dergarzarian, for crying out loud!"

I put my hands together and clap enthusiastically.

"Great performance!" I say. "In case you didn't notice, we're not on Broadway."

"I gave up my two homes because you promised the archbishop would get me a casino license and free land to put it on.[3] When the representative of the Church and the government of Cyprus makes a promise, they must uphold it," he says with hostility.

A wave of nausea rises in my throat. I'm enraged about his lies and stunned by his betrayal. I told my government not to prosecute him so that he would continue to help us go after other illicit dealers.

"Don't you dare make false allegations against me," I say.[4]

"The Church paid you a two-hundred-fifty-thousand-dollar fee. We put you and your family up for a month in Cyprus. We are finished now except that you owe the Church the fake Andreas."[5]

"I handed Munich to you, and you treat me with no respect or decency."

"You're up to your old tricks, Van Rijn. You are not the changed man you parade yourself to be, you are the same as you ever were."

His voice becomes monotone, his demeanor chilling.

"You are not in charge anymore," he says as he exits the lobby, smiling.[6, 7]

I struggle to make sense of his betrayal. I believe it comes down to dollars and cents. The further he drives a wedge between the police and me, the more he positions himself to manipulate the situation. I stand in the way of his receiving a bigger payday. I must warn Stella and Tassos that the only way to stop him now is for us to present a united front.

Halfway between Limassol and Larnaca lies a small village on the south coast of Cyprus called Zygi where Tassos and Stella and I agree to meet at a local café.

"Van Rijn is pitting us against each other," I say. "He wants the archbishop to give him land, access to a casino license, cash, and he's making false accusations against me," I say. "He is a danger to us."

Tassos speaks first. "To us or to you? Why are you so aggressive with him? He's helping us. He's our prime witness!"

"How do you see this situation playing out?" I ask.

"He's not the man you say he is. I don't share your view of him," says Tassos.

"He is trying to exploit us to get more money, and he will withhold his testimony and the fake Andreas until he gets it. He wants to settle in Cyprus!" I say.

"So why is it your concern? You don't live here," Tassos says. Stella injects her opinion.

"What makes you think you're the only person capable of managing Van Rijn? We know how to deal with him quite well. He's not coming after us!"

"No offense," I say, "but I've dealt with this man and his games for eleven years. You can heed my warning or not. This is to protect the case as much as you two."

Stony, expressionless faces stare back at me.

"I suggest we take a photograph together and send it into the Cyprus weekly, which he reads. It will send the message that his games will not be tolerated."

Stella responds unenthusiastically, "Interesting. We will think about it."

❦

Later that day, I return to the archbishop's private headquarters at the palace, the only place of refuge for me these days.

"I'm sorry about this nonsense after all you've done."

"Stella and Tassos have created the perfect setting to enable Van Rijn to exploit the case," I tell the archbishop.

"The government has to go through me first, so don't worry about it."

"Your Beatitude, I feel that the artifacts would have already been returned to Cyprus if we were leading the case." When the archbishop listens, you can feel him concentrating.

"I want you to do something for me."

"Anything," I say.

"Bring the initial purchase of artifacts home to Cyprus for Christmas," he says.

"I will check with Michael, but I think we can arrange for the family to spend Christmas in Cyprus, yes," I reply.

"I want you to arrive before sunset, and let it be only you and Michael that escort the artifacts off the plane. This is the last thing the government will let you do alone. Glory has many fathers, my child."

<center>⚜</center>

Despite me turning Van Rijn over to the police and providing them with the bank statements and receipts of the Church account I set up in the Netherlands for the sting, Tassos requests an accounting of the money again. Van Rijn is now quarreling over the exchange rate that we agreed upon.

The police are desperate for Van Rijn's cooperation, so they dispute the exchange rate in his defense to try to secure additional funds from the Church. The police do not want to risk losing Van Rijn as a witness. I submit all necessary information to the police in order for them to secure the fake Andreas, I notify the attorney general's office, and the Ministry of Foreign Affairs, that the professional relationship between the Church and Van Rijn ceases here and I turn over all pertinent documents and responsibility for Van Rijn over to the police.[8]

The police however, continue to pressure the Archbishop, "They want me to finance a longer stay for Van Rijn. He has more information. What is your opinion, Tasoula?"

"It's one thing for us to pay him a fee to expose the dealers. If he receives a penny for telling us to whom he and Dikmen sold our looted artifacts, I not only will have a moral issue with that scenario, it will jeopardize the outcome of our other pending civil cases. How can the Church sue possessors of our stolen property and pay Van Rijn, who is the one who sold these looted treasures to them in the first place? This is the sole reason we changed our strategy to go after the dealers and not the possessors,"[9] I say.

"I understand," says the archbishop.

<center>285</center>

"Our agreement with Van Rijn is finished. We are not obligated to adopt him!"

"Then I shall back your decision," the archbishop replies.

❧

Back in The Hague, Michael unlocks the vault in our basement wall. It's late when I remove the frescoes and prepare them for their return to Cyprus. I use the moment to say good-bye to my fellow refugees. Each fresco has a unique beauty and character to it. One can feel the artist's connection to a higher source during the creation process as faith and devotion register in every detail. They seem out of place away from the walls of the church from where they originated. They are homeless artifacts, unable to return to their original environment in northern Cyprus because of the occupation. The artifacts will remain in the Byzantine Museum next to the archbishop's palace and wait like the rest of us refugees for the day we can return home.

For the last eleven years I have sacrificed much to experience this moment. Once I return these sacred refugees to Cyprus, I wonder if I will finally have the peace of mind I've been searching for.[10]

Twenty-Seven

RETURN OF THE REFUGEES

A s the wheels of the 747 touch the tarmac in Cyprus, Alecos Markides officially declares that he will not be running for the presidency, but I imagine, being a party man, that his office will do what they can to help win the election.

I get butterflies in my stomach as I gather my belongings. The weight of it all hits me as the stewardess opens the door for us to deplane. The archbishop's instruction to "be alone when you deplane" echoes in my thoughts. Michael stands a few feet behind me, while a friend sees to the children. All will be escorted by a bishop to a waiting area inside the terminal.

Descending the stairs, my senses are overwhelmed with the mixture of sea air and the perfume of scented flowers, a fragrance unique to Cyprus and evocative of my childhood. Even the warm rays of the sun cannot calm my nerves. At the bottom of the steps I see the friendly face of Bishop Vasilios leading a contingent of clergy to meet me. Underneath my tough exterior there is still a young refugee traumatized by war, who has visualized this moment for the last twenty-four years of her life.

Each bishop picks up a carton of artifacts until all are in hand, then Bishop Vasilios signals me to start walking toward the van that will transport the artifacts to the archbishop's palace. The bishops follow me in procession. There

are photographers and videographers present from local and international media outlets filming our every move as we march together like an army of spiritual warriors bringing our wounded artifacts home to heal.

The archbishop, in his direction to have me deplane alone, sends a powerful visual message to the government, the media, and to the people of Cyprus that in truth it is the act of a laywoman, with his support, who made the repatriation of these sacred artifacts possible.

I thought that bringing the artifacts home would heal my own inability to return home to Famagusta, but as I make the transfer of the artifacts to the archbishop, my wounds remain. The war ruined my ability to trust, and the archbishop restored it. I feel that nothing can break the bond we share, but something unexpected is lurking just under the surface. Something I could have never anticipated.

<div align="center">⚜</div>

Wearing a black Valentino suit with my hair pulled back in a simple bun, I arrive at the archbishop's palace feeling uneasy. The archbishop is dressed in his cassock, looking very much like the refined spiritual leader he is. Van Rijn enters with Tassos.

"Relax, this is a special moment for you." he says reassuringly.

One glance at Tassos and Stella and I wonder whether Van Rijn has them both seduced. Van Rijn disarms you with his "good guy" persona. All the while, he is studying your mind, your personality traits, your flaws, and your weaknesses. If your integrity can be bought, he will sense the hole in the fabric of your morality and tear at it.

Van Rijn is an opportunist. He has been on the run for many years with police authorities on his heels ready to take him down for his past transgressions. A clever businessman, he saw an opportunity to switch sides and become an informer before his past caught up with him.

When Van Rijn could not compromise me, I became another sort of sacred object that he wanted to collect. I believe he considered me his equal so far as intellect and strategy, but my gifts were used for a different purpose. I wanted to believe he was serious about redemption, and

I wanted to save him from himself. When his father died before I could share what his son had done to help Cyprus, it changed the dynamic between us.

The archbishop continues giving his guests a grand tour of the palace and Van Rijn seizes every opportunity to be photographed next to him. Tassos is all dressed up in his formal suit.

"Why did you have to bring him here?" I ask in Greek.

He squeezes his eyebrows in defiance.

"Why must you take all the credit?" he asks. "You think you can handle him better than me? I've been a policeman my whole life."

"He is going to compromise us," I say. "I'm not—" He puts his hand up signaling for me to stop.

"What did the guy ever do to you but help you make a name for yourself in the papers? Give credit already."

"Tassos, you're making a mistake."

"Enjoy your glory," he says and walks to the opposite side of the room. So, I try to reason with Stella.

"Stella, I feel anxious about the way the police are managing Van Rijn. The German police and I were able to discuss strategy, we communicated about every aspect of the case, and manage to work flawlessly together."

Her pale complexion is suddenly flushed with tones of red as the blood rushes to her face.

"How dare you criticize the police of Cyprus!"

I've never seen her so angry. "I'm illustrating the problem," I say.

"I control the police! When you criticize the police, you criticize the work of the attorney general and myself."

"The way the police are working is slowing down our ability to get the artifacts out of Germany," I say.

"Do you know what the problem is? You're the problem. The next time you want to have a conversation, come and speak to me without your husband. Let's see how tall you are then," and she walks away. I follow her into the hallway.

"Stella, please. I didn't mean to offend you. We are supposed to be working as a team."

"There is only one team, and that is you and the archbishop of Cyprus, Chrysostomos I."

Stella walks down the stairs. The assistant to the archbishop, Mr. Demetrakis, stops her. "Madame, what is the problem, please?"

"She's my problem," Stella says, pointing at me.

Bishop Vasilios appears, looking for me.

"The archbishop is about to speak."

He sees Stella upset and he ushers us into his office.

"Stella, I came to you for help. I would love to sit down with you and the police so we can all work together," I say.

"Okay," says Stella. "Why don't you come to the police station at fifteen hundred hours this afternoon and we can have that talk."

"I'll be there," I say, and we embrace each other. The moment makes me believe that we now have an opportunity to overcome our differences and work in unison to bring the artifacts back from Munich. There is a sudden generous burst of applause, but I miss what the audience is responding to.

Bishop Vasilios approaches me, beaming.

"You must be in shock," he says.

I shake my head no, embarrassed that my thoughts are so preoccupied.

"The archbishop just nominated you to receive the Order of Saint Barnabas medal," says Bishop Vasilios.

"The Order of Saint Barnabas, I don't know what that is," I say.

The Gold Medal of Saint Barnabas the Apostle is the highest distinction bestowed by archbishop Chrysostomos I and the Church of Cyprus. Knowing what Saint Barnabas means to the people of the Cyprus, this is a medal of great importance.

Bishop Vasilios explains, "It's the highest honor given to a civilian. You will be the first woman recipient, so please wipe that confused look off your face and smile!"

"Stella wants me to come down to the police station," I say, still in shock.

Bishop Vasilios's facial expression changes to concern.

"You must not go there alone, Tasoula. Regardless of what she says."

❧

The British colonial style exterior of police headquarters in Nicosia is in direct contrast to the sparse and modest décor inside. Michael and me are led to Tassos Panayiotou's office where the smell of stale smoke is mixed with the scent of perfume, which challenges my asthma. Tassos sits behind a large old steel desk that seems to have a history of its own, with Stella Ioannides alongside him smoking from her long cigarette holder.

"So," says Stella, "you have given everything you have to the police of Cyprus?"

"Of course. From the first day I began working with Michel Van Rijn, the Ministry of Foreign Affairs and the attorney general's office have received copies of my notes concerning any meetings, information, and requests he made." I say. My body struggles to keep up with how fast my heart is pumping blood.

Stella says, "Bring him in."

Michel Van Rijn enters the room and takes a seat next to me, opposite Stella and Tassos.

"All these years, I have been feeding you information that I assumed you were communicating to your government. Where are all the files and the evidence I gave you about Aydin Dikmen?" he says.

"What evidence?" I ask.

Van Rijn says, "The evidence about Dikmen's smuggling. You keep it all for yourself and you withhold it from the police."

The police are silent.

I feel my entire body go into shock.

"What the hell is going on here?" I ask, expecting an explanation from Tassos and Stella. "I don't know what you're referring to!"

"You're lying," he says, pointing his finger at me.

Those words provoke my husband to lift his six-foot-four frame out of the chair. "Enough is enough!" Turning to the police, he says, "Get him out of here immediately."

Van Rijn wears a devilish smile when he says, "Have a nice day, golden couple," as he exits the room.

Michael unleashes his anger. "Forget that she is an honorary consul. Forget that she is the representative of the Church. Forget that she has dedicated her life serving your country at personal danger. She is a Cypriot, for God's sake! Her word is equal to Michel Van Rijn's? You allow him to insult her dignity and you sit there and do nothing to protect her!"

"We wanted to pit them against each other to see who is telling the truth," says Tassos.

"Shame on you! We're out of here," he says, as he extends his hand to me.

<div align="center">⚶</div>

The next day, the sound of the hotel room service cart being wheeled into the suite of my hotel room wakes me from a fitful sleep. My thoughts are trapped in the noxious details of yesterday. I wonder if it is even possible for us to get on the same page to work together for the greater good of seeing to the return of the artifacts.

Reaching for the newspaper, I see an article about me being nominated for the Order of Saint Barnabas medal. My parents will be so proud, especially my mother, who lives and breathes by the Orthodox Church.

An envelope is slipped under the hotel door, and I debate whether or not to eat before opening it. Michael beats me to the punch retrieves the envelope and places it on top of a nearby table.

He pours himself some tea and selects a croissant while I serve him scrambled eggs and bacon. Seeing the paper opened to the article about me, he says, trying to lift my spirits,[1] "Your nomination for the Saint Barnabas Medal is big news in Cyprus. Don't let the attitudes of a few ruin this moment for you."

Opening the envelope, I see an eight-page manifesto from Van Rijn, laying out his case of lies against me, which has been distributed to the attorney general and the minister of foreign affairs. After reading the first few pages, I faint.[2]

My circumstances have all the makings of a Greek tragedy, which brings me to recall the myth of Psyche, known as the deity of the soul.

Due to the jealousy and manipulation of others, she loses what she treasures most. When she is sent to the underworld by Aphrodite on a quest to overcome impossible obstacles, Psyche proves in the end that her passion and commitment to the virtue of love is greater than her enemies' fear and desire to destroy her.

I have not come this far to give up now. From where I don't know, but I must find the courage to rise.

Twenty-Eight

IT'S CRIMINAL

1998

Refusing to be used like a Monopoly game piece by Van Rijn, I cut off communication with him. My instinct is that he will not be able to stay away for long, and right now cutting him off is my only defense.

After reading my Munich statement, the attorney general requests that I come to London to discuss it. "I wasn't aware of how much you did," he says in our telephone conversation, which gives me hope that I might be able to improve the relationship with his office.

Meanwhile, I put my energy into locating the real Andreas mosaic, which remains a mystery. Peter Kitschler has the key to the safe that Van Rijn gave me, but that's all we have. Over the years, Van Rijn has told me different stories about who is in possession of the Andreas mosaic, from giving it to his Montenegrin bodyguards in exchange for payment to it being ostensibly owned by a German doctor who lived somewhere outside of Munich. I search

through my earlier notes to see if there is anything that I might have missed and there, in a file for dealer Robert Roozemond, I find a card for a doctor in Munich named Schmidt. His name was given to Mr. Kyprianou and me when we first met with Roozemond at his gallery back in 1988. Roozemond had described Schmidt as a man who collects Byzantine art. Could Schmidt be in possession of Andreas?

After making further inquiries with a Dutch journalist, he provides me with a recent photograph of the Andreas mosaic in Van Rijn's possession. I forward a copy to Papageorgiou, who confirms it to be a fake Andreas, and send it on to Peter Kitschler, the Cypriot government, and the police. The fake Andreas I believe is in Van Rijn's hands. It may or may not lead to the real Andreas mosaic, but once Peter Kitschler has the name of the doctor he begins a search, as we will need the fake Andreas to prosecute Dikmen for selling a "forgery."[1,2] The Bavarian police continue to ask for my statement.[3,4]

꧁

It's a cold, gray January day as I make my way to meet the attorney general who is visiting the Cyprus High Commission office on Princess Street, near the Oxford Circus tube station in London.[5] Stella leads me into a conference. Attorney General Markides joins us moments later. After a cordial greeting, he gets down to business.

"David Hole, and Polak, can find no reason why my statement should be withheld. As a Dutch citizen I am free to release it, and the Germans are pressuring me to send it. I'm feeling a bit pulled in all directions."[6] I say respectfully.

"The archbishop and I took a major risk in executing the Munich sting," he says.

"Sir, with all due respect, the archbishop is the one who put everything on the line by placing his trust in me."

The attorney general looks at me, and then his watch. "Stella, would you finish with Mrs. Hadjitofi, please." Barely looking at me, he says, "Good day," and exits.

Stella and I are now left to battle over the wording of my statement.

"Here," she says circling a sentence. "Change this to say, 'Under the instruction of the police.'" she says. There are circles throughout the statement, so I read it again carefully.

Not believing my own eyes, I ask for clarification. "Stella, you have circled every place where I say that I report to the Church and the archbishop."

"Yes, that's exactly right. You are an agent of the police."

They want me to change the wording of my statement to accommodate their need to expand their role in the operation.

❧

While I'm in London I learn that the attorney general's office has requested that Peter Kitschler postpone raiding Dr. Schmidt's residence in Munich for a few weeks. The delay is now timed so that the raid will take place coincidentally between the first and second round of presidential elections in Cyprus.

"They are trying to skew my statement to read that I was an instrument of the police and not the other way around," I say to the archbishop, whom I call before boarding a plane back to Holland. The archbishop responds in turn by sending the government and police copies of my power of attorney to remind them that, like it or not, I speak for the Church and they will have to work with me.[7]

The Munich case comes to a standstill. The attorney general's office still has not released my statement. The Cypriots are intimating that if I do release my statement to the Germans and anything goes wrong with the criminal case, it will be my responsibility. Mr. Papageorgiou's list of which stolen artifacts belong to Cyprus also remains on hold in his office. The more time that passes, the less likely it will be that Aydin Dikmen will want to strike a deal with the German police, which means that the return of the artifacts could be exposed to counterclaims. When Attorney General Markides places a gag order on me with the press I find it confusing. The Bavarian police told me exposure in the news is what will keep me safe.

The opposing direction causes great distress.

I revise my statement based on suggestions from our lawyer in Germany and call the attorney general's office for his comments. Stella responds with a fax that has a slightly threatening tone: "Do not send your statement to the Germans without our approval; if you do the case will be your responsibility."[8] I write to Stella saying please tell me what detail you want so I can sign it and send it off. No response.[9]

March is upon us when Peter Kitschler phones me from Munich in a state of panic.

"I don't understand what they are waiting for, but I'm going to contact my counterpart of the art crime unit of the Netherlands Interpol to inquire if I can get your statement as a Dutch citizen. Do you have a Dutch passport?" he asks.

"Peter, I would be considered a traitor if I release my statement to the Dutch without Cyprus's approval. I will forward the information on to the Cypriots and ask them to contact him."[10] The irony of this situation is cutting. If I give my statement to the Bavarian police, it will feel as if I committed an act of betrayal against the Cypriot government, and yet if I don't cooperate with the Bavarian police, they will fail to prosecute Dikmen, and the return of the artifacts will become caught up in a civil trial.

The Munich case is headed for disastrous results. Something has got to give, so I let go.

I write to Bishop Vasilios, telling him that I am withdrawing my participation in the Munich case. I'm not willing to falsify my statement for anyone. Minor edits are fine, but I will not compromise my truth. If the government wants me to testify, I will. If they choose not to use me as a witness, my involvement with the case will now cease.[11] At this point, unless a higher power intercedes, the future of the Munich case lies in the path of failure.

⁓

An urgent call to my home from the archbishop signals trouble.

"Tasoula, every day the police and attorney general's office come with a new complaint. They say that you are interfering in the case and you are

withholding evidence. They are going to incriminate and discredit you. I want you to come to Cyprus with David Hole. And please, no meetings with these people unless Bishop Vasilios is present with you." I go to Cyprus with David Hole three days later.

At the palace with David Hole, the archbishop, and Bishop Vasilios, we receive confirmation that the Cypriot government does not have sufficient evidence for an extradition. The Cypriots could not link Dikmen to the actual stealing of the artifacts and now the Germans are failing to prosecute Dikmen in Germany because the Cypriots refuse to release our statements.

"Don't worry, I will stand by you," says the archbishop, which brings me to tears. He calls his secretary Demetrakis into his office and says, "When Tasoula is in Cyprus, I want you to stand by her as you would me. Be the first person she sees when she arrives at the airport and the last one before she boards her return flight."

Demetrakis is experienced around these types of situations. He was the man that former President Makarios III depended on while he was in exile. Demetrakis, a man of few words but sturdy character, bows his head in agreement. The archbishop turns to Bishop Vasilios. "Van Rijn fears Tasoula. If we place Polak in charge of handling her statement and the dispute with Van Rijn, it will give Tasoula a layer of protection from those who target her."

"Your Beatitude," I say, "I feel terrible about what is happening here."

"Take a step back. Allow me to sort this out. It will be all right," he tells me. "The humble soul is blessed. Go in grace, my child."

༄

A perfect sun sets over the Saint Raphael Marina in Limassol, where I am sitting with my parents having dinner at the Sailor's Restaurant in Cyprus. I hope the serenity of the sea and the nurturing warmth of my parents help to create a perfect ending to an otherwise horrific day.

"You don't look well, Tasoula. Is everything okay? You are much too thin," my mother says as she passes me a basket of bread. Since Munich I

have lost at least twenty pounds, and stress is preventing me from gaining any of it back.

"I'm fine, Mom. It's the dress that makes me look skinny. I'm going to buy five more of them," I say, laughing, trying to take her keen eyes off of me. "How are Miriam, Yiola, and Andreas doing?" I ask, placing the focus on my siblings.

Dishes of freshly grilled tuna, salmon, and shrimp are placed before us, as we dine in a nirvana-like setting. Watching the yachts sailing into the harbor to moor for the night, I'm able to forget my troubles for a few hours as we enjoy each other's company.

We leave the restaurant and walk to the nearby St. Raphael Hotel, a five-star resort, where we have a nightcap before calling it an evening. Dad pulls me aside. "I don't want to see you in this state when you come next. Get hold of yourself and whatever it is that is causing you to lose weight like this." This moment reminds me of when I left Cyprus at seventeen years of age to make a new future for myself. I was scared out of my wits, and he knew fear would cloud my judgment. His no-nonsense approach laid the law down. "Don't shame the family. I'm counting on you," he said.

I leave Cyprus on February 10, unwilling to let this situation impact my health any longer. Instead, I quiet my fears with the thought that I am in the hands of the best possible people. My bond with the archbishop is unbreakable, and I trust him.

<center>⁓</center>

By the end of February all of my files detailing my repatriation work have been copied. One set of copies has been placed in Polak's office vault and another is in my safe at home.

Polak informs the Cypriot police that they can review my files in his office at their convenience. Neither the police nor anyone from the attorney general's office ever review the files. Nonetheless, the attorney general declares in a letter to the archbishop that I am responsible for their key witness—Van Rijn—leaving Cyprus.[12, 13]

꧂

Circumstances continue to go from bad to worse when Stella Joannides receives a letter from the law firm Schilling & Lom, acting attorneys for Van Rijn, threatening legal action. He claims he was promised a casino license, free land on which to build it, between one and two million euros, 10 percent of the value of what was recovered in Munich, and thousands of dollars in expenses. He is also asking for additional monies due to an incorrect exchange rate, and he threatens to place a claim on the Munich artifacts if he is not paid.[14] Van Rijn is also claiming that he was instructed by the Cypriot police to lie under oath about purchasing the fake Andreas and that the government jeopardized his safety when the police took information he gave them in confidence and raided dealer Dritsoulas's gallery in Germany without his consultation. Van Rijn claims he has evidence to compromise the police and attorney general's office and that he will release the taped recordings of telephone conversations to the press.[15]

In a February raid on Dritsoulas's gallery in Munich, the Bavarian police recovered another pair of Royal Doors; these are from the church of Ayia Paraskevi in Angastina, authenticated by Mr. Papageorgiou. Dritsoulas's attorneys will not release the doors to the Cypriots. His lawyers want proof of ownership. Yet the attorney general's office continues to resist clarifying their position as to when the evidence will be released to support the restitution claims.[16]

"My words are intended to support you, so please do not take what I have to say as if it is sprinkled with bitterness," says the archbishop.

"Of course," I respond.

"I want you to know that it doesn't matter to me what you promised to Mr. Van Rijn. I will do whatever you ask. Do you understand?"

"Your Beatitude, I know that the attorney general is putting immense pressure on you. I beg of you, please, do not agree to pay Van Rijn any more money. If you cave in to his demands now, you will place the Church and me in even more jeopardy. You must trust me on this."

"I wanted to be sure, Tasoula," he says. "This is the last time I will ever question you."

I am alone in this like I was in the war, except as a child I could never see or feel God's presence, but now I do—he is in the faces of the bishop and the archbishop.

Twenty-Nine

CIVIL UNREST

Feeling that my world has turned upside down, I look for a way to reverse it as circumstances continue to work against me.

The case of the Royal Doors in Japan and whether the Church plans to press charges against Mr. Roozemond and the Kanazawa College of Art is still pending. Proceedings against Robert Roozemond will have had to be initiated before the Dutch court can file a claim against Kanazawa College. A suit will be a lengthy process with an unforeseeable outcome, and we conclude that it does not make practical sense to proceed. Roozemond never addressed Papageorgiou's request to identify the doors in person, but he and his legal adviser offered other options to Papageorgiou, which, they claim, went unanswered between 1991 and 1995. Roozemond claims this to be ample time to wait for a response before selling the Royal Doors to Kanazawa College. These facts, according to Mr. Polak, could weaken our case.

The archbishop and I fought incredibly hard for the return of these doors, but I'm afraid this is a fight we must surrender for now. This is an example of how dealers find loopholes in the law to legitimize the sale of illicit property. It is not just the dealers who are at fault here, it is all those who create a demand for these objects, who do a bare minimum of due diligence in

investigating the legal status of what they are purchasing. I may have lost this battle, but the war is not over.[1]

<center>⊷</center>

Aristotle said, "Fear is pain arising from the anticipation of evil."

Just as the Cypriots have no case for extradition, there is also no evidence to back up their claim that I am the cause of their failings in Germany. The sting and the opportunity to bring these artifacts home should only have been cause of celebration.

The archbishop's advice to have Polak take over the handling of negotiations with Van Rijn had all parties treading more carefully. The attorney general's office of Cyprus continues to withhold evidence requested by the German authorities.

As my representative, Polak responds to Van Rijn's attorneys concerning issues involving me. The remarks made by the attorney general are his unsubstantiated interpretations of the arrangement made between Van Rijn and the Church. His office is not only siding with Van Rijn; they are working in alliance with him. Van Rijn's testimony was never a condition of the agreement I negotiated with him for the Church. The Church's purpose is to recover the artifacts. The attorney general's position is to prosecute. It is the police and attorney generals responsibility to retrieve a statement from Van Rijn.

There is an obligation on the part of the state to share Mr. Papageorgiou's official reports identifying the artifacts for Cyprus with the Church's attorney in Germany. Without documentation and proof of what Munich artifacts belong to Cyprus (Papageorgiou's report), the church cannot repatriate its stolen artifacts. Attorney David Hole formulated a claim in October of 1997 on behalf of the Church and the state to obtain possession of the artifacts, but not having Papageorgiou's report places us at a dead end.

Every one of Van Rijn's accusations against me is disputed as lies and backed up with evidence.[2] Polak forwards a response to Stella and notifies her that the Church will be dealing directly with Van Rijn's attorneys.[3]

As April descends upon us, we are told that the Cypriots and the Germans will need Van Rijn's direct testimony in order to prosecute Dikmen. Hole

suggests revisions to my statement; I implement the changes and forward it to him a day later.[4]

⚜

Hearing a fax arrive, I walk over to the machine to investigate.

"Tomorrow is my late father's birthday. You remember, the man you were going to visit and subsequently call by phone? Signed, MVR."[5]

Van Rijn is signaling me. Here is my opening to lure him back to the negotiating table.[6] Polak responds that we are open to meeting with Van Rijn and his lawyers. Unbeknownst to them, we are prepared to make a deal for the difference in the exchange rate in return for the fake Andreas. Polak puts off Van Rijn's attorney after he makes outrageous preconditions. Van Rijn sends me copies of correspondence that Stella sent to his attorney. In one letter she guarantees he will receive $44,597, which is not part of any agreement I made with Van Rijn.[7]

⚜

When an invitation from the Greek minister of foreign affairs to be a guest speaker in Athens at the International Day of Museums arrives, I remember an ongoing civil case that the Church is involved with in Greece, and write to the Church's attorney for an update. The case involves an icon, "The Enthroned Virgin Mary and Child," which originated from the iconostasis of the monastery of Antiphonitis in the village of Kalograia and looted during the invasion of Cyprus.

The Enthroned Virgin Mary icon was exhibited on loan from Panagiotis Pervanas in the Byzantine & Christian Museum in Athens in 1984.[8] Pervanas, a Greek who lived in Switzerland, purchased it from Sotheby's. Archeologists recognized the icons in a catalogue from Petsopoulos's exhibition as being stolen from Cyprus and reported it. The Church began a civil case against Pervanas in 1993.

No one thought to invoke the Convention for the Protection of Cultural Heritage in the Event of Armed Conflict (the Hague Protocol). If I can get

Greece to invoke the protocol in this case, we will get the icon returned, and it will set precedent for the Dutch to invoke it in the Lans case, which is still ongoing. In light of this new development, I go to the Greek minister for culture, Evangelos Venizelos, and ask for his assistance. He confirms that Greece is part of the treaty and that I should meet with him in Athens.

After several weeks, Minister Venizelos has still not invoked the treaty.[9] I call to discuss the matter with the archbishop.

"You must contact the president of Greece and tell him that he cannot ask the British for return of the Parthenon Marbles with one hand and deny invoking the protocol for Cyprus with the other. How can Cyprus ask for the application of the treaty in Holland for the Lans case if we are not demanding it of Greece?" I say.

"This is why you are a target," says the archbishop. "You put everyone else to shame in the way you think," he continues. "Send me a note and I'll get it to President Stephanopoulos."

I write a summary of the case, which the archbishop forwards to the President. A short time later, the ambassador of Greece notifies the archbishop that the Greek government will be returning the icon of the Enthroned Virgin Mary to Cyprus. Case closed.

<p style="text-align:center">⁕</p>

Concerned, the Cypriots have not provided proof of provenance regarding the Munich evidence after seven months' time, I write to the minister of foreign affairs asking for his intervention. The Germans will only consider extradition of Dikmen after he has been prosecuted in Germany. Dritsoulas is about to put a counter claim on part of the Munich artifacts. The Dutch and German lawyers of the Church are advising that a clear distinction be made between the civil and criminal case and suggest that we appeal for the return of the artifacts to the Germans as quickly as possible. Both the archbishop and I are extremely fearful about the fate of the artifacts.[10]

After months and months of waiting to receive comments from the attorney general's office about my statement, it arrives in the form of two sentences. Polak sends my statement back with revisions and informs them

that if they don't send the statement within the week, we will send it directly to the German authorities ourselves. The Cypriots do not comply with a May tenth deadline, and so we proceed."

<center>⚜</center>

As the last days of June fade into July, Van Rijn returns.

"Forget about lawyers. I want to meet with you alone, behind customs, at Schiphol airport," he says.

The game is back on. I get advice from a friend who works at Interpol on how to tape Van Rijn and rush off to purchase a recorder at a spy shop in Amsterdam. Van Rijn will ask me if I am recording him, which places me in a moral dilemma. How do I justify lying, and will Van Rijn, who is such a good reader of people, be able to see that I am? The archbishop advises me that what I am doing is in self-defense, and that helps me to cope.

I drive to Schiphol, buy an airline ticket to London, and meet Van Rijn behind the customs area.

He's seated at a table by the self-serve coffee shop. I slowly take my seat, moving in confidence, looking him in the eyes.

"Are you wired?" he asks.

"Would I do something like that? You are the one who wires!" I respond with my Greek/Dutch/English accent deliberately played up, breaking the ice and making him laugh.

"Why did you do what you did to me?" I ask in a more serious tone.

"You left me no choice. I have kids to feed. You made me believe that every Cypriot is like you!"

"You tried to destroy me, Van Rijn," I say, looking directly into his eyes.

He goes on making excuses until I can't bear to hear another word.

"I never lied to you. Never made a promise I didn't keep. Do you have any idea what you put me through?" I say.

His facial expression tells me he's about to confess when my mobile phone rings. It's Michael warning me that the tape recorder is about to go off and I should excuse myself to go to the restroom to flip the tape.

"Michael needs me. Would you excuse me?" He graciously encourages me to take the call. In the restroom I flip the tape, refresh my lipstick, and return to the table.

"I'm waiting for you to answer me, Van Rijn. Why did you lie to the authorities and tell them I promised you a casino, land, and more money?"

He looks at me, and I can see he feels bad.

"I'm sorry. I had to discredit you to get you out of the picture, so I lied about the casino and the land. You never promised me those things. Nor did the archbishop. I felt I deserved more than I got. Munich was such a success, and I had nothing to show for it. I am sorry for everything I put you through. I'm desperate. I've burned my bridges and can't go back to my old life. I need money." I breathe easier now knowing that I have proof that he lied on tape.

"Do you have any idea how your people talk about you?" he asks.

I don't respond. At the end of the day, I still wear the hat of an honorary consul.

"I can damage your government badly with what I have these people saying on tape. It will destroy your government's image if it gets out to the press," he says, as he hands me a letter that Stella wrote to his lawyers. In it she states that I am working on my own and never had the authority to speak for the government of Cyprus. Stella even suggests that Van Rijn go after me if he does not get the money he is owed.[12]

"I have Tassos on tape asking me to lie to the German authorities and Stella guaranteeing that the attorney general's office will get the Church to pay me money."

"I don't believe you," I say. He pulls out a tape and plays it for me.

"Yes, Van Rijn. She is an impossible woman and she has caused you a lot of harm. The attorney general has just put her in her place with the media. The minimum amount you will receive is $44,597. That is now agreed."

It seems to be Stella's voice. I'm devastated.

"When are you going to give me the fake Andreas, Van Rijn?"[13]

"Stella promises the Church will pay me $44,597 and there is no mention of getting the fake Andreas in return. Unless the Church pays me additional money, I see no reason to return it."[14]

"The Church will not be blackmailed, Van Rijn, under any conditions."

"Pay me some money and I'll give you the tapes. I guarantee you will change your mind when you hear the evidence," he says.

"It is the fake mosaic I am after."

"Then I'll see you in court," Van Rijn says.

᪣

On July 16 I fly to Munich with Polak to deliver my statement to Peter Kitschler. While we are there, we meet with David Hole, who informs us that Van Rijn's lawyers are filing an *ex parte* application to freeze the Munich assets in anticipation of a judgment against the Church of Cyprus and the Republic of Cyprus. The timing couldn't be worse as the question of voluntary return is being presented to Aydin Dikmen's attorney. Van Rijn is in the process of trying to sell the tapes of Stella and Tassos to Dikmen's attorney, just as he tried to tape our conversations and work both sides of the fence during the Peg Goldberg Kanakaria case in America.[15]

David Hole briefs us. "In order to establish that a person is trafficking in Germany, the prosecution has to prove that the objects have been in the subject's possession for less than ten years or there must be evidence that a connection between the subject and the thief exists, which in Dikmen's case cannot be proven. The only link we have to prosecute Dikmen is Van Rijn and his collaborators who were already guaranteed anonymity. Dikman's continued silence poses additional obstacles. The Germans will probably only be able to prosecute Dikmen for representing that the fake Andreas mosaic was real and believe that Van Rijn's testimony will not offer evidence in regard to trafficking. Dikmen can be charged with perjury for not reporting the artifacts found in his possession on October seventh. During the Kanakaria case, he was convicted of tax invasion for which he received a suspended jail sentence. If he is convicted on the forgery charge, the suspended sentence will go into effect."[16]

The attorney general's office forbids David Hole to give us access to the eight binders of provenance evidence prepared by Papageorgiou, which David Hole will be presenting to the German authorities.[17] Having to deal with

his two clients, the Church and state, separately has posed an extenuating conflict of interest for Hole.

<center>⛥</center>

Even with one foot in Cyprus and the other in the Netherlands, I manage to keep the peace on the home front. Michael understands my situation and the dilemma I face trying to get the Munich case back on track.

Van Rijn is in the catbird seat. We hope to get his statement about the sale of the fake Andreas, but he will be angling to get paid for it. The question is how little can we get away with giving him. As I leave for the airport, a fax comes in from David Hole. Van Rijn's attorney is threatening to issue a court order to place a hold on the artifacts in Germany until his claims against the state and the Church are resolved.[18]

<center>⛥</center>

Cyprus in July means cloudless skies, intense heat, and celebration of Commandaria, a sweet dessert wine made in Cyprus from sun-dried grapes in an ancient style of winemaking that dates back to the twelfth century.

Arriving at the palace in Nicosia, I am struck by the archbishop's appearance. He looks tired and thin as he leads me into the study in his private quarters. I feel guilty burdening him with anything more than he is already carrying at the moment.

"Your Beatitude, you seem troubled. Are you feeling all right?" I ask, but he doesn't answer me. He continues to stare off into space as he stirs his tea.

"Your Beatitude," I say gently, trying to coax him into conversation.

He turns his attention to me but seems distant.

"I would like to seek medical consultation in the Netherlands. Would you consider arranging an appointment for me to see someone there? I can't risk a doctor's visit here; it will be all over the newspapers the next day."

"Of course. When do you want to come?"

"Let's get this Munich case into the secure hands of another attorney and settle the dispute with Van Rijn first."

"Bishop Vasilios should be present at all your meetings, don't you think?" I ask.

The archbishop agrees.

Smiling, he says, "It's useless to try and beat these people at their own game. It's time to make new rules."

"Okay," I say.

"I'm calling a meeting between the Church and the government, but in essence it will be in the spirit of a truce. The attendees will be Bishop Vasilios, the attorney general, Tassos, Stella, Mr. Polak, Mr. Hole, and myself. I want the government to believe that I have crossed over to their way of thinking. Your absence, in their minds, will make them think that you are no longer in charge."

"I don't understand," I say.

"If you are out of the picture it will give me a chance to place Polak in charge."

I love the archbishop's ability to see the situation from two diametrically opposed ways of thinking and design a plan that could very well derail the stalemate between us and the Cypriots.

❦

A ringing phone wakes Michael and me out of a dead sleep. I quickly grab the receiver and head downstairs so as not to wake the children.

"For your own good, listen to this!"

I then hear Van Rijn playing me excerpts from the tape recordings he's made of the police and Stella. He also plays me a conversation he has had with Dikmen's attorney whom he tries to strike a deal with.

"Who else would give you the benefit of hearing this!"

Tassos and Stella trade insults about me.

The Church's position is compromised. Van Rijn can now try to extort additional funds.

❦

AUGUST 24, 1998, THE ARCHBISHOP'S PALACE, NICOSIA

The archbishop, Bishop Vasilios, Attorney General Markides, Stella Ioannides, Tassos Panayiotou, Mr. Hole, Mr. Polak, and two additional police representatives, who are not identified, arrive at the archbishop's palace at high noon. The attorney general lays out the state's position.

"Convicting Dikmen for the looting of the artifacts is barred by statute in Germany, which means we cannot get approval to extradite him to Cyprus. We can try him for selling the fraudulent Andreas, but we will need Van Rijn's cooperation in order to get Lazlo's testimony."

"What about the perjury charges?" asks Polak.

"Yes, Dikmen made statements under oath in connection to a tax debt for which he can be prosecuted," the attorney general continues.

"Van Rijn has agreed to testify, to get Lazlo to testify, and to cooperate in returning the fake Andreas for an additional sum," says Stella. "Both Tassos and I recommend that the Church negotiate with him on this matter," says Stella.

"It's really not something the Church feels it should pay money for," says Polak "Mr. Van Rijn seems to think the Church and the Republic are not operating from the same front."

"Our office does not support Van Rijn," says the attorney general.

"That is not the fault of the Republic. This is coming from the Church," adds Stella.

"Apparently, your office does act as an intermediary for Van Rijn," says Polak. "Van Rijn knew about this meeting today. He didn't get that information from me. Your office is recommending that the Church negotiate with Van Rijn," says Polak.

"There is a discrepancy between the information given by Mrs. Hadjitofi and that given by Van Rijn," says Markides.

"I find it curious that you regard the statements of Mrs. Hadjitofi and Mr. Van Rijn to be on the same level," Polak tells the attorney general. "Mrs. Hadjitofi's statement is backed up with documentation to your office, to the archbishop, to the Ministry of Foreign Affairs. Mr. Van Rijn has no proof and no witnesses."

"You should pay him. He can provide additional information," says Stella.

"Under whose authority was he told that he would be paid this $44,597? This is not part of the Church's deal with Van Rijn," asks Polak.

"The archbishop approved it," says Stella.

Polak replies, "Please, this was promised to Van Rijn in a letter from your office on May twenty-sixth. You committed money to Van Rijn on the Church's behalf on your own authority." Polak exhibits memos that Van Rijn forwarded to the Church backing up what he has just said.

"Mrs. Hadjitofi has disrupted an action by the Cypriot authorities in Greece!" says Stella, which gets a smile out of the archbishop.

"I'm not aware of any facts supporting your allegation," says Mr. Polak.

"It's not an allegation, it's a fact," says Stella. "Nothing will be put in writing."

What Stella refers to is my trip to Greece to recover the Enthroned Virgin Mary icon.

Mr. Hole presents a summary of the meeting. All parties agree that a civil case should be avoided. It is decided that Polak will be acting on the Church's behalf and will take the lead in negotiating. Van Rijn will receive $44,597, for which the Church wants conditions stipulated, but the attorney general's office does not. The Church is now in charge again.[19]

❦

My phone is ringing.

"I hear you are back in charge, woman!" reels the voice of Van Rijn when I pick up the phone. "Congratulations."[20] Van Rijn knew the outcome of the meeting even before I did.

Van Rijn and Polak have several phone meetings, but Van Rijn produces no evidence to justify his claims. He played tapes of Stella where she tried to minimize the roles of both the Church and me in the Munich sting operation. Van Rijn complains that he risked his life in pursuit of the Cypriot artifacts and that he will settle now for replace with $545,000. This is typical Van Rijn. The settlement number will continue to change by the hour.

I've had about all I can stand. On the twentieth of September, Polak and I meet with Van Rijn once again at the Hotel des Indes.

"Do you maintain the same legal position that Mrs. Hadjitofi and the Church promised you a casino, land, and additional money?" asks Polak.

Van Rijn is not as chipper and confident as he was the last time I saw him. "I had a heavy drinking problem at the time. I don't recall what I was promised," he says.

Van Rijn will always tell me one story when we are meeting alone and another when there are others involved. Now that Polak has the authority to strike a deal with Van Rijn, his natural inclination is to try to get maximum dollar out of the Church. Mr. Polak fleshes out his arguments, then I go in with a bottom line number to strike the deal.

"There has been a slight change," he says. "I had to borrow money. It was necessary for me to pledge the fake Andreas against it."

"Are you in a position to physically deliver it?" I ask.

"Yes," he responds. "I can deliver the fake Andreas, Lazlo's testimony, and I'll drop all litigation for a payment of one hundred fifty thousand dollars."

"We will have to get back to you," says Polak.

"This is take it or leave it deal," says Van Rijn. "I'm not interested in a lower offer."

"We will have to get back to you," I repeat, as Mr. Polak and I stand to leave.[21]

The next day, Van Rijn meets me at Polak's office.

"Here's our take it or leave it deal," I say. "We will pay you a hundred thousand Dutch guilders ($22,207), plus I'll reimburse you for your flight to Holland, in exchange for delivery of the fake Andreas, a guarantee that you will get Lazlo to testify, and you agree to drop all charges against the Church and the Republic of Cyprus." He looks at us, realizing we will not budge.

"Where do I sign?" asks Van Rijn.[22]

<div align="center">❧</div>

September 25, at the Hotel des Indes, at our usual table, Mr. Polak and I meet Van Rijn for the turnover of the fake Andreas.

"We did it, you and I," Van Rijn says as he pushes a cardboard box across the table toward me.

"And Lazlo?" I ask.

Van Rijn responds, "I promise. He will testify. You tell me that I never give you something for nothing, so here it is." Van Rijn pushes a box of thirty-five audiotapes across the table.

He has turned over all of his recorded conversations with Stella Ioannides, (Attorney General's Office), Tassos Panayiotou (Police), Marios Andreou (Police), Marios Matsakis (member of the Cypriot Parliament), and Aydin Dikmen's lawyer.[23]

"What I do for you I do for no one."

His words stun me. *Why?* I think to myself. I can't give what I don't know how to give! I'm a person who focuses on what still needs to be done and does not appreciate the accomplishment in the moment. This is in part why I could not give the approval to Van Rijn that he so desperately seeked. On the other hand, withholding is also part of my strategy, because his help came with a price.

◈

On October 27, Polak submits a written summary of the Lans argument to the court. Now we await the verdict.[24] I also take great pleasure in sending a signed agreement where Van Rijn admitted he lied to the minister of foreign affairs and the director general of the Ministry of Foreign Affairs, which clears my name. I have waited for this moment since that awful day in in December of 1997 when Van Rijn discredited me in front of the police and the attorney general's office. Van Rijn admitted that his only way to get more money from the state and the Church was to remove me as possible interference. Van Rijn told me he was shocked at how easily the attorney general's office and the police were willing to take his word over mine. I've heard the taped conversations, and they do not reflect well on the people involved. There are no winners in this situation.

I reported to the attorney general that I was in receipt of Van Rijn's taped conversations and offered to forward them to his office but received

no response. Van Rijn continues to try to get back in my good graces. He faxes apology notes almost daily along with tips about stolen artifacts. I do not reply.

<center>⚜</center>

As Socrates said, "One thing I know, that I know nothing. This is the source of my wisdom."

After five years of trying to get pregnant I finally succeed. The news couldn't come at a worse time, but I have always been told that God does not give us more than we can handle. Michael is euphoric, and he deserves to feel this way. Please, God, I pray, don't let anything happen to this child.

<center>⚜</center>

The public prosecutor in Munich, Mr. R. Alt, a man with a friendly disposition, greets Bishop Karayiannis Vasilios and me in the reception area of his office with a warm smile. The assistant prosecutor and Officer Siemandel, who worked with Peter Kitschler on the Munich sting, are also present.[25]

"This will help in the prosecution of Dikmen," says Alt.

"I would like to request a receipt for the fake Andreas, please, with a note that it will be turned back over to the Church after the termination of this prosecution," I say.

"Of course," Alt responds.

"Dikmen has not consented to the return of the artifacts to Cyprus. We can now confront him with the fact that we have the fake Andreas and see if this helps to sway him," says Alt. "If he declines, we will try to reach a settlement by mitigation of the charges in return for his consent to return the artifacts," says Alt, confident that our chances are good.

"Will our bargaining position improve if the Church litigates against Dikmen for the nine hundred seventy five thousand Dutch guilders ($500,000) that Van Rijn paid to him through the intermediaries during the initial phase of the sting?" I ask.

"Unfortunately, the bills were never marked so they can't be traced back to the Church," he says.

The expression on his face shows his thinking.

"You can't prove it. Besides, Dikmen's money is held in a private limited company in Turkey. It will be difficult for the Church to attach any claim on Dikmen's possessions, as the German tax authorities have a higher priority on any claims."

"If Dikmen does not consent to the return of the artifacts, I would suggest the Church start civil proceedings," says Alt, providing information I would prefer not to have heard. "Right now we are waiting for Lazlo's hearing in the Dutch court. A trial for Dikmen in Germany will probably begin in November 1998.

Jan Fred van Wijnen could be a witness for the prosecution of Dikmen as he saw the fake Andreas in Van Rijn's car. I also have a tape recording of Van Rijn negotiating with Dikmen's lawyer.

We move on to a meeting with Mr. Kitschler, Mr. Siemandel, and other law enforcement officers including the Bavarian chief of police.

"Part of the deal that will be offered to Dikmen is that if he reveals the whereabouts of the real Andreas, we will agree to six months' less imprisonment," says Mr. Siemandel. I feel that the Germans are pulling for us. They have seen firsthand what the state has put me through, and their support is most welcome. To be able to find the real Andreas would help to erase the bad memories of the past year.

Before we head to the airport, we stop off in the basement of police headquarters where approximately a hundred artifacts belonging to the Church are stored. The eyes of the Kanakaria mosaic of Thomas follow me, calling me to take it home, but I must reluctantly leave it behind.

⁓

We speak to David Hole about getting a copy of the evidence that was submitted to the Munich prosecutor on behalf of the church, and he continues to send notes back to us that he needs the attorney general's approval. Hole represents the Church and the government yet we continue to be denied access to the evidence, and may have to take legal action to get it.

There is no rest for the weary. Van Rijn is furious that I have not publicized the tapes he gave me, so he threatens to go to a reporter who will take the tapes public.[26] It's not a matter of trying to cover them up as he claims. My goal is to get the artifacts back, and that is where I am concentrating my energies at the moment, not in exacting revenge. He notifies the German police, who now wish to have the tapes as well. I share only the tapes relative to Dikmen's attorney.[27]

The same day I receive a very upsetting phone call from the archbishop.

"Tasoula, I see the people and I recognize them but I can't remember their names."

"Your Beatitude, do you want me to come? I will get on a plane tonight and be with you in the morning."

There is silence.

"How can I help, Your Beatitude? Does the Holy Synod know?"

"No, not yet. I want to see a doctor first. Can you arrange it?" he asks.

"Yes, right away," I say, full of worry. I start planning how to get the archbishop out of Cyprus and into the Netherlands to receive medical attention. Socially, my network is extensive in the Netherlands and I know one of the royal house doctors personally, who would act with the utmost discretion. It is imperative that the press believes he is coming to Holland to finish business on the Munich and Lans case.

❧

Like the American Santa Claus, Sinterklaas has a long white beard, but the style of his long red cape makes him look more saintly than festive. For three weeks now Andreas has placed his and Sophia's shoes by the fireplace. Each night he sings the Sinterklass song before going to bed in the hope that when he rises there will be a small present or treat in each of their shoes. The final day of Sinterklass is now upon us. Tonight he departs Holland and I've arranged for an actor dressed like Sinterklaas to come to our home as a surprise for our children.

Not all is rosy. I feel terribly off today. I'm having terrible cramping and have Michael rush me to the doctor.

"I'm sorry, Mrs. Hadjitofi, I regret to tell you that you've had a miscarriage."

I take one look at Michael and start crying. I feel as if I'm a high-speed train that never stops until it crashes. I am so preoccupied with the return of these artifacts I am losing sight of the things that are most important to me. Yet still, I cannot stop, I cannot give up, regardless of what it is costing me, and I don't understand why.

"This is good news, Tasoula. You can get pregnant! You just need to finish with this Munich ordeal and get back to our life together so we can try again," says Michael.

Without his calm, sturdy, dependable support, life would have been much tougher for me.

Arriving home, just in time to see the joy on the children's faces as they sit on Sinterklass's lap to listen to a story, there is no time for regrets, only space for renewal.

Thirty

MAKING PEACE

THE HAGUE, 1999

Socrates said, "It is not living that matters, but living rightly."

The last several months have been backbreaking, culminating with my recent miscarriage. Losing this baby created an emotional earthquake, forcing me into a reflective state, questioning where I am at this stage of my life and if it is where I wish to be. Tragedy will do that to you. So will turning forty, which will happen in a few weeks. This birthday has found its way into my psyche, demanding that I take immediate inventory. Forty is the age where I should feel that I have "arrived." On paper, that is proven. In spirit, there is something still missing.

My innate drive to feed my soul with what inspires me has also left a trail of destruction in its path. I can justify all of my actions, both personally and professionally. My intentions are pure with no question or doubt. So what is it that I contribute to these situations that helps to keep me in this bubble of turmoil? Why is my insatiable appetite for justice met with such resistance?

Why, when I am on the side of right, can everything feel so wrong and go so wrong at times?

These questions are no longer the relevant ones for me to ponder. Part of me acknowledges that challenges must be overcome, and I battle to rise above them with the force of an ancient warrior. Another part of me understands that there is something in the struggle that I am meant to see and learn from in order to improve myself and become a better human being. It is the dynamic of these two parts that make me whole.

Struggle is what leads us to metamorphosis. Whether it's the silkworm that twists in a figure-eight position 300,000 times to produce one kilometer of filament or the process of a caterpillar morphing into a beautiful butterfly, it is the process of the journey and who we become in the face of it that matters. I realize that the peace that I am searching for still eludes me, so I commit to taking time to look at why—and pray that I will have the courage to embrace whatever it is I discover. The first step is in recognizing that there is a problem. Up until now I have been busy defending myself, the icons, and surviving one battle after the next. I feel I must step out of the line of fire and into the light of reflection.

My husband and my children have provided fertile ground for me to grow in my roles as entrepreneur, consul, and icon hunter, but they have sacrificed their own desires in the process of supporting mine, allowing me wiggle room as a wife and mother to explore my ambitions. When I am with them I give them my all, but I am not with them as much as they would like me to be. I'm very lucky, in that the miscarriage has brought Michael and me closer, when it could have broken us. The news that I am able to get pregnant helps me overcome my fear of being unable to give Michael another child. This time I will take care of myself. I decide to stop the speeding locomotive train that I've been driving before it crashes and can't get on the tracks again. Taking time out to acknowledge and celebrate my fortieth birthday seems like a good way to begin.

"What do you want?" asks Michael.

I think about it for a few days and decide that what would make me happiest is to celebrate with my parents and thank them for giving me life.

"You are sure this is what you want to do with your fortieth?" he asks again.

"Yes, Michael, and a special dinner with you and friends when I get back." Just like that, my wish is granted. He will stay home with the children and the nannies so that I will have a complete break from worrying about my responsibilities, and I make arrangements to go to Greece and take my parents with me. This will be their first trip to Athens and an opportunity for me to figure out what I will do with the rest of my life.

<p style="text-align:center">༺ঞ༻</p>

The Dutch court, however, is about to hand down its ruling in the Lans case. When we last left off, the MPs posed questions to the Dutch Parliament regarding the selling of looted Cypriot artifacts in Holland, citing the Lans case as a specific example. The MPs questioned why Holland has not invoked the Hague Convention of 1954, being that it is a signatory of the treaty, as are Cyprus and Turkey. Minister Sorgdrager replies that although the Netherlands ratified the treaty, the Parliament has not yet implemented it.[1]

On February 4, the Rotterdam Court rules against the Church of Cyprus.[2] The court rules that the Protocol, in order to be effective in the Netherlands, had to be implemented, which did not happen until 2007. The decision noted that the Church did not succeed in proving that Lans acted in bad faith at the time of acquisition because the price that Lans paid was substantial. Dergazarian was not known as an unreliable dealer at the time and it could not be concluded from the circumstances that Dergazarian collaborated with Van Rijn. The Court dismisses the claims of the Church.

It is devastating news. Polak, whose wife just delivered their daughter on February 2nd, is equally disappointed and shocked by the ruling. He pledges to reach out to a professor of law at Leiden University to get an opinion on whether or not to appeal the decision of the court of Rotterdam. For now, the four icons of the apostles Paul, Peter, Mark, and John looted from the monastery of Antiphonitis will not return to the Church of Cyprus, nor will they be welcomed by the thousands of people who long to pray with them again.[3] Instead, they will return to the Lans family.

The Church and I also reach out for a second opinion on the Munich case to Oppenhoff & Radler. We inquire as to whether or not it is possible to provoke a formal decision of the Oberstaatsanwalt Alt regarding the return of the Church artifacts and want to know their opinion on whether or not to contest the decision in the German courts. We inquire as to the cost and length of a civil procedure and whether or not we will have a financial claim against Dikmen as a way to place pressure on him through litigation. Last, we needed to know if it would make sense to litigate against Dikmen in order to effectuate an attachment of the third-party artifacts.[4]

✢

Arriving directly from the airport at the archbishop's palace in Cyprus, I am anxious about what condition I will find him in. He appears to be in great health and spirits. The Lans decision was not in our favor but, working quietly behind the scenes, I did manage to cheer him up with the recovery of an icon from the Antiphonitis Church which was discovered in the collection of Ms. Marianna Latsi (daughter of the Greek shipping magnate) several weeks ago. Unknowingly, she had purchased a looted fresco from the Antiphonitis Church (as tipped off by Van Rijn) in Paris from the Greek dealer Dritsoulas. After informing Ms. Latsi, she graciously agreed to return the icon to the Church. The archbishop was very relieved to secure the fresco without a lawsuit.[5]

"The Lans case is not over yet," I say. "Let Polak check into whether or not it will be worthwhile to appeal. It just doesn't make sense how the Dutch court ruled on this."

"How are you feeling?" he inquires. He is such a remarkable man. Here he is concerned for my well-being when he is faced with a possibly serious health challenge.

"I'm fine, actually, better than fine, and looking forward to taking my parents to Greece. Why don't you join us?" I ask, half serious. The archbishop laughs and for just a few minutes he is free from worry.

"Your Beatitude, one of the general practioners of the Dutch royal house, a lovely man, has agreed to absolute discretion. We are arranging for you

to come to the Netherlands. The details will be handled with the utmost delicacy. Give me a date and leave the rest to me."

The archbishop is a man who doesn't normally show his emotions. A man of his position, a leader of so many, cannot show vulnerability because he is the pillar for everyone else to turn to. Now I see the man behind the throne, and it makes me well up with tears to see how relieved he is to hear that he will be taken care of now.

This is a man who has placed his faith in me; now he places his life with me as well. He has come to me with his secret, and it is the greatest honor he could have given me. After everything he has done for me, I want to protect his good name as he has protected mine.

"Go to your parents," he says. "They will be anxious to see you. And give them my love."

<center>⌘</center>

My parents and I are having a wonderful time touring the Acropolis, built in the fifth century by the statesman Pericles and constructed in honor of the goddess Athena. The environment inspires us to delve further into our Hellenic identity. The sacred rock of the Parthenon built under the creative eye of sculptor Phidias tells the stories that past civilizations left behind for us to marvel at. Even as I stand among these great Greek sculptures while on vacation, I am reminded that the Parthenon Marbles were controversially removed from here and sit in the British Museum. One day I hope to see their return home.

This trip is all about spoiling my parents. I take them to port of Tourkolimano in Piraeus; I find the perfect open-air restaurant, built on a foundation that juts out from the pier into the water with a view of the mountains in the distance. The fishing boats are mixed in with the yachts and sailboats, and the activities of the boaters keep us entertained while we eat small plates of Greek delicacies like grilled calamari, red mullet, rock lobster, and grilled octopus. Sipping ouzo, my parents reminisce about growing up in the village of Mandres.

"She had her eye on me," my father says. "I was younger and not quite ready to settle down," he continues. "She was a seamstress and I was a tailor,

<center>323</center>

and our families thought 'perfect match,' and here we are," he says, oozing the natural charm that makes him the ladies man that he is. Even the young waitress flirts with him every time she brings us food. He has an irresistible smile and a character that is like catnip for women.

"You needed me to keep you in line," she fires back. "I made my own wedding dress," she tells me with pride. "The entire village celebrated with us for four days. There were several hundred people, Greek and Turkish Cypriots, and we danced for days," she recalls, smiling. Listening to my parents speak about the traditions of my culture saddens me, in that my own children will not have the same experience when their father and I grow old. Michael was raised in London and I in Cyprus. Now that we have lived abroad for all these years, our customs and traditions have become more Dutch influenced. There is a sadness I feel about not being able to carry forth these traditions in the same homeland that my parents carried them forth, as their parents did before them. It is in the sharing of these stories that I realize they must also be documented and recorded with the same care that the ancient Greeks took when building the Acropolis. The human experience, the narratives that showcase our customs and traditions, must be passed down with equal importance. The people of Cyprus are its most valuable hidden treasures.

"The next day our parents came to look at our sheets to confirm the marriage was consummated," my mother says, blushing. "That was the tradition," she adds.

"Then I had to take a chicken and nail it to the front door so that all the men would know to stay away from my wife, also a tradition," my father says, to the laughter of all three of us.

Sadly, there are no photographs to memorialize these events or our family life together in Cyprus. The war took everything from us, but thankfully we still have each other. As a bright red sun sets in the sky to close this unforgettable day, it appears to slip right into the sea as day turns into dusk. My parents have survived war and still stand, both individually and collectively. It is this example that reinforces the strength within me to finish what I set out to do.

It is our last night in Greece, and despite the fact that I have a queasy stomach, we must celebrate. I have fulfilled my dream to celebrate my birthday by paying tribute to my parents. I have also given myself a time-out to

think about where I want to take the next forty years of my life. What I come away with is that I have been living to work and not working to live. There will always be another stolen icon to recover or court case to investigate. Art trafficking is big business, and there are many greedy people in the world who have no qualms about selling someone else's cultural identity. I throw myself into these challenging situations with abandon, but lately I am under attack for it. You can't put out a fire when you're standing in the middle of one.

I wish the conflict with the few civil servants of Cyprus could have been avoided.

I was unable to see it at the time, but I was not willing to stand in Tassos's or Stella's shoes and view things from their prospective. When I am in a situation where I do not feel there is a leader present, I take charge. I did not trust in their strategy to bring the icons home to Munich. I had the support of the archbishop and I thought I had the support of the attorney general. Having the backing of both these influential men should have elevated the subject of repatriating our cultural heritage to be above politics, where it belongs.

In the end, the political aspirations of the attorney general and the reluctance of his office and the police to work in parallel with me impeded the return of the looted artifacts found in Dikmen's possession. In retrospect, I think that being so driven was a mistake. The justice I sought was for my country. I wanted the Turks to pay for what they had done to Cyprus during the war and for their continued occupation. I'm devastated by the disrespect the Turkish military showed my Orthodox faith. To this day the Christians of Cyprus must seek permission to perform religious services in the occupied area. Our religious freedoms are violated daily.

I recognize that if we cannot show each other empathy, regardless of whether we agree with each other's points of view, religion, culture, traditions or customs, there can be no opportunity for peace and reconciliation.

The Dutch, Greeks, British, Turks, Japanese, Cypriots, and Americans all profited from the destruction of our Cypriot cultural heritage because they fueled a demand for religious and cultural symbols. Greed does not discriminate. It crosses cultural lines and geographical boundaries; it impacts all faiths, nationalities, colors, and creeds. It is something innate in every human being. We can either choose to worship greed or choose to live by a

moral code that treasures our cultural past. It is only fitting on my last night in Greece that I set myself completely free from all of these feelings in a way consistent with my culture and tradition.

Breaking plates is a Greek folkloric tradition dating back to medieval times having to do with mourning and loss as well as conspicuous consumption. You must pay for every plate you break and tonight I will do so with pleasure. If I let go of the past, let go of everything negative that has had a grip on me—all the hurt, betrayal and frustration—I will be free and will have a fresh canvas on which to create anew.

We arrive at Syratki Restaurant in Athens, where inside a dimly lit room there is a handful of tables, a stage where a singer backed by drums, guitar, bouzouki, and mandolin perform Rebetiko, a style of urban popular song of the Greeks, especially for the poor class.

"*Tsifteteli*," I say, referencing a traditional Anatolian style. The leader acknowledges my request, and the music begins. As I take the center of the floor, people get up and push their tables away from me to give me space to dance. As a girl in Cyprus I danced all the time. I lift my arms up, throw my head back, and cross one leg over the other. I feel the rhythm of the music in every move I make. I dance the story, the story of my life. With each flick of my wrist, snap of my head, swaying of my back, I dance out the pain, anger, fear, disappointment, frustration, happiness, gratitude, and love. Some in the crowd clap and others throw flowers at my feet. With one quick pull I strip the table of its cloth, step onto the chair, then atop the table to dance some more.

My father rises from his chair and makes his way onto the dance floor, where he takes my hand. I step down from the table and join him on the dance floor. We dance together just as we used to around the campfire in Mandres when I was a little girl. Out of the corner of my eye I see my mother's face, also recalling shared memories. We break plates, dance some more, break plates again, all to the delight of the crowd, which cheers, "*Opa!*"

❧

Returning to Cyprus a new woman with a new vision, I learn that I am also pregnant. I take this as a gift, even as a sign of my own rebirth. I know

that my passion lies in protecting cultural heritage. I want to take the lessons I learned from Cyprus and spread them to the rest of the world so that others may share in the knowledge I have uncovered in the process. However, I need to approach it from a different angle. What the specifics of that path will be, I have not yet imagined.

I am euphoric over the news that I am to give birth again.

"Everything is going to work out this time," Michael says with the utmost confidence, and I believe him.

In mid-March, a scathing article is released in the *Cyprus Weekly* written by Attorney General Markides's brother-in law, George Lanitis. His "journal" professes the attorney general's innocence in the role he played in the Munich operation and refers to me as a "lone wolf" character that recklessly wasted the Church's money in my pursuit to recover the stolen artifacts. Every statement is painted with negativity and misrepresents the events surrounding the Munich case as well as the relationship between Van Rijn and me. Lanitis managed to secure a copy of the contract between the Church and Van Rijn and quoted parts of it out of context.[6] The archbishop wastes no time in responding to Mr. Lanitis.[7] He defends the claims made against me and informs the readers that every move I made was indeed sanctioned by Church and state.

I realize that regardless of how much I forgive and try to move on, some will continue to try to hurt me. All of a sudden, I am right back in the thick of the chaos.

❦

Arriving at the same hospital where I delivered my twins prematurely triggers the ghosts of births past. Because of my age, it is recommended that I get an amniocentesis. I'm five months pregnant now, as Michael takes my arm in his, energetically signaling that he will not let anything happen to me.

"I don't want you involved with icon hunting anymore."

"Don't worry, Michael, as you said, it will all be fine," I say, trying to reassure him. As I lie on the table and the doctor begins, I realize I am back at the same hospital getting the same test that ultimately led to my delivering

my twins prematurely. I hold my breath, begging God to let me have this baby with no complications. We are so anxious waiting for the results we spend a week in Korfu to try to calm ourselves. The test goes perfectly, and we are told that we are having a baby girl!

Arriving back to work is a breeze now that I know all is well with my little girl. The Munich case, however, is still tied up in a knot. The attorney general's office is still refusing to let us review any of the evidence they put together, and now we have no legal representation in Germany, as David Hole resigns due to a conflict of interest representing both church and state. Markides's office is also refusing to update us on the case. There is a serious risk of the Church losing control of the 350 artifacts currently in the hands of German police, because we have no idea what is happening with the case.

The attorney general's office and the Department of Antiquities now claim that, according to "a new law," the artifacts belong to the state and not to the Church.[8] I speak to several experts who contradict this, and I inform the archbishop. I'm dumbfounded by their lack of awareness and fearful that their actions may cause 350 priceless sacred artifacts to be lost forever.[9]

❧

I write to two law firms: L Papaphilippou and Co. and Tassos Papadopoulos and Associates inquiring about the new antiquities law, I am informed by both firms that no such antiquities law exists. The Church remains the owner of the sacred monuments and artifacts.

In addition, the Church, represented by Polak in the Netherlands, decides to file an appeal in the Lans case.[10] Unfortunately, we also lose the appeal due to statute of limitations.

I'm working from home on June third, when ambassador Zenon's driver delivers a letter to my office at Octagon. My secretary alerts me.

"It looks rather official and its in Greek," he says. "Shall I drop it off to you now?"

"Yes, please," I say, wondering what it could be.

"Madame," it begins, "I wish to inform you that it was decided appropriately that when you receive this letter your title as honorary consul in

The Hague and your services are terminated."[11] It continues, "The embassy is informing all the related Dutch authorities and foreign diplomatic missions in Holland. The secretary of the embassy will contact you to deal with the practical issues of stamps and anything to do with your consulate. I was given instructions to thank you on behalf of Cyprus for your services." It was signed by A. Zenon.

I called the Minister of Foreign Affairs in Cyprus to inquire whether it was his decision to terminate me and I am told that he is in China and will not return for another ten days.

It feels like a blow. I love my work as a volunteer diplomat. I am seven months pregnant, trying to take a leisure day at home to relax with my children, and this happens. I dial Michael at his office, weeping.

"Please come home, Michael."

He arrives minutes later.

He leaves strict instructions for the nannies, "No calls are to come in here except from the archbishop. Anyone calls from the government, Mrs. Hadjitofi is not available."

I have my office staff remove the consular sign from the front of my building, the one next to the Octagon Professionals sign, that I once took so much pride in. I instruct my staff to throw the sign in a box, with stationery, stamps, and anything else to do with the position, and deliver it to Ambassador Zenon's office.

I phone the archbishop and give him the news. "I'm calling the president! They can't do this to you," he says.

"Your Beatitude, I'm not interested in returning to the position."

The same day, the archbishop decides to decorate me with The Order of Saint Barnabas medal right away instead of waiting for the artifacts to return from Munich as it was originally planned. The Cyprus papers read, STATE DISMISSES CONSUL WHILE CHURCH HONORS.[12]

"I will not let them do this to you," the archbishop says terribly upset.

꧁꧂

On July 9, 1999, I receive the Order of Saint Barnabas gold medal. The ceremony is stunning. The Holy Synod created the medal in 1951 to honor

individuals who offer their services to their homeland and to the Church of Cyprus.[13] The speeches made on my honor are moving. The president of Cyprus attends, my parents are there, and I am completely humbled by the tribute.[14]

This medal was given to presidents, patriarchs, and I am the first and only woman to ever receive it. The archbishop asks to see me privately in his office.

"Thank you for today. To receive this award is quite special," I say.

"I'm going to ask that the president see us tomorrow to reinstate you as consul."

Smiling through my tears I say, "No, it's over for me." He pulls open his top drawer and pulls out a letter to the president of Cyprus. I take it from him and say, "This is all I need," holding up the letter. "To know that you are willing to meet with the president on my behalf," I say with tears flowing. "This is enough."

"No, it's not right what they did to you!" He smiles and says, "By the way, I'm feeling much better. Let's hold off with the doctor until after the baby is born. If things change, I'll call you."

"No memory issues? You're sure?" I ask.

"Everything is perfect," he says. "See to your parents."

My parents are waiting patiently for me in the hallway with Bishop Vasilios. My mother places her hand on my abdomen and says, "An angel is coming,"

Dad hugs me and says, "You'd better hurry before you give birth to that baby on the plane."

"Your Beatitude, one day we will tell our story."

The archbishop says, "You promise?"

He likes the idea. I can tell by his smile.

⊰⊱

Back in the Netherlands, the Association of Consuls in Holland throws a celebration to honor me, and more than six hundred people turn out. I purchase cups and fill them with sweets from Paphos, and under a picture of a broken fresco I have text inscribed to say, "The story they tell is the

story of every refugee. Tasoula Hadjitofi—A refugee from Famagusta." It was another magical moment.

I have more important things to look forward to in my life. At the doctor's office for a scheduled checkup a couple of weeks later, my blood pressure is too high and I am diagnosed with gestational diabetes. The baby is positioned low, and the umbilical cord has wrapped itself around her neck. I'm admitted into the hospital and placed on bed rest.

"Why is this happening to us?" I ask Michael, who has just arrived.

"Relax, I'm glad you are here, and now you will rest without a doubt."

Because of my history I am kept in the hospital for several weeks until the baby is due. It is September 9, 1999, and I feel as if I am ready to burst. I'm dilating very slowly and want to deliver this baby today. On my way downstairs to get an epidural, I notice that the emergency room is packed with pregnant women. "What are all these women doing here?" I ask the nurse.

"Today is 9/9/99, and if you are born this day you will receive a letter from the queen. All these ladies are here to get their letter." My doctor arrives to deliver, but instead of a baby I receive an apology: "I'm afraid I won't be able to take you until tomorrow."

Michael arrives at my room with champagne in hand, but our celebration will have to wait. The morning of the tenth things are still slow going. "Please, anyone, give me an epidural," I cry. A doctor, who is not my gynecologist, decides to wheel me down to the emergency room so that I may be given one.

"You still have a long way to go," she says as she breaks my water and sends me for an epidural. A junior nurse over to stay with me. Shortly thereafter, I feel a sharp pain and the baby moving. "Michael! The baby is coming!"

"Hold on, darling, we're in the emergency room hallway, she can't be coming! The doctor just said it will take time."

I'm moving about in every direction, unable to find a comfortable position, and Michael can hardly keep me from jumping off the table. "She's coming!" I yell, to the dismay of people in the emergency room watching television. I'm sweating, then I'm cold, then a pain comes, so I scream, "She's coming!" Finally, I let out a gut-wrenching cry, open my legs, and realize everyone is watching me now instead of the television.

Michael and the nurse look at me, and then each other. "Oh my God!" they both cry out for support at the same time and then the nurse helps me deliver right there in the middle of the emergency room. My daughter Marina is in such a rush to come into this world that she left her placenta inside and they wheel me to the operating room to have it removed. Marina is handed to Michael, who gets to bond with her first as I am rushed off to surgery. He is able to step into that priceless moment normally reserved for mother and child. It is love at first sight for Michael and very fitting that he would be blessed with this honor.

Marina is healthy, happy, and obviously raring to go! It is overwhelming for me. After all this time, the number of attempts and disappointments, my miracle baby has arrived. Marina's birth is also my time to be reborn. One look at her gorgeous little face and I know everything is about to change for the better.

When we return home from the hospital, Sophia is delighted to see her new baby sister and Andreas is quite the big brother. No longer having to worry about my consulship, I indulge myself in motherhood. Yes, of course, I'm still working diligently on Munich and the Lans case and my business, but I keep my word to myself and to Michael to slow down. Giving birth to Marina at this later stage in life affords me the financial security to focus my undivided attention on the children and Michael now. Each day is a gift to me as I leave the day-to-day management of Octagon to care for my newborn.

FEBRUARY 2000, NICOSIA, CYPRUS

Sitting in the archbishop's office with my baby Marina strapped to my chest, I compose a press release, which says that the archbishop will be traveling to the Netherlands tomorrow to meet with the Church's attorney, Polak, and with Church representative Tasoula Hadjitofi to discuss the pending Munich and Lans cases. I instruct the archbishop's secretary to hold off sending the press release to the media until long after we board the plane.

By the time Cyprus wakes up, the archbishop will be safely in the Netherlands under the care of one of the royal house physicians. The last couple of

months I have noticed a change in him. If there is something more seriously wrong, we will know by the end of this week.

The archbishop is taken to see Professor W. A. "Pim" van Gool, a professor of neurology with special reference to dementias at the Academic Medical Center in Amsterdam. Of all the people who might run this impressive unit, Pim van Gool happens to be Polak's brother-in-law. Fate intercedes in our favor once again.

I use my business contacts to further protect the archbishop's identity. I rent several rooms at the Kasteel De Wittenburg, a private boutique establishment in Wassenaar, off the beaten path, in case any reporters are in search of him.

I hire a driver to chauffeur us to various doctor's appointments and labs for testing. The archbishop naps in the middle of the day, and in the evening I prepare lavish home-cooked meals, inviting a close-knit circle of discreet friends to join us.

The archbishop is diagnosed with memory loss, probably Alzheimer's disease.

"Tasoula, I'm going to need your help," the archbishop tells me.

From this point on, I travel to Cyprus every six weeks with a doctor from the Netherlands, and we bring a supply of his medication from Holland, labeled in Dutch, to prevent people from figuring out that he is in the beginning stages of dementia.

"I want to know details about what is coming, when my judgment will be impaired, as I want to abdicate before that point. I will need your help to do that," he says. This is a cruel blow. Putting everything else aside—the icons, the Munich and Lans cases—this man is family to me, a father figure who has given me unconditional support. To know that I will be slowly losing him to a dreadful disease with no cure leaves me with the thought that nothing is permanent, that when we are lucky enough to have someone in our lives whom we cherish, someone who is remarkable in every way, we must never take them for granted.

APRIL 2000, EASTER IN CYPRUS

The archbishop will lead the Easter service, and we will be christening Marina the following day.

The Easter service is especially meaningful to me this year. As the archbishop says the words we all long to hear, "Christos Anesti," I stomp my feet and yell "Christos Anesti" with a new passion. It gives me chills to be here and I feel, in a way, that I have had my own resurrection. I will continue to work with the Church to recover the stolen artifacts, but not at the expense of my health and family. The archbishop must follow suit.

When all the files are scrutinized in years to come, they will see that it was a refugee of war, an archbishop, and an art dealer-turned-informant who put Aydin Dikmen in jail temporarily and recovered more than five thousand sacred artifacts from Cyprus and around the world. As a refugee in search of her identity, I felt empowered becoming involved in protecting cultural heritage. Repatriating the artifacts helped me to reclaim what was rightfully mine. Now I invite other refugees to walk with me and become a Cultural Crime Watcher. Every piece of cultural history tells a story and although we all ultimately have different stories to tell we must see the bigger picture and rebuild our future with the ruins of our past.

❧

On Easter Monday, the day after Easter Sunday, we travel to the Royal Monastery of Kykkos, one of the most famous in Cyprus and where the monks still live in isolation. Located on the far edge of the Troodos Mountains, in one of the most picturesque spots on the island; it is the place where men stand guard at President Makarios III's tomb. It lies on top of the mountains overlooking Cyprus.

Before the ceremony, I watch the archbishop and Marina share a special connection all their own as he holds her and talks with her playfully. He makes the sign of the cross on the crown of her head, the bottoms of her feet, and in the palms of her hands, enticing her to giggle. Watching the two of them pleases me so. My beautiful daughter grabs for his emblem and smiles at him. He responds in kind, and this moment is forever etched in my mind. As he begins the ceremony to bring Marina into the Orthodox world, I feel grateful to be celebrating this moment,

my culture, and traditions in my homeland. This is the image that I hold onto when I think of him, a snapshot lodged in my memory of the great man that he was. It is symbolic that as we proclaim the resurrection of Christ, the christening of my daughter into the Orthodox religion, that my faith is also reborn.

Thirty-One

DEALERS OF GOD

Despite the archbishop's return to the Netherlands for additional care in 2001, and my regular trips with his Dutch doctor every four to six weeks to check on his condition in Cyprus, his health declines. The archbishop's physical condition worsens drastically when he has a fall in 2002. Once he is admitted into the hospital in Nicosia for injuries associated with the fall, the doctors become aware of the medications he is taking, and our secret is revealed.

In 2002 I appeal to the Holy Synod to retire the archbishop, which they eventually do. I continue to visit him through the years in Cyprus and even during his darkest moments, when he does not respond to others, he connects with me, to the delight of his nurses.

The Munich case from 2000 to 2006 stalls. A new attorney general removes Stella from the case and begins a civil suit against Dikmen.

In 2007, the Dutch Parliament changes their legislation opening the door for Cyprus to request the return of the four icons from Antiphonitis, government to government. I never get to share the news with my beloved archbishop, as his condition worsens once again. In December in The Hague the streets are filled with the sounds of Christmas as traditional music plays

from Dutch mobiles. I think about the archbishop as I pick up a music box, in the Bijkenkorf department store, looking forward to visiting him in Cyprus, when the phone rings.

It's Bishop Vasilios. He pauses for a moment and I think, *No, God, no.*

"Grandad just left us, and you are the first to know."

I knew this day would come, and yet I could not prepare for it. I find a seat in the store and break down in tears as the reality of what I lost is made real. Michael and I attend the funeral in Cyprus. I pay my respects to the great man who is wearing the handwoven gown with golden threads that I had specially made for him. He looks so peaceful as he lay in the Saint John Chapel next to his palace. I remember the times we shared and what we accomplished together. He was my spiritual father and I loved him. And so it is especially difficult for me to watch his opponents arriving in their fancy cars, sitting in the first row, talking on their cell phones, wearing their fancy watches. There is no respect even among the holy men. As I look around I notice that greed has become what some people worship instead of God. A desire for money and power appears to take precedence over all else. I realize that Dealers of God are everywhere, not just in the international trade of art houses.

After his funeral, I close that chapter on my life as destiny calls me into service once again.

Thirty-Two

WALK OF TRUTH

When my daughter Marina is born, I make a commitment to my children not to pass on the fear and anger that I hold for the Turkish people, something that took root in childhood. I have no wish to taint my children's experience or allow the mistrust that I've inherited to be passed on to another generation. War destroys every ounce of trust between nations. Recognizing the extent of the destruction of the symbols of my faith makes me want to understand the conflict that exists between Turkey and Cyprus on a deeper level. I dedicate a few years of my life to learning everything I can about the Turkish culture. I begin with the language and, through taking weekly walks with my Turkish teacher, Erhan Gurer, we exchange our favorite artists, musicians, writers, poets, photographers, and philosophers so that we may each explore each other's culture with a fresh perspective. We even confide what we believe about each other's culture and concerns about each other's religion. Because there is a respectful space for dialogue to emerge between us, a trust is born and a friendship created.

In 2011, based on my passion to continue to spread the word about the importance of protecting cultural heritage, and to share the lessons learned from Cyprus, I establish a nongovernmental organization (NGO) called Walk of Truth. The name comes from my own "Walk of Truth," a reflection on the lessons learned from my experiences. I set out on this journey to reclaim my identity and what I discover is that it has been with be all the while. Who I am as a person and what I stand for lives within. I thought that my identity was stolen from me but no one can take that away from you unless you let them. Each of us carries a personal history. Through the course of our work and our personal lives, we unknowingly trigger one another's emotional wounds. This exposes our vulnerabilities and causes an adverse impact on our productivity and on the environment. Our inner conflicts create misunderstandings between us, leading to the destruction of relationships, which also escalates to a national level. When egos dominate, there is a lack of respect for diversity and religious beliefs that poisons the atmosphere.

Walk of Truth gives me a platform to continue the idea that culture can be what connects us, not what divides us. It can only be achieved if we stop pretending we are the same and explore and discover each other's diversity with respect. The cultural history of the world belongs to each of us, which is why we must all contribute to protect it. Walk of Truth gives me the opportunity to continue my repatriation work and to engage the public in my efforts.

After I witnessed the destruction of cultural heritage taking place in other parts of the world, I decided to share my network of contacts and expertise to empower others living or fleeing from areas of conflict to be engaged in the repatriation of their own arts. I launched Cultural Crime Watchers Worldwide (CCWW), which will provide a twenty-four-hour anonymous hotline for refugees, displaced citizens, and individuals around the globe to join me as peaceful warriors in the battle against the destruction of cultural heritage and art trafficking. CCWW will allow individuals to report the looting, destruction, and trading of cultural heritage with the goal of encouraging ethical trade.

As a refugee, I hope to inspire millions of other refugees around the world to see that they can make a difference. My way was to see to the return of

the sacred artifacts and I invite everyone out there to join my movement of peaceful warriors wishing to reclaim their identity.

These priceless artifacts and antiquities that hold a road map to our past and shed light on our advance into a civilized society are treated without regard for their spiritual and emotional value. When a religious monument is conquered by another faith like the Church of Ayia Sofia in Istanbul, the resentment and mistrust is passed from generation to generation. Without trust, there can be no peace and reconciliation.

We create a demand with our greed and justify our actions to buy and sell religious symbols because we have lost our moral compass.

THE WRAP UP

Munich

In September 2010, the Bavarian court issues a decision and rules in favor of Cyprus. Dikmen, files and appeal. The court rules that some of the artifacts will be returned to Cyprus in March of 2013.[1]

In March of 2013, the Bavarian court issued a partial decision clearing the way for 173 of those Cypriot artifacts from the Munich sting to return to Cyprus. The remaining artifacts that were taken from churches in the occupied area that cannot be sufficiently proven to be of Cypriot origin, require further investigation.[2] One of the sacred artifacts returning to Cyprus is the Saint Thomas mosaic from the Church of Panagia Kanakaria and it along with other returned artifacts are now displayed in the Byzantine Museum of Cyprus in Nicosia.

In March of 2015, the Bavarian court issues a decision on the Munich case in regard to the fate of another thirty-four artifacts. It is decided that these artifacts will also return to Cyprus. There are forty-nine additional artifacts where sufficient proof of provenance has not been provided and these will be auctioned off in Germany.

Walk of Truth sends a letter to the minister of justice in Germany to demand the entire catalogue of confiscated artifacts from the Munich

operation be published so that other nations may reclaim their artifacts, as Cyprus did. Up until this day, no list was ever made public.

Lans

At a roundtable debate organized by Walk of Truth at the Peace Palace on September 13, 2013 in The Hague titled, "Art Trafficking and Restitution: Lessons Learned from Cyprus and Afghanistan," it is announced that after nineteen years of court battles, a lengthy civil trial, and my persistent lobbying of the Houses of Parliament to amend the existing law to comply with the Hague Protocol, the Dutch government has agreed to return the four icons from the Lans case to the Republic of Cyprus. The icons return home on September 18, 2013.[3]

When the Munich and Lans artifacts are returned to Cyprus, I am not invited by church or state to welcome them home. As I hear what I worked on for almost thirty years be presented as a victory of church and state, I smile. What is important is that the Cypriot people rejoice with me as these refugee artifacts are returned home. My mission is accomplished.

Thirty-Three

IT AIN'T OVER

n my favorite glass room that overlooks our garden, I sip my morning cup of freshly brewed Lady Grey tea and pick up my ringing phone.

"Tazulaah! Listen!" It's the voice of Van Rijn yelling above the sound of wind and the crashing waves.

"I'm in Zanzibar, my father's favorite place. It's beautiful here!" I hear waves crashing in the near distance. "I'm all dressed up in my tuxedo, woman. Can you guess what I am doing?" says Van Rijn.

"I can't imagine," I say.

"I came to bury his memory." Van Rijn drops his father's answering machine in a hole he dug in the sand. Looking at the Indian Ocean he says, "Tazulaah. Can you hear that, Tasoula? I'm free of him now. He no longer has a hold on me. You should be free, too. You should bury Cyprus. I can make that happen, Tazulaah. I have a lead to your Andreas. It's time we put an end to Munich. Are you there?"

EPILOGUE

ronically, the end of my forty-year odyssey leads me back to the Mediterranean waters of Cyprus where it all began. On July 9, 2013, a small, chartered bus pulls into Agios Dometios, the main border crossing from Nicosia into northern Cyprus, a painful reminder that I am a refugee within my own country. Once we are issued temporary visas, we drive into the Turkish-occupied area of Cyprus, and head toward Famagusta. My father, cousin Savakis, and a small group of friends accompany me. My father spots the first tears on my face.

"You can do this, Tasoula," he says and holds my hand as he did when I was a small child.

At this moment everything inside me is aching for what was. The closer I come to facing the ghosts of my past, the more I tremble.

As the bus travels farther down the highway, I am stunned by the changed landscape. The road signs and the village names have all been changed from Greek to Turkish; the Saint Barnabas Monastery, where my cousin Vasilios lived as a young monk, is under Turkish control and has been turned into a museum. We, the faithful, are now required to pay in order to enter and pray, something I could never agree to. The last time I saw the monastery and the ancient city of Salamis was April 1974, when my family and I attended Holy Thursday service and made a picnic amid the ruins of Salamis on our way to celebrate Easter in Mandres.

When the borders first opened in 2003, my parents, my siblings, and their families first made the pilgrimage. I traveled to Cyprus to help prepare them for the journey, but I could not summon the courage to accompany them. I make this journey today because I am ready to transform the anger I feel within. Bringing the icons back to Cyprus did not heal the pain I felt about my inability to return home as I thought it might. I still find myself overwhelmed with a need to rid myself of this haunting burden.

It is important for me to smell the air of Famagusta, to touch the sand I played in with my siblings as a child, and to walk barefoot in the waters that embrace my city. Perhaps I will discover, after being abroad since 1976, just how much of that girl from Famagusta is still left in me.

The bus turns off the two-lane highway onto a smaller road and into a parking lot. Hand in hand, my father and I walk by buildings that were destroyed in the invasion. I look up at the bombed-out hotels and apartment buildings, stunned to see that they have been frozen in time since 1974.

The sand is blistering hot as we continue to the beach and walk past European tourists sunning themselves, completely oblivious to the history and suffering that took place in the very location they chose to vacation. This land is sacred to us. Our people died defending our country, and we are the silent witnesses to the atrocities that took place on this soil.

We continue on for about two tenths of a mile, until we reach the farthest tip of this stretch of beach. As I turn to my right, just across the bay, I see Varosha, the area of Famagusta where I was born. Once my childhood home, it is now a ghost city.

I let go of my father's hand and enter the sea fully clothed, captivated by the view of my birthplace in the distance. This is the photograph that you see on the cover of the book. Every emotion I have overwhelms my heart as my eyes rest on the ghost city. Just a short swim away and I can become that young girl from Famagusta again. I am sad, I am angry, I am horrified—I am in mourning.

I don't hear the cries of my father or my friends who urge me to return to shore. Their voices are muted by the sounds of the waves brushing up against the shoreline and by the voices of my youth. Varosha calls to me from a distance, so I continue wading until the sea reaches my waistline. The

quickened beating of my own heart senses the Turkish soldiers standing on a platform to my right with their guns pointed at my head, shouting for me to return. I am fearless. I have waited forty years for this moment, and their guns do not scare me.

I look across the water and I want to shout to the world, "I am a girl from Famagusta. I am from this ghost city, but I am no ghost. I exist and I want to be heard." Which law or international treaty gives these soldiers the right to kill me for wanting to go home? If we are silent when the law is abused, we have lost our moral compass.

Varosha stands as an outdoor museum to remind us of the impact of war. This apocalyptic remnant of the invasion is a warning to the rest of the world. It is a symbol of wasteful destruction and the social impact of cultural cleansing. Facing my painful memories, I realize that I have been living in the same purgatory as my parents. I, too, have been waiting year after year for politicians to come up with a solution to the Cyprus issue. There will be no resolution until we, the people, make it so.

I am finally able to let go of my anger and resentment as I realize that everything I have gone through to this moment now bids me to call upon every Cypriot—Greek and Turkish—wherever they are, to peacefully walk home with me. I also call upon every good citizen around the world who rejects violence and injustice to join me in this peaceful march. To the 65 million refugees, asylum seekers, and internally displaced people that exist in the world today, who are adrift, struggling, and fearful, I am one with you.

My parents are at the end of their lives. With each passing day my fear of being unable to bury them next to their ancestors consumes me. My parents deserve to have in death what the politicians could not give them in life, something that is our God given right . . . the freedom to go home.

One person can change the world; this we know. Be that person and walk with me.

If you would like to find out more about my work and become a culture crimewatcher go to www.walkoftruth.org and please visit www.tasoulahadjitofi.com.

ENDNOTES

CHAPTER ONE: THE SET-UP
1 Document 2.2.1.10 TH Archive—Pretrial Brief—2.2.1.11—*New York Times* article.

CHAPTER TWO: HERE WE GO AGAIN
1 Document 2.1.1.3, 2.1.1.6, 2.1.1.7, 2.1.1.8, 2.1.1.9 and 2.1.1.10 TH Archive—Request for adviser.
2 http://www.loc.gov/law/help/cultural-property-destruction/cyprus.php
3 http://www.academia.edu/9306082/
 Christianity_in_Cyprus_in_the_Fourth_to_Seventh_Centuries_2014
4 J. Dalibard, Cyprus: Status on the Conservation of Cultural Property 3 (UNESCO, Jan. 1976) (internal report) http://unesdoc.unesco.org/images/0002/0002117/021772eb.pdf.
5 TH Archive. Jacque Dalibard Heritage Approach to Life—Macodrom Library/Archives & Research Collections—Carleton University.
6 Document 2.2.16.15 TH Archive—Dated 10/08/97—Outline of Deal to Attorney General.

CHAPTER FOUR: DATE WITH A DEVIL
1 http://www.bbc.com/news/magazine-25496729
2 http://www.smithsonianmag.com/travel/
 endangered-site-famagusta-walled-city-cyprus-54478493/?no-ist
3 Press Conference, Munich—The Hague—Speech Papageorgiou—TH Archive.

CHAPTER FIVE: REFUGEE
1 www.nytimes.com/2001/05/11/world/nikos-sampson-66-cyprus-president-after-coup-dies.html
2 Nasuh Uslu, *The Cyprus Question as an Issue of Turkish Foreign Policy and Turkish-American Relations, 1959–2003.* (Nova Publishers, 2003).
3 Uslu, pp. 118–119.

CHAPTER SIX: THE DANCE
1 TH Archive—2.1.1.11 Papageorgiou to UNESCO.
2 Document 2.2.1.12 TH Archive—Fax from head of police, Mr. Karayias.
3 Document 2.2.1.8 TH Archive—*Kathimerini* newspaper-Greek language.
4 Document 2.2.4.39 TH Archive—*New Yorker* article, July 13, 1989.
5 www.swissinfo.ch/eng/culture/
switzerland-restores-image-over-art-trafficking/9005486
6 Document 2.2.1.20 TH Archive—*Time* magazine, July 1989.
7 Document 2.2.12.14 TH Archive—*Texas Monthly*, January 1997.
8 Document 2.2.1.10 TH Archive—Pretrial brief—Kanakaria case.
9 Document 2.2.1.36 TH Archive—T. Hadjitofi fax to Director General 11/1989 RZ.

CHAPTER SEVEN: A SIGN
1 Document 2.2.1.3 TH Archive—Photograph of Archangel Michael icon given by Van Rijn.
2 Document 2.2.1.27 TH Archive—Fax from Van Rijn.
3 Document 2.2.1.36 TH Archive—Roozemond to TH.
4 Document 2.2.1.32 TH Archive—Roozemond Letter. Document 2.2.1.36 TH Archive—TH to Kyprianou on Roozemond letter.
5 Document 2.2.1.24 TH Archive—Notes about meeting with Van Rijn faxed to Michael Kyprianou.
6 Document 2.2.1.25 TH Archive—Agreed order on the Kanakaria case rules in favor of Cyprus and the Church being the legal owners of the sixth-century mosaics.

CHAPTER NINE: HAPPY NEW YEAR!
1 Document 2.1.2.42 TH Archive De Wijenburgh Bankruptcy.
2 Document 2.2.2.1 TH Archive—Weijenburgh—sighting of Royal Doors.
3 Document 2.2.2.5 TH Archive—Tasoula's fax to Kyprianou.
4 Document 2.2.2.11 TH Archive—Roozemond's letter to Papageorgiou.
5 Document 2.2.2.34 TH Archive—Papageorgiou to Roozemond.
6 Document 2.2.7.15 TH Archive—Note Papageorgiou.

CHAPTER TEN: BAPTISM BY FIRE
1 Document 2.2.1.22 TH Archive—Agreed order on the case Autocephalous Greek-Orthodox Church of Cyprus v. Goldberg.
2 Document 2.2.2.25 TH Archive—Tasoulas Fax to the MFA.
3 Document 2.2.2.31 TH Archive—TH fax to Attorney General re: Thies.
4 Document 2.2.2.32 TH Archive—TH fax to Kyprianou.
5 Document 2.2.2.40 TH Archive—TH fax to Kyprianou and Director General.
6 Document 2.2.2.43 TH Archive—Fax to Savvides and Iakovides.
7 Document 2.2.1.38 TH Archive—NRC Article "Defensless Monasteries" (English translation). Document 2.2.2.20 TH Archive—Settlement agreement Roozemond and NRC (English translation). Document 2.2.2.23 TH Archive—Settlement agreement Roozemond and NRC (original agreement in Dutch).
8 Document 2.2.3.1 TH Archive—Wybenga letter to Kyprianou—draft for Tasoula's comments.

CHAPTER ELEVEN: LIFE AND DEATH

1 Documents 2.2.3.17, 2.2.3.19, 2.2.3.20 TH Archive.

CHAPTER TWELVE: WHAT LIES BENEATH

1 Document 2.2.3.6 TH Archive—Letter to Sotheby's from Kyprianou.

2 Document 2.2.3.8 TH Archive—Letter to Kyprianou from Sotheby's.

3 Document 2.2.3.17 TH Archive—Copy of East Christian Art Exhibit catalogue—Petsopoulos.

4 Document 2.2.3.11 TH Archive—Letter from Kyprianou to Sotheby's.

5 Documents 2.2.3.9. 2.2.3.11 TH Archive—Letter from Kyprianou to Sotheby's.

6 Document 2.2.3.12 TH Archive—Letter from Sotheby's to Kyprianou.

7 Document 2.2.3.10 TH Archive—Copy of document from Roozemond to Sotheby's.

8 Document 2.2.4.3 TH Archive—TH to M. Kyprianou on Papageorgiou identifying Cypriot icons from De Wijenburgh slides.

9 Document 2.2.4.1 TH Archive—TH note to Archbishop about her involvement in tracing artifacts. Document 2.2.4.4 TH Archive—Kyprianou Fax to TH—asking if she wrote to the Archbishop yet (page 1, in Greek).

10 Document 2.2.4.1 TH Archive—TH to archbishop.

11 Document 2.2.4.10 TH Archive—Evidence from Stoop about icons purchased (page 3, in Dutch). Document 2.2.4.16 TH Archive—Statement of Stoop (pages 8–10, in Dutch).

12 TH Archive 2.2.4.16—Article 10 Statement of Stoop/Correspondence with Kounoupias and Romke Wybenga. Also Article 5 (page 4).

13 Document 2.2.4.16 TH Archive—Mr. Toorennaar's deposition.

14 Document 2.2.4.16 TH Archive—Mr. Toorennaar's deposition.

15 Document 2.2.4.16 TH Archive—Mr. Toorenaar affidavit.

16 Document 2.1.1.19 TH Archive—Invoice Roozemond to Mulié (in Dutch).

17 Document 2.1.1.20 TH Archive—Roozemond to Mulié John the Baptist (in Dutch).

18 Document 2.1.1.21 TH Archive—Roozemond Mulié John the Baptist (in Dutch).

CHAPTER THIRTEEN: THE BIRTH OF AN ICON HUNTER

1 Documents 2.2.4.19 and 2.2.3.11 TH Archive—Wijnburgh documents (in Dutch).

2 Document 2.2.4.23 TH Archive—Beker letter to Kounoupias re: John the Baptist.

3 Document 2.2.4.30 TH Archive—Roozemond's statement re: John the Baptist.

4 Document 2.2.4.30 TH Archive—Roozemond's statement re: John The Baptist.

5 Document 2.2.5.25 TH Archive—Axia Receipts—Bills of lading.

6 Document 2.2.4.38 TH Archive—TH confirms her appointment with archbishop.

7 Document 2.2.4.54 TH Archive—TH notes while meeting with Van Rijn.

8 Document 2.2.4.53 TH Archive—Memo to the archbishop re: Van Rijn from TH.

9 Document 2.2.4.56 TH Archive—Memo to Kyprianou from TH re: VR's statement JTB.

10 Document 2.2.4. 57 TH Archive—Kyprianou's assurance to VR re: statement.

11 Document 2.2.4.62 TH Archive—Tasoula's assurance to VR re: statement.

12 Document 2.2.4.45 TH Archive—Tasoula's fax to the Ministry regarding 8/5/92 meeting with archbishop.

13 Document 2.2.4.64 TH Archive—Private detective Toorenaar's report on Schiphol.

14 Document 2.2.4.51 TH Archive—TH letter to Ministry Attachment archbishop nomination for committee for stolen art.

CHAPTER FOURTEEN: ON MY OWN

1 Document 2.2.5.40 TH Archive—TH letter to the Lanses.
2 Document 2.2.5.40 TH Archive—TH letter to the Lanses.
3 Document 2.2.5.49 TH Archive—Copies from a book about the four Apostles icons. Document 2.2.5.35 TH Archive—TH letter to the Lanses. Document 2.2.5.41 TH Archive—TH to archbishop for Lans and Papageorgiou visit.
4 Documents 2.2.5.43 and 2.2.5.44 TH Archive.
5 Document 2.2.5.45 TH Archive—Archbishop accepts Tasoula's proposal and assigns Polak as the Church's lawyer. Also Document 2.2.5.46 TH Archive.
6 Document 2.2.5.70 TH Archive.
7 Documents 2.2.5.52 and 2.2.5.55 and 2.2.5.62 TH Archive.
8 Document 2.2.5.68 TH Archive.
9 Document 2.2.1.3 TH Archive—Photograph of Archangel Michael provided to TH by VR.
10 Document 2.2.5.56 TH Archive—TH to the Ministry about Archangel Michael.
11 Document 2.2.5.55 TH Archive—TH to archbishop re: Update on Lans and Archangel Michael.
12 Document 2.2.5.63 TH Archive—Son's letter to T.
13 Document 2.2.5.66 TH Archive—Tasoula's letter to a possessor of Archangel Michael.
14 Document 2.2.5.78 TH Archive—Doctor/Church agreement Archangel Michael.
15 Document 2.2.6.7 TH Archive.
16 Document 2.2.6.1 TH Archive—Letter from Lans attorney about an exhibition in Holland.

CHAPTER FIFTEEN: NO JUSTICE

1 Document 2.2.7.14 TH Archive—Extension Polak.
2 Document 2.2.7.15 TH Archive—Papageorgiou's confirmation of Royal Doors.
3 Document 2.2.7.20 TH Archive—Notes of Lans Meeting. Also, Document 2.2.7.32, TH Archive—Letter from Polak.
4 Document 2.2.7.32 TH Archive—Letter from Polak.
5 Michel Van Rijn, *Hot Art, Cold Cash* (Little Brown & Company, 1993), pages 8, 9, 13, 15–21.
6 Document 2.2.8.2 TH Archive—Dergazarian statement written by Van Rijn.
7 Document 2.2.7.33 TH Archive—VR handwritten notes to TH re; Royal Doors.
8 Document 2.2.8.3 TH Archive—TH to Ministry—invoke Protocol.
9 Document 2.2.8.8. TH Archive—Minister Alecos Michaelides to Minister Hans van Mierlo on invoking the Protocol (pages 3–5, in English). Also http://portal.unesco.org/en/ev.php-URL_ID=15391&URL_DO=DO_TOPIC&URL_SECTION=201.html
10 Document 2.2.8.6 TH Archive—TH to Polak, draft of Royal Doors letter. Also, Document 2.2.8.7 TH Archive—Polak's comments on draft letter.
11 Document 2.2.7.33 TH Archive—VR response to Royal Doors letter.
12 Document 2.2.8.33 TH Archive—TH VR lawyer re: Royal Doors letter. Also, Document 2.2.8.13 TH Archive—Final Royal Doors letter.
13 Document 2.2.8.34 TH Archive—TH updates archbishop.
14 Document 2.2.8.27 TH Archive—Papa to TH VR's expenses.
15 Document 2.2.8.36 TH Archive—Power of Attorney/Fax to Van Rijn.
16 Document 2.2.8.39 TH Archive—Handwritten note from TH to Kanazawa Recipients.

17 Document 2.2.8.39 TH Archive.
18 Documents 2.2.8.43, 2.2.8.44, 2.2.8.48 TH Archive.
19 Document 2.2.8.48 TH Archive—VR Fax to T in Japan.
20 Document 2.2.9.15 TH Archive—Asahi Shimbun.

CHAPTER SIXTEEN: NO PEACE
1 Document 2.2.9.45 TH Archive—Petition Royal Doors (Greek and English).
2 Document 2.2.9.6 TH Archive—Info to Yamada.
3 Document 2.2.9.31 TH Archive—TH to Kanazawa.
4 Document 2.2.9.41 TH Archive—Kanata Law Firm.
5 Document 2.2.9.39 TH Archive—TH to Ministry.
6 Document 2.2.9.4 TH Archive—TH to Ministry.
7 Document 2.2.8.54 TH Archive—VR to Geraldine Norman.
8 Document 2.2.8.55 TH Archive—Article Van Rijn.
9 Document 2.2.9.63 TH Archive—Meeting with the Ducth re: Lans.
10 Document 2.2.9.60 TH Archive—Royal Doors: Legal advice.
11 Document 2.2.9.74 TH Archive—Polak to Japanese lawyer.
12 Document 2.2.9.81 TH Archive—TH to Kanata Law Firm.
13 Document 2.2.10.21 TH Archive—Law firm to TH Royal Doors.
14 Document 2.2.11.29 TH Archive—TH to President of Cyprus.
15 Document 2.2.11.34 TH Archive—President's letter to TH.
16 Document 2.2.11.54 TH Archive—Kanazawa to archbishop.
17 Document 2.2.10.3 TH Archive—Article in *Algemeen Dagblad* Ambassador coming
 (English translation).
18 Document 2.2.10.4 TH Archive—Roozemond letter to archbishop.
19 Document 2.2.10.4 TH Archive—Roozemond's open letter to the archbishop and media.
20 Document 2.2.11.19 TH Archive—Polak to Roozemond re: TH.
21 Document 2.2.11.17 TH Archive—Archbishop response to Roozemond.
22 Document 2.2.10.9 TH Archive—Letter to the British Museum from Van Rijn.
23 Document 2.2.10.13 TH Archive—Polak response to the British Museum (Dutch and
 English).
24 Document 2.2.10.17 TH Archive—TH to British Museum.
25 Document 2.2.10.22 TH Archive—TH to Papageorgiou re: Lans.
26 Document 2.2.10.14 TH Archive—Polak Extension.
27 Document 2.2.15.6 TH Archive—Letter to Tweede Kamer der Staten General re: support
 from Dutch Govt.
28 Document 2.2.19.37 TH Archive—Reply Minister of Justice Mr. Sorgdrager.

CHAPTER SEVENTEEN: THE ROAD TO MUNICH
1 Document 2.2.12.13 TH Archive—Summary of Lans.
2 Document 2.2.12.36 TH Archive—TH to MFA.
3 Document 2.2.13.9 TH Archive.
4 Document 2.2.13.10 TH Archive.
5 Document 2.2.13.35 TH Archive.
6 Document 2.2.15.7 TH Archive—Polk Letter of Extension.
7 Document 2.2.15.20 TH Archive—Copy of Article from the Cyprus News Agency

(CAN). Doument 2.2.15.21 TH Archive—Article in *De Telegraaf* (Greek translation/ Dutch original). Document 2.2.40.5 TH Archive—Article Church sues Roozemond Royal Doors.

8 Document 2.2.15.5 TH Archive—De Volkskrant Article Van Rijn (in Dutch).

9 Document 2.2.15.63 TH Archive—German police inform TH and TP Dikmen suffers from AIDS. Oct. 1997 (in Greek).

10 Documents 2.2.15.3, 2.2.15.5 TH Archive—Greek handwritten notes to the archbishop (in Greek)/Article on Van Rijn (in Dutch).

CHAPTER EIGHTEEN: NOT SO FUNNY BUSINESS
1 Document TH Archive 2.2.15.3.

2 Document 2.2.15.10 TH Archive—TH to Ambassador Zenon—Requesting appointment.

3 Document 2.2.15.34 TH Archive.

4 Documents 2.2.15.23 and 2.2.15.24 TH Archive—TH to Zenon.

CHAPTER NINETEEN: IN THE NAME OF THE FATHER
1 Document 2.2.15.30 TH Archive—Strategy to archbishop and AG.

2 Document 2.2.15.40 TH Archive—ABN AMRO Account.

3 Document 2.2.15.30 TH Archive—Strategy.

4 Document 2.2.15.42 TH Archive.

5 Document 2.2.15.28 TH Archive—TH to AG (Greek) Confirmation about Munich Part 1.

CHAPTER TWENTY: THE RETURN
1 Document 2.2.15.40 TH Archive—TH fax to wire money into bank account for VR trade.

2 Document 2.2.15.45 TH Archive—Watson signs receipt MVR payment.

3 Documents 2.2.15.56 & 2.2.15.47 2.2.15.45 TH Archive—Watson to TH.

4 Documents 2.2.16.14 and 2.2.16.16 TH Archive (in English and Greek).

5 Document 2.2.15.48 TH Archive—TH to SI—artifacts delivered.

6 Document 2.2.15.68 TH Archive—agreement with Jan Fred.

7 Document 2.2.15.55 TH Archive—Polak to TH re: Lans development.

CHAPTER TWENTY-ONE: TESTING . . . ONE, TWO
1 Document 2.2.15.63 TH Archive—Report in Greek; Tassos Panayiotou activity with MVR.

2 Document 2.2.15.63 TH Archive—Trip to Munich via Bremme (in Greek—page 7).

3 Document 2.2.15.63 TH Archive—(page 7—Greek—evidence for chapter).

CHAPTER TWENTY-TWO: CAPTURING THE GOLD
1 Document 2.2.17.31 TH Archive—Press Release Cyprus.

2 Document 2.2.16.33 TH Archive—Fax to David Hole Attorney for the Church in Germany.

3 Document 2.2.21.5 TH Archive—TH press release on new artifacts found. Document 2.2.21.12 TH Archive—Newspaper articles from Cyprus.

4 Document 2.2.21.72 TH Archive (in Greek).

CHAPTER TWENTY-THREE: LESSONS LEARNED
1 Document 2.2.18.12 TH Archive—FedEx Receipt of Key to Kitschler—Note from TH.

CHAPTER TWENTY-FOUR: POWER STRUGGLE
1 Document 2.2.21.74 TH Archive—TH to DG, MFA, Police re: Van Rijn.
2 Document 2.2.20.34 TH Archive—VR to TH casino clippings wants a license 11/11/97.

CHAPTER TWENTY-FIVE: TACTICAL WARFARE
1 Document 2.2.19.15 TH Archive—Legal advice re: third party claim.
2 Document 2.2.20.18 TH Archive—TH to AB DG re: Turkish Ambassador (in Greek).
3 Document 2.2.19.24 TH Archive—Poster.
4 Document 2.2.20.62 TH Archive—Dec 6th Text removed from poster Dutch article (page 13, in Dutch) and Document 2.2.20.77 TH Archive—Article on Censorship (in Dutch).
5 Documents 2.2.18.37–2.2.18.97 TH Archive—various press articles.
6 Document 2.2.21.10 TH Archive—Polak on Lans.
7 Document 2.2.20.8 TH Archive—Winkelman—Fax copy of invitation for Exhibition Fax Cyprus.
8 Document 2.2.20.14 TH Archive—November 8th Speech TH Opening of Exhibit.

CHAPTER TWENTY-SIX: THE DEVIL IS IN THE DETAILS
1 Documents 2.2.20.32 and 2.2.20.36 TH Archive.
2 Document 2.2.21.25 TH Archive—VR letter to TH after Hilton meeting 12/10.
3 Document 2.2.22.8 TH Archive—Handwritten notes from Tasoula re: Van Rijn.
4 Document 2.2.21.25 TH Archive—MVR private not to TH.
5 Document 2.2.21.26 TH Archive—TH answers MVR addresses his note below.
6 Document 2.2.20.2 TH Archive (in Greek).
7 Documents 2.2.21.15, 2.2.20.34, 2.2.20.42 TH Archive.
8 Document 2.2.21.24 TH Archive—TH letter to AG, MFA, archbishop about turning VR over (in Greek).
9 Document 2.2.21.15 TH Archive—Moral Dilemma TH to archbishop (in Greek).
10 Documents 2.2.21.42 and 2.21.46 and 2.2.21.51 and 2.2.21.68 TH Archive—Invoices for packing.

CHAPTER TWENTY-SEVEN: RETURN OF THE REFUGEES
1 Documents 2.2.21.70 and 2.2.21.71 TH Archive.
2 Documents 2.2.21.25, 2.2.21.54, 2.2.21.52, 2.2.21.53 2.2.21.38,2.2.21.55 TH Archive.

CHAPTER TWENTY-EIGHT: IT'S CRIMINAL
1 Document 2.2.20.9 TH Archive—Hole to TH.
2 Document 2.2.22.21 TH Archive—TH to Kitschler info on Schmidt and Andreas.
3 Documents 2.2.22.36 and 2.2.34.11 TH Archive—Bavarian police need report 1/13/98.
4 Document 2.2.22.18 TH Archive (in Greek).
5 Document 2.2.22.37 TH Archive—Stella to TH 1/16/98 Stella, London.
6 Document 2.2.22.36 TH Archive—Hole to TH on Siemandel needs report 1/7/98.
7 Documents 2.2.22.45/47/48/49 TH Archive—POA 1/16/97.

8 Documents 2.2.22.53/59/60 TH Archive—Statement and faxes from Stella (in English and Greek).
9 Document 2.2.23.1 TH Archive—To AG's office re: statement.
10 Document 2.2.23.2 TH Archive—TH to chief of police Cyprus.
11 Document 2.2.23.3 TH Archive—TH memo to Bishop Vasilios withdraw from Munich case.
12 Document 2.2.23.11 TH Archive—2/12/98 Polak to Hole on TH and Police investigation.
13 Document 2.2.23.17 TH Archive (in Greek).
14 Document 2.2.23.20 TH Archive—Schilling to Stella 2/20/98.
15 Documents 2.2.24.9 and 2.2.24.27 and 2.2.24.29 TH Archive—Polak to AG and Stella.
16 Document 2.2.24.30 TH Archive—DH to TH Dritsoulas Royal Doors.

CHAPTER TWENTY-NINE: CIVIL UNREST
1 Document 2.2.20.7 TH Archive—RP to TH re: Royal Doors to proceed or not.
2 Document 2.2.23.35 TH Archive—Polak to AB re: response to Schilling and VR.
3 Document 2.2.23.46 TH Archive.
4 Document 2.2.23.48 TH Archive—Hole to Polak re: TH report VR testimony.
5 Document 2.2.24.3 TH Archive—VR to TH fax about father.
6 Document 2.2.23.46 TH Archive—Polak responds to Schilling 3/24/98.
7 Document 2.2.24.67 TH Archive—Stella to Schilling & Lom 5/29/98.
8 Document 2.2.5.29 TH Archive—Kyprianou to TH (in Greek).
9 Document 2.2.25.32 TH Archive—Bitsaxis to TH Greek State looking to ratify Hague Conv. (in Greek).
10 Document 2.2.24.30 TH Archive—TH to MFA Hole's letter, 2.2.24.41 TH to MFA Help!
11 Document 2.2.24.69 TH Archive—AG misses deadline for Germany.
12 Document 2.2.25.28 TH Archive—TH to BV—copy of Stellas letter to Schilling.
13 Documents 2.2.25.25/26/27/29 TH Archive—Notes on VR meeting airport.
14 Document 2.2.25.40 TH Archive.
15 Document 2.2.25.34 TH Archive—Hole to TH Van Rign claim on Munich artifacts.
16 Document 2.2.25.38 TH Archive—Polak to AB—Summary of Munich Case.
17 Document 2.2.25.34 TH Archive—Fax from Hole on Munich Case.
18 Document 2.2.25.40 TH Archive—David Hole MVR court order on artifacts in Munich.
19 Document 2.2.26.31 TH Archive—Minutes from AB meeting with AG—Stella gets boot.
20 Document 2.2.27.5 TH Archive—Polak to AB minutes from conversations with MVR.
21 Document 2.2.27.39 TH Archive—Polak to AB minutes from meeting at Schiphol.
22 Documents 2.2.27.40/46/47 TH Archive—MVR Settlement in Munich.
23 Document 2.2.29.9 TH Archive—TH to MFA, AG, DG, AB, TH summarizes her ordeal with Munich case—tells them she has tapes, VR lied about her.
24 Document 2.2.28.31 TH Archive—Written Summary of Lans English.
25 Documents 2.2.28.1/2/4/11 TH Archive—Munich—Notes from fake Andreas turnover.
26 Document 2.2.29.26 TH Archive (First Page).
27 Document 2.2.29.42 TH Archive—TH to MFA sending tapes to German police.

CHAPTER THIRTY: MAKING PEACE

1 Document 2.2.19.37 TH Archive—Unofficial translation.
2 Document 2.2.31.14 TH Archive—Rotterdam Court decision.
3 Document 2.2.32.17 TH Archive—Polak researches appeal.
4 Document 2.2.30.23 TH Archive—DeBrauw Blackstone Westbroek.
5 Document 2.2.31.13 TH Archive—Article on Angel Head Latsi (in Greek).
6 Document 2.2.32.10 TH Archive—Lanitis article—*Cyprus Weekly* March 1999.
7 Document 2.2.32.11 TH Archive—AB letter to *Cyprus Weekly* response to Lanitis.
8 Document 2.2.33.17 TH Archive (in Greek).
9 Document 2.2.32.32 TH Archive—Letter to law firm TH.
10 Documents 2.2.33.1 and 2.2.33.4 TH Archive.
11 Document 2.2.33.10 TH Archive—Termination of Consul position.
12 Document 2.2.33.25 TH Archive (in Greek).
13 Document 2.2. 33.29 TH Archive—Article on TH St. Barnabas medal.
14 Document 2.2.33.34 TH Archive (in Greek).

CHAPTER THIRTY-TWO: WALK OF TRUTH

1 Documents 2.2.48.41 (in German), 2.2.48. 55 (in English) TH Archive—Munich court rules Artifacts return to Cyprus 9/2010.
2 Documents 2.2.48.41 (in German) and 2.2.48.42 (in Greek) documents 2.2.48.43–2.2.48.45, 2.2.48.47–2.2.48.66 (in Greek, Dutch, German, English). TH Archive.
3 Documents 2.2.48.74 (in Dutch), 2.2.48.77 (in English), TH Archive.

ACKNOWLEDGMENTS

The special relationship that motivated me throughout the long and arduous journey of combating art trafficking was the one that I enjoyed with the late spiritual leader of Cyprus, His Beatitude, Archbishop Chrysostomos I, of the Autocephalous Church of Cyprus, whom I loved, respected and lost too early. Without his unconditional trust there would be no Icon Hunter.

To my husband Michael Hadjitofi and my three treasures—Andreas, Sophia, and Marina—your love is my inspiration. And to my butterfly Anastasia who resides in heaven, I carry you in my heart.

To my siblings Miriam, Yiola, and Andreas, their husbands, wives and children, I hope that one day you understand how deeply I love you. Savas and Flora Kyriacou—you are a brother and sister to me.

To the men, women, and children who lost their lives during the Turkish invasion of Cyprus and to their families who continue to mourn them, my heart is with you.

To the people of Cyprus who gave me my best memories of youth.

And to the people of The Netherlands who embraced me as one of their own.

To Michel Van Rijn, who was the first to make me aware of the cultural cleansing that took place in the occupied area of Cyprus. Thank you for sharing your knowledge about art traffickers and the world of illicit trade which I now dedicate my life to stopping.

In 2012 one hundred people from around the world were invited to attend the first "Spirit of Humanity" conference held in Reykjavik. Kathy Barrett was one of the invitees, as was I. We thank the sponsors of that conference for bringing us together as that meeting planted the seeds for our friendship and my book to be born. Kathy became a true soul mate during this journey.

To the following people who have worked tirelessly to help make this book a reality . . .

Bishop Vasilios now Metropolitan of Constantia and Famagusta, who stood by me and protected me using his charismatic brand of diplomacy.

Metropolitan Timotheos, of Vostra, Representative of the Greek Orthodox Patriarchate of Jerusalem in Cyprus, for sharing his insights and experiences.

Judge Yiorgos Pikis, who people with values revere and those who lost them fear.

Elena Tsingki, for her dedicated efforts in research and documentation.

Marina Schiza, who took the journey with me all the way and is still dedicated to the cause.

Bruce Clark, who challenged my thinking with his wealth of knowledge. He is a friend and a brother to me who believed in my story from the day we met.

Thomas Kline, for his legal expertise and whose connections made this book possible.

Rob Polak, who has the gift of making complex legal arguments understood by all.

Dr. Willy Bruggeman who raised my esteem and respect for law enforcement and kept me safe.

Andy Barrett, whose deeds went beyond the call of duty, especially as I commandeered the lion's share of Kathy's time.

Alexandra Rodrigues, who placed my work above herself and her family.

Mahi Solomou and Dionisis Dionisiou, who utilized every opportunity to promote my work.

Television stars Andreas Georgiou & Koulis Nikolaou and their Brousko team for taking me to Famagusta in 2013.

Pim Dieben, for his friendship and his pictures of Munich, which to-date are used by Cypriots worldwide.

Jessica Case, my publisher, who recognized the value of my story.

Stephanie Abou, my agent, whose guidance helped this book to be born into the world.

David Davoli, my entertainment lawyer for his legal guidance.

Jan Fred van Wijnen, for exposing the issue of art trafficking in the 90's.

Demetrakis Demitriades for safeguarding me like an icon whenever I was in Cyprus.

Nick Kounoupias, for his legal support and friendship.

Ayaan Hirsi Ali, who insisted that my story was the one people needed to hear and who encouraged me to write it.

Tex Gunning, who took me under his wing and shared the importance of self-awareness and the power of silence at the Call of the Time in Oxford.

United Kingdom MP David Burrowes and Baroness Berridge of the Vale of Catmose, for bringing the issue of art trafficking to the House of Lords and House of Commons.

Research/Translations/Visuals
David Hands
Craig Johnson
Myrto Aristidou
Laoura-Maria Fotiou

Katerina Karatzia
Koula Charalambous
Annebeth Rosenboom
Gerda Frankenhuis
Catherine Hickley
Dionysis Alexiou

Countless people have supported my work throughout the years. Space restrictions prohibit me from crediting them here, but their names are acknowledged at www.walkoftruth.org. Without their efforts none of this would be possible.

Thank you to the volunteers and friends of Walk Of Truth, and Cultural Crime Watchers worldwide.

. . . And to the media who helped me to find my voice.

<div align="center">⚜</div>

Attempts were made to interview those named in the book and the over-whelming majority complied.